AT THE NATUR

ATEST SOURCE OF

REATEST SOURCE

AND THE GREATEST

ECTUAL INTEREST.

SOURCE OF SO

MAKES LIFE

# David Attenborough

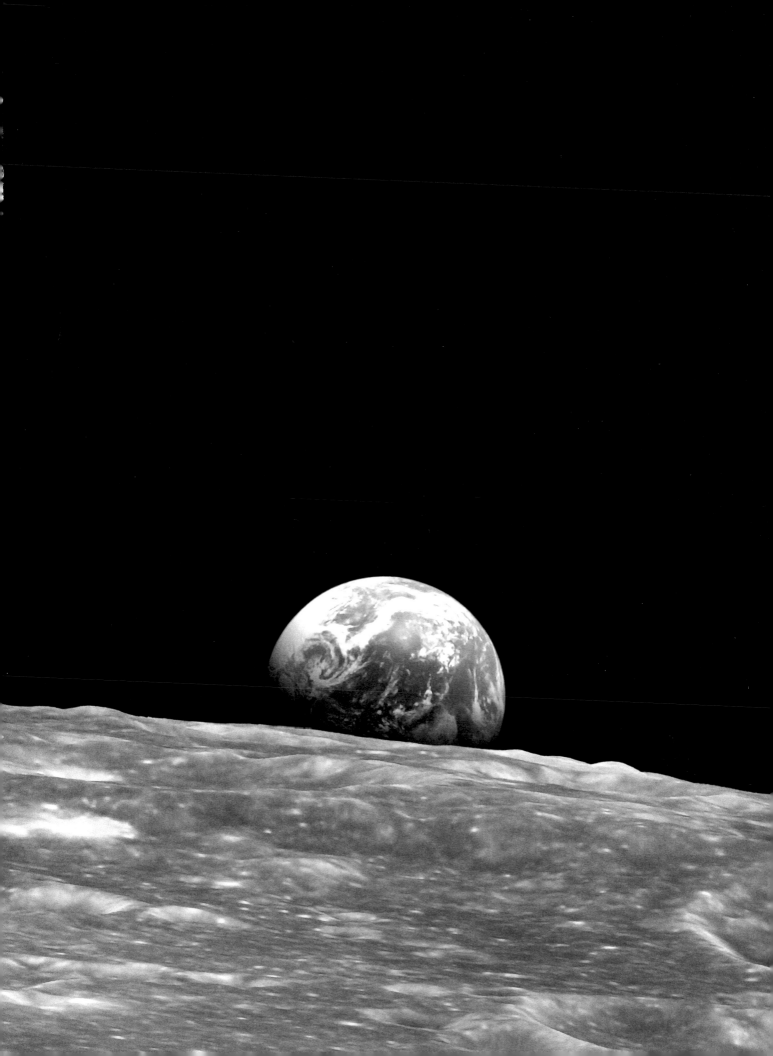

# OUR PLANET

## ALASTAIR FOTHERGILL & KEITH SCHOLEY
## WITH FRED PEARCE

### Foreword by DAVID ATTENBOROUGH

BANTAM
PRESS

# FOREWORD

We are the most inquisitive and inventive of all animals. Fifty years ago, our curiosity about the worlds beyond our planet led to one of the most stupendous achievements in human history. We travelled to the moon. Paradoxically, the pictures of Earth taken on that Apollo mission made us see our own world anew. Until then, it had seemed vast and its resources infinite. Those pictures helped us realise more vividly than ever before that the Earth is unique and wonderful but also that its space and resources are limited.

Now, 50 years on, we have no doubt that profound changes are happening on our planet. We are entering a new geological era, not as in the past when changes happened over millions of years, not even over thousands of years or centuries, but within decades – within my lifetime.

These changes are as rapid and as great as when the planet was struck by an asteroid. But this time they result from the global impact of our own species. In just four decades, the number of wild animals has halved, and biodiversity is declining in every region of the world, all as a consequence of the way we have chosen to live. It is a global catastrophe.

But as the problems are of our making, so the solutions can be ours too. As this book tells us, from every region of the world there are stories that reveal nature's resilience and show how restoration is possible. In this digital age, we can communicate that message to all parts of the globe, at the same time showing the glories, the splendours, the marvels of the natural world that still exist on our planet.

If large enough areas are connected and protected, wildlife thrives and we benefit. Where we protect marine hotspots, we benefit from the increase in fish and other marine resources. Where we restore the natural water cycle, we benefit from the resulting fecundity of life in the rivers, wetlands and floodplains. Forests are dynamic and resilient and can rise from the ashes, if we let them, and will continue to provide resources and global functions from which, again, we benefit.

That the natural world is resilient gives me great hope. Technology also offers hope, that revolutionary ways will be found to store and transmit energy from renewable sources, doing away with any need to burn fossil fuels. Neither is it too late to choose the future we want if we act now – and act together. There is a shift worldwide. More people than ever are aware of the problems – and the solutions. So we must back the leaders who are prepared to do something and pressure those who are not.

The action also has to be global. The chance for that to happen is when the world's nations meet to review the steps being taken to halt both climate change and the loss of biodiversity. From those meetings we must hope that there will come a change in our politics and economics. The future of all life on this planet depends on our willingness to take action now.

David Attenborough

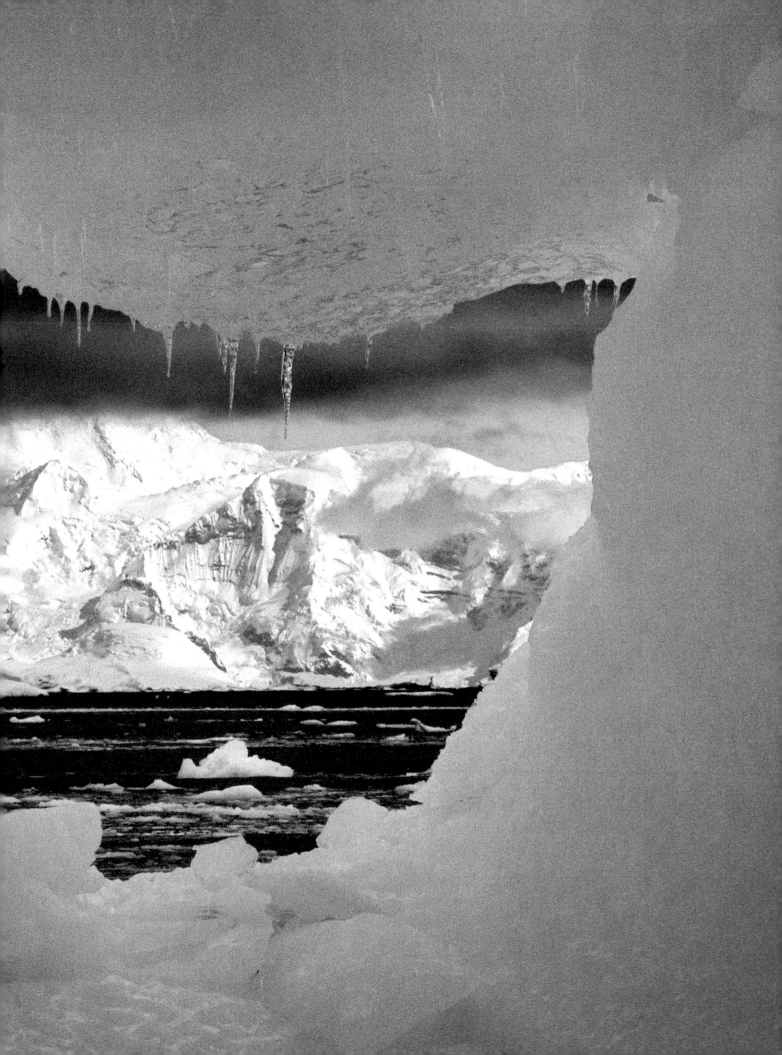

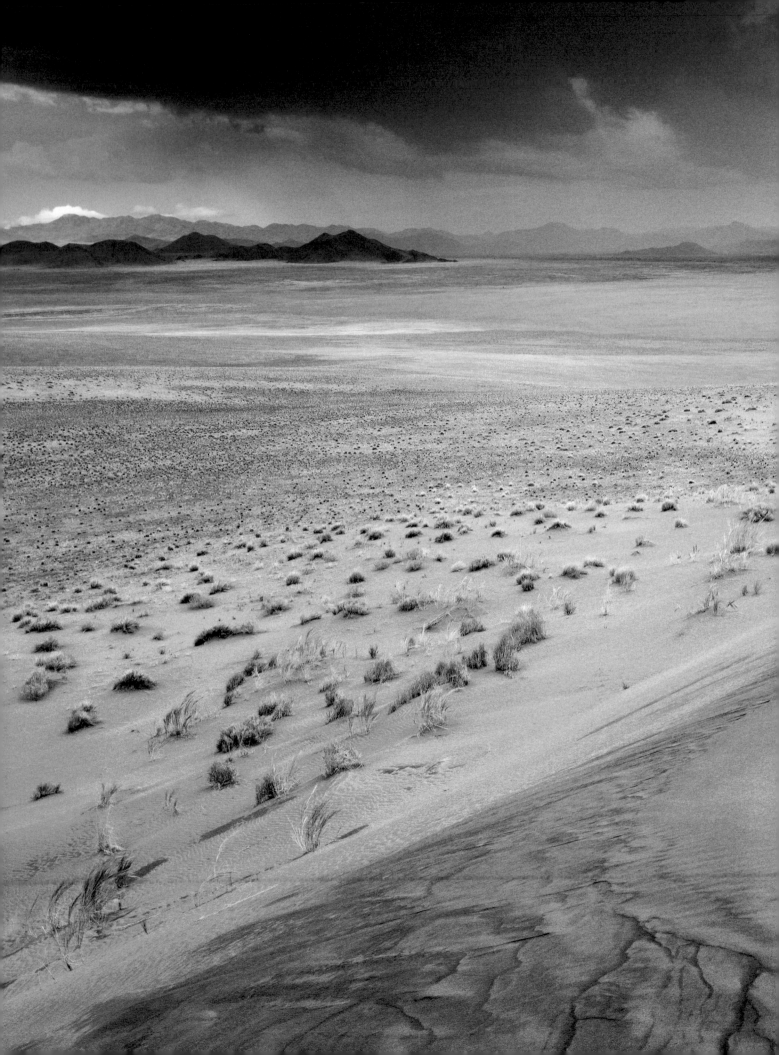

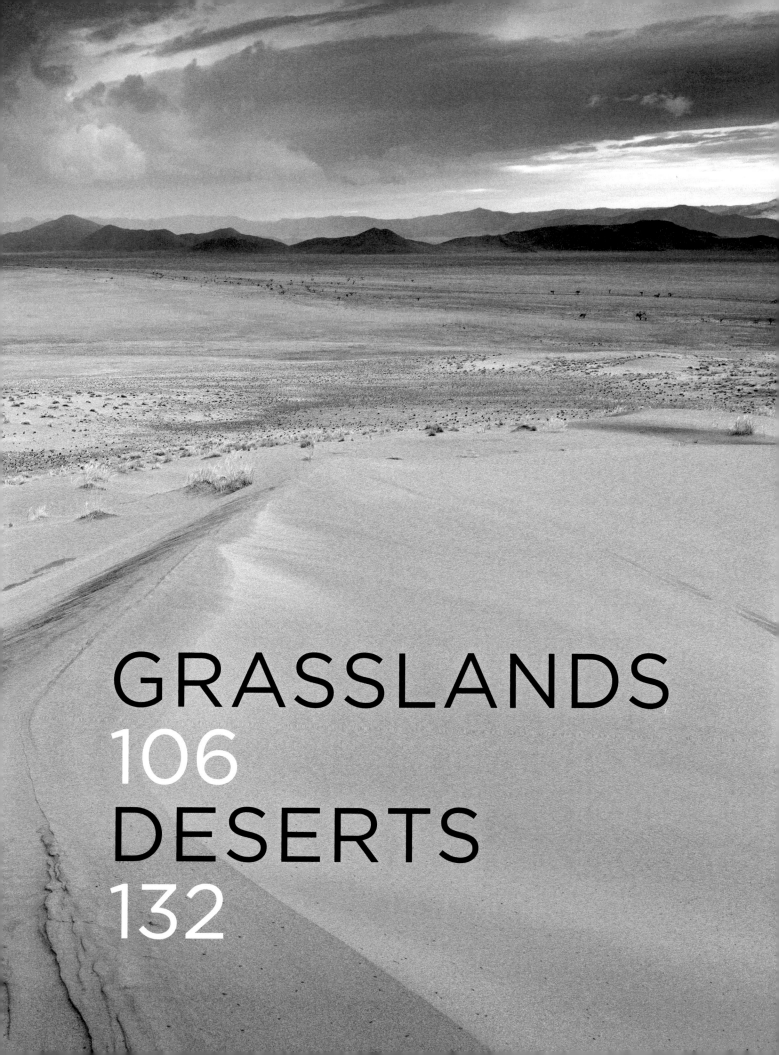

GRASSLANDS
DESERTS

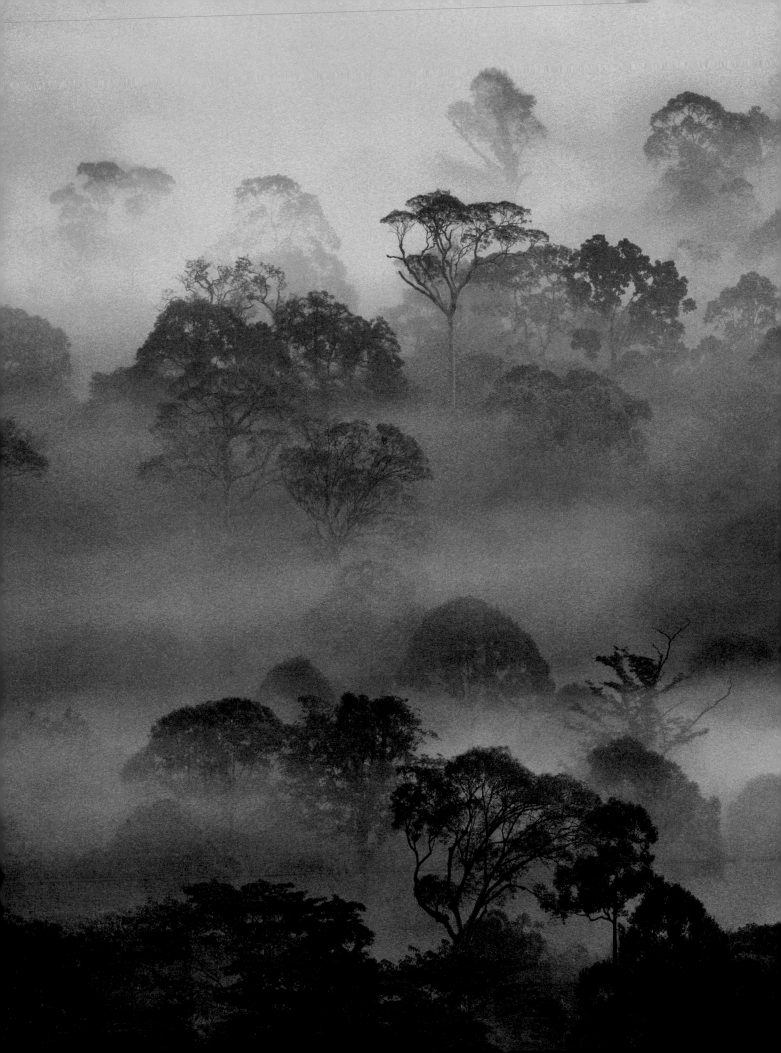

# FORESTS

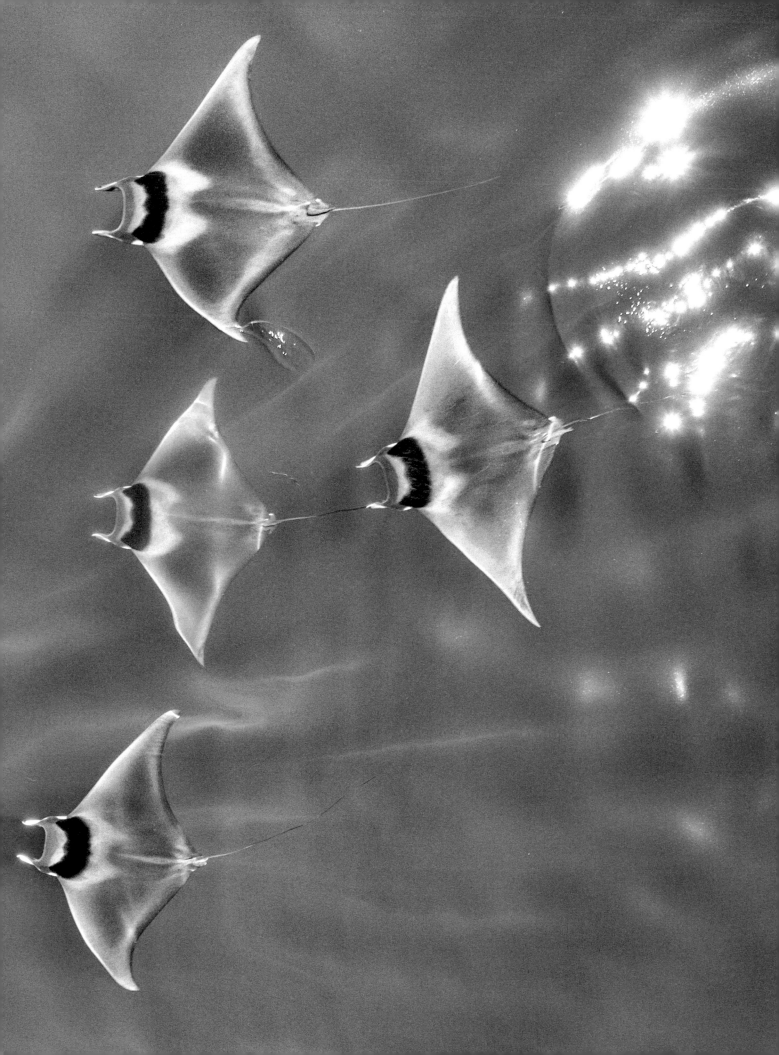

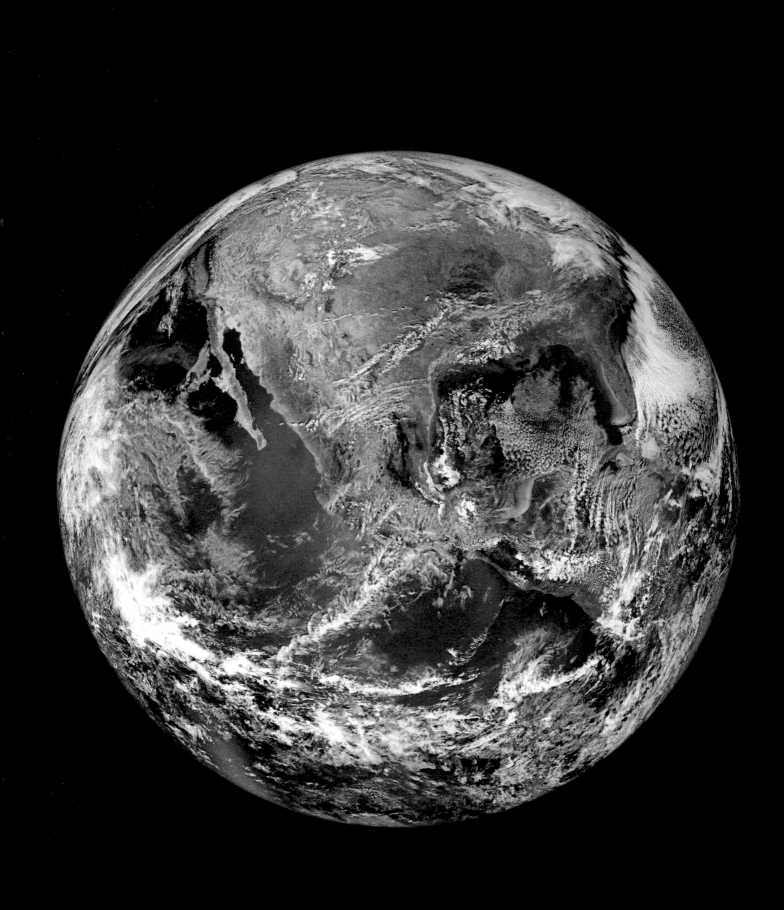

# THIS IS OUR PLANET

Here is the bad news. Planet Earth is now our planet, and we humans are running amok, killing its wildlife and trashing its life-support systems. But inside the bad news lies the good news. For if we finally recognize the peril we are in, then we have the chance to redeem ourselves – to begin a great restoration of nature on our planet. And the best news is that we still can.

It is clear that we have not been good tenants of our home. The fridge is poorly stocked. The furniture is broken. The plumbing no longer works properly and there have been floods. There is a hole in the roof. Someone has been playing with the temperature controls. And the garden has been concreted over. You get the picture. We need to grow up. We need to get house-proud, write ourselves a clean-up list and get on with the job.

# WE ARE AT OUR OWN TIPPING POINT, THE MOMENT WHEN WE HAVE FINALLY RECOGNIZED THE PERILOUS STATE OF OUR WORLD

OPPOSITE

**THE DIVIDING LINE**
A logging truck carries eucalyptus cleared from a plantation alongside virgin rainforest in the Brazilian Amazon. A hybrid eucalyptus that takes just seven years to grow to harvest size was introduced to Brazil in the 1990s, offering an alternative to logging more of the Amazon – the great climate regulator and 'carbon sink'. The downside is that eucalyptus plantations rely on heavy use of agrochemicals and harbour little or no native wildlife.

Scientists call this chaotic household the Anthropocene. It is an epoch in which more than 7 billion of us *Homo sapiens* have become the driving force of nature. We have drained most wetlands, chopped down most forests, ploughed most grasslands, barricaded most rivers, moved thousands of species across the planet, lit the darkness, melted glaciers, raised sea levels, strengthened hurricanes, altered the seasons.

For nearly 200,000 years, we were at the mercy of nature. It decided whether and how we survived. Now, we presume to decree how nature survives. The power has felt good – that nature was just a frontier to be tamed and exploited in our onward march to domination. But if we go on as we are, then nature will have its revenge. We have built a precarious civilization that remains utterly dependent on the things we seem intent on trashing – a stable climate, fertile soils, air fit to breathe and water available where and when we need it. Technology cannot replace planetary life-support systems. Our planet is our home. It's not nature that is fragile, it is us.

But there is hope. We rightly fear tipping points in natural systems – tipping points that could unravel the connections that make natural ecosystems work, and plunge the planet any day into a state that we are poorly equipped to deal with. But we are also at our own tipping point, the moment when we have finally recognized the perilous state of our world.

At the start of the twenty-first century, we inhabit a unique moment in the history of our planet and our species. Yes, the damage we have inflicted is huge. But we now realize what we are doing. And for a brief time, we have the opportunity to do something about it – to get the housekeeping right before we burn the place down.

By the end of the century, there may be an additional 3 billion people on the planet. So the challenge is clear. To meet the essential needs of a population of 10 billion people or more, keep the climate within safe bounds and give nature enough space to recover and flourish.

And we can do it. For, while humans can sometimes be selfish hedonists, what actually distinguishes our species is our ability to cooperate, to think about tomorrow and to consider the welfare of future generations. Even – dare we say it – to be altruistic. Our ability to do bad things may be unparalleled, but so too is our ability to contemplate what we are doing, and to change.

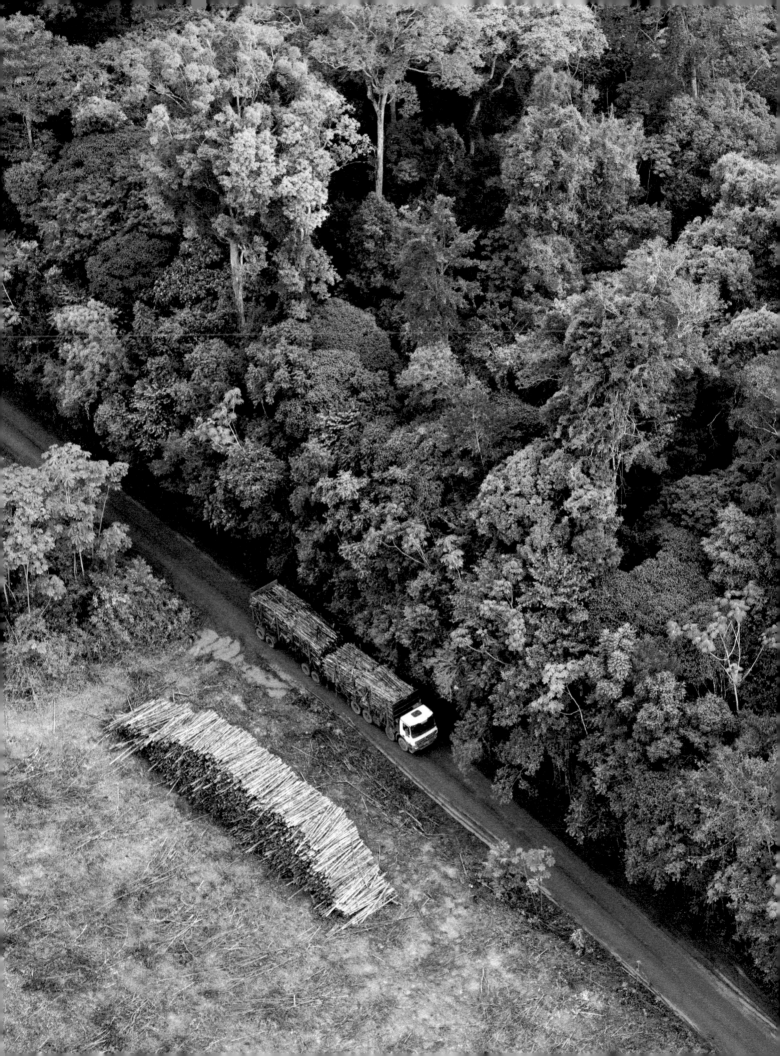

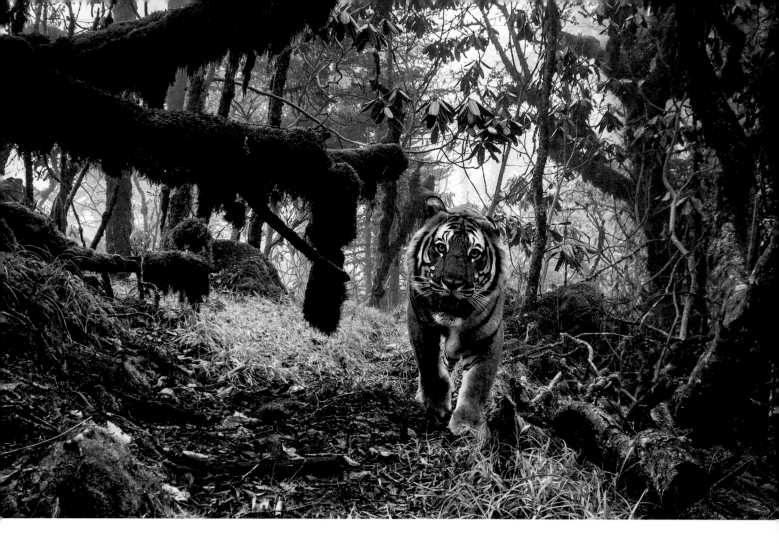

ABOVE

**PATHWAY TO SANCTUARY**
A male Bengal tiger, caught by
a camera trap in mountain forest
in central Bhutan. WWF believed
this forest corridor to be an
important link between protected
areas. The picture proved this and
added a new individual to known
tigers in Bhutan – now more than
100. It has also led to plans for
safeguarding the tigers' forest
pathways between reserves, so
helping the population to increase.

This book, while a portrait of a planet in peril, is also a portrait of
a planet that can be restored. It marvels at nature's resilience and
ability to carry on amid the mayhem – with polar regions steadying
global climate, deserts fertilizing forests and oceans, and jungles
and mountains making rain for grasslands. But it recognizes there
are limits to this adaptability. The links that maintain the dazzling
variety of life on Earth could also become its vulnerability. If they
are cut, then everything collapses.

So this book is also a final call for action – for a great ecological
restoration – to foster nature's regeneration, starting today. We make
the call in the belief that it is not too late – that such a task is both
possible and in the vital interests of humanity.

The underlying good-news story is that a planet on which nature
is restored will also be a planet that can deliver a better life for us,
its reformed custodians. It will be a planet where what economists
now call 'natural capital' is restored – where the harvests of the
oceans and the soils are rich, where the atmosphere is fit to breathe
and the climate is stable and predictable.

No corporation with a future runs down its assets, empties its
warehouses and cleans out its bank accounts. And, if we want a

future, we cannot run our planet that way either. Not any longer. In the coming chapters, our journey across the different biological realms of our planet will tell stories of the unparalleled destruction of nature at the hands of humans. It will tell how in the process we have wrecked many of the natural cycles that make up the planet's life-support systems.

Following in the tracks of the makers of the *Our Planet* films, we will roam from the shrinking tropical jungles to the emptied high seas, from the melting polar icecaps to desiccated grasslands turning to desert, and from rivers that no longer flow freely to the frightening white skeletons of empty coral reefs that once teemed with fish.

The destruction is on the scale of past mass extinctions, like the aftermath of the asteroid that wiped out the dinosaurs. You will weep for what is lost. But you will also marvel at how much is left and at nature's insatiable ability to renew itself, to adapt and to evolve. Given the chance, forests can and do regrow; soils can reform; rivers can flow anew; grasslands can flourish where today there are deserts; fish stocks can bounce back; and endangered species from huge whales to tiny insects can recover.

This book tells stories of how we can give nature that chance – and how, sometimes, we are already turning things around. We know how to fix climate change, to recycle materials and to protect wilderness. Rewilding can happen and is happening, even in the most unlikely circumstances. Just look at the wolves, lynx and bears returning to the exclusion zone round the Chernobyl nuclear sarcophagus. The land may be radioactive, but the absence of humans gives nature the run of what has turned into Europe's largest rewilding project.

The world will never be as it was. Innocence, once lost, can never be regained. Much that was pristine is now sullied. But nature is not yet broken. We believe its processes can be restored, its assets revived and its wildness recovered. Above all, we travel in hope. Because the good news is that this is our planet, and we can remake it if we will.

NEXT PAGE
**THE GREAT BLUE HOPE**
A blue whale and her calf cruise past the coast of Mexico. Decimated by whaling in the past century, numbers of this endangered whale – the largest animal ever to have lived – are starting to rebuild. It will take many decades before the population reaches anything near its former size. But with international protection, and if its main food, krill, remains abundant, then there is hope for the great blue's recovery.

NATURE IS NOT YET BROKEN. WE BELIEVE ITS PROCESSES CAN BE RESTORED, ITS ASSETS REVIVED AND ITS WILDNESS RECOVERED. THE GOOD NEWS IS THAT THIS IS OUR PLANET, AND WE CAN REMAKE IT IF WE WILL

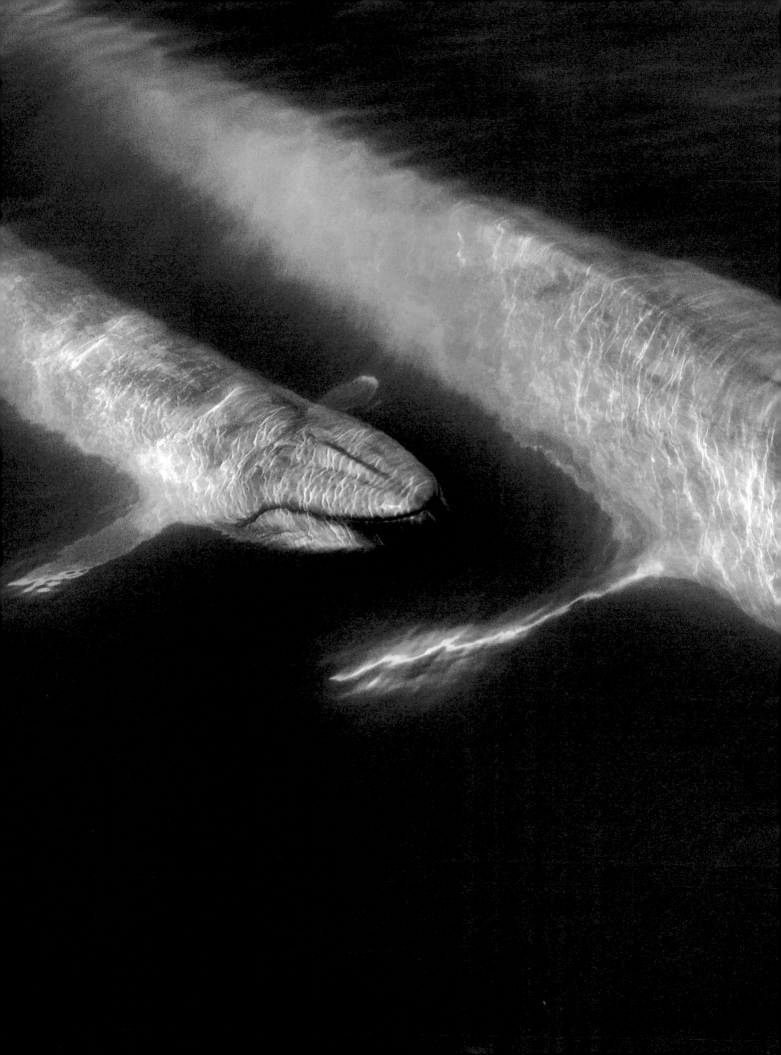

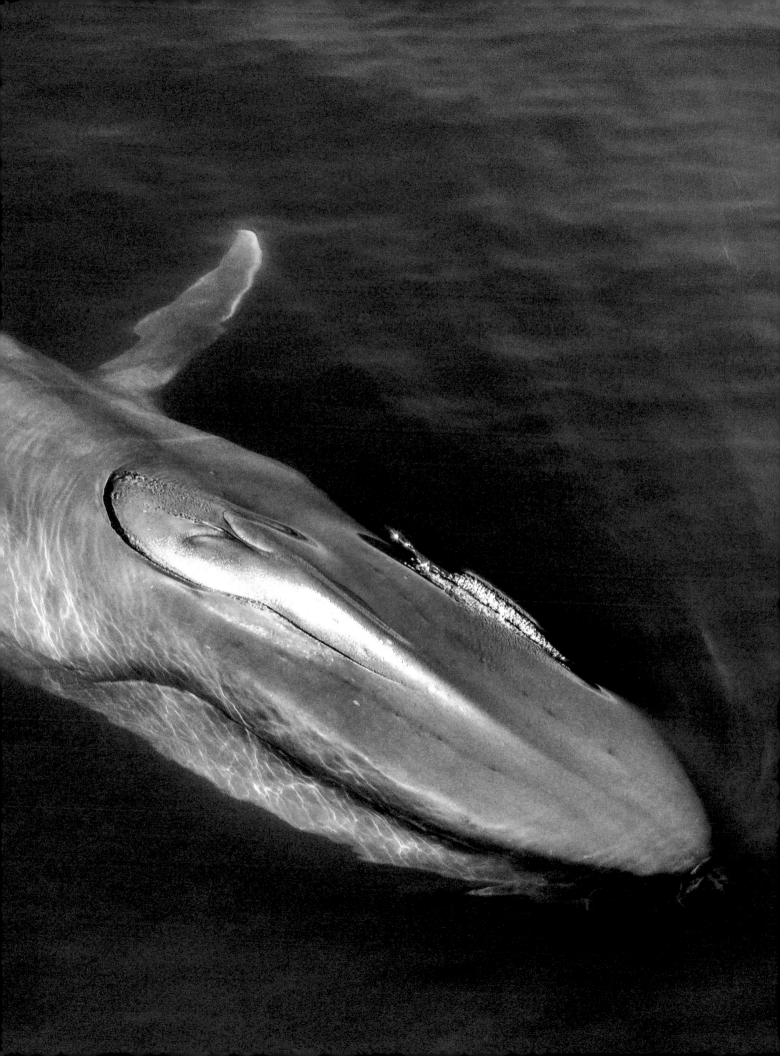

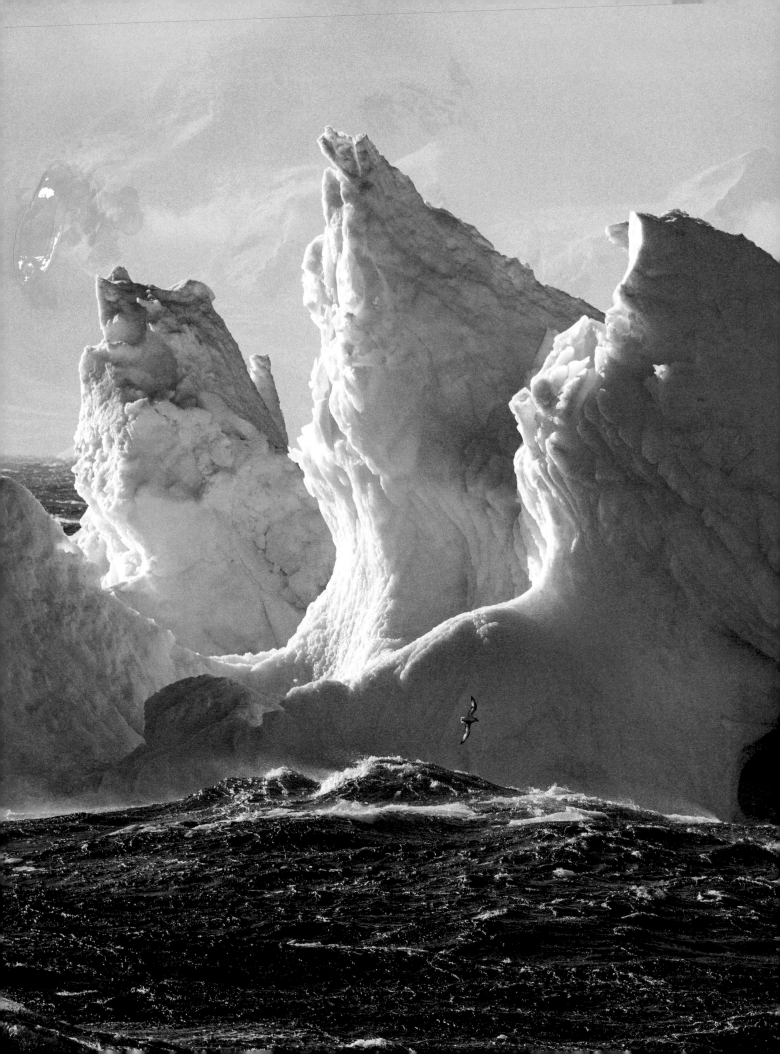

# FROZEN WORLDS

'All ecosystems are suffering the negative impacts of climate change, but nowhere is this playing out as vividly as in the two polar regions. Our frozen worlds are no longer as frozen as they should be. In the Arctic, we are well beyond visible melting effects in the summer: we are witnessing significant loss of sea-ice cover even during the winter, causing further warming of global temperatures. In the Antarctic, land-based ice sheets are melting from below and are beginning to affect ocean currents and the global climate. What happens in the poles does not stay in the poles. We cannot simply cry for the cryosphere. We must stand up to our generational responsibility and act with urgency on climate change.'

**CHRISTIANA FIGUERES**
Founding partner of Global Optimism and Convener of Mission 2020

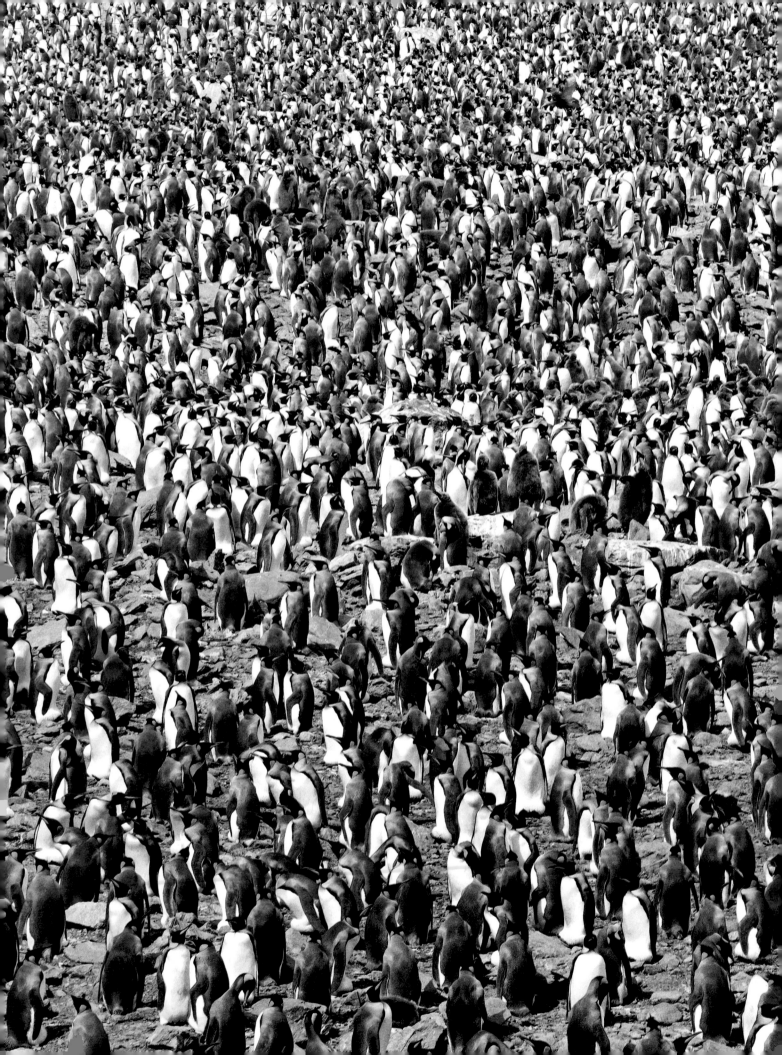

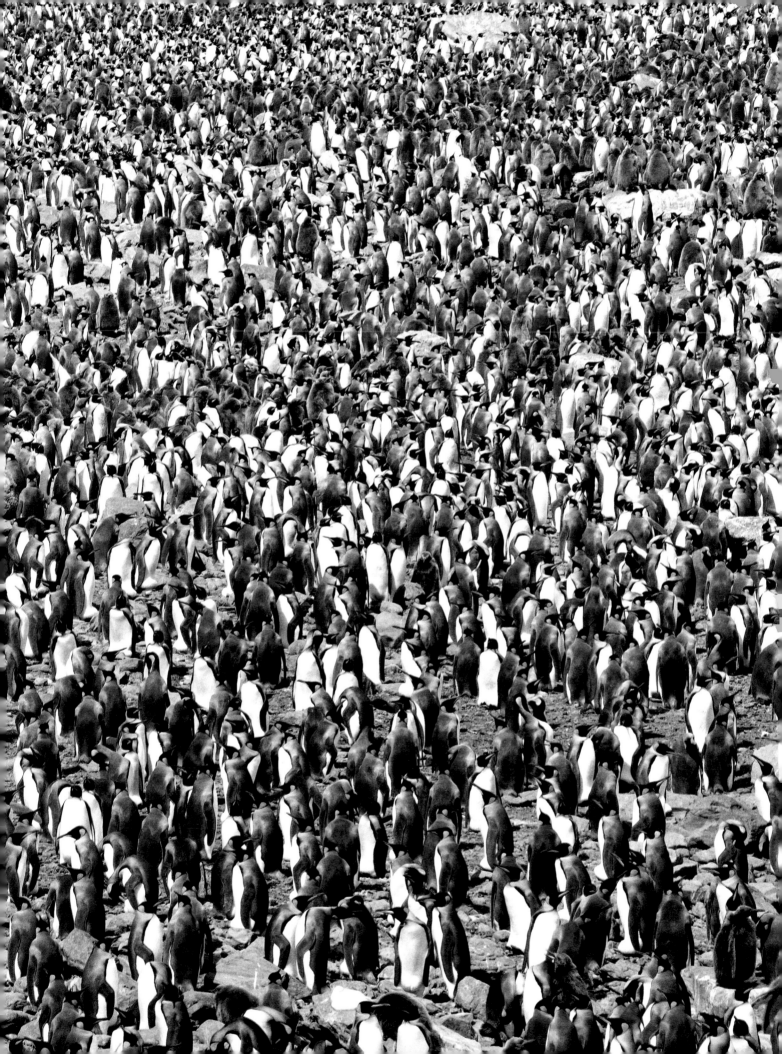

OPPOSITE

**LEAP FOR LIFE**

An Adélie penguin having surfaced at speed, shoots out of the sea – the best way to avoid any leopard seal lurking at the edge of the ice. But a much greater and long-term threat is warming in the ocean and on land. This will affect their nesting areas, bringing early snow melt or unprecedented rain, and will also alter the availability of krill and fish.

PREVIOUS PAGE

**KING COLONY CROWD**

Part of the king penguin breeding colony at St Andrews Bay on the subAntarctic island of South Georgia. More than 300,000 kings crowd the bay. The island's relatively warm winters mean that the chicks can survive here over winter.

OPENING PAGE

**ICE SPECTACLE**

A Cape petrel, hunting krill, skims the waves in front of an iceberg in the Antarctic Peninsula's Gerlache Strait.

NEXT PAGE

**ICE GRAZERS**

Krill grazing on phytoplankton on the underside of sea ice off South Georgia. Krill provide the food for most Antarctic animals, including fish, penguins, seals and whales. Should krill numbers reduce significantly because of overfishing, ocean acidification or declining winter sea ice, on which they depend, the consequences for other ocean animals would be severe.

At the frozen far south of our planet, on the shores of the great ice continent of Antarctica, spring is a time of renewal and rebirth. It begins with the melting of the great expanse of sea ice that doubles Antarctica's size in winter. Then visitors begin to come ashore from the ice. Adélie penguins are the first and most numerous. At least 8 million arrive in October after an austral winter feeding at sea.

They reach ice-covered land at different spots around the continent, and head uphill until they find patches of ice-free ground where they can nest. Some will have travelled huge distances from their wintering areas, by sea and over sea ice, to reach land. Several hundred thousand or more may gather at these ice-free areas. Once a nest is established, the male and female take turns to incubate the eggs and feed the chicks, alternating with a return to the sea for krill, fish and squid.

Adélies, together with the metre-high emperors, are the only penguins to make the Antarctic their true home – our planet's coldest, driest, windiest and highest continent – though three others breed on the tip of the Antarctic Peninsula, where conditions are less harsh. Antarctica is a frozen land mass almost the size of Russia, surrounded by ocean and topped for the past 30 million years by ice as much as 5 kilometres (3 miles) thick. It is cut off from the rest of the world by fierce winds and an ocean current that circles the tempestuous Southern Ocean. The frozen continent never thaws, changes little and is home to no permanent land mammals, including humans. So how do the Adélies survive the continent's brutal winters, when temperatures can reach -80°C (-112°F)? The answer is, they don't. Instead, they overwinter at sea among or beyond the sea ice.

The surrounding waters of the Southern Ocean are warm compared to the punishing cold of the continent itself. Much of it is ice-covered, but this floating ice is the foundation for one of the planet's most productive ecosystems, a polar Serengeti that feeds the penguins, the whales and much else. For living in cracks and on its underside are marine algae. Across the region, these thin smears amount to billions of tonnes – food for the marine cornucopia. The ice-algae are the marine equivalent of terrestrial grasslands. They are the main food for Antarctic krill – among our planet's most abundant creatures.

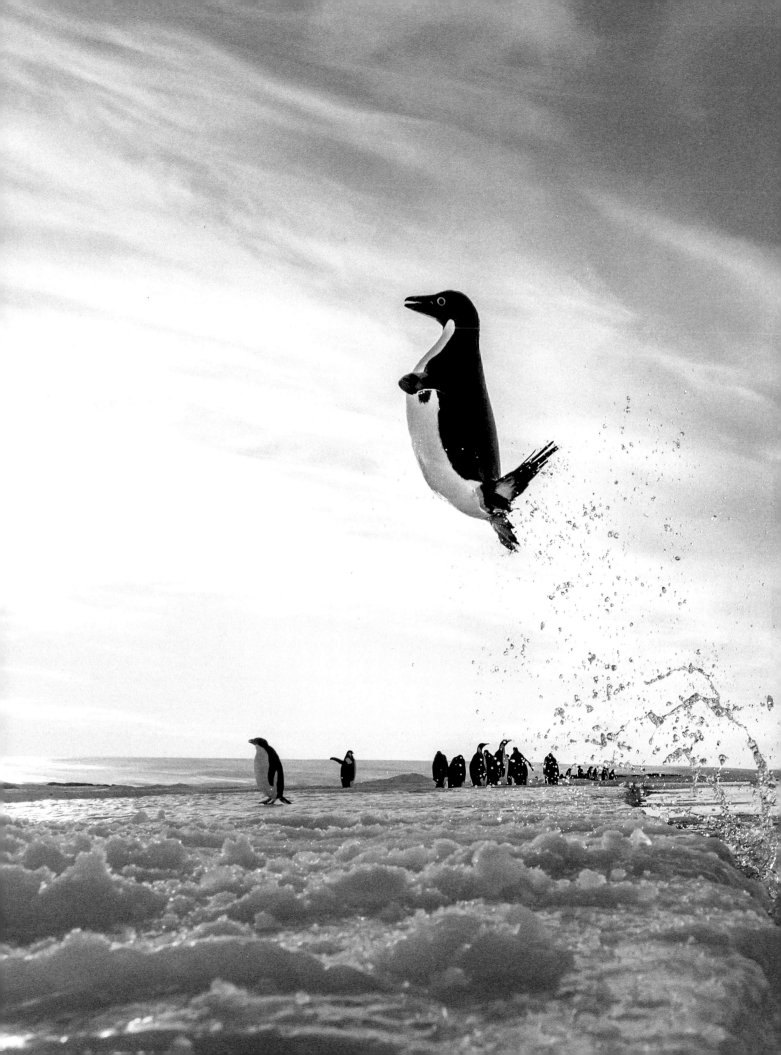

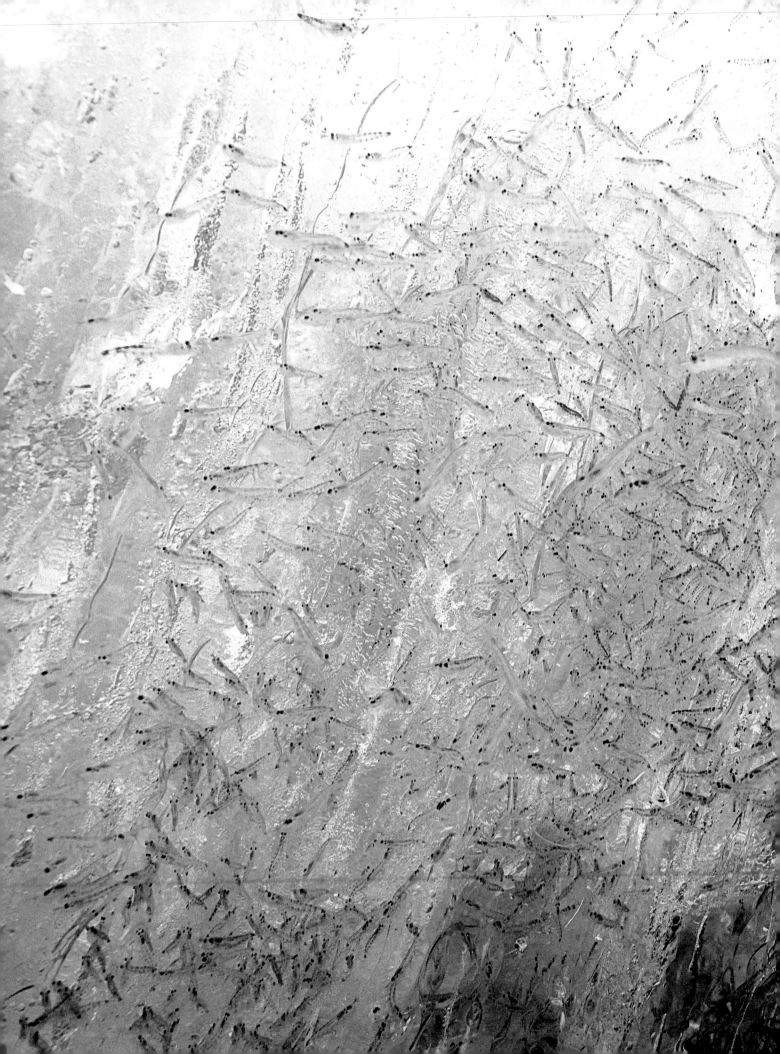

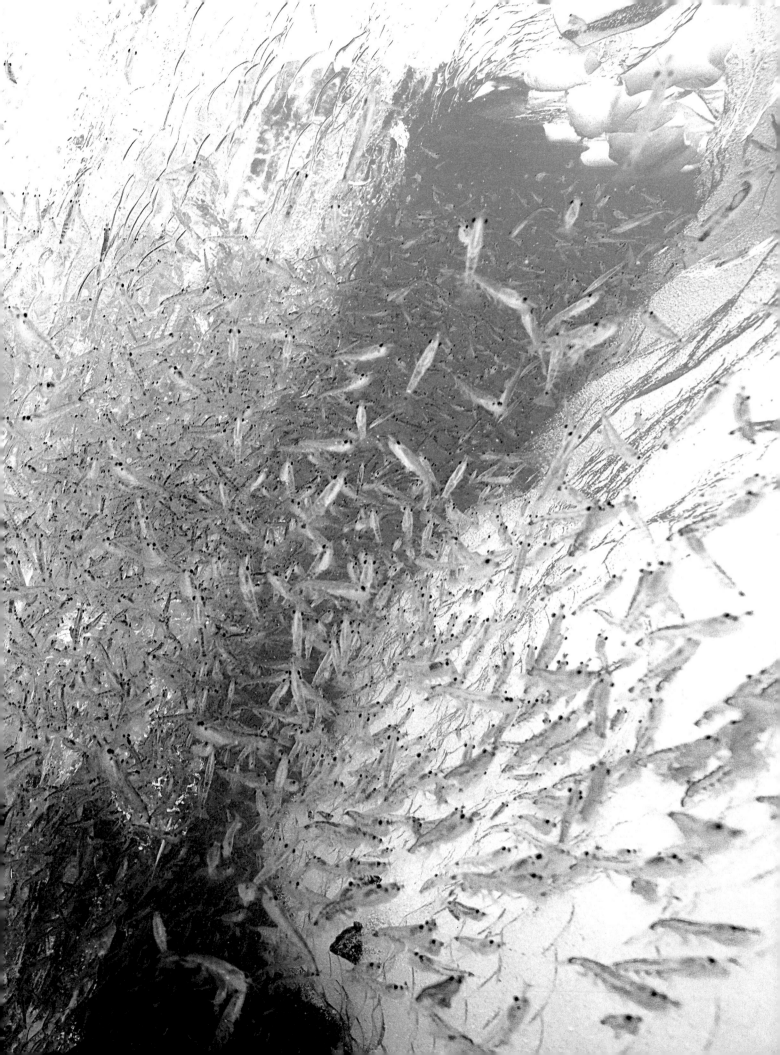

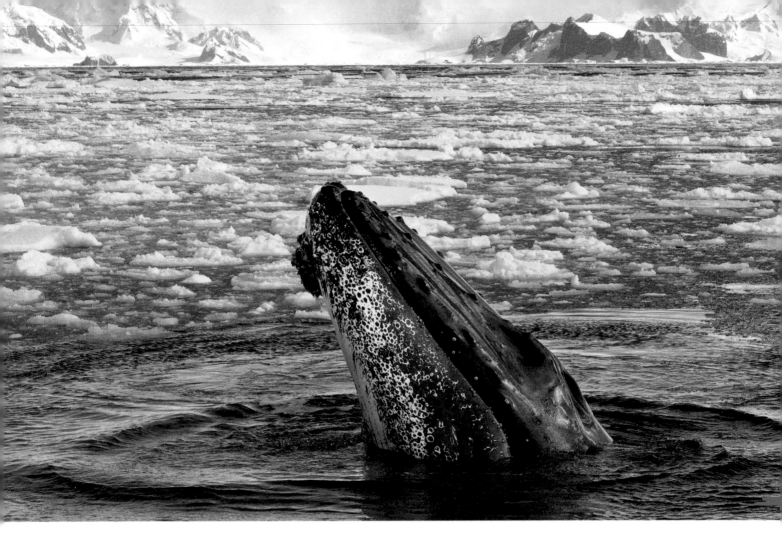

Krill are small, prawn-like crustaceans, no longer than 5 centimetres (2 inches) and with an average lifespan of seven years. They spend most of their time in the depths, often in vast swarms that can cover hundreds of square kilometres. The krill swim to the surface under the cover of night, when they feed on phytoplankton (microalgae) in the open ocean or use their rake-like bristles to scrape algae from the ice.

The total world krill population is estimated at about 780 trillion – weighing more than the total human population. Almost everything in the Southern Ocean depends on krill. The penguins feast on them. Humpback whales undertake one of the longest mammal migrations on the planet – travelling up to 8,000 kilometres (5,000 miles) from their tropical breeding grounds – so they can gorge on them. About 2 tonnes a day is a typical portion. Even the top predators of the Southern Ocean, the killer whales, ultimately depend indirectly on the tiny crustaceans, chasing through the cold waters to catch and eat the penguins, seals and even, occasionally, krill-eating whales.

In the air above the Southern Ocean, cruising on the circumpolar winds, are wandering albatrosses. With a wingspan up to 3.5 metres (11 feet) – the largest of any bird – they can stay aloft for months at a time, circumnavigating the ocean in search of food, whether krill or

ALMOST EVERYTHING IN THE SOUTHERN
OCEAN DEPENDS ON KRILL. THE PENGUINS
FEAST ON THEM. HUMPBACK WHALES
UNDERTAKE ONE OF THE LONGEST MAMMAL
MIGRATIONS ON THE PLANET ... SO THEY
CAN GORGE ON THEM

the fish that feed on krill. A parent may fly thousands of kilometres to bring food to its single chick, which will wait alone on its nest on one of the isolated subAntarctic islands that pepper the ocean.

Many of these islands amid the vastness of the Southern Ocean are extraordinary wildlife oases. The richest is South Georgia, which at times has the densest concentration of marine mammals anywhere on the planet. It is far enough away from the Antarctic freezer to be clear of sea ice and relatively warm in winter, and so it can be home to life all year round. Wandering albatross chicks spend a full year on their nests here before fledging, often waiting seven days between feeds as their parents cruise the skies. South Georgia also hosts several hundred thousand breeding pairs of king penguins, whose chicks spend up to 16 months on the island before being ready to take the plunge into the icy waters. By contrast, penguin species at colonies on the Antarctic continent have just a few months to fledge before winter.

The ancient Antarctic ice is one of our planet's best memory stores. It holds a record of past temperatures and carbon-dioxide ($CO_2$) levels going back half a million years, trapped in bubbles within the buried ice. Cores of ice, drilled and brought to the surface in the 1980s and 1990s at the former Soviet science base, Vostok Station, in Antarctica, for the first time revealed two vital things for the study of climate change. First, that temperatures and $CO_2$ levels have always been in lock step, going up and down in synchrony with each other; and second, that both have reached unprecedented highs during the period of the record.

So what will climate change mean for Antarctica and its surrounding ocean? Some predict that the land surface round the coast may become greener and herald the arrival of non-native invasive species. Recent decades of warming have already seen a quadrupling in the amount of moss across parts of the Antarctic Peninsula, where snow and ice disappears.

An immediate concern is for those Adélie penguins that summer on the Antarctic Peninsula. This region has been the most influenced by warming sea water and wind currents in the Southern Ocean.

NEXT PAGE
**KING CHICK CRÈCHE**
A crèche of king penguin chicks awaits the return of parents with food in their crops. These chicks are just a portion of the massive autumn congregation in St Andrews Bay, on the subAntarctic island of South Georgia.

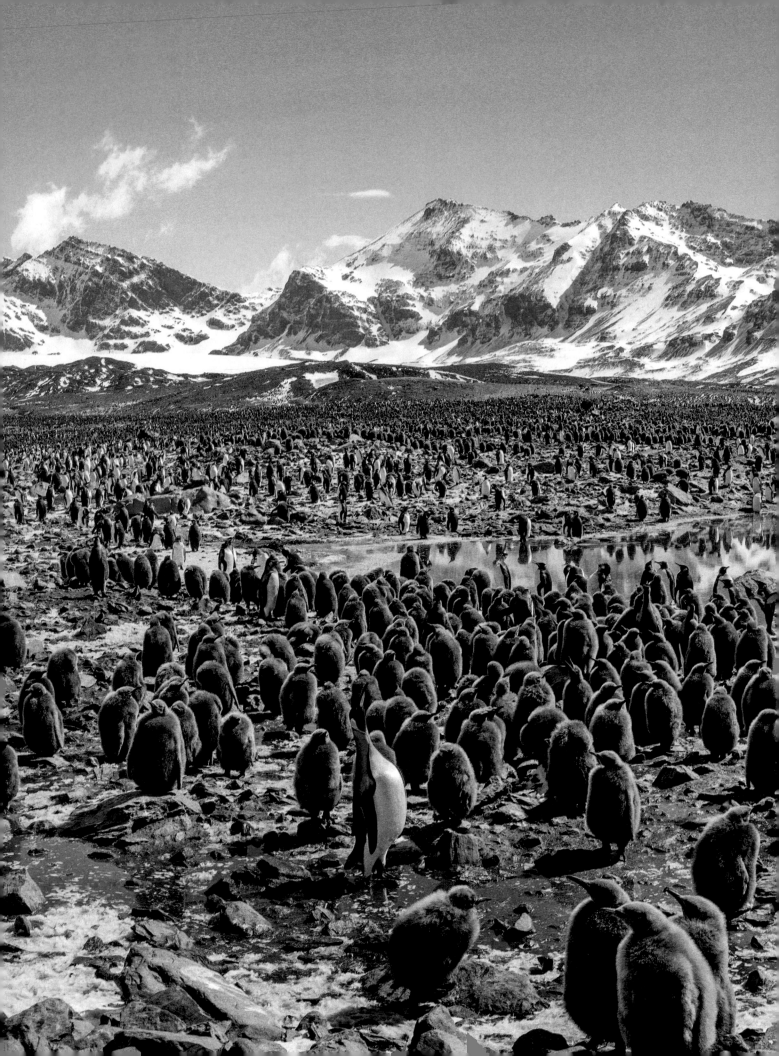

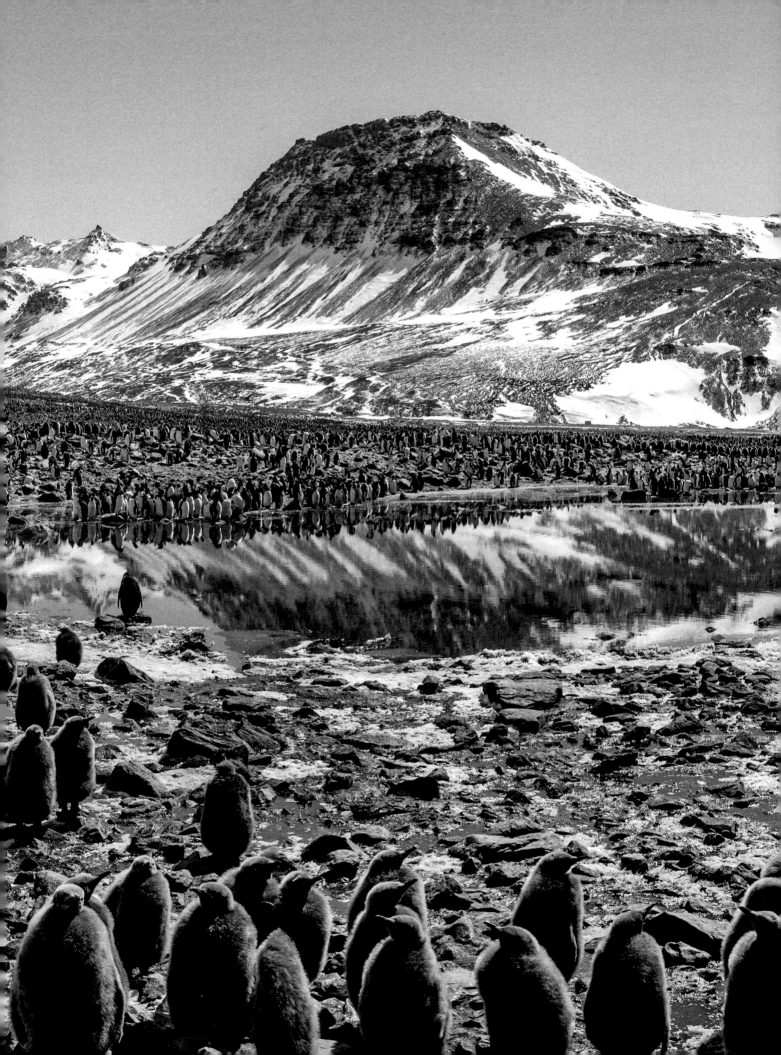

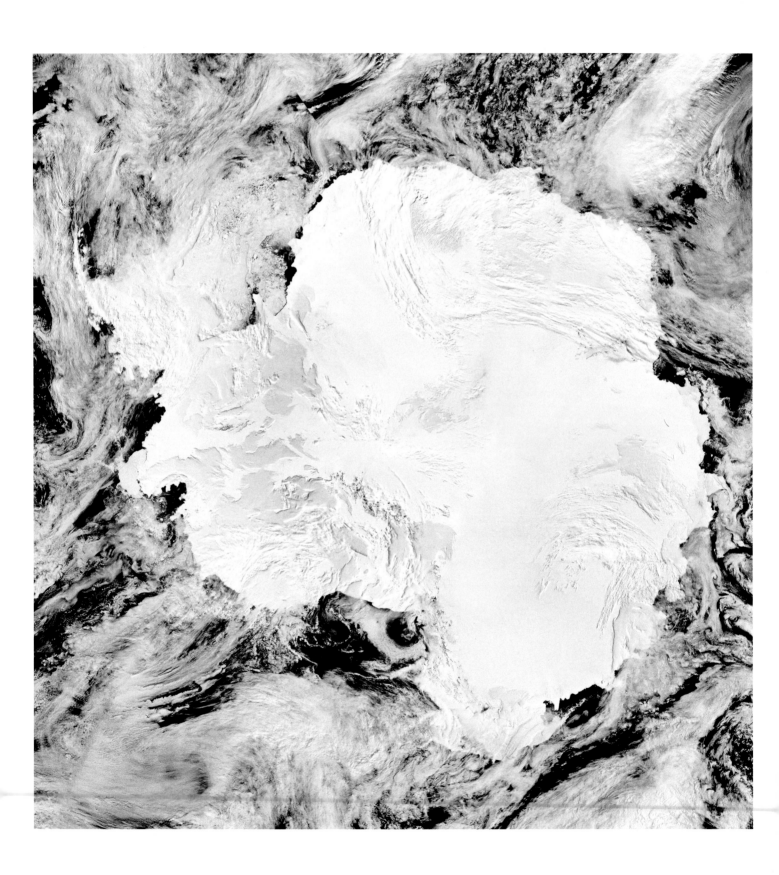

# PHYTOPLANKTON WILL DECLINE. THAT MEANS KRILL WILL DECLINE, TOO, AND THEREFORE EVERYTHING THAT FEEDS ON KRILL … DEVASTATING FOR THE ENTIRE ECOSYSTEM

One Adélie colony at the northern tip of the Antarctic Peninsula has, over 30 years, lost 80 per cent of its penguins, probably because of the disappearance of nearby sea ice, which stimulates the food chain on which they rely. So far, the loss has been counterbalanced by rising Adélie populations in East Antarctica, where the amount of sea ice has in places actually increased. But that may not last.

Some marine species might thrive as the Southern Ocean warms and as more light penetrates to the ocean floor through thinning ice. Researchers have found a recent explosion of deep-sea sponges, sea stars, brittle stars and sea cucumbers on the floor beneath the Ross Sea, a giant bay directly south of New Zealand. But this rush of life may be misleading. Researchers in the Bellingshausen Sea near the Antarctic Peninsula found an invasion of undersea worms and other new species that pushed out established ones, and resulted in an overall loss of biodiversity.

Marine biologists believe that about four fifths of the native invertebrate species that live on the seabed around Antarctica are threatened by climate change. With about a quarter of the sea ice likely to be lost this century, according to the Intergovernmental Panel on Climate Change, phytoplankton will also decline. That means krill will decline, too, and therefore everything in the Southern Ocean that feeds on krill, from fish and squid to penguins and humpback whales. A crash in krill populations could be devastating for the entire ecosystem.

That fate already seems to be facing the walruses of the Arctic. For them, the sea ice provides two services. It nurtures the algae that are the base of the marine food chain. And it is a platform from which the walruses can dive – for clams and mussels on the ocean bed – and rest on between feeding expeditions. But as the Arctic warms, Pacific walruses in the far north are losing these ice platforms. They are being forced ashore as refugees from a changing climate.

In the Chukchi Sea, between Siberia and Alaska – a major feeding ground for Pacific walruses – little ice now survives the summer. Most of what remains is far to the north, over deep ocean. So the walruses

OPPOSITE
**THE FROZEN CONTINENT**
A NASA satellite image of Antarctica – the coldest, driest and windiest place on Earth. The Antarctic Peninsula is top left.

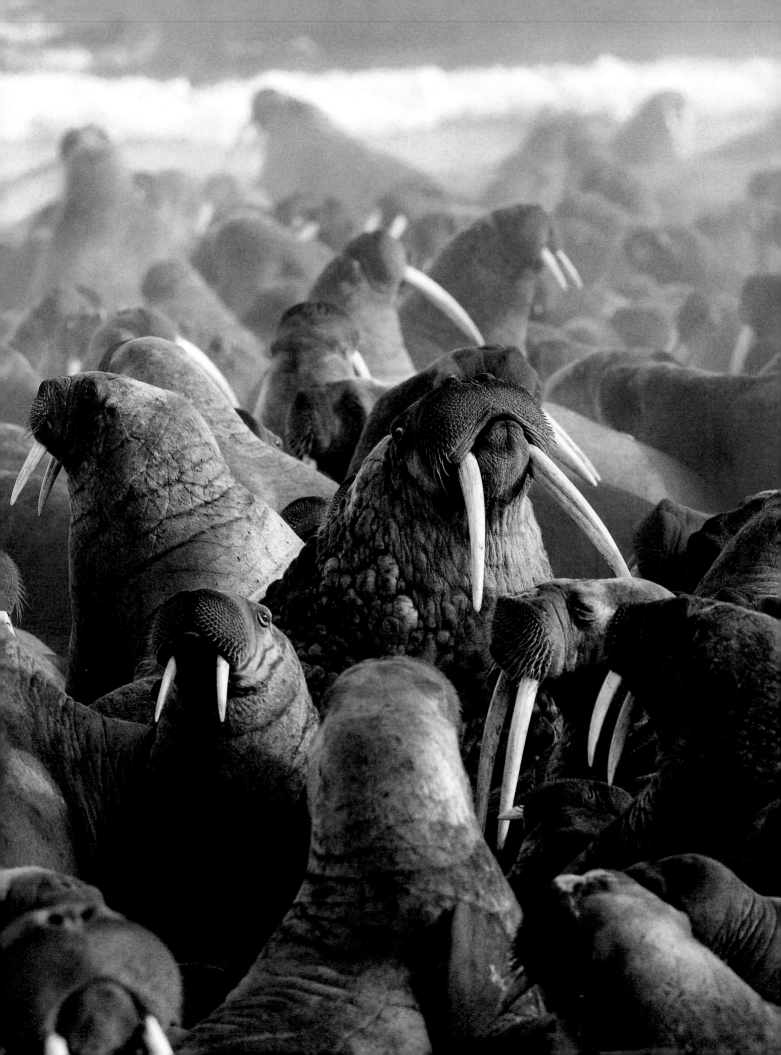

are heading south, to headlands along the Siberian coast, where they can haul out and rest up. The trouble is that these rocky refugee camps are becoming overwhelmed by the sheer numbers of walruses. The Chukchi Sea's eastern shore has seen a tenfold increase. As many as 100,000 walruses huddle together, blubber-on-blubber, in what may be one of the greatest congregations of large mammals on our planet.

As space runs out, newcomers at some haul-outs climb as high as 50 metres (165 feet) up cliffs to find somewhere to rest. There, exhausted, hungry and disoriented by the height, the flipper-footed animals may slip and fall or are panicked by packs of feral dogs or human disturbance and plunge to their deaths on the rocks below. At one haul-out on the shore of the Chukchi Sea, when the *Our Planet* team were filming, more than 650 carcasses were found on the shore.

The difference between the Arctic and Antarctic is not immediately obvious. On the surface, they appear the same – just endless white ice. But in every other respect, they are polar opposites. While the Antarctic is a continent surrounded by ocean, the Arctic is an ocean surrounded by land. While the deep ice on Antarctica has helped keep the South Pole region cool, warming in the Arctic has so far been much greater, resulting in a dramatic loss of sea ice that is already proving extremely challenging for many species.

The Arctic is so cold that it is usually covered in ice. The ice expands and contracts with the seasons. In March, after months of 24-hour winter darkness and sub-zero temperatures, it spans the ocean, connecting the frozen tundras of Siberia with North America. Polar bears can cross between the continents.

In summer, higher temperatures and day-round sun melt much of the ice, which reaches a minimum in September. But in recent decades, this seasonal cycle has been upset. Less and less ice survives the summer melt, and the winter ice formation is reduced. What remains of the ice is much thinner than before. Also, in many places sea ice is thawing earlier and refreezing later – meaning that species such as polar bears have less time to feed out on the ice, and spend more time ashore, increasingly coming into contact with humans.

What is happening in our planet's far north looks like a bellwether for climate change gathering pace around the world. The whole planet is warming.

OPPOSITE

**AUTUMN MIGRANTS**
Migrating Pacific walruses – mothers and youngsters – hauled out, along with thousands of others, on the Siberian coast in the Russian High Arctic. The beach is one of the few suitable resting places the migrant walruses have in autumn, now that the ice has melted out into the deep Arctic Ocean, following a succession of extremely warm summers. The walruses are excessively packed into limited space, malnourished and stressed from having to swim a distance offshore to feed at depth, without the ice floes to rest on.

NEXT PAGE

**CLIMATE-CHANGE REFUGEES**
Thousands of Pacific walruses on the world's largest haul-out area – a headland at the edge of the Chukchi Sea. In the autumn of 2017, more than 100,000 – most of the Pacific population – ended up using this resting area. The walruses are locked into a traditional migration north, following the ice. But now that the ice melts so much further north, as far north as Wrangle Island, they are deprived of the resting platforms they need while feeding off the continental shelf.

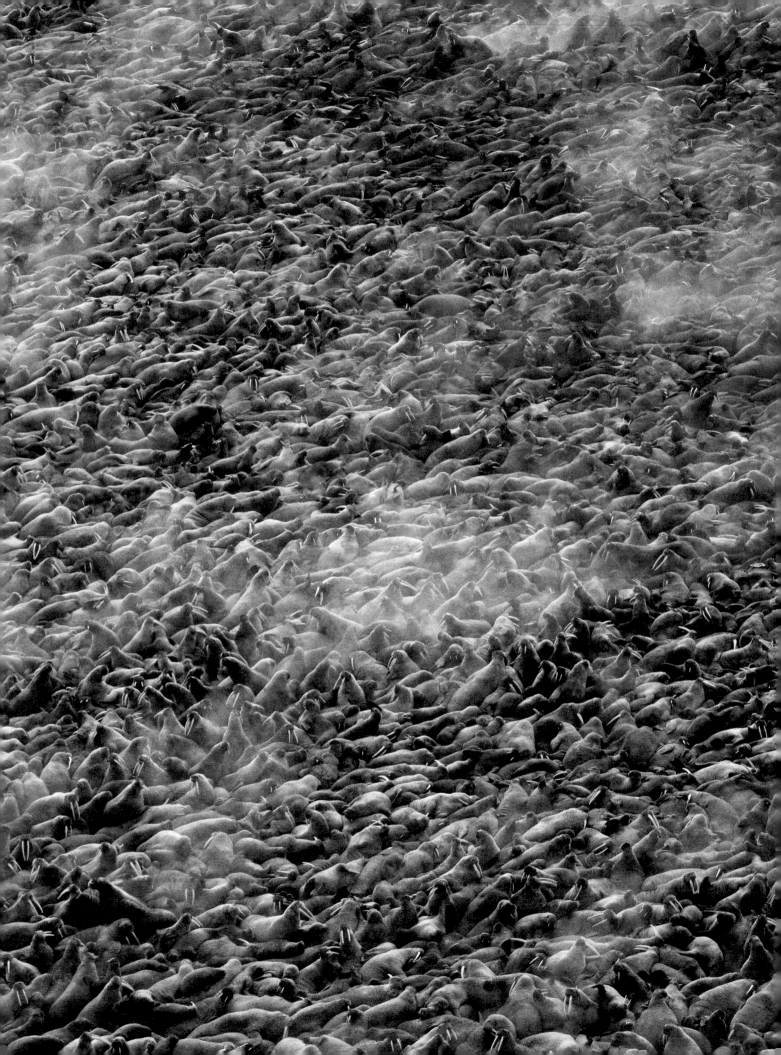

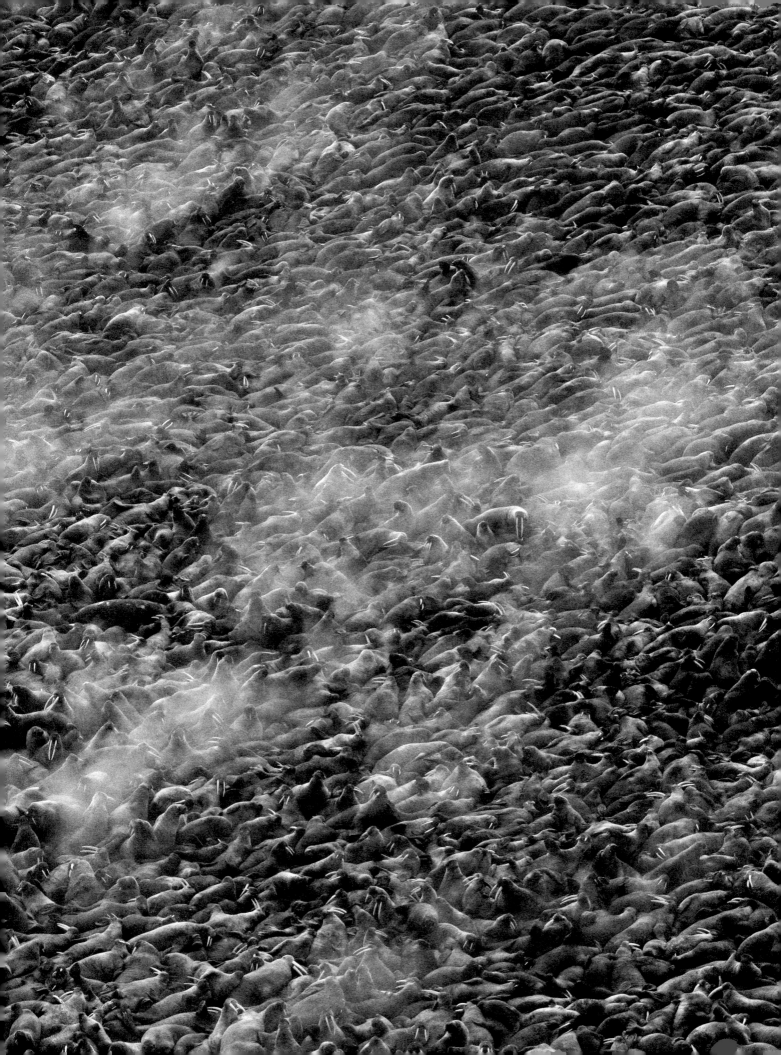

# UNLESS THE WORLD CAN KEEP GLOBAL WARMING BELOW ABOUT 1.5 DEGREES CELSIUS ... SCIENTISTS BELIEVE THAT, BY MID-CENTURY ... IN SUMMER, VIRTUALLY ALL OF THE ARCTIC OCEAN WILL BE ICE-FREE

OPPOSITE, ABOVE

**THE MAXIMUM ...**

March 2017: For the third year in a row, after a warm winter, the annual maximum extent of floating Arctic sea ice set a record low.

OPPOSITE, BELOW

**... AND THE MINIMUM**

September 2017: At the end of summer, the extent of the floating Arctic sea ice at the North Pole reached a record low.

NEXT PAGE

**THE LAST SUMMER ICEBERGS**

Icebergs floating in late summer in Scoresby Sound, the world's largest fjord system, on the east coast of Greenland. Here big icebergs, calved from the large Daugaard-Jensen Glacier, crash into rocks when drifting through a narrow passage. The rapid melting of Greenland's land ice threatens a big rise in global sea levels.

This is the result of the accumulation in the atmosphere of so-called greenhouse gases that trap the sun's heat. They include carbon dioxide ($CO_2$), which we emit in large quantities by burning carbon-based fuels such as coal, oil and natural gas. But in the Arctic, warming is happening more than twice as fast as it is on the rest of the planet, and that's because the loss of sea ice increases the warming.

Ice is white. It reflects 85 per cent of the sun's radiation back into space, helping keep the Arctic cool. But in recent decades, as the ice has melted, this white surface has been replaced by ever more dark ocean, which reflects back only 10 per cent of the sun's rays. The remaining energy is absorbed and heats the air and water all around.

The most immediate effect of this is that more of the ice floating on the Arctic Ocean melts in summer. The warmer it gets, the more ice melts, which causes yet more heating. Ice re-forms as temperatures drop in winter. But what returns is much thinner, because much of the ice that used to last from year to year has been lost.

Until recently, most of the Arctic was covered in permanent ice that lasted the summer. But more than 40 per cent of it has gone, and the average thickness of Arctic ice has declined by two thirds since 1975, down to 1.2 metres (4 feet). This is turning into a runaway effect. As the winter ice gets thinner, it is ever more vulnerable to melting the following summer.

Unless the world can keep global warming below about 1.5 degrees Celsius – which will mean 3 degrees of warming in the Arctic – then scientists believe that, by mid-century, the only permanent sea ice left in the Arctic will be in the extreme high north, packed against the shores of northwestern Greenland and the Canadian archipelago north of Baffin. In summer, virtually all of the Arctic Ocean will be ice-free.

The consequences of warming are already dramatic for the Arctic ecosystems and the humans who live there. But the implications go far beyond. For the loss of the Arctic 'mirror' at the top of the world is having a global effect in accelerating warming everywhere.

A decade ago, agricultural researchers who run the world's seed banks created a 'doomsday vault' in tunnels blasted into a mountain on the Norwegian island of Svalbard, not far from the North Pole.

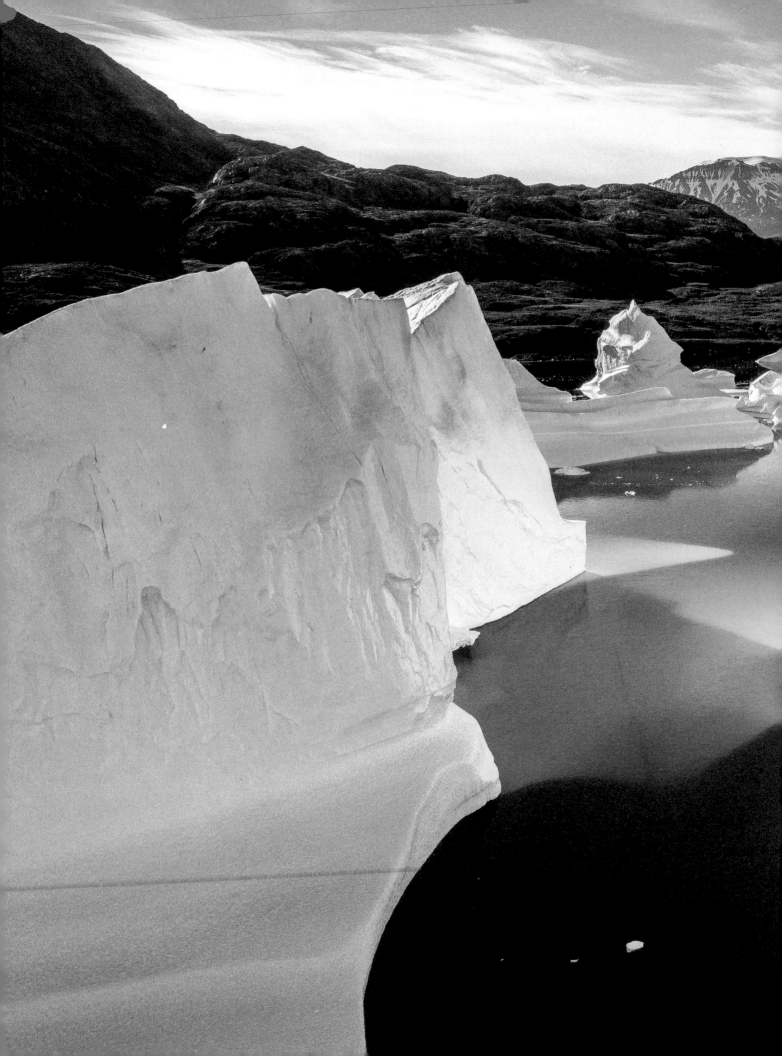

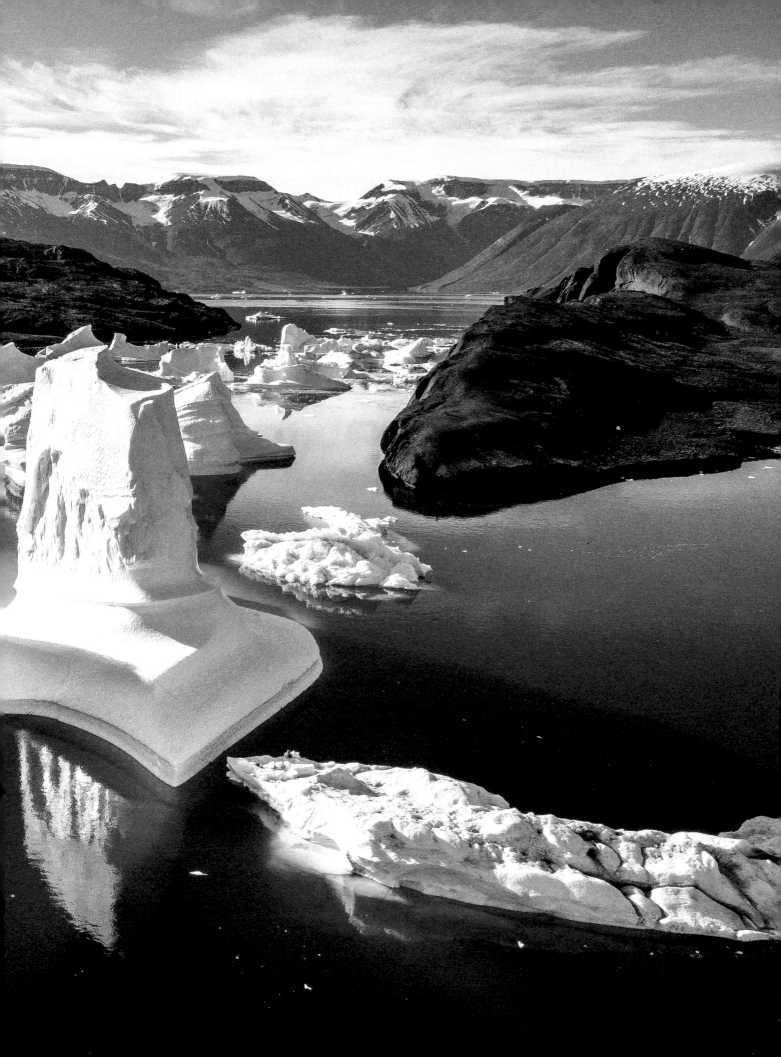

Its purpose was to hold samples of wild and cultivated varieties of the world's crop seeds to create a permanent store, safe from any imaginable global disaster, whether nuclear war, an asteroid hit, global warming or sea-level rise. Any survivors of a future apocalypse would at least be able to find seeds to grow crops to feed themselves.

But in the summer of 2017, as temperatures reached unheard-of levels on Svalbard, the ice on the mountain began to melt and entered the access tunnel. Preparations had to be made to protect the tunnel against further flooding. It seems that one of the doomsday disasters dreamed up by the seed researchers is already under way.

Nobody had predicted that Arctic melting would happen so soon or so fast. The effects are extending across the continents that surround the Arctic. June snow cover in Canada, Alaska, Siberia and Scandinavia has halved in the past 40 years. Traditional hunting, fishing and herding lifestyles of the 40 indigenous groups that live in the Arctic are being disrupted by shifting and unpredictable ice offshore, by grazing land lost to new phenomena such as tundra fires, and by changing migration patterns of creatures both in the ocean and on land.

With temperatures in places rising faster in the soil than at the surface, the permafrost is also disappearing fast. For thousands of years, the land stretching across Siberia, northern Canada and Alaska has been frozen, sometimes to a depth of 700 metres (2,300 feet). But today the surface layers are turning from hard ice to bog, causing buckled roads, burst pipelines, toppled buildings, methane fires and craters.

A report for the Arctic Council, an intergovernmental body where all Arctic nations meet, has warned that 20 per cent of permafrost near the surface may melt by 2040.

A growing concern is that more and more methane from rotting plants that has been trapped in the Arctic permafrost is now bubbling up. Methane is a greenhouse gas with even more warming potential than $CO_2$. If melting continues and the gas starts to enter the atmosphere in large quantities, as many scientists predict, then it will accelerate warming, perhaps dramatically.

The ice-free Arctic that is emerging as the world warms is profoundly different biologically as well as physically from anything in the past 2 million years. Nature is adaptable and some wildlife will benefit from being let loose from the deep freeze. Many Atlantic and Pacific fish are

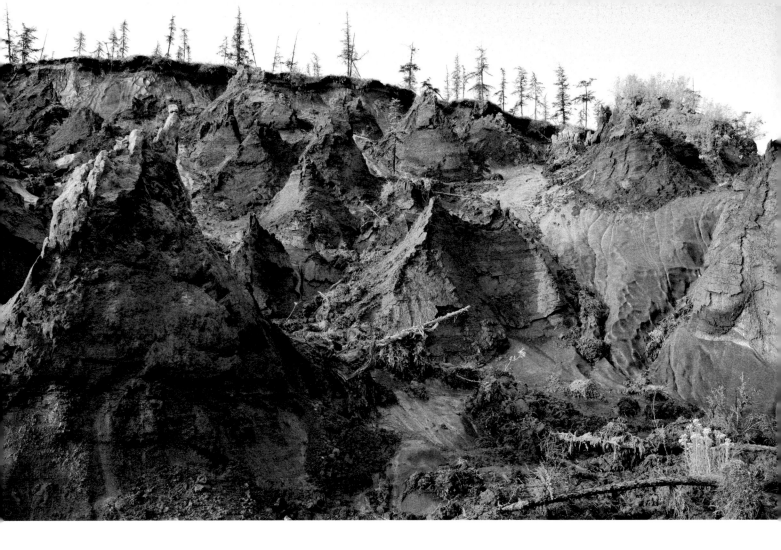

swimming north, for instance. Mackerel are winners. But the Arctic has never been an ecological wasteland, so there will be losers as well.

Arctic sea ice has always been a refuge for marine life. Take coral, for example. We think of coral as forming reefs that fringe tropical islands, but some of the world's most spectacular coral is in cold and deep waters on the bed of the Arctic Ocean, beneath near-permanent ice cover. Like tropical reefs, this coral provides habitat for other marine species to thrive.

The world's northernmost known cold-water coral is on Karasik Seamount on the Langseth Ridge north of Svalbard, just 400 kilometres (250 miles) from the North Pole. 'It is teeming with life,' blogged Antje Boetius, a German marine biologist, after sending a submersible craft down to take pictures. 'There are huge white starfish, blue snails, red crabs and white and brown clams, between... giant sponges up to a metre in size [and] hundreds of years old.' Many of these cold-water reefs are also nurseries for commercially important fish such as species of redfish – deep-sea rockfish – that populate northern waters.

These cold-water specialists are likely to lose out as the Arctic is invaded by life that thrives with a bit more warmth. But almost all

**IMPERMAFROST**
Melting Siberian permafrost – soil that has been permanently frozen for more than 2 million years – collapses into a river valley. The melting of permafrost is releasing huge amounts of carbon dioxide and methane, which will accelerate global warming. It is also causing roads and railways to collapse, pipelines to break and buildings to sink into the ground.

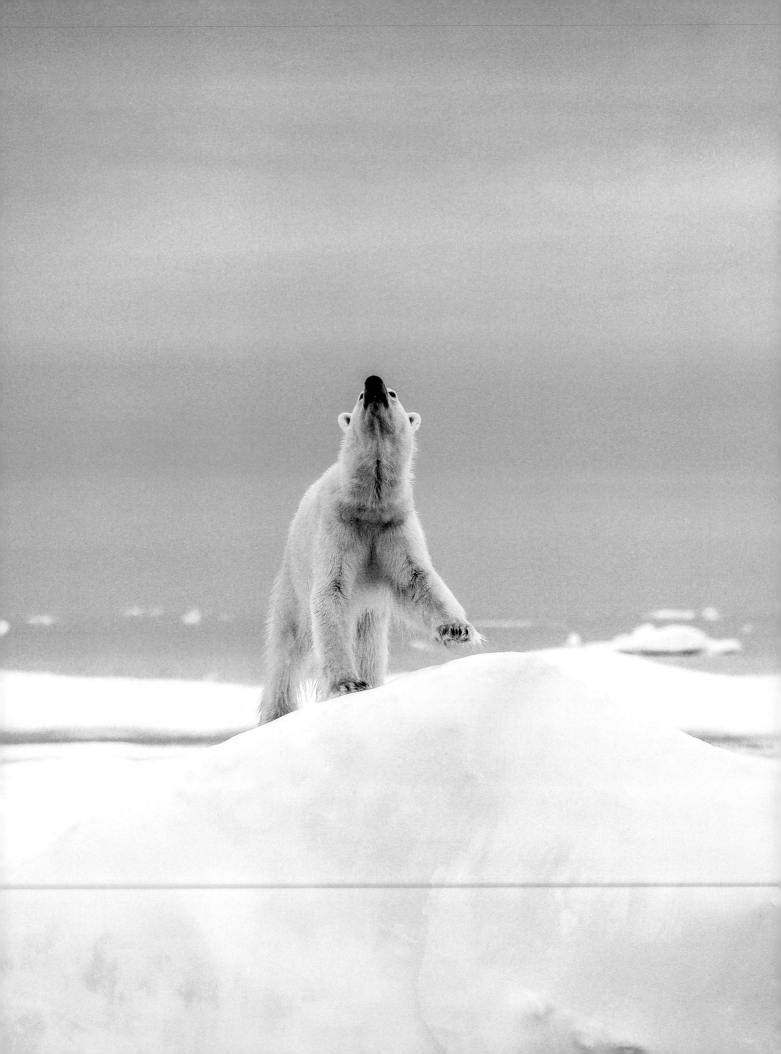

# POLAR BEARS EVOLVED TO TAKE ADVANTAGE OF ARCTIC ICE FOR HUNTING. SO AS THE ICE DISAPPEARS ... WE COULD LOSE A THIRD OF THE WORLD'S POLAR BEARS BY 2050

existing life could suffer, because marine life in the Arctic is heavily dependent on the sea ice that is disappearing.

Most obviously, floating sea ice is vital to marine mammals such as polar bears, seals and walruses. They all spend part of their year on the edges of the ice. It provides vantage points as well as resting grounds.

Ringed seals spend much of their time hunting in ocean water beneath the ice. They also play cat and mouse with polar bears lurking on the surface. The seals scratch holes in the ice with the claws on their flippers so they can come up for air. Polar bears hang around the holes looking for a meal. The seals improve their chances of survival by making several holes, so the bears don't know where to wait. But thinning ice changes the dynamics of the hunt. It makes it easier for the seals to cut holes, but it makes hiding harder.

Ringed seals hide their newborn pups in lairs dug into the snow on top of the ice. But in a poor snow year, the roofs of the lairs collapse prematurely leaving the pups exposed. And where the snow is no longer thick enough, the pups are being born on the open ice. They don't stand a chance. In the short term, the bears may gain the upper hand. But when the ice is gone, both will lose out, because neither will have any ice from which to hunt.

The Arctic is home to between 22,000 and 31,000 polar bears. On the face of it, they are doing well. Their numbers are up from as few as 6,000 a quarter of a century ago, thanks to reduced hunting by humans after an international treaty to protect them was agreed in 1973. In fact, they are among the few large carnivores on Earth that are still found across most of their former habitat. But polar bears evolved to take advantage of Arctic ice for hunting. So as the ice disappears, scientists have predicted that we could lose a third of the world's polar bears by 2050.

The more southerly populations are already losing hunting grounds, particularly around the Hudson Bay where ice now disappears for up to four months each summer. Some are moving further north to where the ice survives longest, but others are forced onto land. Canadian scientists have tracked in detail how bears that live in and around the Bay spend more time on land than they once did, fasting, eating berries and scavenging from human settlements, such as Churchill, where they come into ever greater conflict with humans.

THE TIMING OF THE SPRING BLOOMS HAS ALSO CHANGED DRAMATICALLY. THIS BIOLOGICAL RUSH, SO IMPORTANT FOR MARINE LIFE, IS HAPPENING UP TO 50 DAYS EARLIER IN SOME PLACES

**ICE-EDGE TUSKERS**
Narwhals (the males with tusks) feeding in summer off Baffin Island in the Canadian High Arctic. Their behaviour – what they eat, when and where females go to give birth – is tied to the annual expansion and contraction of the sea ice. In winter, as the ice expands, they follow the ice edge south, feeding among the pack ice. Narwhals suck up their prey, mainly fish, squid, shrimps and crabs, and dive deep after Greenland halibut.

In the long run, being forced to spend more time on land means less time to catch seals and build up the fat stores that will affect both polar bear survival and their ability to reproduce and rear cubs. They might also interbreed with their close land-based relatives, the brown and grizzly bears, which are moving north as the world warms. In fact, there are already reports from around the Hudson Bay of grizzly-polar hybrids, dubbed grolar bears.

Other marine mammals face similar challenges. The narwhal is one of three whale species, along with the bowhead and beluga, that swim in the waters of the Arctic all year round, with lives tied to the annual expansion and retreat of Arctic sea ice. Narwhals from Canada and West Greenland mostly spend their winters feeding intensely in deep water in Baffin Bay, west of Greenland. They congregate in areas with heavy pack ice and dive deep in search of their main food, Greenland halibut. They also feed on polar cod under the ice. But the shrinking ice is reducing their hunting area, and in open water, they are increasingly in danger of being hunted themselves – by killer whales that are moving into the Arctic as the ice disappears.

Among the richest hotspots for Arctic wildlife are semi-permanent areas of open water amid sea ice, which are often created by upwelling water. They are known as polynyas. In them, massive blooms of algae form, and wildlife congregates. Polynyas are critical for the world's largest populations of little auks, polar bears, narwhals and another of the Arctic's ice-dependent whales, the bowhead. Bowheads spend their entire lives around the ice, and can live for 200 years or more, making them among the planet's oldest living vertebrates. UNESCO has proposed listing several polynyas as World Heritage Sites. Yet polynyas are themselves seriously threatened by the disappearance of ice.

A big concern for the future of marine life is the fate of algae. Warmer waters have increased algae production by about 20 per cent in the past two decades, creating more 'blooms', which provide a feast at the ice edge for tiny crustaceans (the zooplankton), that are in turn eaten by fish, birds and marine mammals. But the loss of ice will ultimately affect the availability of this plankton bounty.

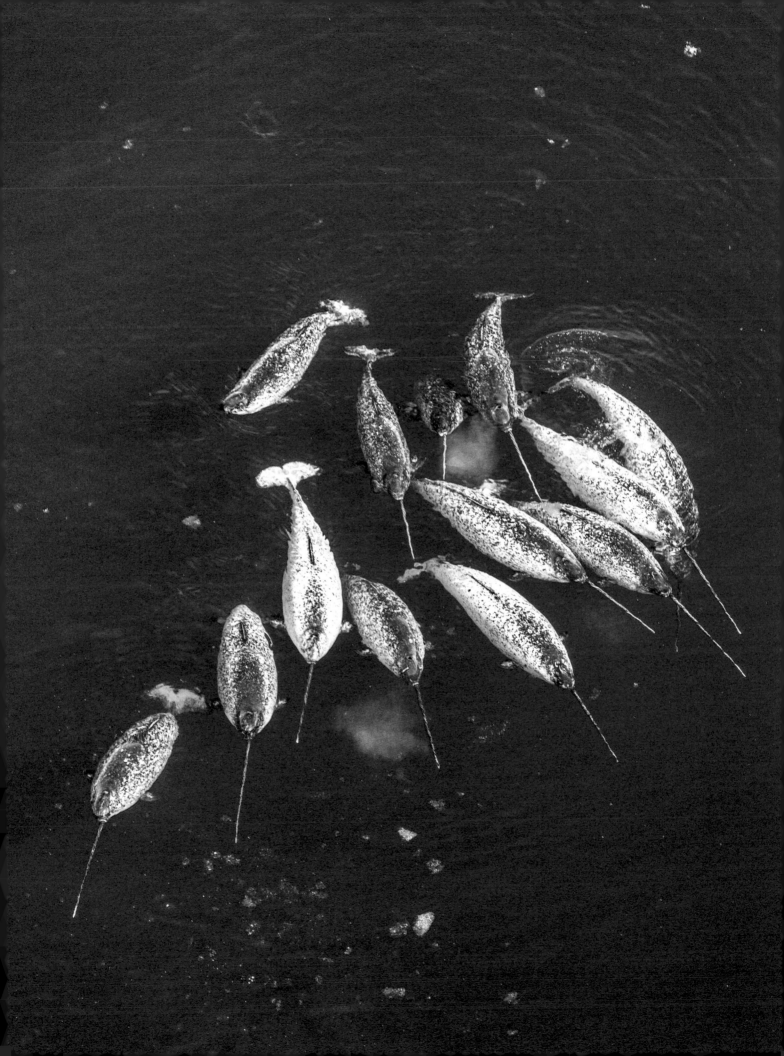

# EACH SPRING AND AUTUMN, ABOUT 12 MILLION SEABIRDS PASS FROM THE PACIFIC INTO THE ARCTIC OCEAN. EN ROUTE, THEY NEST, FORAGE AND BREED IN THE NARROW BERING STRAIT

**OPPOSITE**

**FOOD CONVOY**

Little auks returning en masse to their nests on the rocky shores of an island in the Norwegian Arctic archipelago of Svalbard. They have been feeding at sea on copepods – tiny crustaceans that are their main food, especially during the breeding season. If warming water causes the planktonic copepods to move away, it will have a huge impact on the breeding success of little auks.

**NEXT PAGE**

**KITTIWAKE BONANZA**

A huge flock of black-legged kittiwakes in summer at the base of a glacier in the Hornsund fjord, Svalbard. They are feeding in the area where the meltwater and sea water meet, on tiny animals flushed up from the bottom by the melting glacier.

Already, scientists have noticed a change in the species of algae, affecting the related marine foodwebs. The timing of the spring blooms has also changed dramatically. This biological rush, so important for marine life, is happening up to 50 days earlier in some places. This poses a threat because the life cycles of many species are synchronized with the timing of the blooms. If the blooms no longer happen on time, then some of the Arctic's most important species may suffer.

It will, for example, affect the migrant bird species that currently show up to breed and feast on the Arctic's algal-fuelled bonanza of marine life. Each spring and autumn, about 12 million seabirds pass from the Pacific into the Arctic Ocean. En route, they nest, forage and breed in the narrow Bering Strait. Among them are tiny Arctic terns that fly all the way to Antarctica and back each year. But if the seasons of the ice change, they may arrive to find nothing to eat.

Already in trouble are coastal colonies of Brünnich's guillemot – known also as thick-billed murre – in northern Canada. They rear their chicks on polar cod, which feed on the algal blooms at the ice edge. But the ice is now melting two weeks earlier than it used to, before the chicks hatch. With less food available, more chicks die.

Conservationists are uncertain whether the Brünnich's guillemots can rapidly switch diet to the capelin moving into the area as the edge of the cold Arctic water retreats. If not, they are in trouble, as are the ivory gulls of Arctic Canada, whose numbers have declined by 70 per cent.

As the mix of species in the Arctic changes, new food chains may form, with unpredictable consequences, for humans as well as nature. Mackerel were unknown off Greenland until the past decade. Now they are found in such numbers that they are one of Greenland's main exports, along with halibut and shrimps. Their arrival, along with other fish until recently found only much further south, will encourage other new arrivals to the Arctic – most especially, humans intent on exploiting Arctic resources.

Humans already exploit fish in the more southerly parts of the Arctic – for instance salmon and walleye pollock in the Bering Sea and polar cod and haddock in the Barents Sea, north of Scandinavia.

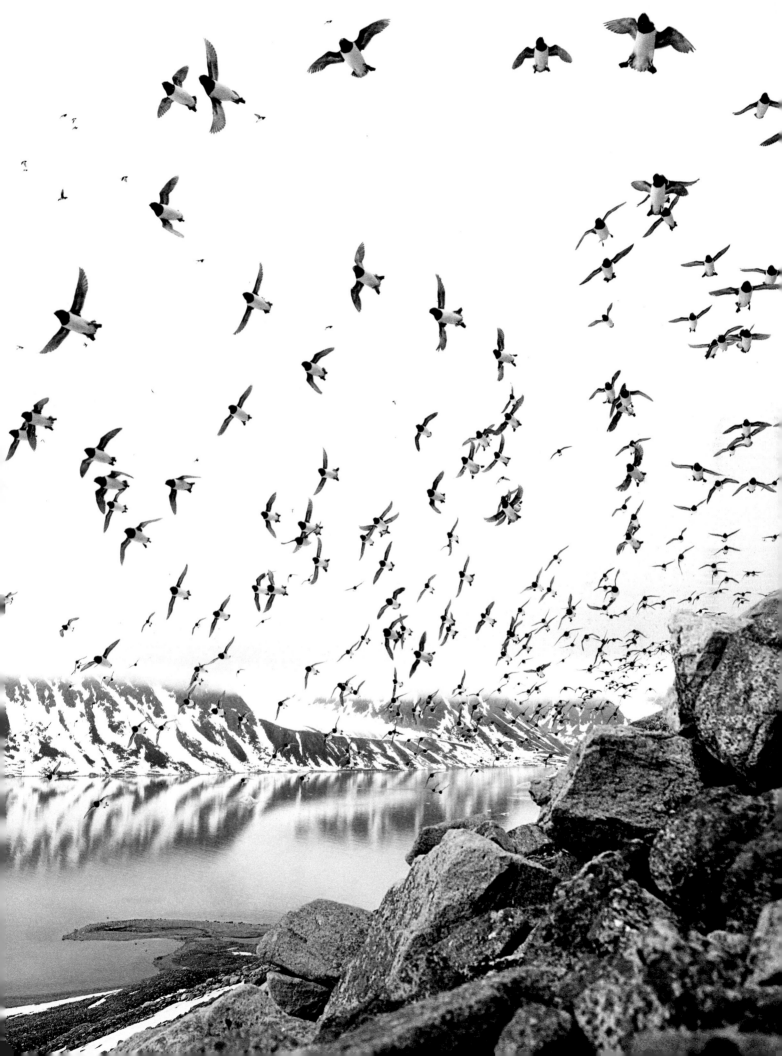

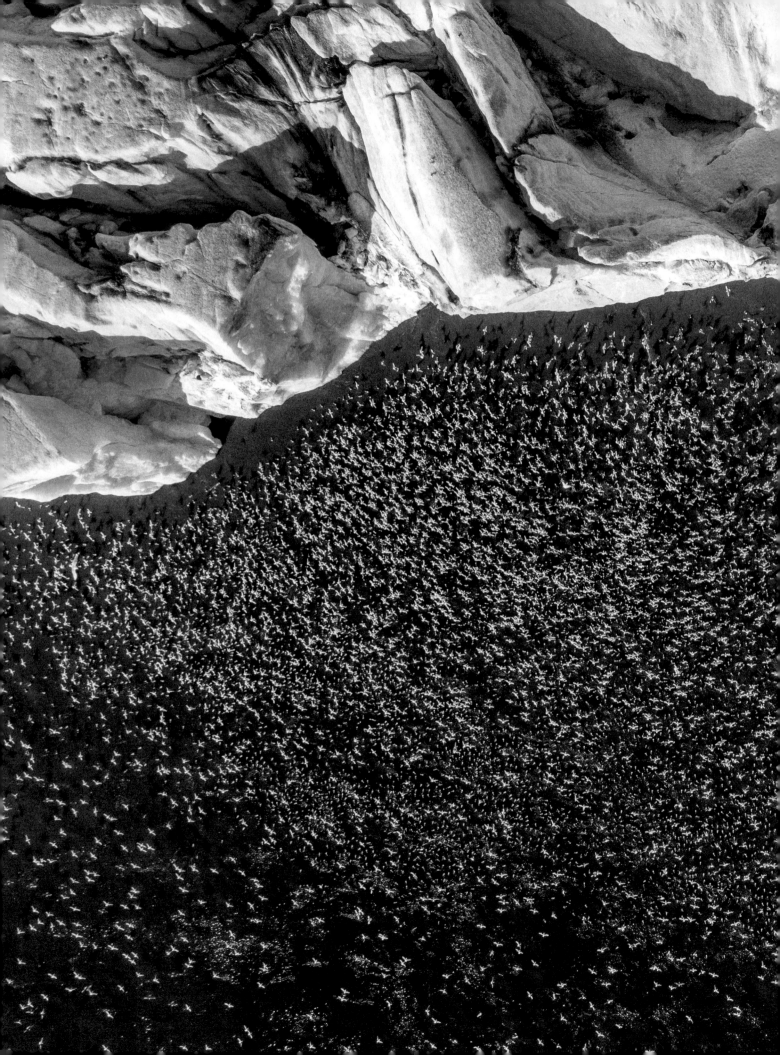

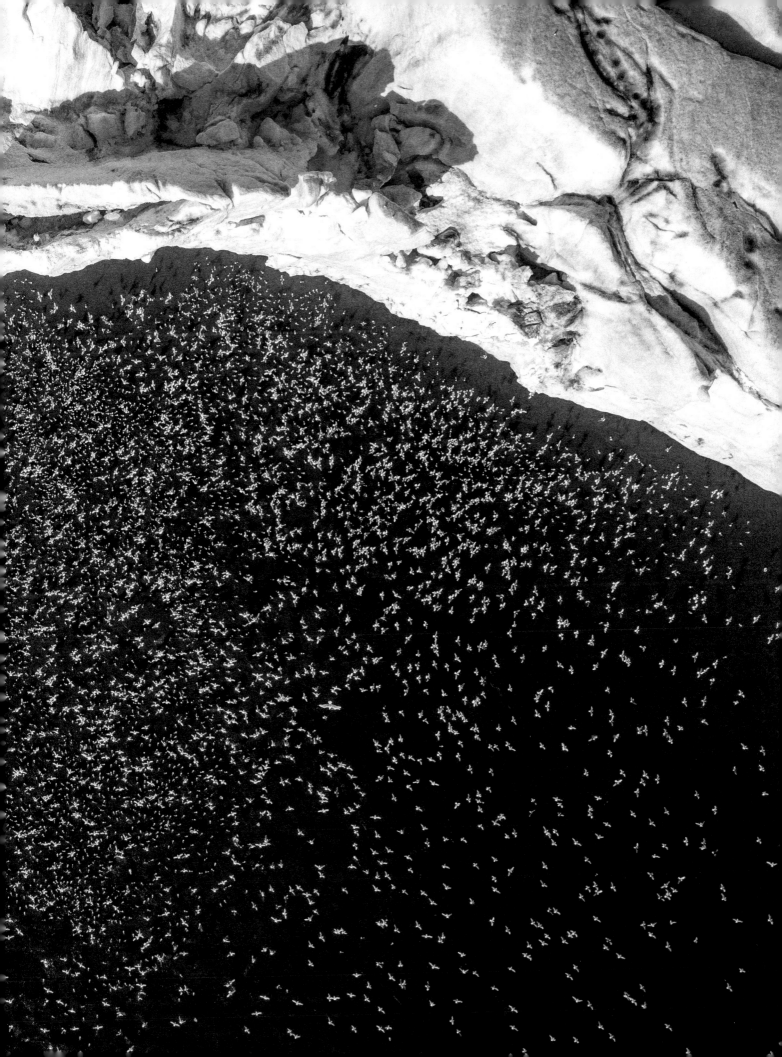

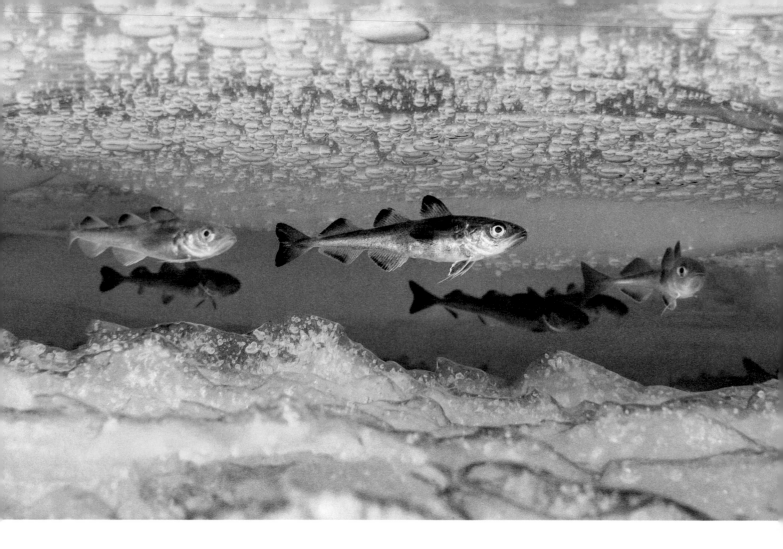

ABOVE
**ICE FISH**
Young polar cod in an ice pocket in the Arctic Ocean. Until they are about two years old, the young cod live around the ice, feeding on small crustaceans such as copepods. Antifreeze in their blood allows them to live at sub-zero temperatures. When they are big enough, they will move into open water, where they are an important food source for marine mammals and seabirds. As the ocean warms, polar cod are also becoming prey for fish such as Atlantic cod as they move north.

Some of these populations could shrink as the Arctic warms. Walleye pollock, which feed primarily along ice edges, are expected to decline along with the ice. But others, such as cod, capelin and halibut, may fare better. One study estimates that the value of Arctic fish populations could increase by 50 per cent by 2050 and be worth about $30 billion.

Many companies are now starting to take cargo along the previously unnavigable northwest and northeast passages, north of Canada and Russia respectively. A route through the Arctic north of Siberia could halve the journey time from China to Europe, taking raw materials east and finished goods west.

Most alarming of all for those who care about conservation in the Arctic is that, once the ice retreats, minerals and hydrocarbons on the Arctic Ocean bed will be much easier to extract. The pickings could be rich. A third of the world's undiscovered natural gas is reckoned to be on the continent shelves beneath the Arctic, for instance. It may seem like the height of folly to take advantage of a warmer, ice-free Arctic to extract more of the fuel that caused the warming in the first place and is continuing to turn up the heat. But most oil companies do not see things that way. And Russia,

IT MAY SEEM LIKE THE HEIGHT OF FOLLY TO TAKE ADVANTAGE OF A WARMER, ICE-FREE ARCTIC TO EXTRACT MORE OF THE FUEL THAT CAUSED THE WARMING IN THE FIRST PLACE ... BUT MOST OIL COMPANIES DO NOT SEE THINGS THAT WAY

which claims most of the Arctic resources, is busy 'militarizing' the region in order to secure them, say analysts. Parts of the Arctic Ocean are not within any nation's borders. But in 2007, Russian explorers planted a flag on the ocean floor at the North Pole.

A strange irony of the polar regions is that human influence on the planetary thermostat is greatest in the places where human populations are sparse. So what can and is being done to protect them?

The Antarctic Treaty, first signed in 1959 by all 12 nations with bases there, bans military and commercial mining activities, effectively setting the continent aside for science. A parallel convention on marine resources controls the catching of krill and fish in the Southern Ocean.

Conservation has been stepped up with the creation of the world's first high-seas marine protected area – the South Shetland Islands Southern Shelf – and the world's largest marine protected area, in the Ross Sea, one of Antarctica's most species-rich bays. Conservationists are also calling for more marine protected areas to be created around the continent, giving the water the same protection currently reserved for the land. This includes proposed marine protected areas for another great bay, the Weddell Sea, and for the Antarctic Peninsula.

Meanwhile, threats to the Arctic are more diverse and immediate. Unlike Antarctica, very little of the Arctic is formally protected. But in late 2017, an international agreement put a 16-year moratorium on commercial fishing in the central Arctic Ocean – an area larger than the Mediterranean Sea, currently protected from fishing by sea ice. Governments have agreed the moratorium so fish populations can be assessed before the ice retreats and ships are allowed onto the new fishing grounds.

That is good news. But biologists want to go much further, to give formal protection to biodiversity hotspots such as the volcanic seamounts where fish spawn, the cold-water coral reefs and the polynyas. Another proposal is to place under formal protection the zone comprising north of Greenland and part of the northeastern

OPPOSITE

**BOWHEAD CHANNEL**
A bowhead whale and her calf surface in the Arctic Ocean ice off the northern coasts of Alaska. Bowheads live among the ice floes, feeding on planktonic animals such as copepods. Extremely thick skulls allow them to break through 18-centimetre (7-inch) ice when they need to create breathing holes.

Canadian island archipelago, known as the Last Ice Area, where sea ice is expected to last longest. It will become an important refuge for many currently common Arctic species including polar bears. But the truth is that, in the Arctic, formal protection needs to go hand in hand with keeping global warming below 1.5 degrees Celsius and the protection of the sea ice from further melting.

Already the Arctic is being changed, by warm temperatures, open waters and thawed soils. And it will exact its revenge. Its melting land ice will accelerate warming worldwide and raise sea levels. As our world warms, we are seeing tides rise more than 3 millimetres every year. But this rate is increasing, suggesting a 60-centimetre (nearly 2-foot) rise by 2100. Most of this is because warmer water takes up more space.

**THE BIG MELT**
A future danger for humans living on the coast is rising sea levels. More than 600 million people live in areas less than 10 metres (30 feet) above sea level. The cause of sea-level rise will be from ice melting on land. Of particular concern is the melting West Antarctic Ice Sheet, which is anchored to submerged mountains and so is also affected by warming sea water. There is still time, though, to halt the big melt.

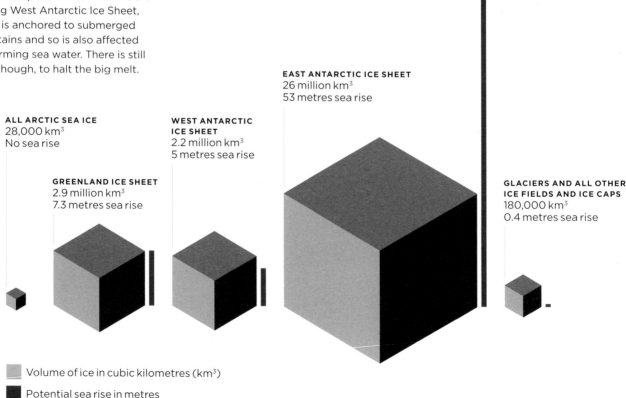

**EAST ANTARCTIC ICE SHEET**
26 million km³
53 metres sea rise

**ALL ARCTIC SEA ICE**
28,000 km³
No sea rise

**WEST ANTARCTIC ICE SHEET**
2.2 million km³
5 metres sea rise

**GREENLAND ICE SHEET**
2.9 million km³
7.3 metres sea rise

**GLACIERS AND ALL OTHER ICE FIELDS AND ICE CAPS**
180,000 km³
0.4 metres sea rise

Volume of ice in cubic kilometres (km³)

Potential sea rise in metres

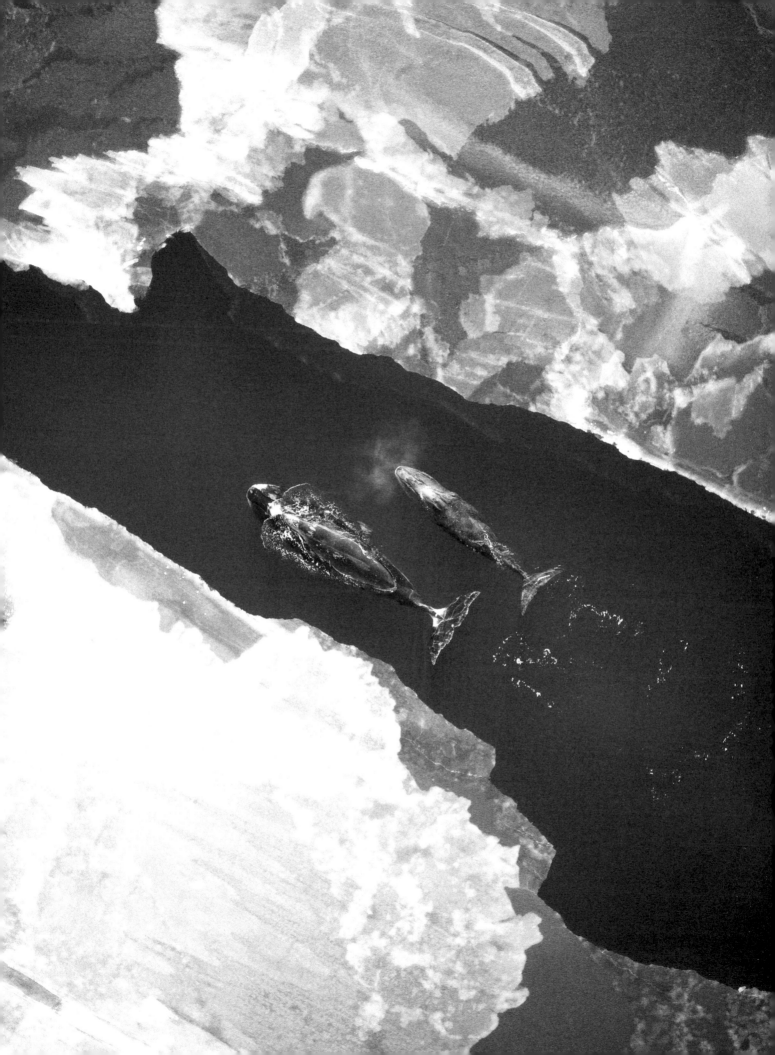

# THE LOSS OF THE WEST ANTARCTIC ICE SHEET COULD DELIVER 5 METRES (16 FEET) OF SEA-LEVEL RISE ... THE SINGLE LARGEST THREAT OF RAPID SEA-LEVEL RISE

**OPPOSITE**

**GREENLAND'S RUNAWAY**
Rivers of meltwater on the surface of the Greenland Ice Sheet in the summer of 2016. The rivers eventually excavate holes in cracks – moulins – that form shafts draining down to the base of the ice. The lubricating effects of the draining water can lead to the ice sheet sliding faster into the sea. The orange spots to the right are the tents of researchers studying the effect. Each year, the ice sheet gains ice from snow and freezing rain and loses ice through melting. But since at least 2002, it has been losing significantly more ice than it has gained. It is also melting from the bottom up wherever it comes into contact with warmer sea water.

**NEXT PAGE**

**GENTOO FLOTILLA**
Diving gentoo penguins – part of a group of more than 100 penguins – off shore of their breeding colony on Danco Island, off the Antarctic Peninsula. They are hunting for krill to bring back for their growing chicks. As the Antarctic sea ice contracted, so the gentoo penguins have expanded their range. This is probably because gentoos are not so dependent on krill as, say, Adélie penguins, and because their larger size also allows them to dive deeper and catch a greater variety of fish.

This thermal expansion of the oceans will continue. But sea-level rise will be accelerated, perhaps dramatically, as melting ice in the polar regions dumps more water into the oceans.

Melting sea ice will have no direct effect on sea levels, because it is already floating in the ocean (if it melts, it will not add extra volume). But when ice on land melts and the water adds to that in the oceans, tides around the world will rise and coastal areas will flood.

There is a lot of ice on land – most of it tied up in three giant ice sheets that cover Greenland and Antarctica. Greenland, an island six times the size of Germany, has a covering of ice up to 3 kilometres (nearly 2 miles) thick. This ice sheet is already losing volume, contributing a millimetre a year to global sea-level rise. If it all melted (which would take centuries at least, but could become unstoppable), it would eventually add 7.3 metres (24 feet).

The biggest area of ice on the planet is the East Antarctic Ice Sheet. It seems stable, both because of its immense size and because it is on firm land. That is good news, because if it all melted, that would raise sea levels by up to 53 metres (175 feet). But its smaller relative, the West Antarctic Ice Sheet, is a different matter.

The West Antarctic Ice Sheet is not on solid land but is anchored to a range of submarine mountains. Scientists have warned that warm ocean currents circulating beneath the ice could cause it to come adrift and float away, melting as it went. Controversially, one of the world's leading experts on Antarctic ice, NASA's Eric Rignot, says this outcome appears in the long run 'unstoppable'.

The loss of the West Antarctic Ice Sheet could deliver 5 metres (16 feet) of sea-level rise. It is, NASA says, the 'single largest threat of rapid sea-level rise'. Its demise would be a global catastrophe, inundating many of the world's great cities and some of its best agricultural land, as well as coastal ecosystems. The loss of ice would likely begin slowly, adding only marginally to sea-level rise for as much as two centuries. But, especially if we have not halted global warming in the meantime, it could accelerate fast.

The lesson seems to be that the urgency is not just to head off gradual warming, but to stop us passing a tipping point in the distant southern polar region that could ultimately swamp our world.

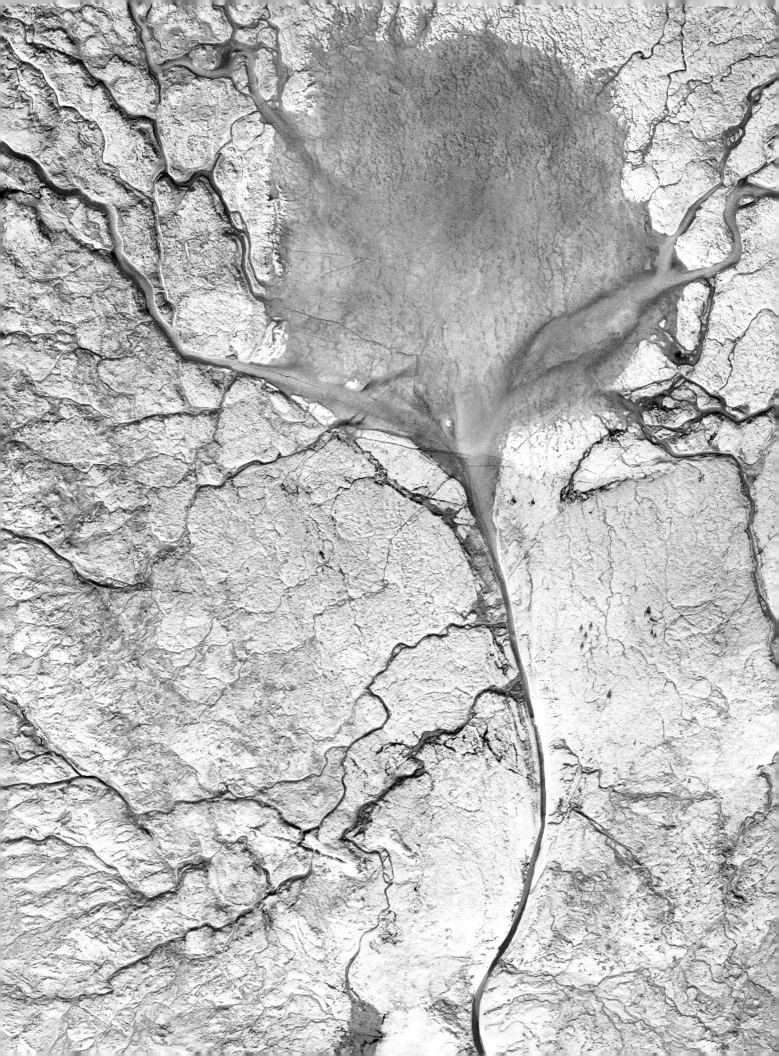

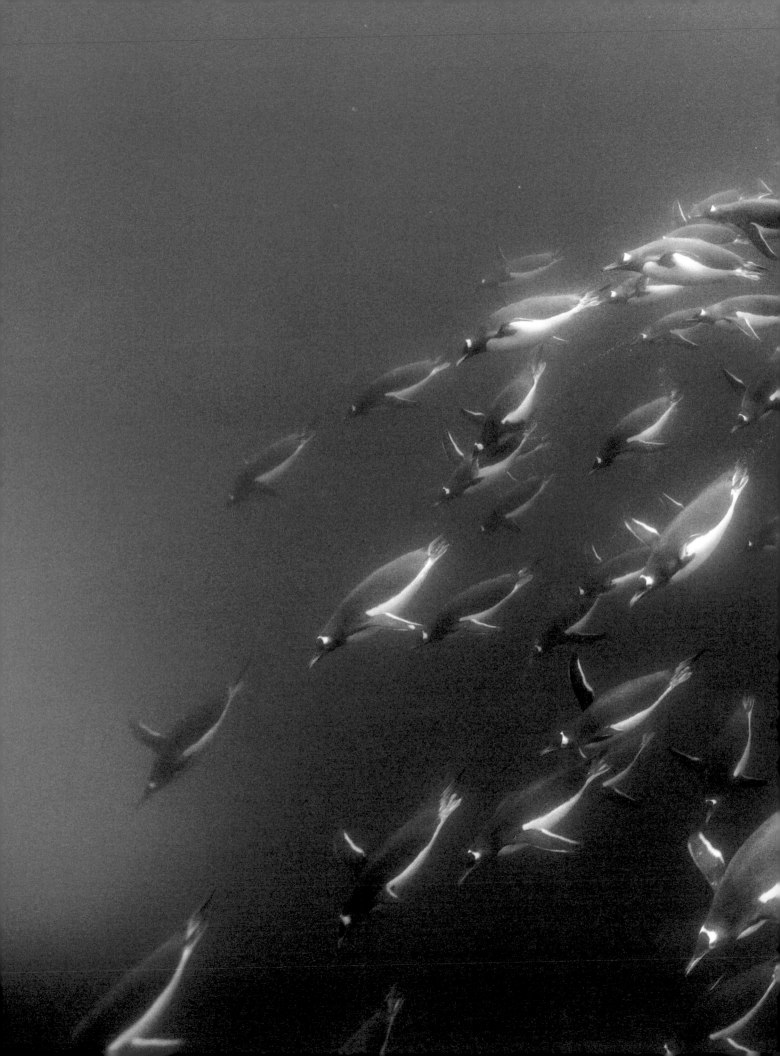

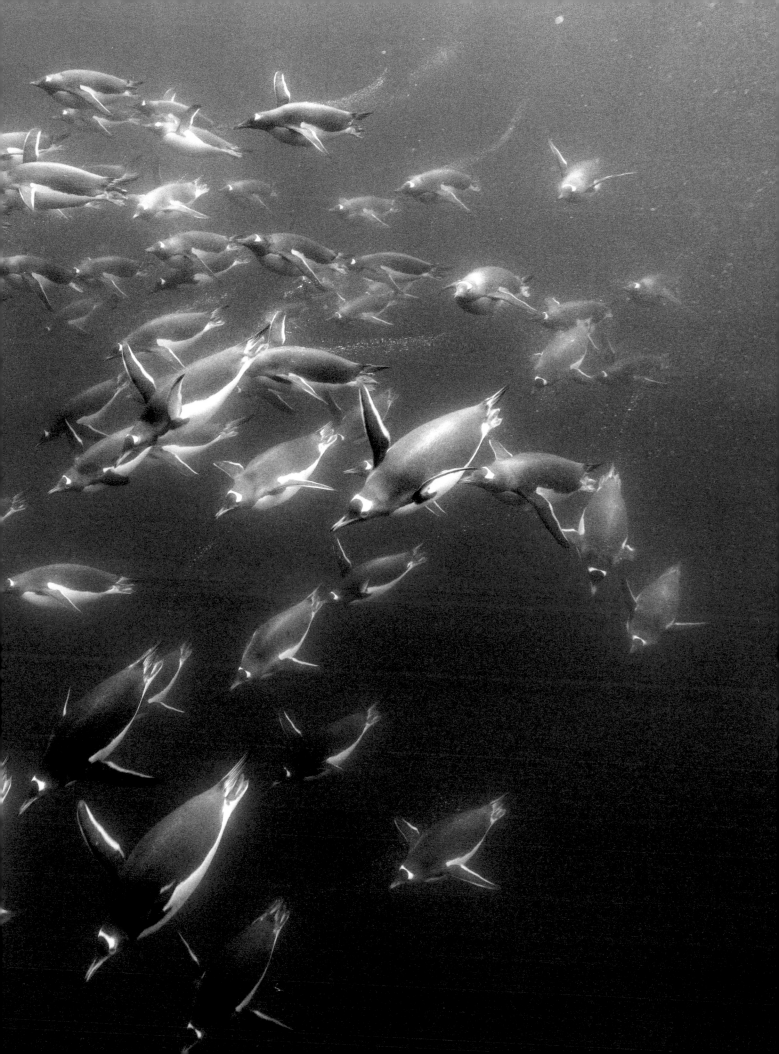

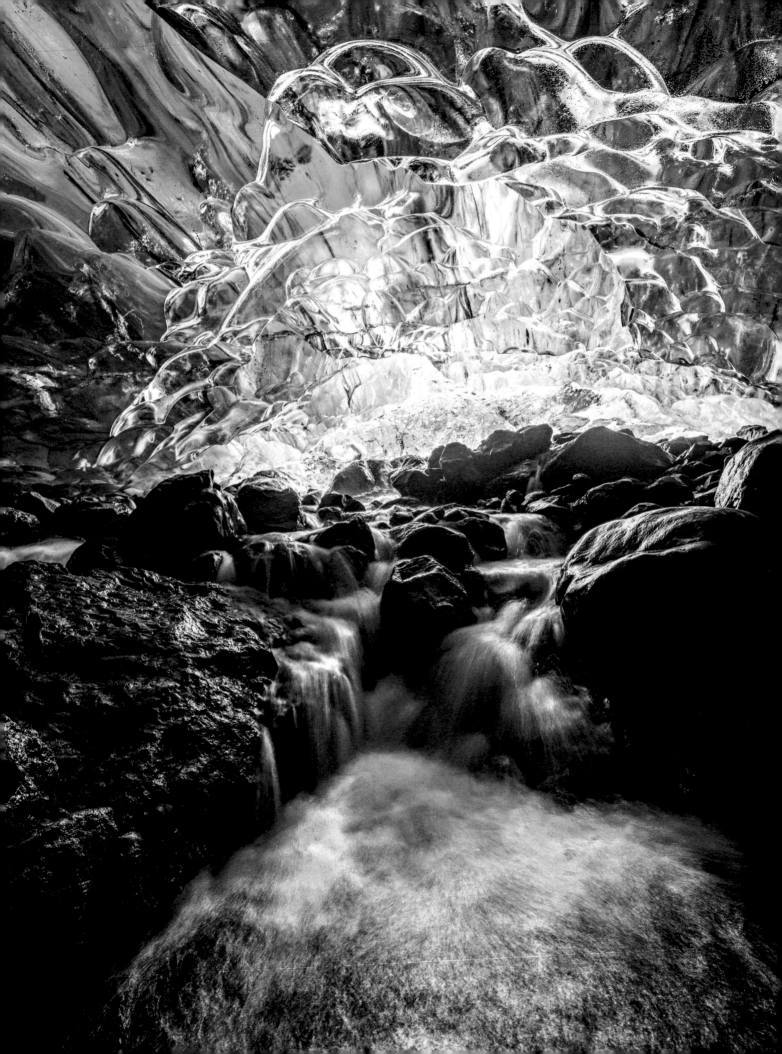

# FRESH WATER

'For centuries, we have disrupted the natural water cycle in an effort to control water for our prosperity. But we have reached a tipping point. Big dams, diversions and levees are not only harming freshwater ecosystems and the diversity of life, they are now often less effective in building water security. With the risk of floods, droughts, wildfires and water shortages on the rise, we must look to solutions that repair the water cycle, and that work with, rather than against, nature's rhythms. The well-being of all of life depends on this.'

**SANDRA POSTEL**
Global freshwater expert and author of *Replenish: The Virtuous Cycle of Water and Prosperity*

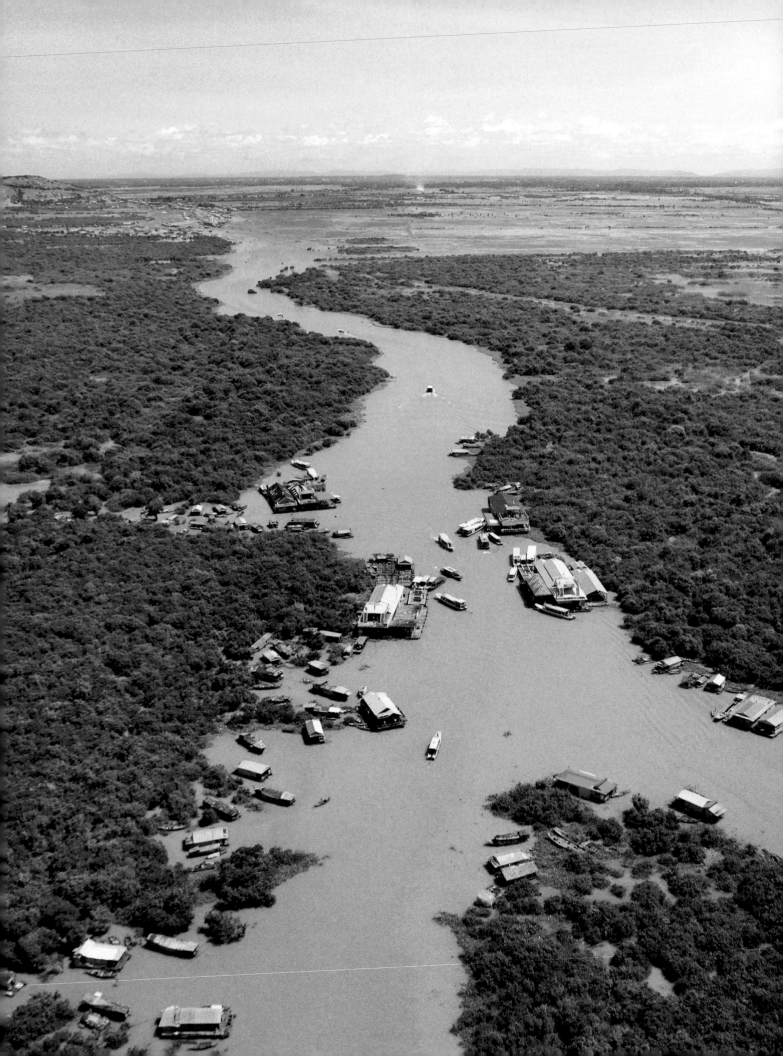

# THE WORLD'S GREAT RIVERS ARE OUR PLANET'S ARTERIES. THEIR FLOWS MAINTAIN THE WATER CYCLE, CARRYING RAIN FALLING ON THE LAND BACK TO THE OCEANS … WHERE IT EVAPORATES INTO THE AIR TO CREATE MORE RAIN

Rivers flow downhill to the sea, right? Not always. For almost half the year, the Tonlé Sap in Cambodia flows backwards, away from the sea. Normally the river drains into the Mekong, the largest river in Southeast Asia. But during the monsoon season, from June to November, the waters flowing down the mighty Mekong are fifty times greater than in the dry season – so great that they invade the channel of the Tonlé Sap and force its waters back upstream for about 200 kilometres (125 miles). They enter a lake, which massively expands, flooding forests all around for another 100 kilometres (60 miles).

For those few months, the Tonlé Sap and its Great Lake gulp down a fifth of the Mekong's monsoon flow. With the water comes fertile silt and billions of fish fry. In the muddy waters around the trees of the flooded forest, the fry grow into fat adults. Millions of birds congregate in the trees to feed on the fish, and thousands of people who live on the lake in floating villages fill their nets. The scene inspired the nineteenth-century French explorer Pierre Loti to call Cambodia a country 'where fish grow on trees'.

When the flood subsides, the Great Lake empties and the Tonlé Sap turns and flows back into the Mekong. The fish swim with it and then migrate up and down the great river. The reversing Tonlé Sap and its flooded forest are the beating heart of one of the most biologically rich rivers on our planet, home to some of the last Irrawaddy dolphins and Mekong giant catfish up to 3 metres (10 feet) long. More fish are caught on the Mekong than anywhere else except the Amazon. It fills the nets of an estimated 60 million people. Its fish 'make a bigger contribution to economic well-being and food security than in any other country', according to the aid agency Oxfam.

The riches of the Tonlé Sap fed one of Asia's greatest empires. The Khmer civilization, which peaked in the twelfth century, was centred on Angkor Wat, a complex of palaces close to the Great Lake. Ever since, the people who live along the Tonlé Sap have held a festival to mark the date when the river turns. Each year, hundreds of canoes decorated with water serpents race down the river to the Cambodian royal palace, which stands where the river joins the Mekong.

The natural wealth created by the Mekong's wild monsoon flood as it spreads across floodplains and invades forests is a vivid reminder

OPPOSITE
**WATERLAND**
Flooded forest on the margins of the Great Lake at the head of the Tonlé Sap River in Cambodia. Life is busy here. Boats head from the floating villages to harvest one of the world's most productive fisheries. The lake's natural wealth is maintained by a surge of water that flows upstream from the giant Mekong River during the monsoon season. But hydroelectric dams on the Mekong threaten to end the flood pulse and damage both the flooded forests and the fisheries.

PREVIOUS PAGE
**SPONGELAND**
The wetlands of Nansemond River is one of the best protected stretches of wetland left in the Chesapeake watershed, on the east coast of the US. Wetlands themselves protect the land from floods and storm surges, trap polluted runoff from the land, and slow the flow of nutrients, sediments and chemical contaminants into rivers. They also provide critical habitat for wildlife.

OPENING PAGE
**FIRE AND ICE**
An ice cave deep inside Vatnajökull Glacier. Spread over southeast Iceland, it is one of Europe's largest glaciers. But for how much longer? It is melting fast due to warmer air above, and it is shrinking by a metre (3 feet) a year. The glacier sits on top of a number of volcanoes, and there are fears that, as the melting reduces the weight of the ice, the volcanoes will become more active, leading to sudden floods or worse.

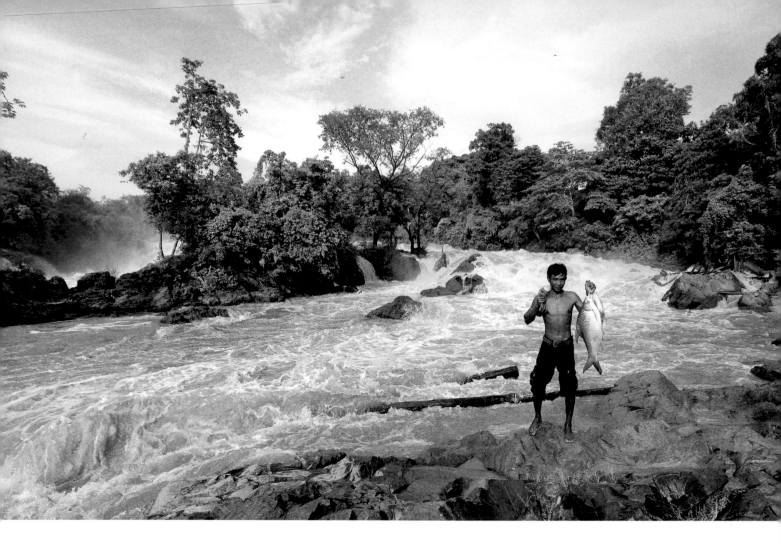

ABOVE
**THE RAGING MEKONG**
A fisherman on the wildest part of the Mekong River, the Khone Phapheng Falls. Here millions of litres of water cascade from Laos into Cambodia, bringing a bounty of fish and rich silt, relied on by at least 40 million people. More than 70 large dams, including a controversial one upstream of the falls, are planned for the Mekong and its tributaries. But for now the river remains relatively free-flowing and one of the world's great arteries.

of what many more of the world's rivers used to be like before we dammed them and tamed their floods. It recalls a time when river flows were dictated by the seasons rather than the needs of electricity consumers or farmers, when nature could take advantage of the seasonal flow cycles to fill the rivers with life.

Freshwater ecosystems and the species they contain are intimately tied to those on land and in the oceans. Take the life of North American salmon. They live most of their lives in the Pacific and Atlantic oceans, but at age five years or so, they forsake the oceans and use mysterious magnetic positioning systems to find their way back to the rivers where they were born. They may swim thousands of miles to reach the rivers, then swim upstream to the very same gravel beds where they hatched.

Here females seek out places that will provide a good flow of oxygen for eggs that they will lay in gravel nests they make on the river bed. Then males fight for access to the females to fertilize their eggs as they are laid. Soon after, both males and females die, and the life cycle renews, with a new generation returning to the ocean a year or so later. Some of these salmon runs have been hindered by hydroelectric dams that block migration or flood gravel beds. More than half the spawning

grounds in the Columbia River have been lost. But other runs still thrive. One of the greatest is that of the sockeye salmon. Nearly half the world's population swim into the Bering Sea and on to Bristol Bay before returning upstream to spawn in the mountains of southwestern Alaska. Typically, 60 million sockeye salmon make the journey each year, along with millions more pink, chinook, coho and chum salmon.

Ecologists call salmon a keystone species, of particular importance in the northwest of America, from Oregon to Alaska. Their spawning runs are the high spot of the year for predators such as bears, wolves, otters and mink, all seeking to benefit from a freshwater migration that some biologists compare to the wildebeest on the Serengeti.

Bears pick fat salmon from the rivers – outrunning them in shallow water or even catching them as they leap up waterfalls – then in forested areas, carry them away for eating. Being messy eaters, bears leave the remains of salmon on the forest floor and in their faeces. In this way, dead salmon provide a quarter of all the nutrients in riparian woodlands. That is several tonnes per hectare each year. Spruce trees in Alaska grow three times faster on the banks of rivers with salmon runs than on those without. They are almost literally made of salmon.

Birds benefit too. Ravens, crows, gulls and eagles all join the salmon feast. Some of the world's highest concentrations of eagles are around key salmon-spawning grounds in Alaska. Up to half a million chum salmon congregate each year on spawning grounds in the upper reaches of the Chilkat River, feeding several thousand bald eagles.

Despite such predation, many adult salmon survive to spawn and then die a natural death in the river. Their rotting carcasses unleash the nutrients that the fish consumed in the ocean, now transferred to the river ecosystems. The link is clear. Rivers with most salmon in autumn have the most estuary breeding birds the following summer.

The world's great rivers are our planet's arteries. Their flows maintain the water cycle, carrying rain falling on the land back to the oceans, from where it evaporates into the air to create more rain. They are also breeding grounds and thoroughfares for nature, linking the planet's ecosystems. Rivers bring water from mountains to deserts. They bring migratory fish from the oceans to their spawning grounds far inland. And they bring rich silt that keeps floodplains fertile and protects estuarine cities from rising seas.

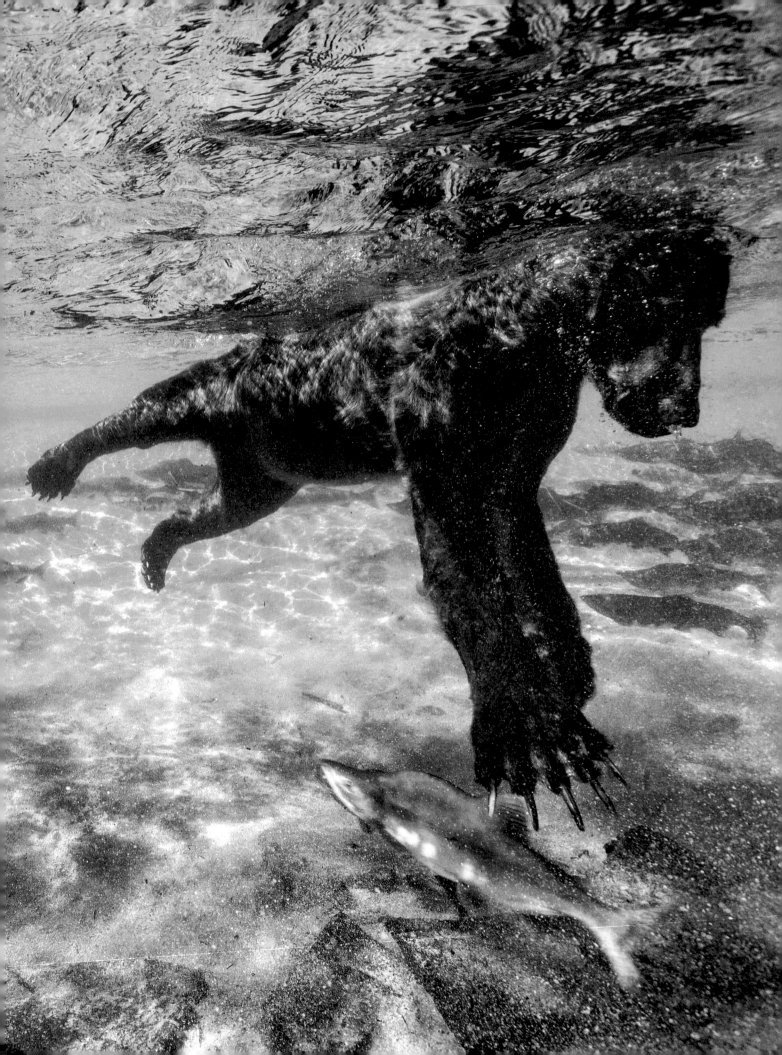

# SALMON PROVIDE A QUARTER OF ALL THE FERTILIZER IN RIPARIAN WOODLANDS

Above all, they bring life. Nearly half of all the world's fish species live in rivers. It is no coincidence that the world's largest and most biodiverse rainforest occupies the drainage basin of the world's largest river, the Amazon.

The great rivers also sustain humanity. Hundreds of millions of people depend on the flow of rivers for their food, either directly from catching fish or indirectly when flooding rivers water their fields and pastures. That is why almost all ancient civilizations began on major rivers, including ancient Egypt on the Nile, Mesopotamia on the Tigris and Euphrates, and China on the Yellow River. Even today, most inland cities sit on river banks, and most of the world's great cities, such as New York, Shanghai and London, sit on river estuaries.

But in recent decades, humans have been abusing these natural life-giving arteries. We have barricaded them in their channels to try to stop floods. And we have built around 60,000 large dams and millions of smaller ones that halt their flow. The water is either diverted down irrigation channels to fields or to city water-supply systems, from where it may never return; or it is poured through turbines to generate electricity, flowing on downstream – out of season and often deprived of fertile silt – disrupting ecosystems all the way to the ocean.

Among the most famous obstructions are the Hoover Dam on the Colorado in the American West; China's Three Gorges, across the Yangtze, the world's third biggest river; and Egypt's Aswan High on the Nile, the world's longest river. This has brought some benefits for the modern world. Approaching a fifth of our electricity comes from hydroelectric dams, and a quarter of our crops are irrigated from rivers.

But the ecological effects have been profound. Almost two thirds of the world's great rivers no longer flow freely because of dams and other infrastructure along their banks. The Mekong has a cascade of dams on its upper reaches in China, with more planned downstream in Laos and Cambodia that threaten the flood pulse of the Tonlé Sap. The world's largest inland fishery could soon be a distant memory.

The Salween currently runs free for 2,800 kilometres (1,740 miles) from the Qinghai–Tibet Plateau through the jungles of Myanmar and Thailand to the Indian Ocean. But seven dams are planned in Myanmar, as well as more upstream in China.

All Europe's large rivers are dammed. The last outside Russia to escape, the Vjosa in Albania, is now earmarked for seven barriers along its 270-kilometre (170-mile) length. Even the Amazon is dammed on many of its biggest tributaries.

OPPOSITE
**BEAR NECESSITY**
A brown bear in Alaska's Katmai National Park dives in a stream to grab a sockeye salmon on its way to spawn. Migrating salmon in Alaska help sustain the densest population of bears on the planet. Even their remains on the floor of the surrounding forests are a major source of nutrients for the trees.

NEXT PAGE
**PAPPA CROC**
A male gharial crocodile guards the hatchlings of eight to ten females on the Chambal River in India – the species' last stronghold. Unlike many other crocodiles, gharials cannot walk overland or tunnel to escape droughts, and they have become critically endangered partly because of water diversions that have led to pools drying up during the long dry season.

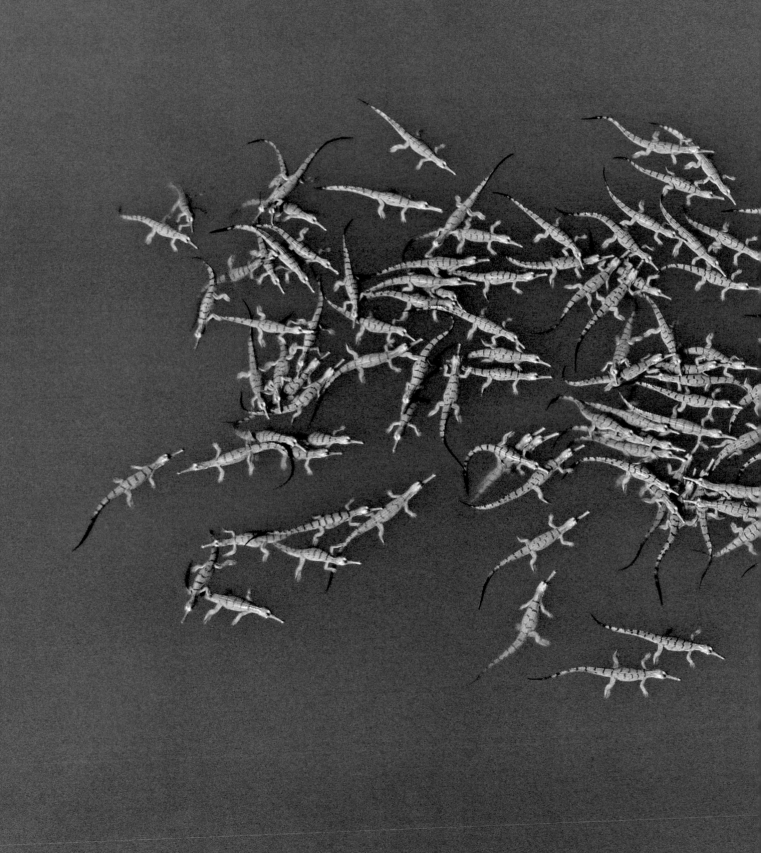

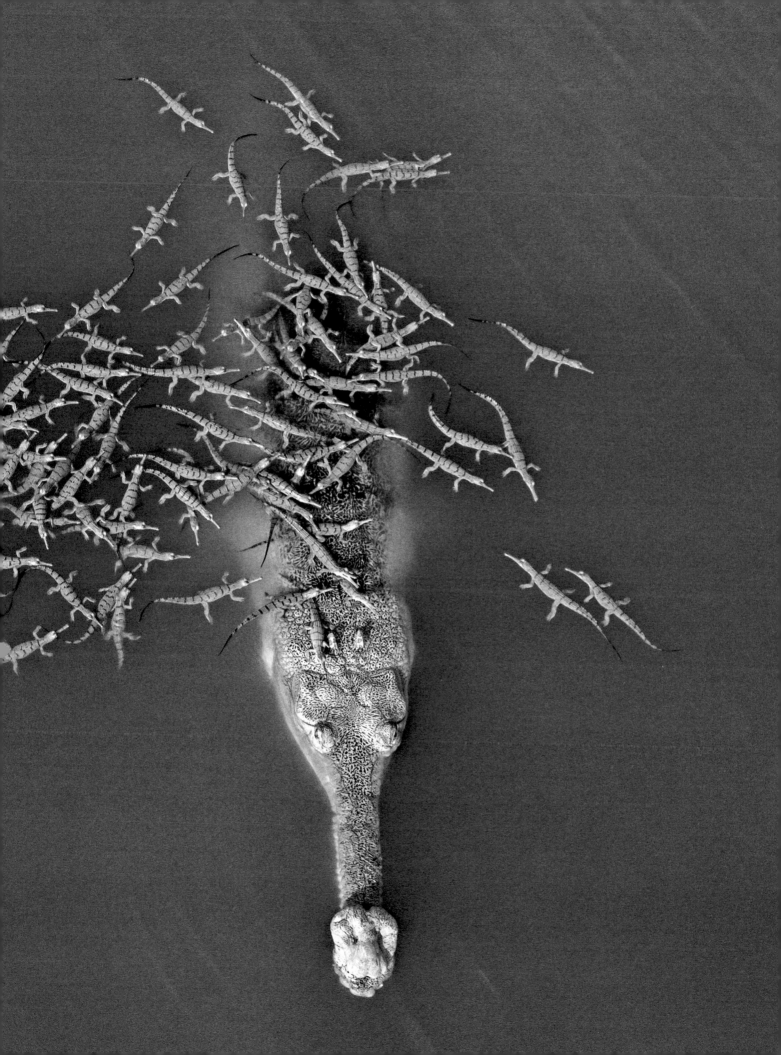

**CLEAN-WATER DIVER**
A European kingfisher dives for minnows from a regular perch into a pool beside the River Tormes in Salamanca, Spain. It is the most resplendent member of a freshwater community that depends on oxygenated and unpolluted water. The kingfisher's long-term decline is thought to be due mainly to river pollution from agricultural-chemical run-off and industrial waste, but the bird is now benefiting from the clean-up of many European waterbodies.

The damage has been catastrophic for many freshwater ecosystems. We take so much water that for much of the time some of the world's biggest rivers no longer reach the sea, leaving their deltas barren and their estuaries clogged with sand, while salty seawater pushes upstream.

Bobcats and beavers once roamed the lagoons and forests of the Colorado River Delta in Mexico, but for 25 years, the river has stopped short, and the delta is a shrivelled wasteland. The parched Indus Delta in Pakistan has lost a million hectares (2.5 million acres) of mangrove forests. Thanks in large part to our engineering works, wildlife in the world's rivers and freshwater wetlands has declined by 80 per cent in the past half century. Yet there is no sign of a halt to dam-building. Another 3,700 are planned or under construction.

Africa is a new focus. On the Blue Nile, Ethiopia is building the continent's biggest dam, and more are planned on the Zambezi in southern Africa and on the continent's biggest river, the Congo.

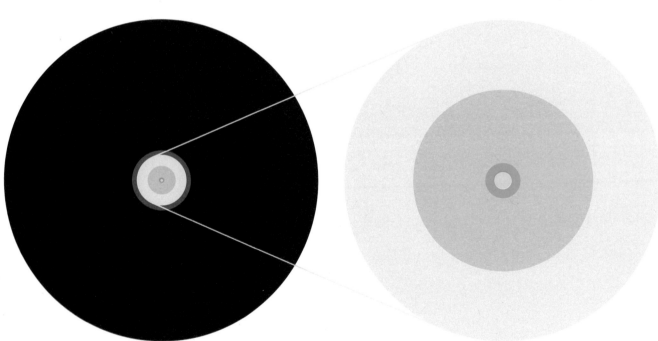

TOTAL WATER ON EARTH

FRESH WATER ON EARTH (2.5%)

**PRECIOUS FRESH WATER**
Only 2.5 per cent of the world's water is not salty. Of this, more than two thirds is locked up as ice, and nearly a third is deep underground. Just 0.3 per cent of fresh water is surface water, only a tiny fraction of which flows in rivers and streams.

**SALTY WATER (97.5%)**
● **Sea water** 96.5%
● **Other salty water** (on land, e.g., lakes or groundwater) 1%
**FRESH WATER (2.5%)**
 **Frozen fresh water** (ice caps, glaciers, perennial snow) 1.72%
 **Underground fresh water** 0.75%
● **Other fresh water** (e.g., in soil, atmosphere, plants) 0.02%
 **Surface water** (lakes, swamps, rivers) 0.01%

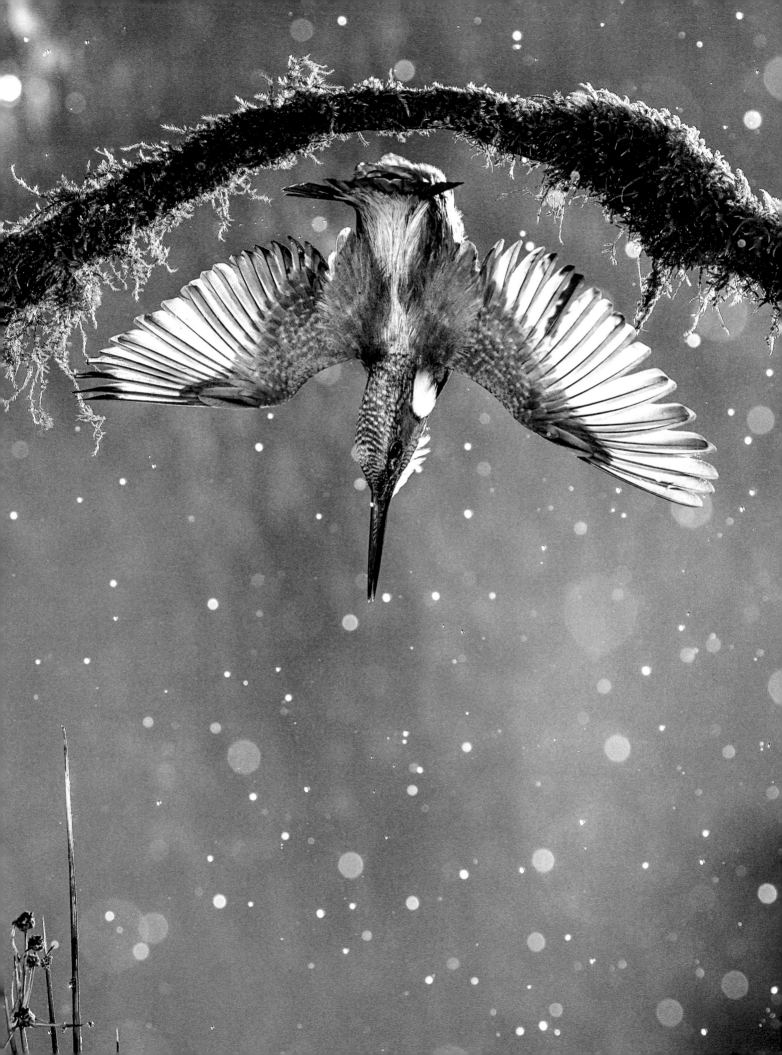

# AN IMPORTANT PART OF THE NATURAL WEALTH OF THE WORLD'S RIVERS COMES FROM THE WETLANDS ALONG THEIR BANKS – THE SWAMPS AND MARSHES, THE FLOODPLAINS AND FENS, THE LAKES AND MIRES

**PANTANAL HEAVYWEIGHTS**
A large jaguar in a 20-minute struggle to the death with an even larger yacare caiman on a forested river bank in Brazil's Pantanal wetland. Jaguars regularly catch caiman along the waterways, though only a large jaguar can successfully tackle a caiman of this size. The Pantanal remains a refuge for both species.

**BRAZIL'S GREAT WATERLAND**
A mosaic of wetland, tropical forest and grassland on the Pantanal plains – the massive upper Paraguay River basin in central western Brazil. It forms one of the world's largest and most important freshwater ecosystems. Its plants and animals are adapted to the seasonal floods and droughts and the ever-changing boundaries between water and land. In strong floods, some 80 per cent of the area may be inundated. Conversion of the grassland to cattle pasture is resulting in increasing water pollution and, in the dry season, erosion of the sandy soil.

Even if you ignore the ecological damage, the economic case for most dams is weak. An Oxford University study found that as much as half of the two trillion dollars spent building large dams in the past century had a negative economic return for the countries concerned. The dams were completed years late and on average at almost twice the budgeted cost. Many hydro-dams suffered from lack of power lines to deliver their electricity; and irrigation dams never had the canals needed to distribute their water. Others flooded fertile farmland and destroyed valuable fisheries. The politicians responsible for commissioning them had often believed inflated promises by engineers or succumbed to corruption or delusions about the potential of dams to deliver economic development.

An important part of the natural wealth of the world's rivers comes from the wetlands along their banks – the swamps and marshes, the floodplains and fens, the lakes and mires that are among the most productive and biologically diverse ecosystems. The mix of water and nutrient-rich silt trickling across the land is super-productive for nature.

The world's largest freshwater wetland is the Pantanal. Mostly in Brazil, its patchwork of lagoons, backwaters, lakes and marshes sprawls across the huge floodplain of the River Paraguay. It is the size of Greece and, like the Amazon rainforest to the north, is a hotspot of biological diversity.

The Pantanal is home to more than 600 bird species, including huge numbers of giant jabiru storks. And it harbours some of the world's most fearsome predators, which are at their most dangerous as the dry season approaches and life concentrates in and around the receding pools and river channels. Capybaras and tapirs trying to escape the 10 million caiman in the water will find jaguars and even huge anacondas lurking on the banks. Jaguars have a bite stronger than any other big cat. They can even capture and kill a caiman.

Much of the Pantanal's catchment area is already used for cattle ranching. But large parts of the wetland can still only be reached by boat. And as forests and grasslands beyond are taken over by farmers, the wetland is of increasing importance as a refuge for wildlife.

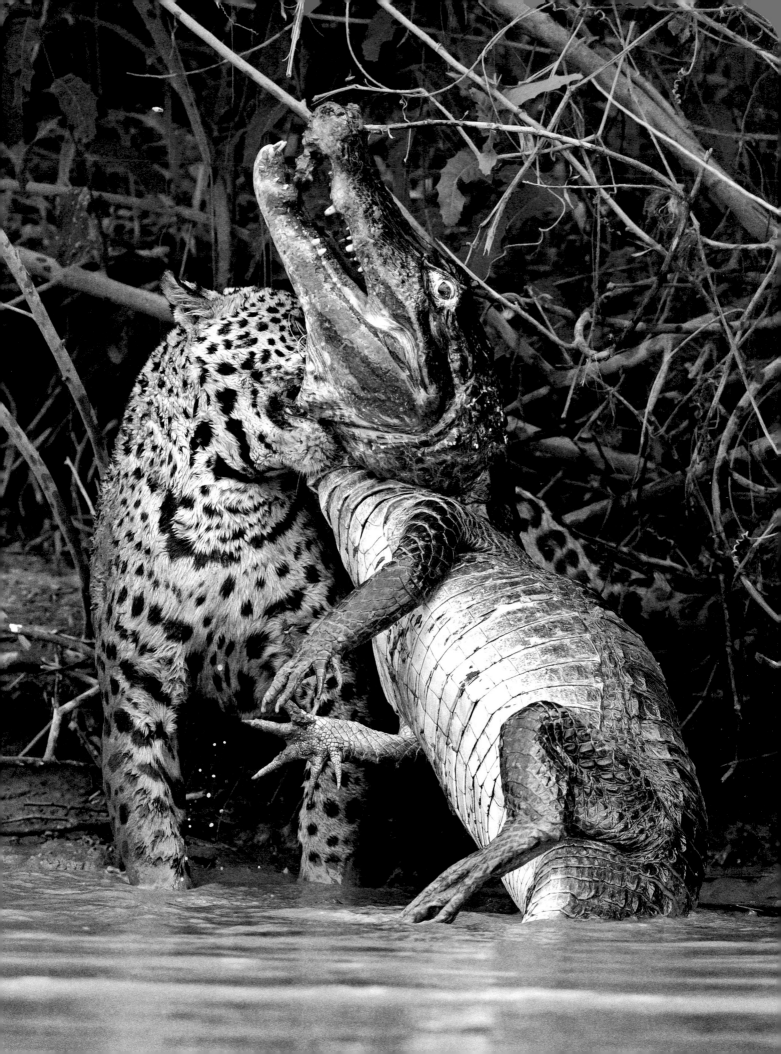

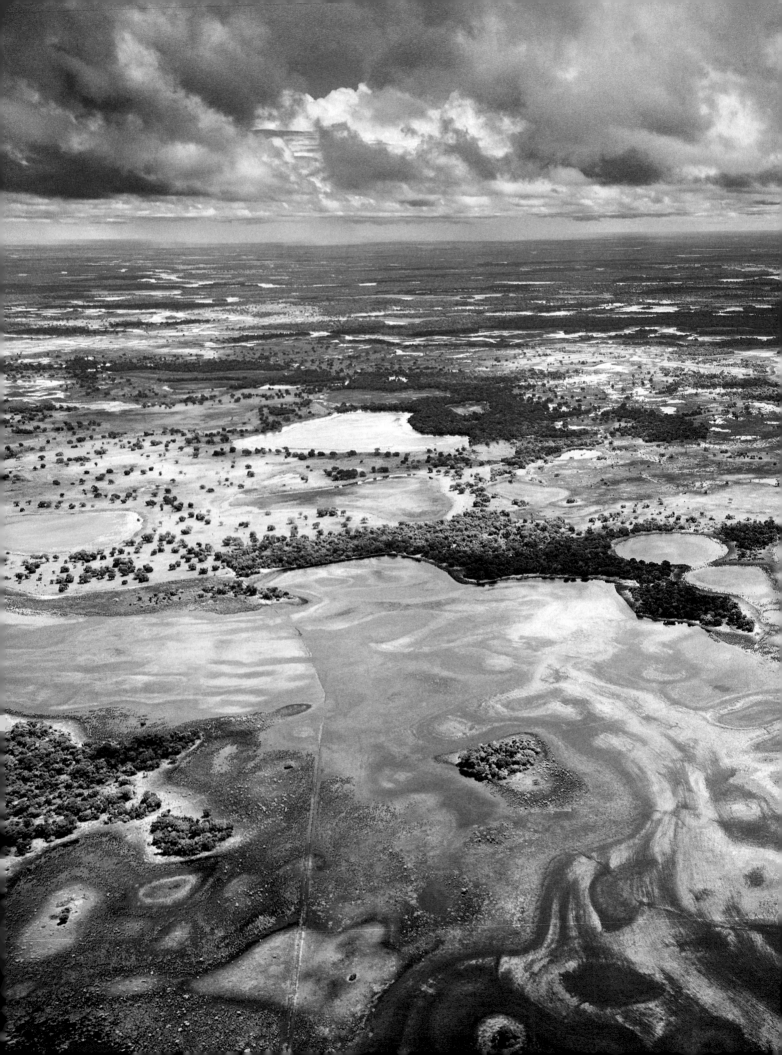

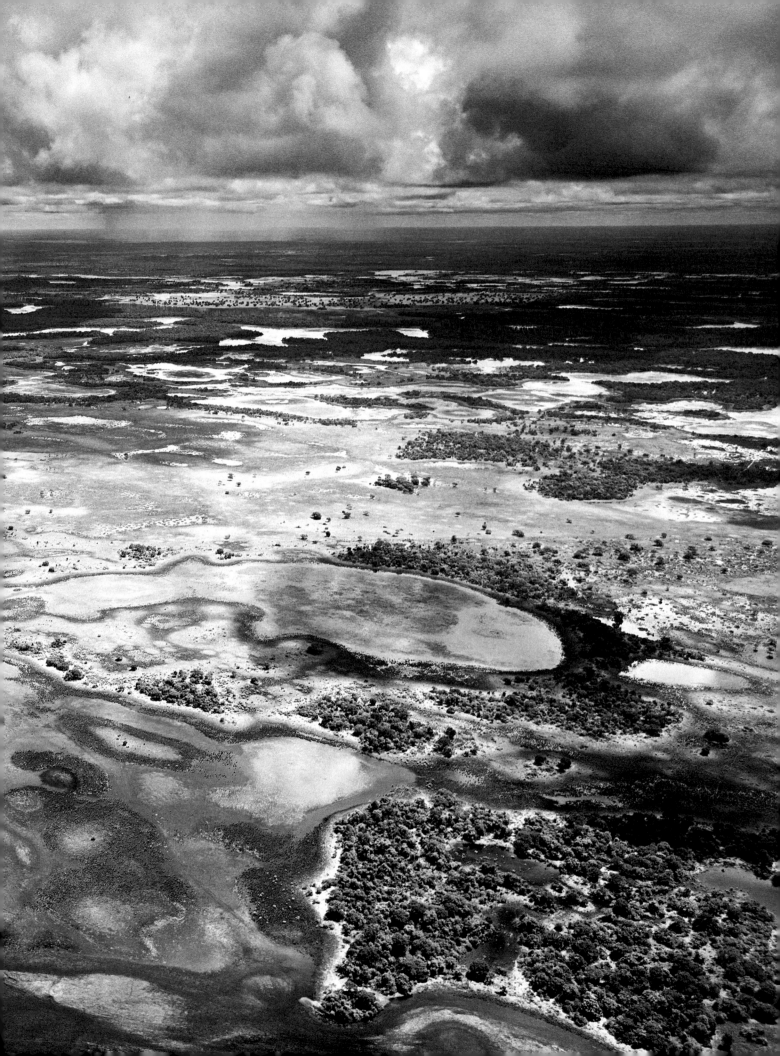

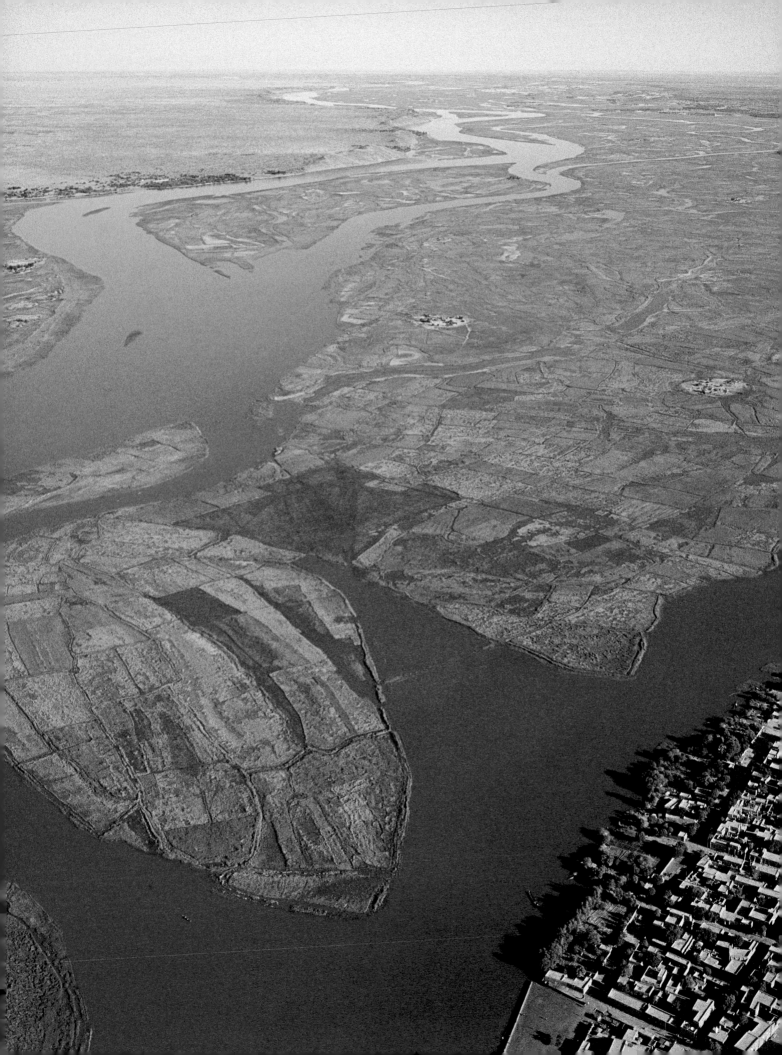

THE NIGER DELTA IS ALSO HOME TO MORE THAN 2 MILLION PEOPLE, WHO STILL LIVE BY HARVESTING ITS RICH RESOURCES. THEY CATCH FISH WHEN THE RIVER IS IN SPATE … THEN GRAZE THEIR CATTLE ON THE HIPPO GRASSES AND PLANT CROPS AS THE WATER RECEDES

Wetlands the world over are refuges for animals. They are especially valuable on the edges of deserts. For instance, the Inner Niger Delta near Timbuktu on the edge of the Sahara is a green jewel the size of Belgium, where West Africa's biggest river spreads across the desert sands. Its waterways, hippo grass fields and flooded forests nurture more than 100 fish species, 24 of them found nowhere else. Manatees swim its waters, and crocodiles and hippos wade in the shallows. Hundreds of thousands of birds from Europe winter here, including cormorants, herons, spoonbills and cranes. The Inner Niger Delta is also home to more than 2 million people, who still live by harvesting its rich resources. They catch fish when the river is in spate and the delta fills with water, then graze their cattle on the hippo grasses and plant crops as the water recedes in the dry season.

Wetlands are also safe havens in times of drought and war. And when the rains fail, they are the last sources of food. During the long, brutal civil war in South Sudan, some 100,000 people fled their homes and took refuge among the reed beds, elephants and hippos of the Sudd, the world's second largest swamp, fed by the waters of the Nile.

Such intact wetlands are vital for nature and people. But we still disregard them. Their very names – bogs, mires, swamps – have become metaphors for things we dislike. So we drain and dyke them; we dam and canalize the rivers that feed them; and we capture their land for farms and cities.

The death of a wetland is a devastating thing. When the water supply is cut off by a dam or river diversion, lakes shrivel, trees crash to the ground, crops go brown in the baking sun, fishing nets are empty, and animal carcasses litter the land. Twenty years ago, dams dried up the Hamoun, a wetland on the remote border between Iran and Afghanistan. Leopards and otters, carp and flamingos all lost their habitat. So did 300,000 humans, who ended up in refugee camps.

The wealth of wetlands is slipping through our fingers. Estimates vary, but about two thirds of wetlands may have been lost in the past 300 years. The US has drained more than half of its wetlands. California lost 90 per cent in the past two centuries. The Mississippi has lost 80 per cent of its floodplain.

OPPOSITE

**RIVER OF LIFE**
West Africa's largest river, the Niger, as it flows beside the ancient desert city of Gao in northern Mali. Seasonally flooded islands of sand planted with rice feed the city, which has been a major trading centre for thousands of years. It is where salt and other goods, transported across the Sahara by camel, were put onto boats to continue their journey to market.

FRESH WATER

83

# CICHLIDS ... HAVE EVOLVED IN PROFUSION IN LAKE TANGANYIKA. THE ANCIENT LAKE CONTAINS SOME 250 SPECIES ... MORE THAN 98 PER CENT OF WHICH ARE FOUND NOWHERE ELSE

OPPOSITE
**LAKE DWELLERS WITH STYLE**
Two species of cichlid fish in East Africa's vast Lake Tanganyika display their unusual lifestyles. These are just 2 out of 245 cichlid species found only in this lake.

OPPOSITE TOP
**MOTHER'S MOUTH**
A female mouthbrooding cichlid *Haplotaxodon microlepis* uses her mouth as a safe retreat for her babies. Her mate's mouth will also be used by the young for shelter.

OPPOSITE BOTTOM
**SHELL-STEALER**
A male shell-stealing cichlid *Lamprologus callipterus* gathers snail shells to tempt a female (left) to live in one of them. Only the much smaller females fit inside the shells, using them for shelter and as a nursery for the eggs and baby cichlids. Should a neighbour's shell pile be nearby, the male might steal those shells, even if one already happens to house a female.

NEXT PAGE
**JUST ADD WATER**
Lake Eyre in South Australia at dawn. The desert lake is usually dry, but it is the lowest point in a vast basin stretching across the arid Australian interior. When it rains anywhere in the basin, the waters come pouring down to rest here until the sun evaporates them. The lake can cover up to 10,000 square kilometres and rapidly becomes a cornucopia of life.

The losses continue. In West Africa, on the River Niger, a hydro-dam is being built that is expected to reduce the fish stocks of the Inner Niger Delta by 30 per cent. Developers also have their eyes on the Sudd wetland. Just as soon as South Sudan's civil war ends, they want to build a canal that will allow the waters of the Nile to bypass the wetland, reducing evaporation and so deliver more water downstream to Sudan and Egypt. And in Brazil they have a scheme to gouge a giant shipping canal right through the Pantanal. The economic aim of the project is to allow ocean-going ships to load up with Brazilian soya beans for China, timber for Europe and natural gas for the world. The dredgers have been busy downstream of the Pantanal. If they keep going, say hydrologists, they could dry up half of the world's largest wetland.

Some of our planet's water can stay put for thousands of years. The lakes of East Africa's Rift Valley are some of the world's most ancient water bodies. The oldest, longest and, at almost 1,500 metres (4,900 feet), deepest of these is Lake Tanganyika, on the border between Tanzania and the Democratic Republic of Congo. Most of the lake's water is devoid of oxygen. Few living things can survive below a depth of about 100 metres (300 feet). Yet the lake is far from dead.

Around its shores, the waters teem with life. In this 'bathtub ring of biodiversity' lurk crocodiles, water cobras, terrapins and more unique species than in the Galápagos Islands. One family of fish dominates. Cichlids, a colourful favourite in aquaria, have evolved in profusion in Lake Tanganyika. The ancient lake contains some 250 species, more than 98 per cent of which are found nowhere else. The largest grow up to a metre long (more than 3 feet); the smallest to just 4 centimetres. A handful have evolved to survive in the oxygen-depleted depths.

While Lake Tanganyika has been around for millions of years, other lakes come and go. Sometimes in a matter of days. In the heart of central Australia lies a giant depression that is among the hottest and driest places on the continent. It occupies a sixth of the giant island and its salt flats were once a favourite spot for attempts on the world land-speed record. But just occasionally, water from rain in distant mountains rushes into the basin. Then a lake swiftly spreads across the flats. Lake Eyre can grow in a few days to cover 10,000 square kilometres (3,860 square miles).

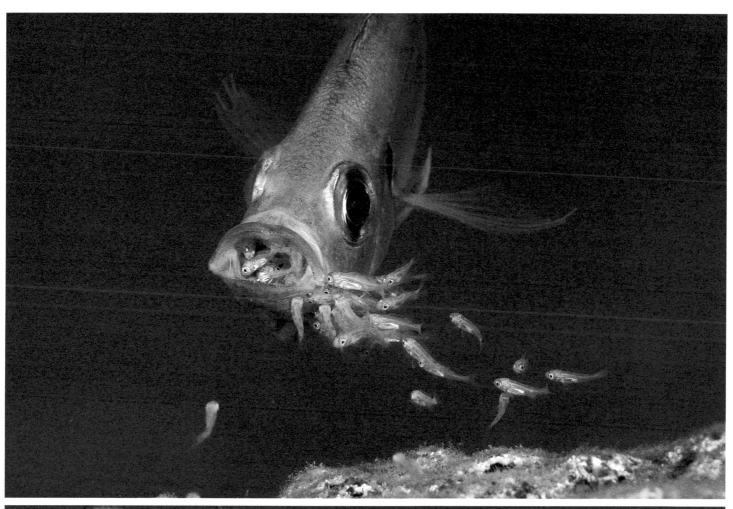

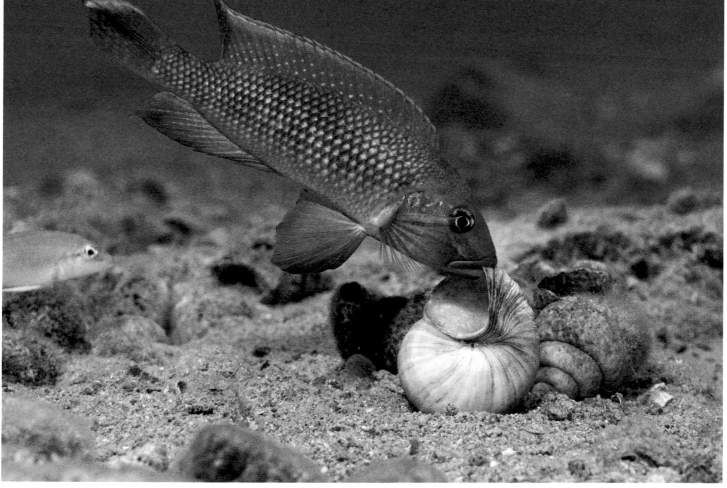

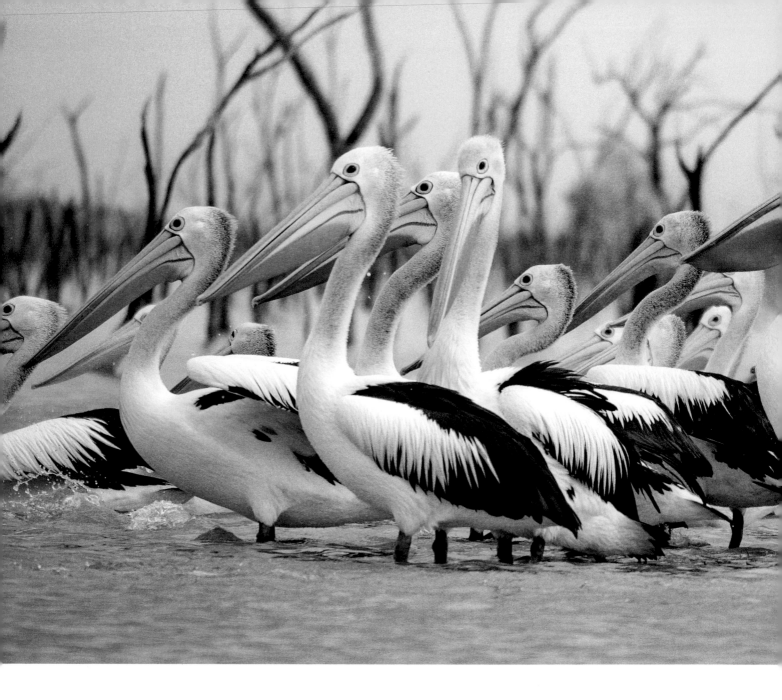

As the lake materializes, dormant insect larvae burst into life; fish holed up in desert pools rush to feed and breed; wild flowers carpet the wet sands around the lake; and sensing an opportunity, hundreds of thousands of waterbirds fly in. Pelicans come from the distant coast of South Australia, forming giant colonies and rapidly producing a new generation of chicks. Usually, the bonanza is short-lived. In the outback sun, the water evaporates, rivers dry and the lake empties. Millions of dead fish mark its former shore. Birds take to the wing, leaving behind those too weak or young to fly. It may stay that way for years. Nowhere shows better than Lake Eyre how, even in the most unlikely places, nature can move back in. Just add water.

But with a permanent loss of water, ecological catastrophe looms. That has happened in places where dams and overuse of water have

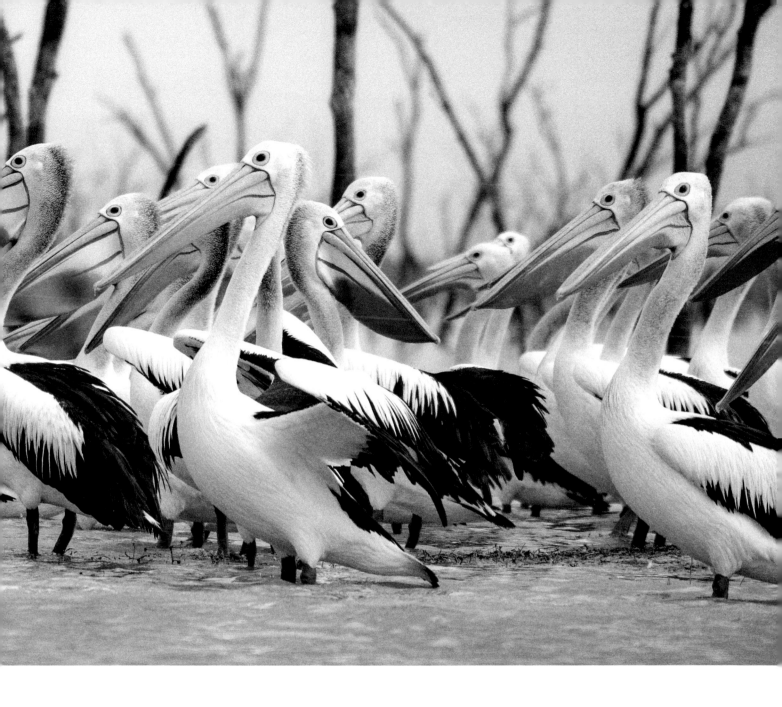

destroyed rivers that flow to inland depressions. The Aral Sea in central Asia was until half a century ago the world's fourth largest inland sea. Its body of fresh water the size of Scotland was constantly topped up by giant rivers flowing out of the Tian Shan and Hindu Kush mountains. It was renowned for its blue waters and stunning beaches. It provided a sixth of all the fish consumed in the Soviet Union. But then a massive Soviet agricultural project diverted the rivers for growing cotton in three central Asian states: Uzbekistan, Kazakhstan and Turkmenistan.

The great inland sea is now a series of salty sumps evaporating in the sun. Its shoreline has retreated by more than 100 kilometres (62 miles), creating a desert where only a handful of people have ever set foot. Its four endemic species of sturgeon are now extinct. The last trawler set to sea in 1984. Meanwhile, without the moderating influence of the sea,

**PELICAN FLY-IN**
Temporary Lake Eyre. Whenever it fills with water, pelicans fly in from the coast hundreds of kilometres away, forming vast pop-up colonies where they feed on the lake's fish and breed. The colonies can be half a million strong, far bigger than any colony on the coast. Nobody is sure how they know when to come.

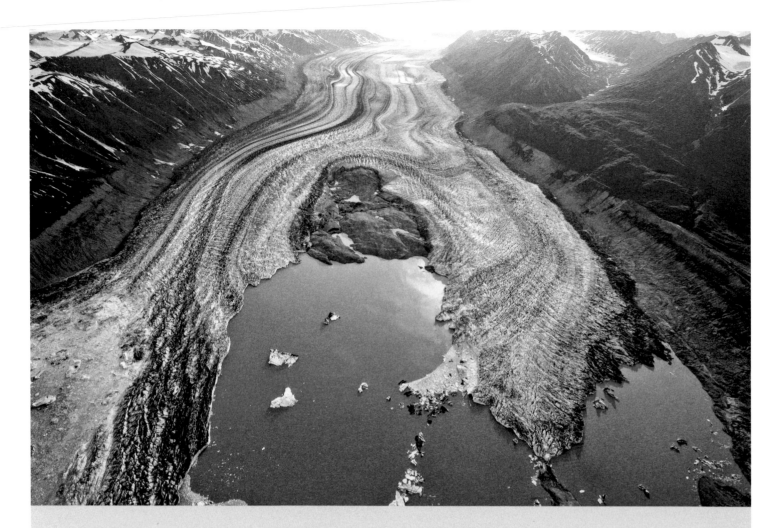

# THE ICE MELT

The planet's water cycle will be seriously impacted by climate change. Already, altered rainfall patterns are affecting river flows and making droughts and storms more intense. Some rivers will dry out as rainfall declines, and faster evaporation results in less water reaching them.

The River Niger on the edge of the Sahara Desert could lose a third of its flow. So could the Nile, which sustains Egypt. The American West could suffer megadroughts lasting many decades. But other rivers will rage more fiercely where rainfall increases.

A looming threat is the loss of mountain glaciers. Currently, the summer melting of glaciers in many parts of the world provides reliable flows for rivers. Even without rainfall, the rivers keep flowing. But as the world warms, many glaciers lose more ice each summer than winter snowfall replaces.

The European Alps, where rivers such as the Rhine and Rhone rise, have already lost half their ice. And a human and ecological catastrophe awaits much of Asia when the glaciers disappear.

The Yellow River and Yangtze in China; the Mekong, Salween and Irrawaddy in Southeast Asia; the Ganges, Brahmaputra and Indus in South Asia all get much of their flow from the summer melting of mountain glaciers in what is often called 'Asia's water tower'.

Great ecosystems such as the Sundarbans, the world's largest mangrove swamp, extending from Bangladesh into India, and the flooded forests of the Tonlé Sap in Cambodia rely on these river flows – as do some 2 billion people across Asia. But the glaciers are losing volume each summer. While the melting goes on, the rivers will keep flowing each summer. But once the ice is gone, the rivers will be at the mercy of the vagaries of rainfall.

ABOVE The fast-melting Kaskawulsh Glacier in Canada's far north. Its rapid retreat has caused a river to move.

the local climate has changed – becoming hotter in summer and colder in winter. And winds blowing across the seabed whip up dust storms that carry salt and the residues of pesticides from the cotton fields. With a poisoned environment and no jobs, many people have fled. The UN has called what has happened here the worst environmental catastrophe of the twentieth century.

In Africa, Lake Chad has suffered similarly. Its waters, on the edge of the Sahara Desert, once spread across up to 25,000 square kilometres (9,650 square miles) and extended into Nigeria, Niger, Cameroon and Chad. But since the 1970s, it has lost more than 90 per cent of its surface area – initially because of drought but more recently because the rivers that kept it full were diverted to irrigate crops hundreds of kilometres away. Once, the lake and its shores were home to hippos, elephants, crocodiles, cheetahs and hyenas. But now the animals are mostly gone, and much of what remains of the lake is covered with dense mats of reeds and water lilies. The desert is invading.

The loss of this ecological wealth also created a human catastrophe. Some 13 million farmers, fishermen and herders have suffered water shortages, crop failures, the death of livestock, collapsed fisheries and increasing poverty. Between 2013 and 2016, more than 2 million refugees left their homes around the lake. Many headed for Europe. The chaos also contributed to the rise of the Boko Haram terrorist group.

We are not learning the lessons of these disasters. Dams currently under construction on the River Omo in Ethiopia will reduce Lake Turkana in Kenya to half its current size. Known to British explorers as the Jade Sea because of its striking colour, Lake Turkana sustains five national parks, where hippos wallow and crocodiles feast on rich fish stocks. As the lake shrivels, the animals will lose their habitat, and half a million people who live by fishing will lose their livelihoods.

As we empty many of the world's great rivers, and as wetlands and lakes shrivel, people who once relied on their waters have to dig and drill to find underground water reserves, known as aquifers. But almost everywhere, more water is being pumped up than is replaced by the rains. Water tables are falling, and after a few years, the wells run dry.

Pumping in India has increased tenfold. Irrigation takes almost twice as much water as the rains replace. Fifty years ago in the state

OPPOSITE
**WINDOW TO THE UNDERWORLD**
One of many freshwater sinkholes in the limestone cave complex of Jackson County, Florida. The pool is fed by a vast underground water system, the Floridan aquifers which underlie all of the state and parts of neighbouring states. This ancient groundwater feeds countless lakes and wells but is being depleted by agricultural and other uses faster than it can be replenished by rainwater percolating down through the limestone.

NEXT PAGE
**OTTER HAVEN**
Otters play in the fresh water of Ely Springs in Jackson Hole, Wyoming. The North American river otter is part of a community of animals that needs open areas of undisturbed, fresh water. They feed on trout, crayfish, amphibians and other creatures also dependent on an unpolluted freshwater system.

of Gujarat, bullocks lifted water in leather buckets from open wells 10 metres (30 feet) deep. Now wells have to be sunk to 400 metres (1,300 feet) before they reach water. Hundreds of millions of Indian farmers and their families risk being left high and dry.

India is not alone. Roughly a tenth of the world's food is being grown using underground water that is not replaced by the rains. Massive irrigation projects pump water from huge ancient stores of underground water beneath the Arabian and Sahara deserts. The Arabian reserve, once among the world's largest, has been almost emptied in less than 40 years.

Beneath the American Great Plains lies the vast Ogallala Aquifer. Named after the Sioux nation that once hunted bison there, it stretches from South Dakota to Texas. In the 1930s, just 600 wells tapped its water. By the late 1970s, there were 200,000 wells, supplying more than a third of the country's irrigated fields. Some years, this water has irrigated three quarters of the wheat traded on the world market, keeping Egyptians fed as the Nile ran dry. But in places, two thirds of the water is gone. This is bad news for farmers, but it could be good for nature. As the farms close, sagebrush and buffalo grass are returning. Bison may soon follow.

In other places, however, pumping out underground water dries up nature, too. Many wetlands owe their existence to underground water – desert oases for instance. From ancient times, the Azraq oasis in Jordan has been a watering hole for camel trains carrying goods across the Arabian Desert, as well as birds migrating between Africa and Europe. Its reed beds and waterways were kept wet by springs bubbling up from a shallow aquifer. They were home to animals such as water buffalo. But since the 1960s, Jordan has been pumping out the aquifer to supply taps in the capital Amman. The springs have largely dried up, and 90 per cent of the reed beds are gone.

Fresh water is our planet's greatest renewable resource. But by emptying rivers, lakes, wetlands and even underground reserves, we are hijacking it on such a scale that the water cycle is threatened, and with it the natural bounty it produces. To revive that natural wealth, we have to learn again how to go with the flow, how to tap into the planet's waters for our needs without destroying them.

Slowly we are learning how that can be done. In recent years in North America, dozens of ill-advised dams from Oregon to Maine have been torn down. As with the Glines Canyon Dam on the Elwha River in Washington state, this has been to allow fish to migrate upstream. In other cases, removing dams has revived wetlands, brought life back to river deltas or created economically valuable fisheries.

In Europe, many rivers are overabstracted to supply water for irrigation and taps, and some suffer serious pollution. But from the industrial cities of Britain to the shores of the Black Sea, the most densely populated continent on Earth is, in places, starting to give rivers back to nature. French engineers are rewilding the country's longest river, the Loire. They have removed the Maisons-Rouges Dam, which had blocked salmon and eel migrations. In Spain, which has more dams than any other European country, they are being cleared from one of its largest rivers, the Duero.

In the past across Europe, huge amounts of concrete have been poured and earth moved to keep rivers inside their banks and prevent them from spreading across their natural floodplains during times of high flow. Usually the floodplains have then been built on or turned into farmland. Yet, perversely, the effect of all these flood-prevention measures has often been to cause bigger floods. This is because the banks concentrate water within the river's main channel and speed its journey to the sea. River levels rise ever higher. Something has to give. Somewhere the banks break and the result is much worse floods than would have happened otherwise.

Europe's river managers are slowly getting wise to this. Local protection can create greater risk downstream. Many managers have become convinced that restoring rivers and reconnecting them with their natural floodplains will not just be good for ecology, it will also reduce the risk to humans from catastrophic floods. There is a win-win for nature and humans.

The change in thinking began on the Rhine. After heavy rains in the Alps in 1995, flows in the river reached record levels, banks burst and there was widespread flooding. In the Netherlands alone, a quarter of a million people were evacuated. A country largely built on land reclaimed from drained wetlands realized that building river banks ever higher no longer protected them from the worst floods. So the country decided instead to reflood up to a sixth of its reclaimed land in order to better protect the rest. In 2002, Germany began to do the same on both the Rhine and Elbe.

Meanwhile on the Danube, Europe's second longest river, Slovakia, the Czech Republic and Austria are reinstating floodplains and natural

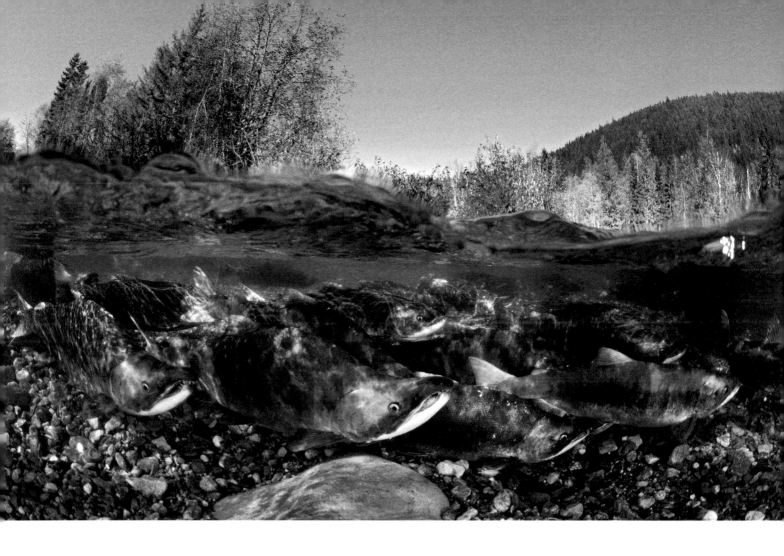

river meanders. And Ukraine has taken down flood-protection banks on two of the largest islands in the Danube's delta, allowing spring flooding, the return of birdlife and the recreation of marshes where cattle can graze.

There is a huge amount more to do. The European Environment Agency has counted half a million man-made barriers across rivers in Europe, one every two kilometres. On many European rivers, almost all the low-lying floodplains have been lost. In England, a 2017 study found that 90 per cent of floodplains 'no longer function properly'. But the direction of travel is clear. Restoring rivers will improve flood protection – or as German legislators put it, they want to 'give our rivers more room again; otherwise they will take it themselves'.

In Australia, it has been drought rather than flood that has provoked a rethink about bringing more natural flows back to their rivers. It started on the Murray-Darling river system, which drains much of the east and south of the country, from Queensland and New South Wales to South Australia. The river provides most of Australia's crops with water for irrigation. But in dry years, farmers often took virtually all the water in the river. The result was a desiccated floodplain stretching for hundreds of kilometres.

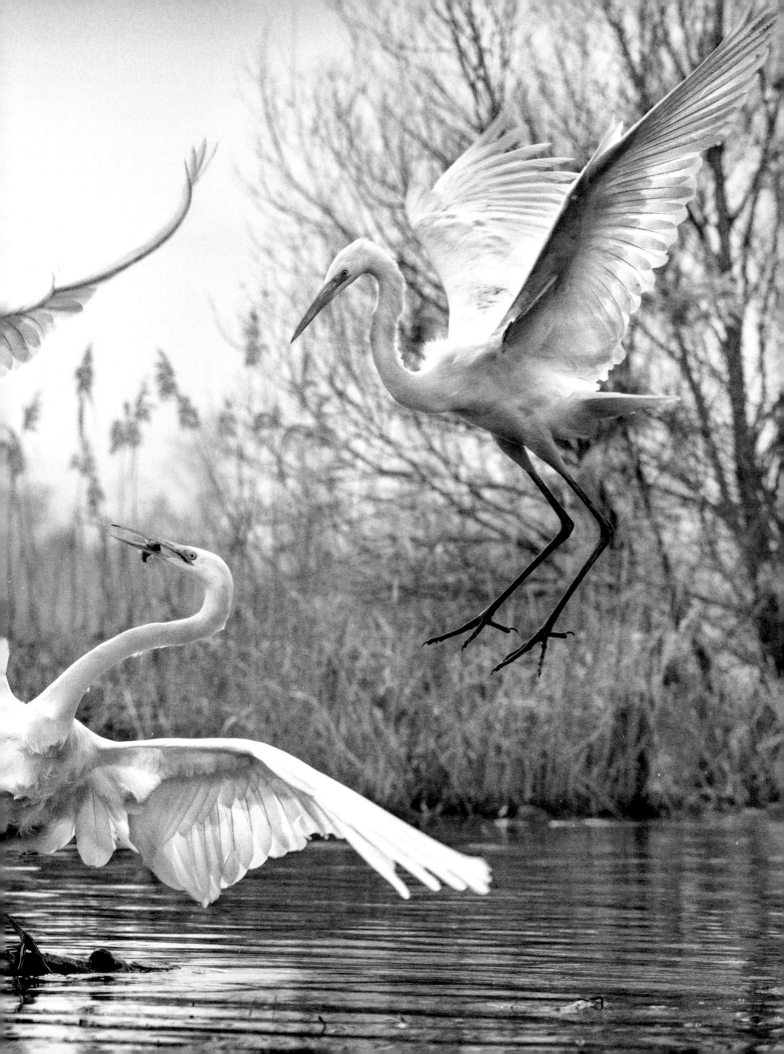

# GIVEN HALF A CHANCE, NATURE FINDS A WAY. BUT WE MUST GIVE IT THAT CHANCE

In 2006, after a decade of drought, tens of thousands of gum trees died. Creatures of the river ecosystem such as cormorants and pelicans, rare squirrel gliders and carpet pythons lost most of their habitat. The river itself came to a halt short of the ocean, its mouth choked with sand. The government decided to act. It set limits on how much water farmers could take from the river, based on the river's flow. In wet years they got more, and in dry years less. The aim was always to keep water in the river.

Meanwhile, the government encouraged a more efficient use of water by creating a market in water rights. Those farmers who switched to less thirsty crops or invested in water-saving technologies such as drip irrigation could sell their water rights to other farmers. Some see the plan, which involved wide public consultation about what Australia wanted from its biggest river system, as a possible model for other rivers and other countries.

So far, roughly three quarters of the planned return of water has been achieved. There is a long way to go before ecosystems fully recover, but native fish populations and native vegetation such as gum trees are both improving. In 2016, the river's flow was at its highest for almost a quarter-century. Salt that had been accumulating on the dried-out floodplain for two decades was being flushed out. The floodplain ponds, known as billabongs, filled once more; nature burst back into life.

River managers in many water-stressed regions of the world are adopting similar methods. From the UK to California to China, they are allocating some of the flow in hard-pressed rivers to nature. Some dams have new rules that, for instance, require them to release water at certain times to mimic aspects of the annual flood pulses that once sustained ecosystems in the river and its wetlands.

It is a start. But what is really needed to save our rivers is a drastic rethink about the way that we use water – on farms, in cities and in our homes.

Two thirds of the water we extract from rivers or underground aquifers goes to irrigate crops. The thirstiest include cotton, rice, sugar and wheat. Yet by some estimates, up to half that water goes to waste. It is poured onto fields and either seeps into the ground or evaporates without reaching crops. Seepage water can often be recovered by pumping, but evaporated water is lost. Drip irrigation that delivers water close to crop roots can reduce losses and help maintain river flows and underground water reserves.

OPPOSITE

**MAYFLIES' EGG RACE**
The Danube's mayflies are back. For several decades, when the river was heavily polluted, they disappeared. But here, on one of the Danube's major tributaries, the River Rába, females swarm at dusk after mating. They will now race upstream to lay their eggs on the water's surface. Then within a few hours, exhausted, they will die.

OPPOSITE
**CRANE FLYWAY**
Family groups of Siberian cranes on migration south, passing over the coastal town of Beidaihe in China. They are part of the eastern population (99 per cent of the total population) of this endangered wetland species – now down to 3,500–3,800 birds. They follow a flyway from breeding grounds in northeastern Siberia to wintering grounds around Poyang Lake in China's lower Yangtze River Basin. Stopover sites in Russia and China are critical for their survival on the 6,000-kilometre (3,730-mile) journey, but many sites have already been lost through water diversions.

NEXT PAGE
**WETLAND CONGREGATION**
The Platte River, Nebraska, one of the last great roosting grounds for migrating sandhill cranes. At least 80 per cent of the global population of sandhill cranes – half a million birds – stop here in one of nature's great ornithological spectacles. Demands on the river's water for farming and cities continue to threaten this vital wetland, but an area of sandbars and water meadows are being restored as a dedicated resting place for the migrating waterbirds.

We can also use water better by plugging leaks in urban water distribution systems, and capturing rainwater as it runs off the asphalt and concrete. Berlin is doing that. Los Angeles has talked about it. And in our homes, everything from tap sprinklers to low-flush toilets could drastically reduce our own personal daily water footprint.

So, while the bad news is that we waste water as if it were available without limit, the good news is we can do immeasurably better.

Earth is the water planet. Water is its ultimate life-giver, and our planet's natural water cycle constantly provides more clean water in the rains. Even rivers that we empty or pollute can flow again, clean and clear, when rains next fall on the land they drain. So the good news is that, if we learn to value flowing water and the ecosystems it maintains, the restoration of rivers and wetlands can happen faster than for most other ecosystems.

And nature will sometimes meet us halfway. Take the birds on the Platte River in the High Plains of the American West. It is a miracle they are still there. When European explorers first moved west across America, the Platte River was free-flowing, and often more than a mile across, watering extensive meadows along its wide valley. But since then, dozens of dams high in the river's headwaters have siphoned off two thirds of the river's flow. Most of its former flow now goes down pipes to fill taps in fast-growing cities such as Denver or to irrigate crops growing on land where the bison once roamed.

Yet even as the river falters, a great wildlife spectacle persists. Each spring, millions of cranes, ducks, swans and geese stop off along the Platte during their annual migration north to breeding grounds in Canada and Alaska. They stay for several weeks to feed and recuperate, just as they have done for probably thousands of years.

For half a million sandhill cranes in particular, nowhere is more important than the Platte. About 80 per cent of the entire global population gathers over a short stretch of the river known as the Big Bend Reach in central Nebraska. They rest on sandbars, feed in the water meadows and indulge in courtship rituals of dancing, throwing sticks and leaping into the air to attract a mate.

The river is not what it was. But it continues to perform a vital role for the birds. If anything, as other wetlands in the American West have been lost, its importance to migrating birds has increased. Pressure to build more dams on the river continues to threaten future flows. But a programme to restore 4,000 hectares (9,900 acres) of sandbars and water meadows brings hope that this vital refuelling stop can be preserved. Given half a chance, nature finds a way. But we must give it that chance.

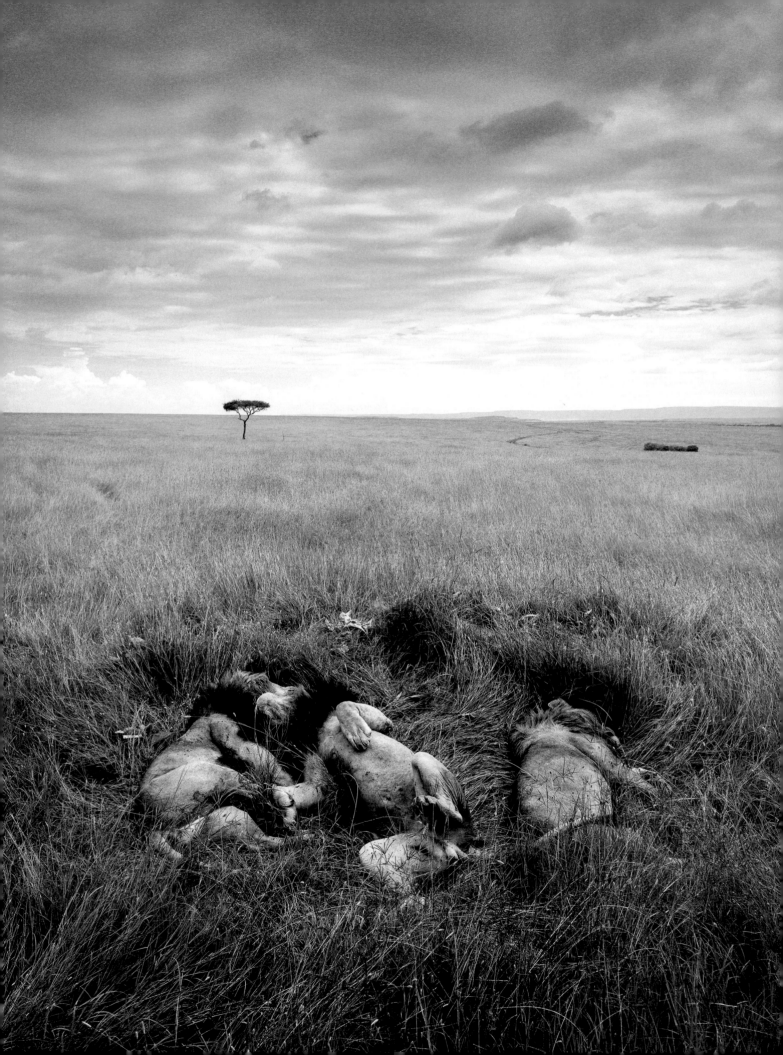

# GRASSLANDS & DESERTS

'Whose heart does not quicken while gazing across the world's great grasslands or deserts? This is not just because grasslands can support the highest biomass of large mammals – wildebeest on the Serengeti or, once, bison on the prairies. Deserts contain some of the planet's most spectacular scenery, and in northwest Namibia, add elephants traversing sand dunes or black rhinos browsing on succulents in an otherwise barren landscape. The wide horizons and life-and-death dance of predator and prey stir in us a primordial memory. This is where pre-humans left the forest and first walked upright. It is unthinkable for us not to counter the threats facing a biome that can truly be called the cradle of mankind.'

**GARTH OWEN-SMITH**
Namibian environmentalist, author and winner of many awards for community-based conservation, including the Prince William Award for Conservation in Africa

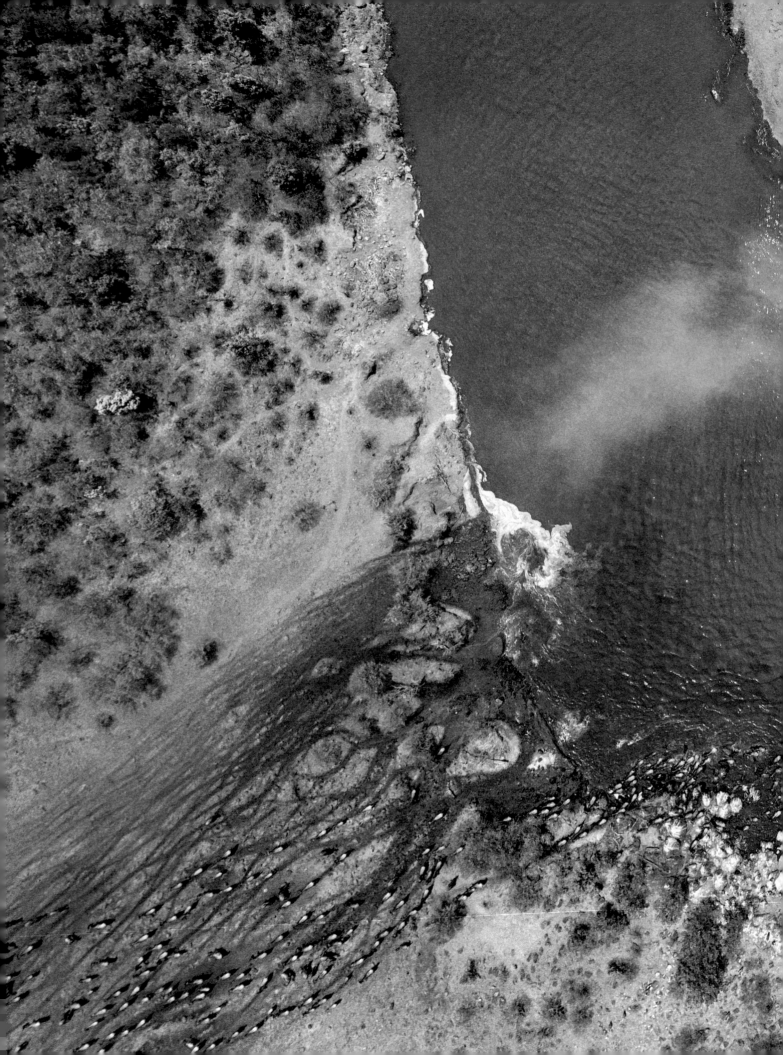

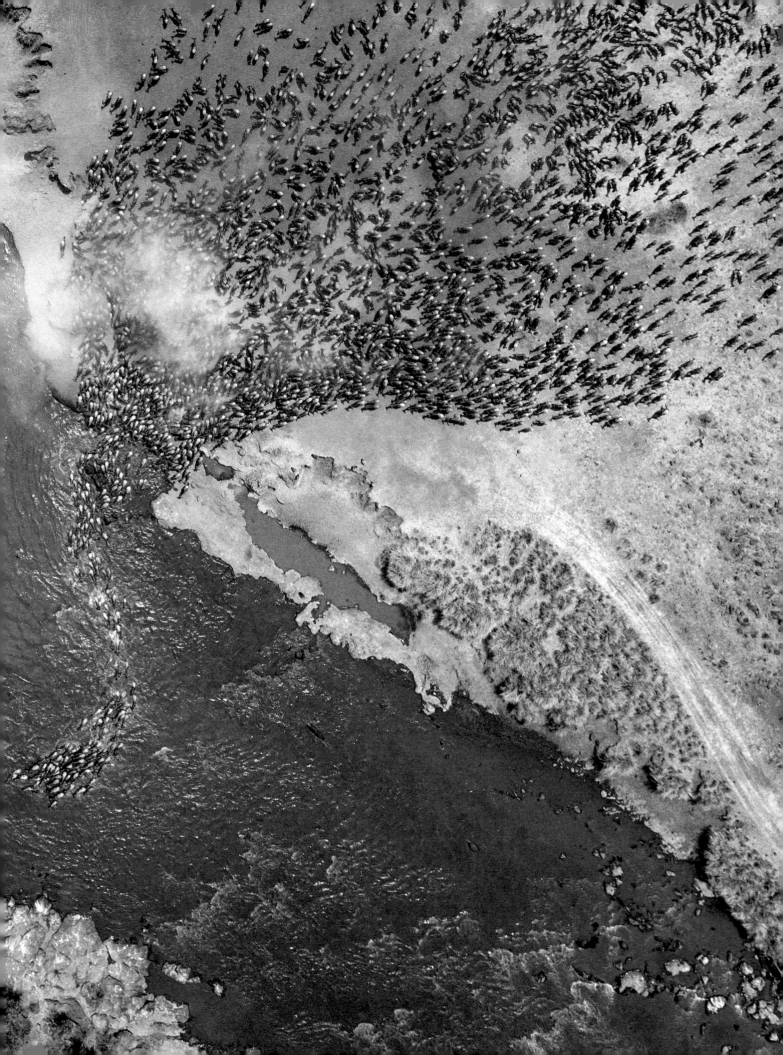

OPPOSITE AND PREVIOUS PAGE
**THE GREAT MIGRATION**
Wildebeest crossing the Mara River during their migration across the Serengeti into Kenya's Maasai Mara Reserve. They are following the rains to find fresh pasture.

OPENING PAGE
**LIONS IN REPOSE**
Three brothers resting after feasting on a wildebeest kill in the Maasai Mara, Kenya.

NEXT PAGE
**SCENE OF PLENTY**
Wildebeest grazing on the Maasai Mara. Lions are ever-present predators, inextricably linked to their grassland prey. Though the lion population in this national reserve and adjoining conservancies is believed to have declined by a third in 20 years, to about 420, it still represents one of the highest densities in Africa. Lion predation, though, has little effect on wildebeest numbers.

The green grass turns black with animals. Like a million ants the size of small cattle, the enormous phalanx of wildebeests stretches to the horizon. The thunder of their hooves fills the air.

The annual migration of wildebeest across the Serengeti plain in East Africa is the greatest wildlife spectacle on Earth – a reminder of the world as it once was. Nowhere else has so many large animals in an unfenced wilderness – 1.3 million wildebeest alone. Each spring they swarm across the plain, heading north into wooded hills in search of fresh grass. Joining them are a quarter of a million zebras and gazelles, forming the largest remaining unaltered animal migration in the world.

Along the way, these armies of herbivores are stalked by thousands of lions, leopards, cheetahs and hyenas. And monster Nile crocodiles await them as they wade the River Mara, the inescapable gateway to the acacia woodlands, where vegetation persists through the dry season. This contest between predator and prey on a journey that can be more than 500 kilometres (310 miles) is likewise unmatched.

The Serengeti, which straddles the border between Tanzania and Kenya, almost exactly on the equator, has always been special. The volcanic soils ensure the vast grassland, covering an area the size of Belgium, is one of the most biologically productive on Earth. Its name, in the local Maasai language, means 'endless plain' – though in fact it is surrounded on all sides by lakes, steep hills and farmland.

The Serengeti is an ecological crucible – seemingly cut off in time and space from the rest of the planet. Former US president Teddy Roosevelt in 1909 called it a Pleistocene landscape, 'a great fragment out of the long-buried past of our race... teeming with beasts of the chase, infinite in number and incredible in variety'.

Roosevelt went to hunt. But half a century later, the German conservationist Bernhard Grzimek – who first mapped its great migrations and whose book and film *Serengeti Shall Not Die* became a manifesto for its conservation – also called it 'a primeval wilderness'.

In truth, the Serengeti is not entirely pristine. Maasai tribes have for centuries tended their cattle here, a coexistence between wild and domesticated animals that has no parallel on other continents. More recently, domesticated animals have brought epidemics of rinderpest

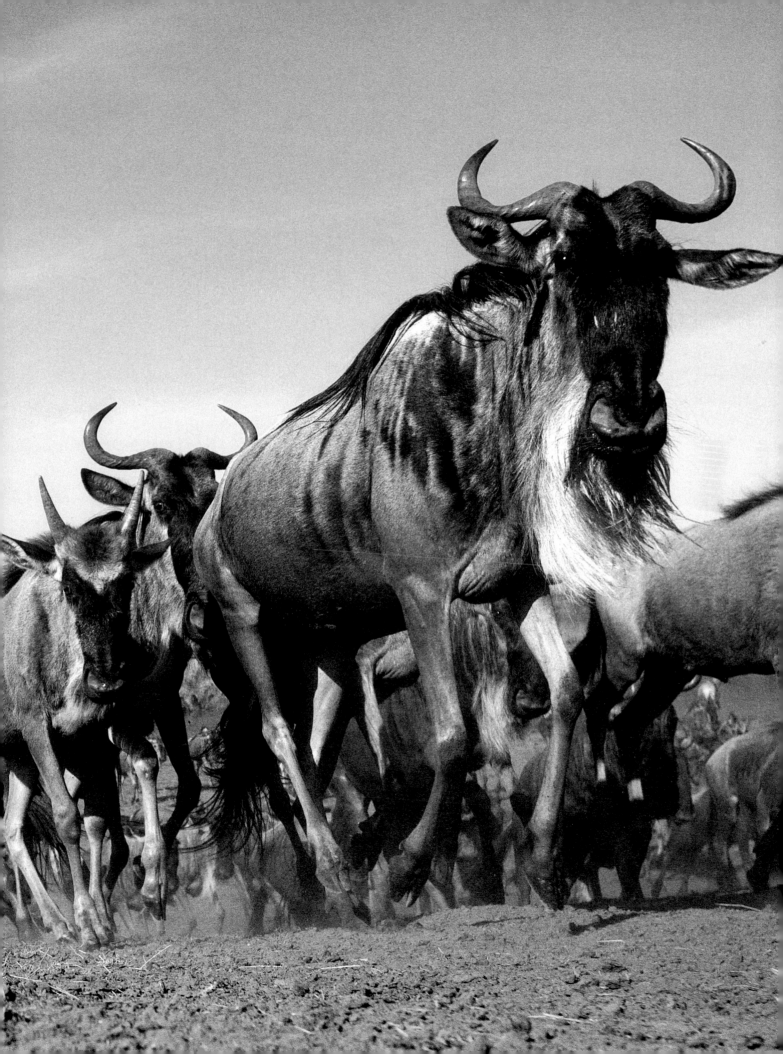

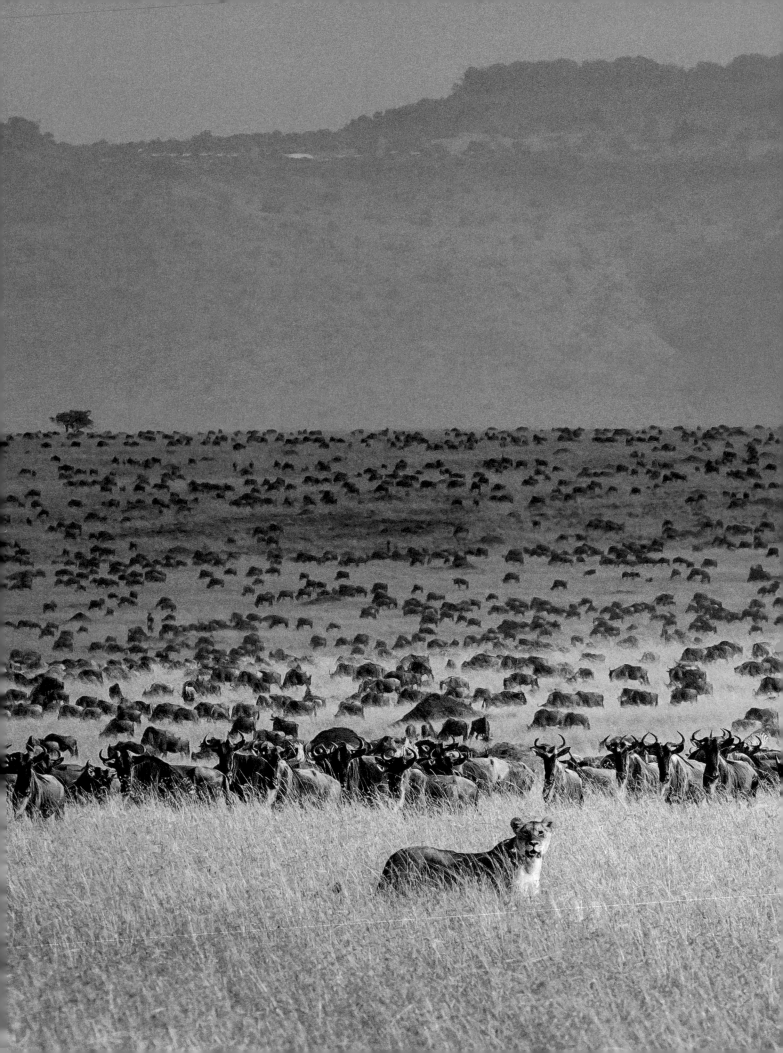

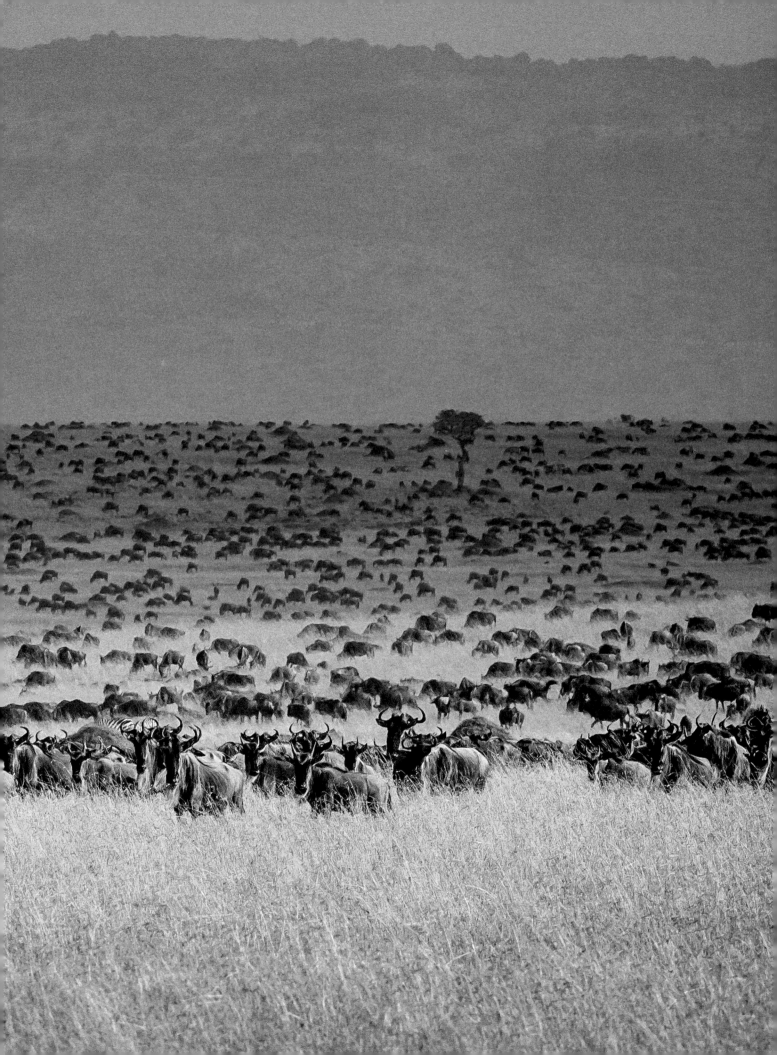

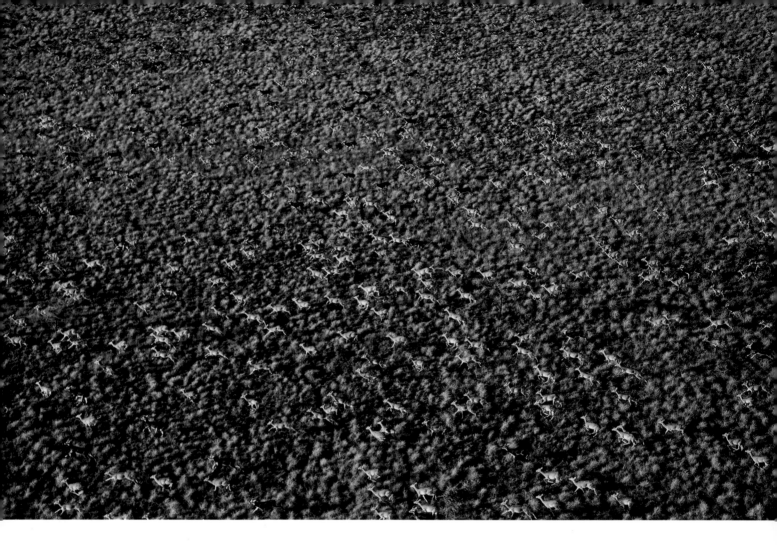

**·ABOVE**

**KOB ON THE RUN**

White-eared kob migrating through South Sudan. The photograph was taken in 2007 as part of an aerial reconnaissance. This showed that at least 800,000 had survived the 22-year Sudanese civil war and that their spectacular annual migrations continued.

and canine distemper. Orgies of safari hunting and poaching have also taken their toll.

But the wide open spaces of the Serengeti have allowed the animals to thrive in adversity. The ecosystem has proved resilient and still functions today much as it must have for millions of years. The wildebeest graze on the short grass; other antelopes nibble on longer swards; gazelles prefer the foliage of shrubs; while giraffes eat the highest leaves on the occasional trees.

Across the plains live some 450 species of birds, including weavers and lovebirds, herons and vultures, bustards and secretary birds – more avian species than almost anywhere on Earth. While slithering in the grass are three of the most deadly snakes on the planet: black and green mambas and puff adders.

There can be few higher priorities for twenty-first-century conservation than protecting the Serengeti and its great migration. But there are other great roll-calls of mammals on the world's grasslands that also deserve our awe and protection. A far less well known great journey is that of white-eared kob across South Sudan, the world's newest nation. Each year, as the wet season approaches, at least 800,000

EACH YEAR, AS THE WET SEASON APPROACHES, AT LEAST 800,000 OF THESE ANTELOPES MOVE OUT OF THE SUDD SWAMP ON THE RIVER NILE, ONE OF THE WORLD'S LARGEST WETLANDS, AND CROSS AN AREA 20 TIMES THE SIZE OF THE SERENGETI TOWARDS NEW PASTURES

of these antelopes move out of the Sudd swamp on the River Nile, one of the world's largest wetlands, and cross an area 20 times the size of the Serengeti towards new pastures in Boma National Park and neighbouring Gambella National Park in Ethiopia. Their travelling herds can stretch for tens of kilometres over a land still unfenced and shared only with sporadic cattle.

During decades of civil war in the late twentieth century, this ancient migration was off-limits to ecologists. Many assumed the animals had become casualties of the conflict. But in fact the kobs, along with fellow migrants such as tiang and Nile lechwe antelopes, warthogs and Mongalla gazelles, reedbuck and ostriches, seem largely untouched by the war. The main concern now is that peace could trigger economic development of a kind that threatens their future.

Grasslands are home to most of the planet's great terrestrial migrations. Many are in Africa, but not all. In the frozen tundra of North America, huge herds of caribou trek between winter foraging grounds in Canada's frozen forests and summer calving grounds. The largest is the Porcupine Herd, named after the mighty river it must cross, which in some years can number as many as 200,000. The 1,500-kilometre (930-mile) round trip to Alaska's Arctic coastal plain is the longest migration by a land animal anywhere. The caribou must also survive grizzlies, golden eagles, wolves and the human hunters that have long followed them, including the 7,000 Gwich'in people, who live in mountain villages along the migration route.

The caribou are used to their pursuers. But the success of the migration is threatened by two things. First, climate change is resulting in heavier snowfall in their wintering grounds. The deep snow delays the migration, and the eventual melting swells the raging rivers that the animals cross on their journey. Meanwhile, warmer summers mean the grass on the calving pastures sprouts earlier and is often past its best by the time the caribou arrive.

NEXT PAGE
**CARIBOU COOL-OFF**
Caribou from the Porcupine Herd resting as they migrate from Alaska's Arctic National Wildlife Refuge. The snow pocket gives them a brief respite from the biting swarms of mosquitoes. Caribou start migrating in early June, within a month of giving birth, moving south in huge numbers from their coastal pastures to their wintering grounds in Alaska or Yukon.

GRASSLANDS & DESERTS

115

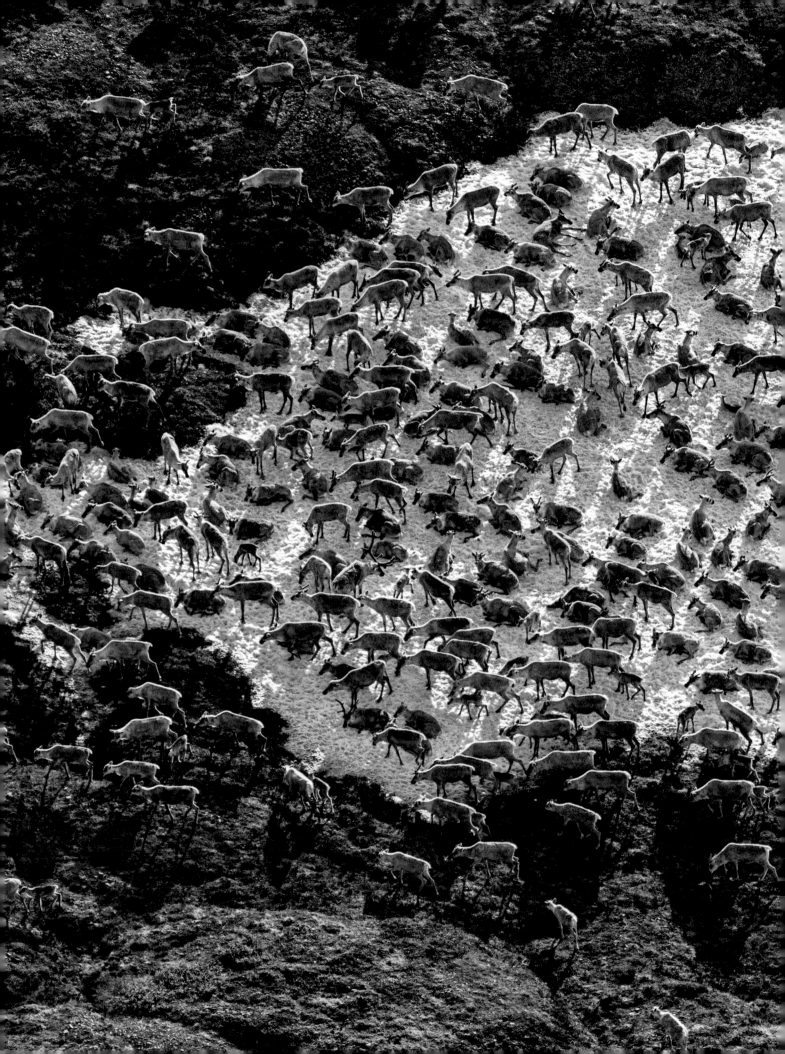

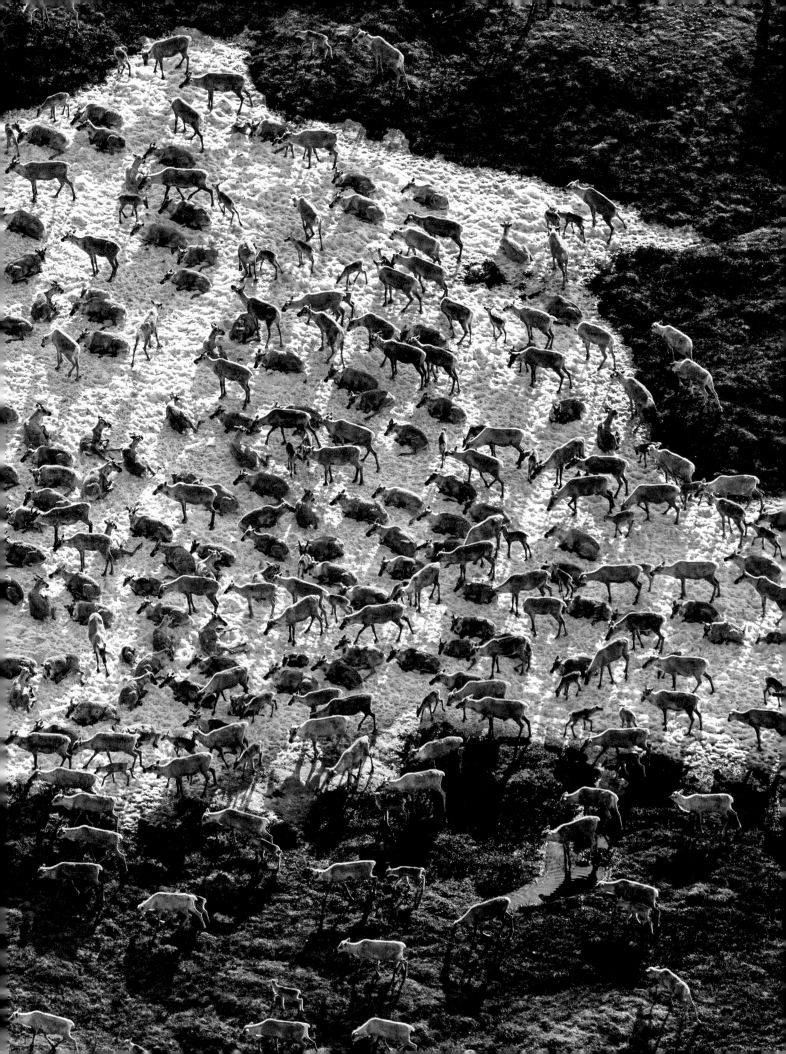

# MORE THAN A FIFTH OF OUR PLANET'S LAND IS COVERED IN GRASS. GRASSLANDS ARE THE WIDE OPEN SPACES WHERE THE PLANET'S BIG BEASTS AND PREDATORS RULE

The second threat is the encroachment of humans. Oil rigs can now be found on the pastures. Until recently, the caribou had their own protected space in Alaska's Arctic National Wildlife Refuge. But in late 2017, the federal government opened up the reserve to oil and gas drilling. That could be disastrous for the caribou.

More than a fifth of our planet's land is covered in grass. Grasslands are the wide open spaces where the planet's big beasts and predators rule. They come in different guises with different names: steppe and savannah, prairie and pampas, cerrado, veld, tussock and more. They are found from the Arctic tundra to the tropics, from mountain valleys to coastal plains, and from the shadow of dense rainforests to the arid edges of deserts. Many contain patches of woodland or marshy river floodplains. And their grasses may be short swards nibbled by grazing animals or high elephant grass where even the largest predator can hide.

They are also where humanity first prospered after leaving the forests – where we learned to hunt the beasts of the plains and discovered the nutritional benefits of the seed grains in grasses.

As our skills grew, we domesticated the tastier and more docile animals and bred and cultivated the grains, transforming them into modern crops such as wheat and barley. As our numbers grew, we began to exclude the wild and to fence in our own animals and crops. The grasslands were where the Earth first became 'our planet'.

The largest region of grassland on the planet today is the Eurasian steppe. It stretches with barely an interruption from Romania in Europe, through Ukraine and Russia to Kazakhstan in central Asia, as far as Mongolia and China, where it borders the Gobi Desert. It has long been home to great herds of saiga antelopes, Przewalski's horses, Mongolian gazelles and Bactrian camels. The horse was first domesticated here and allowed the growth of great empires of nomads. Around 800 years ago, the horse-riding armies of Genghis Khan ruled over most of the steppe, the largest contiguous land empire the world has ever known.

Grasslands have always been about space and movement. Unlike forests, grassland ecosystems are dominated by animals. But the grass is seasonal, because the rains are seasonal. So animals need space to move with the rains. Despite the seeming uniformity of the endless

**THE LONG WALK**
Caribou from the Porcupine Herd, including calves, migrating from summer pastures in Canada's Ivvavik National Park. Different groups from the huge herd migrate at different times, following age-old routes for hundreds of kilometres to their wintering grounds.

THE CERRADO IS PROBABLY THE MOST
BIODIVERSE GRASSLAND ON THE PLANET,
WITH MORE THAN 4,000 ENDEMIC PLANT
SPECIES. FIFTY YEARS AGO, IT WAS A WILD
FRONTIER LAND ... THE CERRADO TODAY
PRODUCES 70 PER CENT OF BRAZIL'S CROPS

grass, these are also dynamic ecosystems, and often benefit from disturbance. Fire can be essential. It recycles nutrients, gets rid of dead material and prevents the encroachment of forest. Every year across the planet, an area of grasslands half the size of the US burns.

Grazing is vital too. The chomping of animal teeth and the trampling of hooves stimulate the growth of grasses and keep down woody growth. Whether they are the wildebeests and zebras of Africa, the antelopes and wild horses of Eurasia, or the deer and bison of North America, grazing animals have maintained grasslands for millions of years.

Humans, too, have long been active managers. Native American hunters transformed the bison-grazed Great Plains with fire long before Europeans showed up; so did Aborigines in the Australian outback. But there are limits. Too much burning and grazing destroys the grasses, reduces biodiversity and erodes soils. In the late nineteenth and early twentieth centuries, the grazing and hoof pressure of European sheep and cattle removed the natural grasses of huge areas of grazing pastures outside Europe.

In Australia, local wild grazers such as kangaroos and wombats, with their padded feet, stepped lightly across the grass. But when settlers loosed 100 million sheep across the outback, these hoofed animals turned much of it to desert – a process only halted when the settlers introduced their own hardier grasses from Europe. The outback survived, but was transformed beyond recognition.

In the twentieth century, the plough moved onto many of the world's grasslands. Soviet engineers turned vast swathes of central Asia into a continuous cotton farm, whose irrigation canals dried up the Aral Sea.

Brazil is converting its huge cerrado grasslands into fields of soya and corn. This is an ecological tragedy on a par with deforestation in the Amazon. The cerrado is probably the most biodiverse grassland on the planet, with more than 4,000 endemic plant species.

Fifty years ago, the cerrado was a wild frontier land, with herds of grazing cattle sharing the high grasses with jaguars, armadillos, giant anteaters, Spix macaws, tapirs and bands of indigenous people.

In 1961, Brazil created a new capital city, Brasilia, in its heart. Since then, three quarters of the cerrado has been ploughed up.

The cerrado today produces 70 per cent of Brazil's crops. It has made the country among the world's biggest exporters of soya, beef and cotton, along with coffee, chickens, sugar, ethanol, tobacco and orange juice. A few of the native flightless rhea birds can still be seen running through the fields of soya, to which they are partial. But most wildlife is in full retreat. Nobody knows how many endemic plant species have been lost.

Elsewhere, hunters have also taken a huge toll. Once, the steppe's most populous large mammal was the saiga. There were tens of millions of them. But in the 1990s, when the collapse of the Soviet Union led to chaos across much of the steppe, most herds were wiped out. Hunters riding motorbikes and carrying automatic weapons rampaged across the animal's heartlands in Kazakhstan, taking saiga horns for sale to China for use in traditional medicines. The survivors are increasingly hemmed in by roads, railways and national border fences. When a lung infection hit one herd in 2015, it swiftly spread, putting the animals in crisis again.

ABOVE
**THE CERRADO IN BLOOM**
A species of *Paepalanthus* flowering on protected cerrado grassland on Brazil's Chapada dos Veadeiros plateau. This is possibly the world's most biologically rich grassland, with more than 35 per cent of the plants found nowhere else.

NEXT PAGE
**THE CERRADO GIANT**
A giant anteater sniffing its way across the cerrado in Brazil's Serra da Canastra National Park in search of termite or ant nests. This huge park protects the most important southern remnant of cerrado grassland.

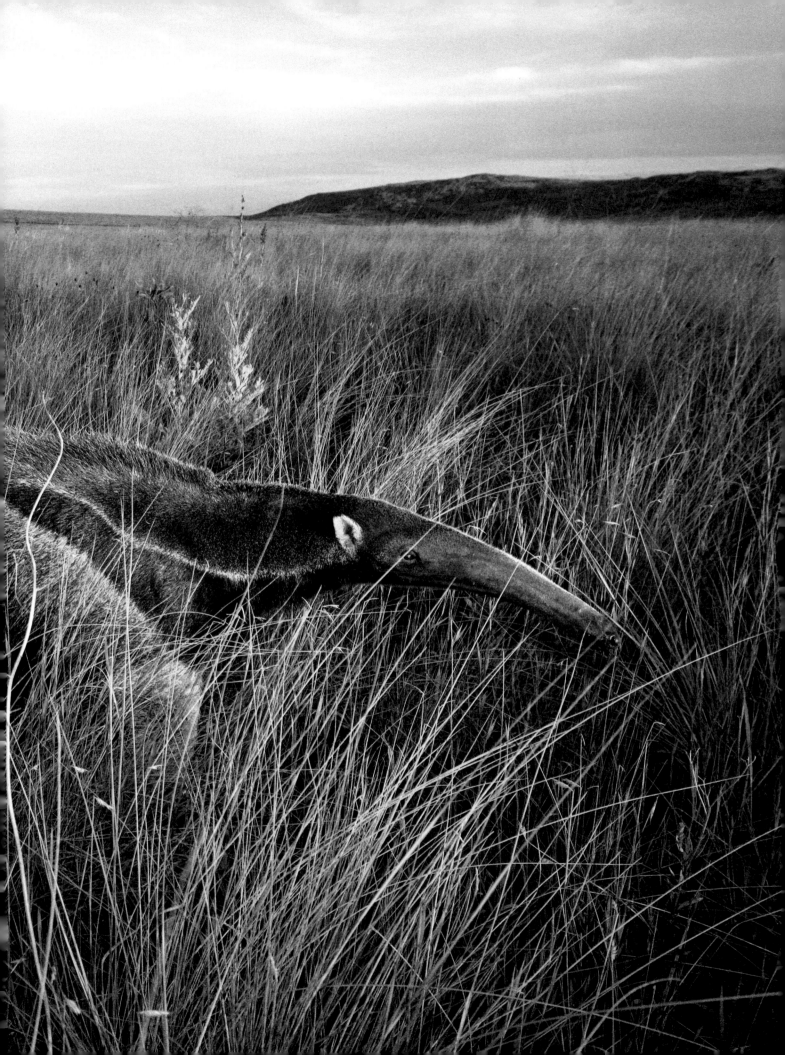

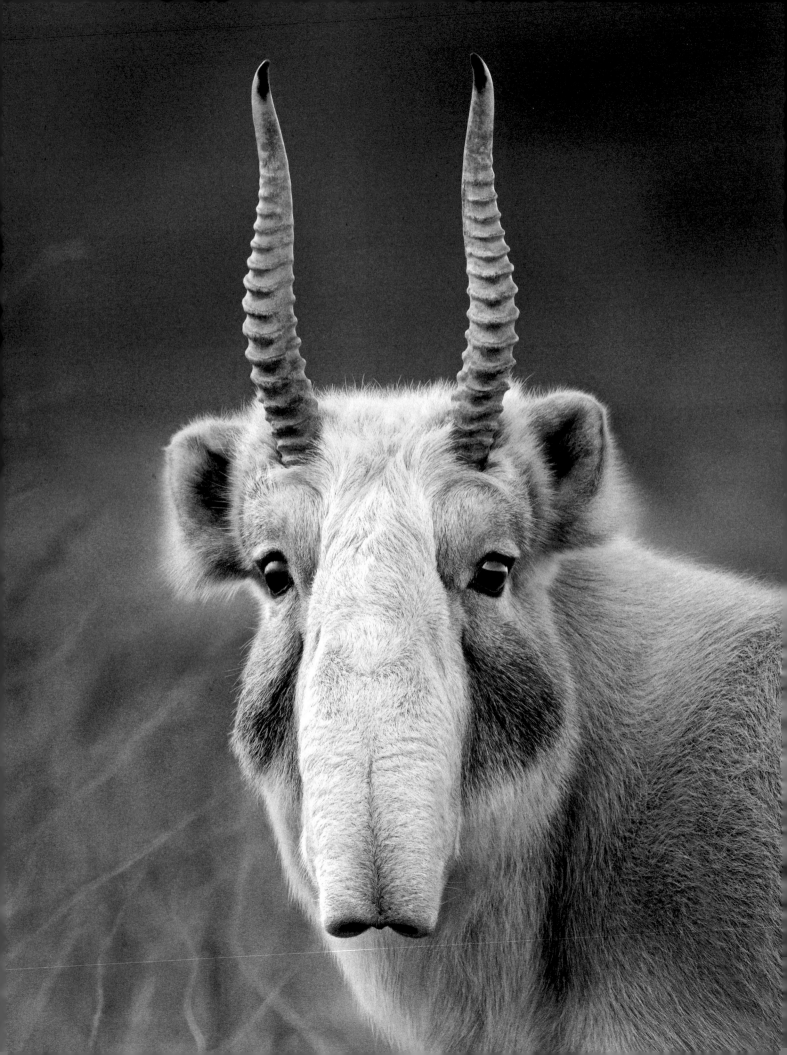

ABOVE ALL, THE REVIVAL OF THE GREAT
GRASSLAND ANIMALS REQUIRES SPACE ...
IN MUCH OF THE WORLD, THERE IS A
HUGE NEED TO REWILD THE GRASSY
PLAINS BY RETURNING FARMLAND
TO ITS FORMER NATURAL STATE

But enough of the gloom. There is hope. The moment may finally have come to revive the world's grasslands and bring back their megafauna. Take the Przewalski's horse. It is named after a nineteenth-century Russian explorer who found what was then thought to be the last wild species of horse in the mountains of Mongolia. By the late 1960s, hunting had exterminated it in the wild. Only a dozen or so survived in zoos. Then a captive-breeding programme began, and in 1992, the first progeny were reintroduced to Mongolia. Przewalski's horse (related to a very early domesticated horse and the closest we have to the wild ancestor of domestic horses) now numbers some 2,000, reintroduced worldwide, including a small herd in the empty exclusion zone around the stricken Chernobyl nuclear reactor in Ukraine. They are reportedly slightly radioactive, but in the space created by the absence of humans, they appear to be doing well.

Above all, the revival of the great grassland animals requires space. So what remains of the ancient grasslands? Altogether the world has lost as much as a third of the open ranges to agricultural or human settlement, an area almost the size of Australia. Just 7.6 per cent are formally protected. But while most temperate grasslands have been annexed for agriculture, in the tundras and tropics, more than two thirds remain, much of it still unfenced and covered in native grasses.

The countries with the highest proportions of grassland within their borders are all in Africa. Benin, the Central African Republic, Botswana, Togo and Somalia head the list – along with Tanzania and Kenya, home of the 'crown jewel' of grasslands, the Serengeti. These must be protected, but in much of the world, there is a huge need to rewild the grassy plains by returning farmland to its former natural state. This is starting to happen. Some former grasslands are being deliberately revived – for tourism, for conservation or for raising exotic livestock.

Rewilding of grasslands is happening in western and central Europe, from Portugal to the delta of the River Danube on the shores of the Black Sea, from the alpine grasslands of Italy to the reindeer pastures of Lapland, where the Sami people reside. But so far, the grandest statement of intent to rewild the grasslands comes from North America.

OPPOSITE
**EURASIA'S STEPPE SURVIVOR**
A male saiga on the steppes of Kazakhstan. Its long nose is an adaptation to the extreme cold and the dusty plains. The antelope once populated the Eurasian steppes in its millions. But with the break-up of the Soviet Union, saiga were slaughtered for meat, and the horns of the males were sought after for use in traditional Chinese medicine. After a return of law and order, their numbers began to bounce back. Then in 2015, an outbreak of a bacterial lung infection, brought on by abnormally high temperatures and humidity, killed 200,000 – more than half of the population. But the species is capable of multiplying rapidly. So with adequate protection from poaching, and as long as the key grazing areas and traditional migration routes remain, the saiga may yet repopulate the plains.

NEXT PAGE
**BACK HOME ON THE RANGE**
American plains bison, bred back from near extinction and now grazing the long-grass prairies on part of their former range. Reduced from millions to just 350 in the nineteenth century, numbers are gradually growing, as is the amount of grassland set aside to recreate the North American Serengeti.

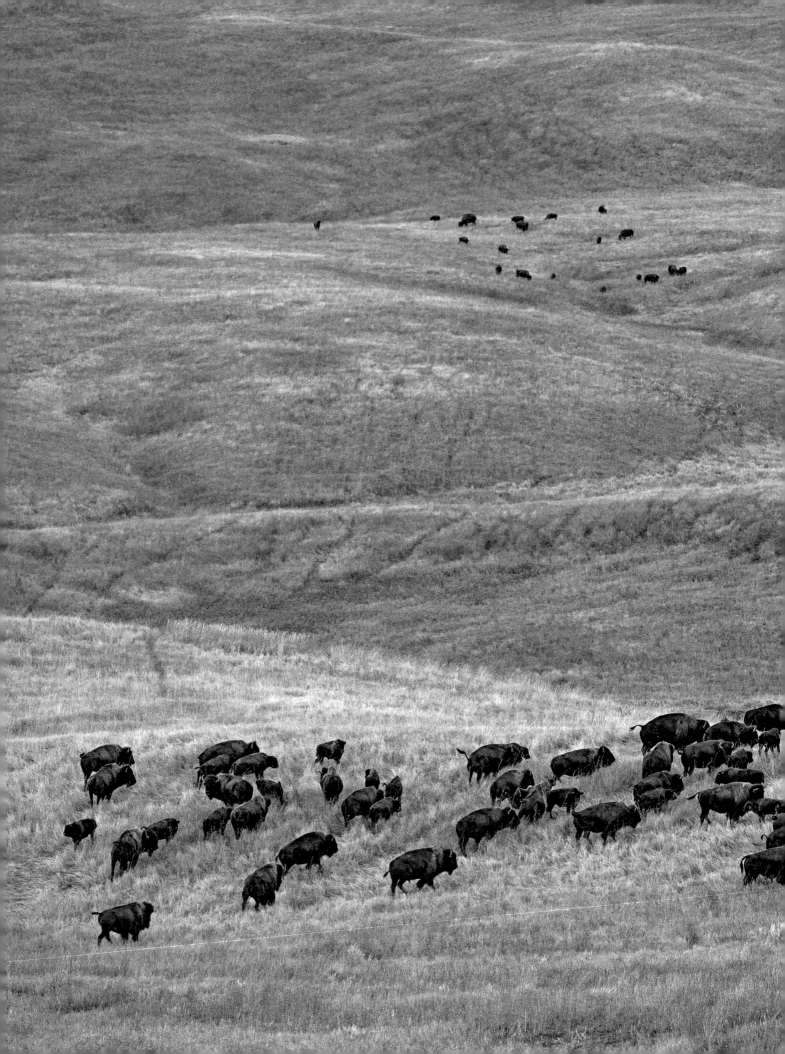

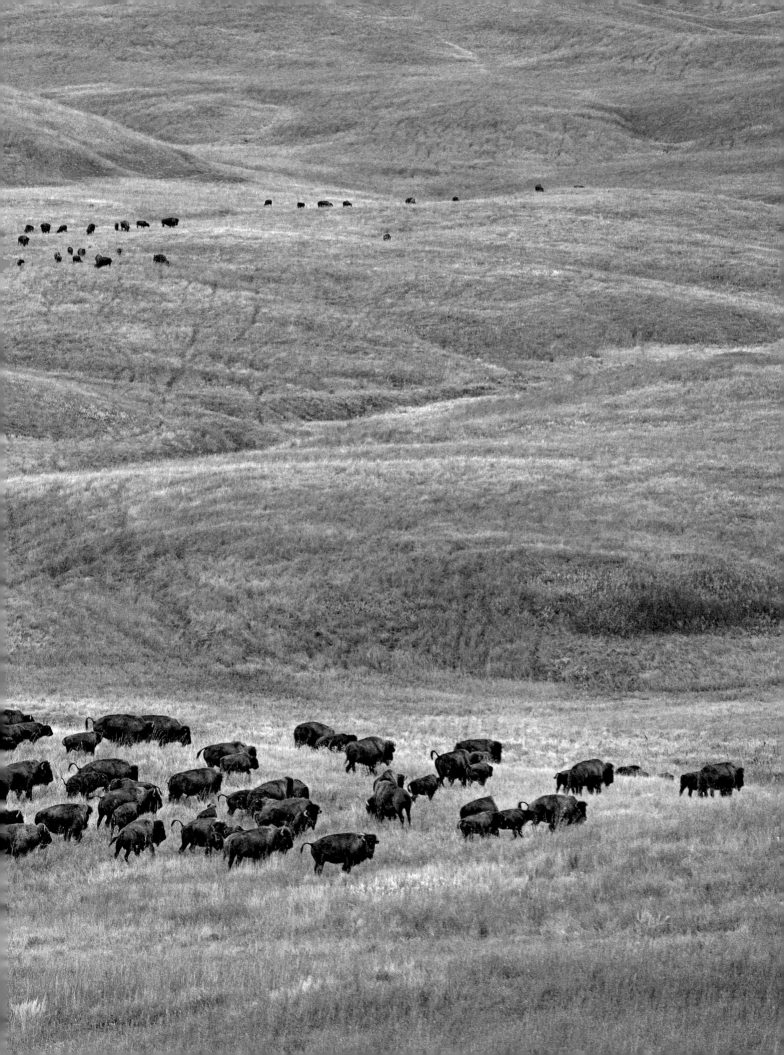

HALF THE PLANET'S WILDLIFE HAS
DISAPPEARED IN THE PAST HALF CENTURY.
BUT IF WE CAN FIND SPACE FOR THE BISON,
THEN SURELY WE CAN FIND SPACE FOR
OTHER MEGAFAUNA TO RETURN

OPPOSITE
**BISON BULL**
A male bison on the tall-grass
Blue Mounds prairie of Minnesota.
His herd, unlike most US herds, is
free of cattle genes and will soon
be able to provide pure-bred bison
to repopulate other prairie reserves.
This is vital because bison crossed
with cattle are smaller and less able
to survive the harsh prairie winters.

NEXT PAGE
**PRONGHORN ON THE MOVE**
Pronghorn trying to negotiate a
fence as they migrate south from
the grasslands of Grand Teton
National Park, Wyoming, to escape
winter. This fence has an unbarbed
pronghorn-friendly bottom wire,
allowing the antelopes to squeeze
under it (they can't jump).
Pronghorn prefer to move across
open spaces, relying on their
exceptional speed to outrun any
predators. But in the course of the
migration, this herd will encounter
some 70 fences. In most cases they
manage to crawl under them. Room
to roam is what most plains animals
require to find fresh nutritious grass.

OUR PLANET

128

When Europeans first set eyes on the Great Plains in North America, they were wild and unfenced, with around 60 million bison grazing tall prairie grasses that extended for hundreds of kilometres. Sharing the wide open spaces with them were cougars, wolves, grizzlies, elk and half a billion prairie dogs in colonies so extensive they were known as towns. Perhaps 10 million Native American Indians lived off the plains' natural bounty.

But Europeans riding Old World horses put paid to all that. The American Indians were conquered, and in the final decades of the nineteenth century, the bison suffered one of the greatest mass slaughters humanity has ever inflicted on large mammals. They were killed to remove a source of food for the American Indians, to make room for cattle and the plough, for their hides and sometimes for the sheer joy of killing. By the century's close, there were just 350 or so left. But that nucleus has been growing.

There are now approaching half a million bison on the Great Plains, though the majority of these are not pure-bred. In northern Montana, close to the Canadian border, wealthy philanthropists have bankrolled the purchase of more than 37,200 hectares (92,000 acres) of untilled old cattle ranches and leased more than three times that of public land to create the American Prairie Reserve. Its mission is to extend that to more than 1.2 million hectares (3 million acres).

Besides bison, the philanthropists are sponsoring the return of other animals, including the pronghorn – North America's fastest land mammal – bighorn sheep, prairie dogs, cougars, and the black-footed ferret – one of North America's most endangered mammal – as well as prairie birds, including hawks and golden eagles. The eventual aim is to recreate an American Serengeti. Bison are essential to that. Their grazing, trampling and even their habit of rolling on the grass will help bring back grass species, encourage insect life and suppress wild fires.

So could their return herald a beginning of the revival of the great grasslands of the world? Could they be the vanguard for the return of wild animals in other places? Half the planet's wildlife has disappeared in the past half century. But if we can find space for the bison, then surely we can find space for other megafauna to return.

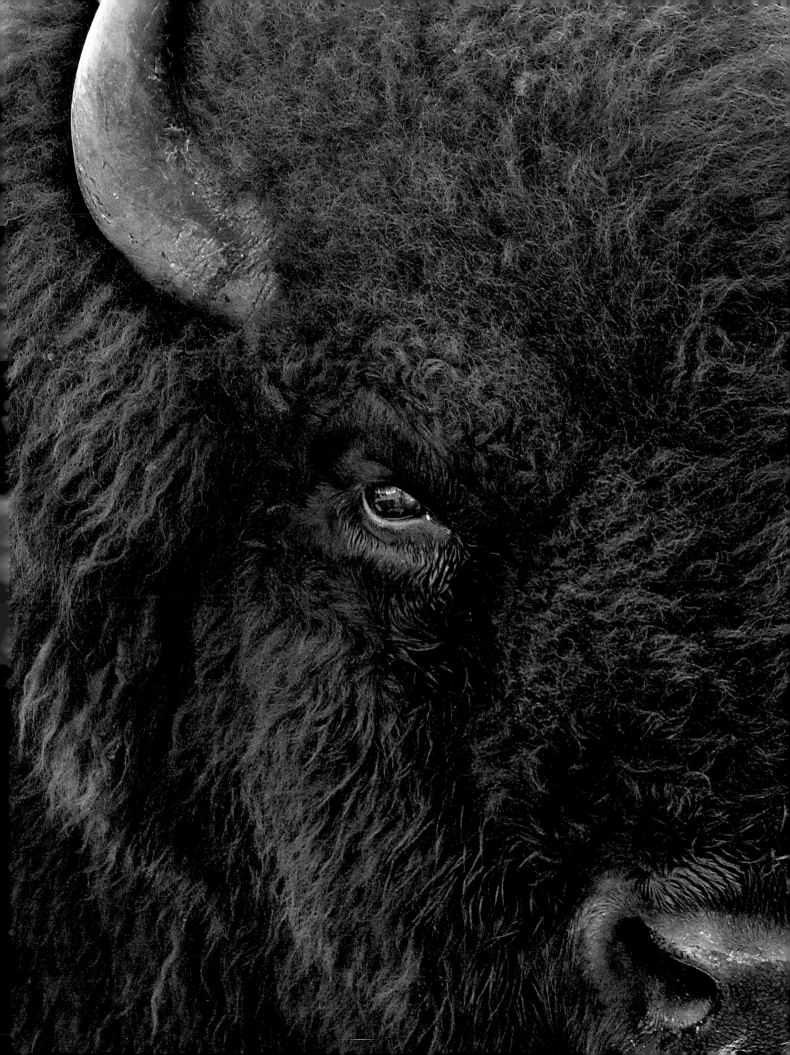

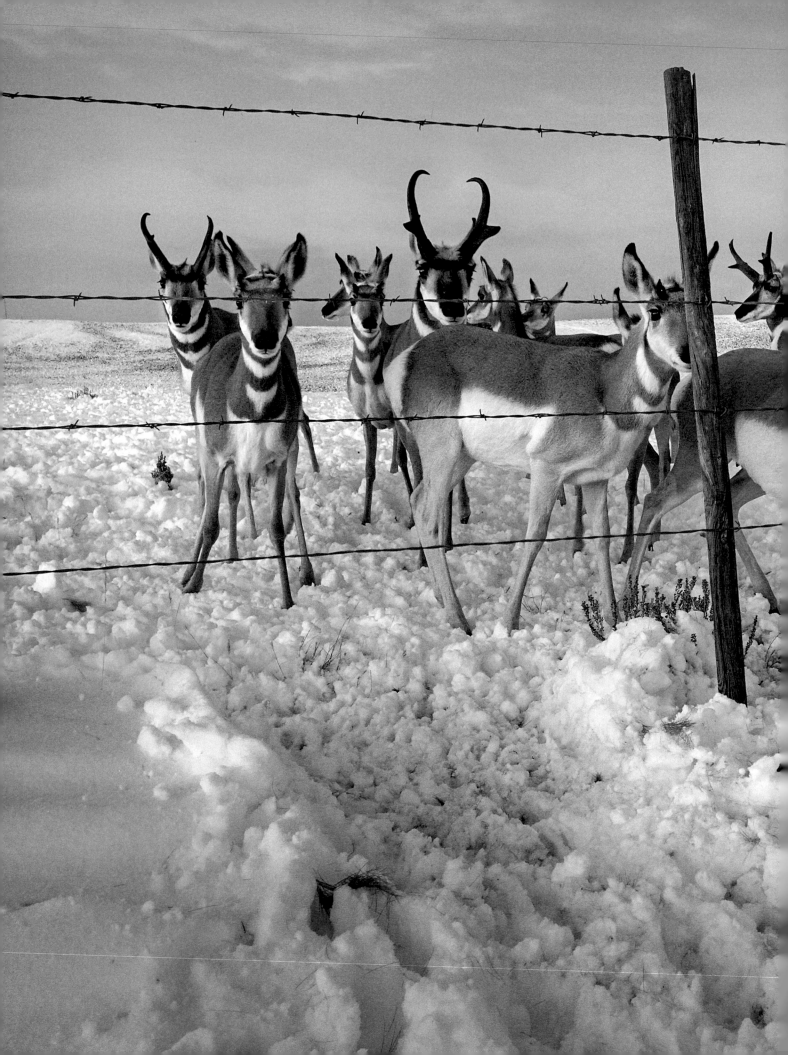

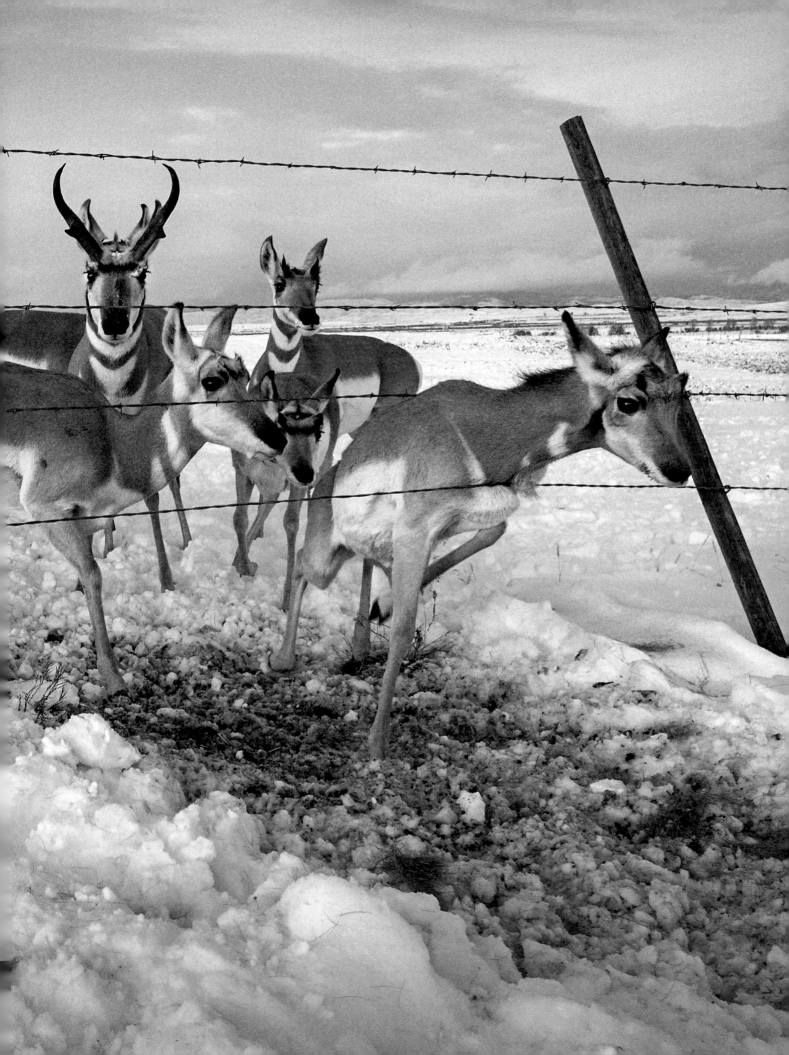

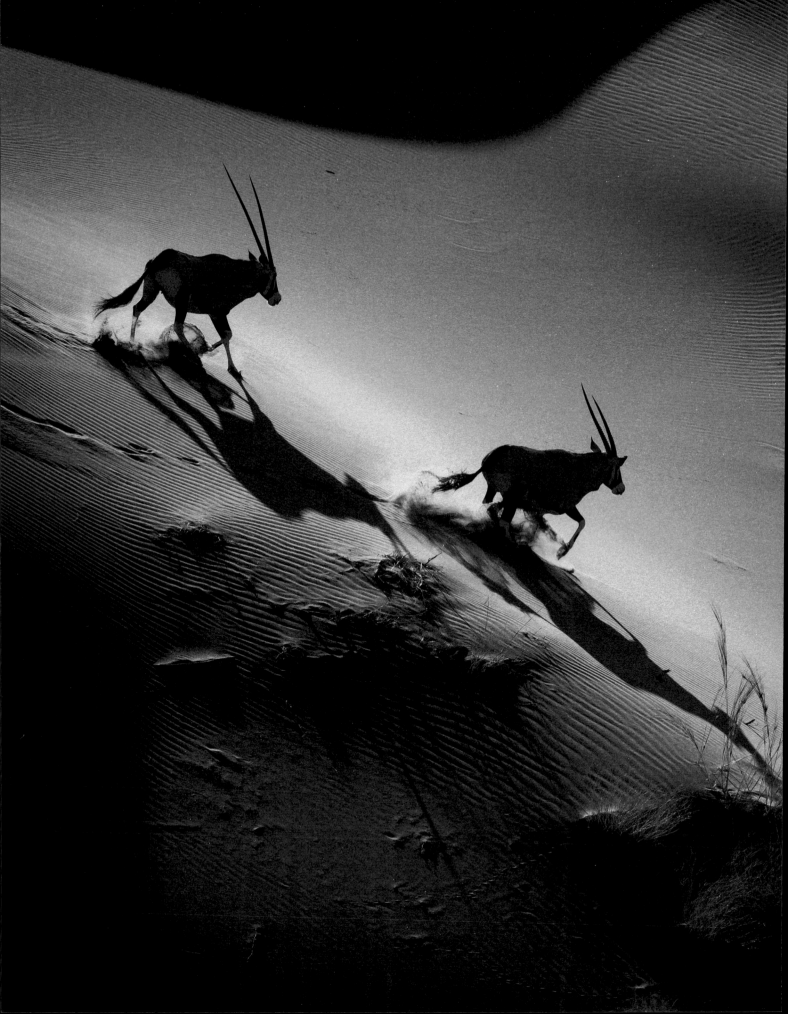

FAR FROM BEING WASTED SPACE, BARREN
AND DEVOID OF LIFE, MOST DESERTS HAVE
UNIQUE ECOSYSTEMS, WITH SPECIALLY
ADAPTED PLANTS AND ANIMALS FOUND
NOWHERE ELSE

The Namib in southwestern Africa is the world's oldest desert. An arid
vastness for more than 50 million years, it makes the Sahara, which was
lush with greenery only 6,000 years ago, look like a newcomer. The
Namib is also a world of extremes, where temperatures can reach 60°C
(140°F), and sand dunes rise to more than 300 metres (985 feet) high.
It has wildlife to match. Of 3,500 species of plants, half are only found
here. One type of shrub, the welwitschia, has only two leaves but can
survive for a thousand years, bursting into life after occasional rains.

The Namib's animals include desert versions of everything from
adders to zebras and bustards to blind moles that can swim through
dry sand. A large desert antelope, the gemsbok, can survive body
temperatures up to 45°C (113°F), thanks to behavioural and physiological
adaptations, including a network of tiny blood vessels that cool the
blood going to the brain.

A unique population of desert elephants can go days without
drinking water and stay alive by tramping long distances on particularly
large feet seemingly adapted to walk through sand, to find succulent
vegetation. They are also smart. Living as smaller than average family
units, mothers pass on to their daughters local knowledge about how
to find water hidden beneath dried-up river beds and remote outposts
of vegetation where they can feed. Such cultural knowledge enables
the population to survive in this desert.

The Namib is also rich in beetles. Over the millions of years that
the desert has existed, many have adapted to catch water from the
fogs that roll in off the Atlantic Ocean. They run to the top of dunes
when moisture is in the air and stand on their heads, so water runs
down their body and into their mouth. Some have evolved geometric
patterns of raised areas on their bodies that maximize the amount
of moisture that condenses from the fog. By copying the pattern,
scientists are developing water-capturing materials for human use.

So should we be saving the deserts? More often our concern is to
prevent the spread of deserts. A combination of the mismanagement of
drylands and climate change has triggered concern about desertification
from Mexico to Mongolia, and the African Sahel to the Indian Thar
Desert. In central China, the Gobi Desert is estimated to gobble up

**DESERT SURVIVORS**
Gemsbok crossing sand dunes
in the Namib Desert, Namibia.
They are adapted for desert life,
able to conserve water and to
keep their body cool enough to
survive the desert heat. They are
most active in the relative cool
of the early morning and evening.
But if it is very hot, they just move
around at night. They search out
water-retaining plants, such as
gemsbok cucumbers, dig up bulbs
and tubers, and have the ability to
digest relatively toxic succulents.

WHERE THIS ANCIENT WATER SURFACES,
THERE ARE NATURAL OASES THAT SUSTAIN
RICH DESERT ECOSYSTEMS. BUT MODERN
WATER PUMPS ... NOW BRING THIS WATER
TO THE SURFACE FOR IRRIGATED DESERT
FARMS. OASES ARE DRYING UP

an area more than twice the size of London each year. The UN estimates a fifth of the world's drylands may be at risk from the loss of vegetation and soil deterioration – an area the size of the US.

But while we may want to prevent the deserts' advance, we should respect and nurture those deserts that we have. Far from being wasted space, barren and devoid of life, most deserts have unique ecosystems, with specially adapted plants and animals found nowhere else. Plants have evolved bulbous stems to store water and special root systems. And small animals avoid the heat by staying underground or moving about only at night.

The Atacama Desert in northern Chile has regions that go decades without a drop of rain. But when it does rain, seeds burst forth within a few hours. After rains in 2017, botanists from around the world rushed in to see more than 200 different species bloom in the Atacama in a kaleidoscope of colours.

Deserts also offer safe refuges for species from outside. Socotra cormorants, a threatened species endemic to the Arabian Peninsula, build their nests in huge colonies on desert-like islands in the Persian Gulf and Arabian Sea. They fly daily to catch fish to feed their young, but the effort is worth it. Out of reach of predators that cannot survive in these conditions, their chicks are safe.

Deserts have surprising global functions too. Desert dust storms may look like nature in meltdown, as meagre soils are whipped from the land. Yet those storms are bringers of life, too. They are the source of minerals that fertilize distant rainforests. Several hundred million tonnes of phosphorus-rich Saharan dust are blown across the Atlantic Ocean each year. Much of it lands over the Amazon basin, where the forests are short of this essential nutrient for plant life. Would the world's largest rainforest survive without the Saharan dust? Maybe not.

Desert dust also delivers iron that is essential for plankton growth in remote areas of the oceans. An estimated three quarters of the iron in the Atlantic Ocean comes from the Sahara. Without desert dust storms on land, parts of the oceans would themselves become deserts. So deserts are valuable. Yet, like other ecosystems, they too are

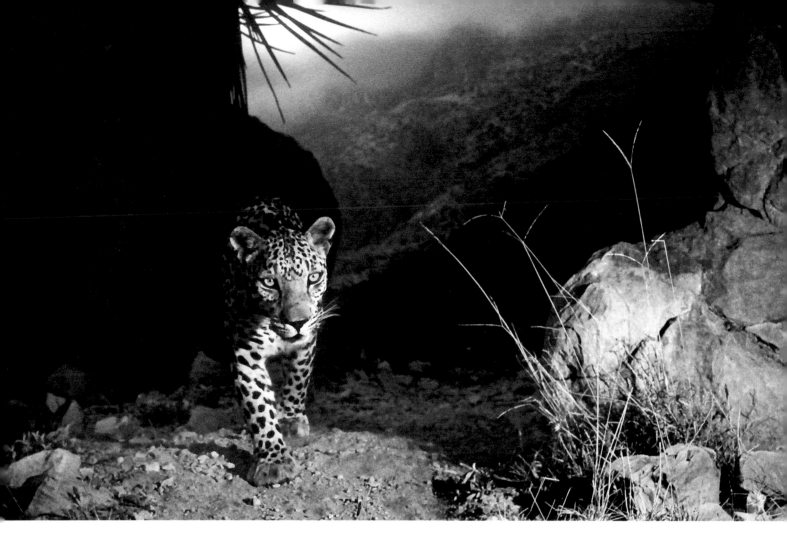

threatened by thoughtless human activity. In Gulf states such as Kuwait, urban infrastructure spreads across the desert landscape destroying dune systems; in the US, off-road vehicles do likewise. Elsewhere huge open-cast mines dig iron and phosphorus, uranium and diamonds from beneath the deserts, and dump waste all around, with little regard for the environment. And everywhere there is the threat of farmers moving in.

Some deserts, notably the Sahara and Arabian deserts, have huge reserves of ancient water beneath the sand, relics of wetter times. Where this ancient water surfaces, there are natural oases that sustain rich desert ecosystems. But modern water pumps – in Saudi Arabia, Libya, Jordan and elsewhere – now bring this water to the surface for irrigated desert farms. Oases are drying up.

Farmers can often be most destructive on the edge of deserts, where survival is hard and farming methods run the risk of destroying fragile natural ecosystems. But it need not be so. In our crowded world, it will not always be possible to give up the land to protect nature. But in such places it is often possible to do much better – to reach an accommodation with nature that limits further damage and allows ecological restoration.

**ARABIAN HOPE**
A rare camera-trap image of an Arabian leopard patrolling its territory in Dhofar, a desert region of Oman. Paler than an African leopard and smaller, this desert-adapted subspecies is extinct in most Arabian countries. The largest population, of just 60 or so animals, survives in Dhofar.

GRASSLANDS & DESERTS

# AN ESTIMATED THREE QUARTERS OF THE IRON IN THE ATLANTIC OCEAN COMES FROM THE SAHARA. WITHOUT DESERT DUST STORMS ON LAND, PARTS OF THE OCEANS WOULD THEMSELVES BECOME DESERTS

OPPOSITE

**DESERT FERTILIZER**
A satellite image showing a massive dust storm off the west coast of Africa carrying sand from the Sahara. The Sahara is the biggest desert on the planet, covering more than a quarter of Africa, and its sand regularly blows across the Atlantic. This sand fertilizes the Amazon rainforest, and without it, many Caribbean islands would be barren.

Two decades ago, many parts of Niger on the fringes of the Sahara were regarded as lost to the desert. Crop yields were falling and farmers were abandoning their land. But since then, the landscape has been transformed as local farmers ignored long-standing advice from government experts to uproot trees on their fields and started to nurture them instead.

It happened by accident, some time in the mid-1980s in Dan Saga, a village in the Maradi region of southern Niger. The story is that young men who returned to their fields late in the season after working abroad planted their millet in a rush, without first clearing their land of woody plants. To their surprise, their fields grew better than the cleared ones of their neighbours. The same thing happened the next year. So from then on, the villagers cultivated stems growing from stumps in their fields. The resulting trees reduced erosion and dropped leaves that fertilized the soil and maintained soil moisture. Before long, the trees were providing firewood, animal fodder and other products, as well as shading crops and villages from wind and sun.

The message spread. Soon hundreds of villages were doing the same, and some 200 million new trees were sprouting across once-barren land, benefiting yields of millet and sorghum, capturing carbon and holding back the desert. More importantly, perhaps, they have broken the mood of desperation. Things can be done better. The advance of the deserts no longer seems inevitable.

The farmers of Niger are not alone in defeating the odds. In the mid-twentieth century, the Machakos district of central Kenya was considered an ecological basket-case on the verge of desertification. British colonial administrators called it an 'appalling example' of environmental degradation that was 'rapidly drifting to a parched desert of rocks, stones and sand'.

But since then, the local Akamba people have protected soils by cutting hillside terraces, catching rain falling on the land to store in farm ponds and planting trees. The local population has increased fivefold and farm productivity has increased tenfold. Yet, far from turning to desert, the land is greener than before. The Akamba did it, says British geographer Michael Mortimore, by defying demography.

# THE PÁRAMOS – HYDROLOGICAL POWERHOUSES

Climb the steep track from the whitewashed colonial town of Cácota in the Colombian Andes, and you come to a treeless world, with swirling winds and fogs. It is a grassland dotted with strange cactus-like plants. But these are sopping wet and their roots sit in saturated soils. Welcome to the páramos.

High in the South American Andes, above the treeline but below the glaciers, the páramos cover at least 7 million hectares (17.3 million acres) of mountainside in Colombia, Ecuador, Peru, Venezuela, Bolivia, Costa Rica and Panama. They are the only wet tropical alpine tundra regions on Earth. And they are hydrological powerhouses – their soils storing more water than any reservoir. The water seeps slowly into lakes, peat bogs, springs, aquifers and, eventually, rivers – rivers that provide 90 per cent of Colombia's water and 60 per cent of its hydroelectricity.

But the sponges are feeling the squeeze. According to the Colombian government,

75 per cent of its páramos could disappear this century due to a combination of climate change and human land invasions. Already, rainfall is becoming more seasonal and evaporation rates are rising. The páramos are drying out.

Meanwhile, farmers are moving farther up the mountainsides, growing crops such as potatoes and raising dairy cattle. The soils are eroding, and with them their capacity to hold water. But a looming threat is also from miners.

There is a lot of gold and silver beneath the páramos. During Colombia's long civil war with FARC guerrillas, mining companies stayed away. Now there is peace, there are huge profits to be made. The Colombian government has declared support for protecting the páramos but also for exploitation of mineral resources. It will find it hard to achieve both.

ABOVE Páramo habitat, Colombia, with bunch-grass and frailejóns – 'palm-like' asters adapted to the humid tundra.

MOST OF THE NATURAL ECOSYSTEMS LOST
TO HUMAN ACTIVITY SO FAR, INCLUDING MOST
OF THE GRASSLANDS, HAVE BEEN LOST TO
AGRICULTURE. PROTECTING WHAT REMAINS
AND RECREATING GRASSLAND HABITATS
REQUIRES PUTTING THAT … INTO REVERSE

Instead of destroying their environment, more people provided more labour to improve the land. It was a home-made green revolution of just the kind that Africa needs if the world is to feed itself while giving more room for nature to thrive.

Most of the natural ecosystems lost to human activity so far, including most of the grasslands, have been lost to agriculture. Protecting what remains and recreating former grassland habitats requires putting that land-grab into reverse – giving fields back to nature. The good news is that, in recent decades, the world has made big strides in producing food more efficiently.

Thanks to the green revolution of high-yielding crops, it takes less than half as much land to feed each person as it did half a century ago. As a result, rising farm yields over the past 25 years have kept pace with rising human numbers, and the area of land under the plough has barely changed in the past 25 years. In parts of the world, we may have reached 'peak farmland'.

Here is some more good news. The boom in human numbers may be coming to a close. Average family sizes are coming down – from the five or six of a generation ago to two or three today. Even though we are living longer, demographers say it seems likely that the global population may peak before the end of the century.

So can we look forward to an end to the long era of grabbing land from nature? Not so fast. The bad news is that we continue to take rich and ecologically valuable land from nature – especially prime grasslands and forests across the tropics – while giving back much poorer land, often poisoned by salt or eroded so badly that it is of little use to us.

'Peak farmland' means little if, behind the raw statistics, we are returning to nature poisoned fields in California or eroded soils on the edge of the Sahara, while continuing to destroy the rainforests of the Amazon and Borneo, and to plough up African grasslands. And while the rise in human numbers may be slowing, our ever more wasteful use of food crops risks preventing us from reaping the ecological benefit.

NEXT PAGE
**PARALLEL NEEDS**
Elephants and cattle trekking across Kenya's Amboseli National Park in 2016, in search of pasture and water. Only when waterholes dry up and boreholes are not operating are Maasai pastoralists allowed to take their cattle into the park to drink.

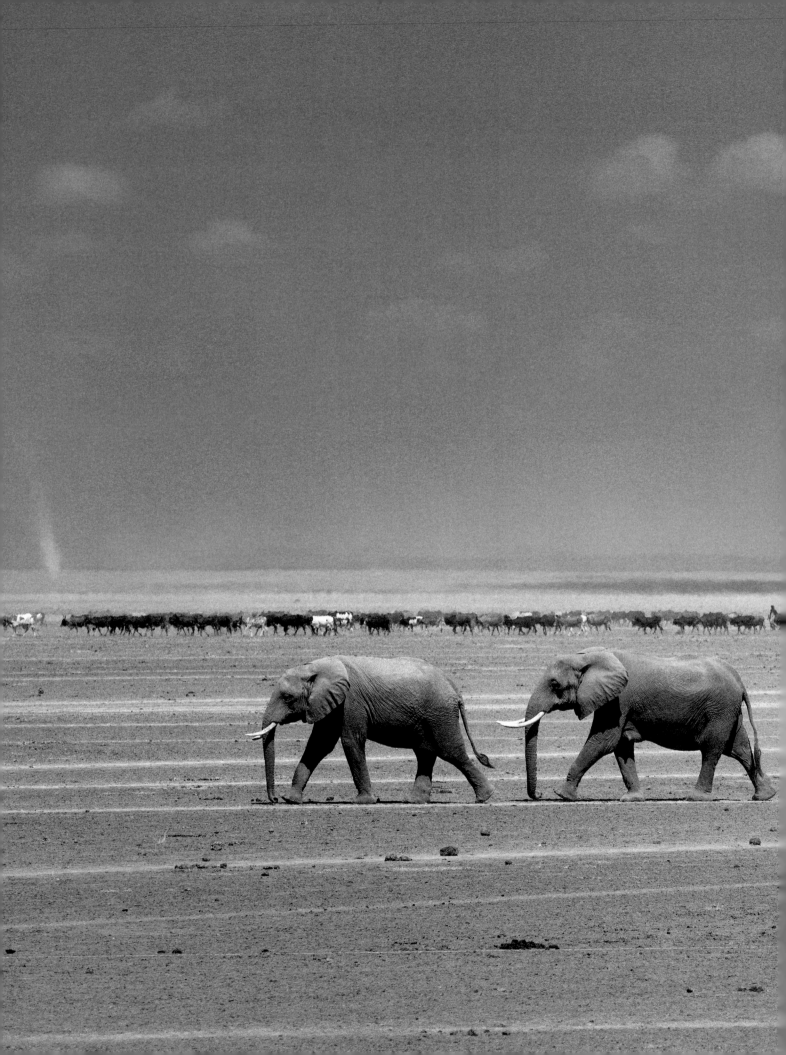

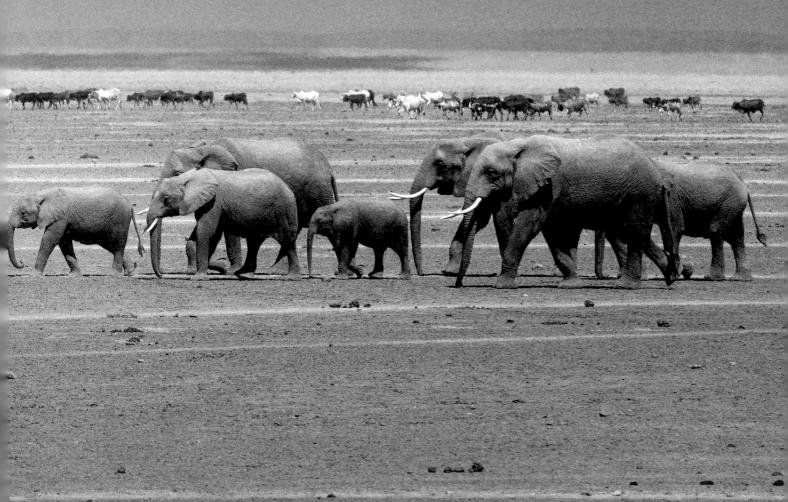

# THE WILD WEST – A DESERTIFICATION STORY

Settlers in the American Southwest changed so much. They often moved into grasslands ill-equipped to cope with grazing animals. Unlike most other parts of the US, there were few grazers there until the Europeans came with their cattle. Those cattle turned the Wild West into an ecological catastrophe.

In the Great Plains to the east and north, bison had long roamed in vast herds. Their regular grazing had created tough grass, and the herds manured the soil. But in the Southwest, the grass had few defences against a sudden invasion of millions of livestock. The teeth of cattle stripped it, and hooves punctured the hard crust that protected the soils from the wind.

What we would now call desertification happened fast after land speculators moved in. In 1884, the Boston-based Aztec Land and Cattle Company bought more than 400,000 hectares (1 million acres) of Arizona pasture along the railway to San Francisco. Trains brought in cattle and hundreds of cowboys. The cowboys became notorious. In Holbrook, a town of 250 people that was the company's Arizona base, they shot 26 people dead in 1886 alone. Human life was cheap in the Wild West. But so was land. And it was squandered.

In 1894, naturalist John Muir called the great livestock herds 'hoofed locusts... carrying desolation'. The natural crust can survive wind speeds of a hundred miles an hour, but cattle break it, says Jayne Belnap, a soil ecologist at the US Geological Survey in Utah.

By the time Aztec sold the ranch in 1901, cattle carcasses were scattered across the exhausted land, which had been eaten up in little more than a decade. The exposed soil simply blew away. A century on, little of it has recovered. Dust clouds head north, occasionally sprinkling Colorado's ski slopes.

ABOVE Modern-day Colorado cowboys moving cattle to a new range to avoid overgrazing and further soil damage.

Globally, we already produce enough food for 10 billion people. But less than half of that harvested food is eaten directly by us. Much is wasted: rotting in warehouses or thrown away by wasteful consumers. Some is turned into biofuels. And ever more is fed to livestock to meet our growing demand for meat and dairy products.

The global population of cattle, pigs, sheep and goats is now around 4.3 billion animals and rising – more than one animal for every two humans. That is not counting the world's 20 billion chickens.

As pasturelands run short, we have been switching to raising livestock in feedlots. Instead of munching the grasslands, they eat soya, corn and other crops – and fishmeal. Growing the crops to feed those animals, so that they can in turn feed us, uses far more land than feeding us directly. It takes eight calories of grain to make one calorie of beef. Dairy products are little better.

**EAT LESS MEAT, SAVE MORE LAND**
Reducing the consumption of animal-based food, particularly beef, would greatly reduce the use of grassland. Indeed, if 2 billion of the world's wealthier people ate 40 per cent less meat, it could save an area of land twice the size of India.

AVERAGE DIETS

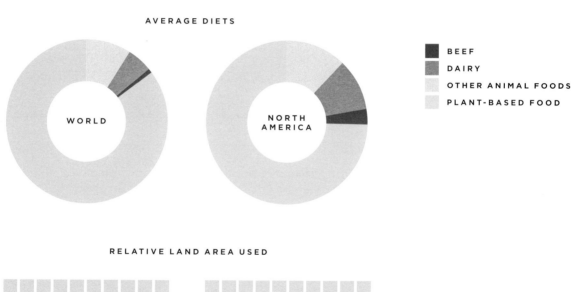

WORLD

NORTH AMERICA

■ BEEF
■ DAIRY
□ OTHER ANIMAL FOODS
□ PLANT-BASED FOOD

RELATIVE LAND AREA USED

THE GREAT ECOLOGICAL RESTORATION
IS LIKELY TO BE LESS ABOUT RESTRAINING
HUMAN NUMBERS AND MORE ABOUT HOW
WE FEED OURSELVES. PUT SIMPLY, WE ...
MUST FARM MUCH MORE EFFICIENTLY, SO
WE DO LESS ENVIRONMENTAL DAMAGE ...
AND WE MUST CHANGE OUR DIETS SO
WE NEED TO GROW LESS

In the past century, the conversion of grasslands to growing feed for livestock has caused more loss of natural ecosystems than anything else. The cerrado in Brazil, for instance, is disappearing largely to grow soya to feed to Chinese and European livestock. If we used our food crops more wisely, feeding the world would be possible without taking more land from nature. But with much of the world adopting western diets rich in meat and dairy products, we are heading fast in the wrong direction.

So achieving the great ecological restoration is likely to be less about restraining human numbers and more about how we feed ourselves. Put simply, we have to do two things. We must farm much more efficiently, so we do less environmental damage for every ton of food we grow. And we must change our diets so we need to grow less. We may not all have to go vegan or even vegetarian, but we should be dramatically reducing our reliance on ecologically ruinous meat and dairy produce.

The most pressing crisis for farmland in the coming decades will be in Africa, threatening the future of the Serengeti and many of its other great unfenced grasslands where nature still runs free. Africa is where most of the increase in human numbers is still to come – and where unmet need for food is also greatest.

So far, the green revolution that transformed agricultural yields in recent decades has largely bypassed Africa. African farmers get less than half as much cereal from their land as Asian farmers and a fifth that of Europeans and North Americans. Bridging that gap is vital. If farm yields in Africa could be raised to Asian levels, then many of the grasslands and their wildlife could survive. If not, then outside protected areas they are probably doomed. There seems to be a period of maximum risk looming in the next few decades, as African numbers and global dietary demands soar. But if we can get through that bottleneck, the grasslands and the great herds may indeed survive.

OPPOSITE
**BEEF BATTERY FARM**
A feedlot in Texas. The picture, created from hundreds of high-resolution satellite images, shows the many pens packed with thousands of cattle (left) and a chemically treated manure lagoon (right) draining into the soil and eventually into the groundwater. Growth hormones, antibiotics and efficient feedlot architecture are what enable such industrial-scale beef production.

NEXT PAGE
**SPACE TO ROAM**
Cheetahs setting out to hunt in Kenya's Maasai Mara – ideal open grassland habitat for their prey and protected as a national reserve. Cheetahs need large areas of connected habitat to catch enough prey, and so they live at very low densities. Of the 33 remaining cheetah populations, only two number more than 1,000, one being in Tanzania and Kenya's Serengeti-Mara-Tsavo region. Overall, the cheetah population is in decline, because of human encroachment on their habitat, persecution, disease and poaching of their cubs.

# FORESTS

'A forest is a dynamic, continuously changing kaleidoscope of habitats, from full tree cover to open glades – an interaction between species and processes. Succession can go in either direction. A storm, a fire, a flood or disease can initiate a more open landscape, maintained by large herbivores. Then another disease or harsh weather event or the development of thorny scrub can help trees to take over again for another period. The countless species that make up such a dynamic landscape, including those from its humus and soils, can involve others from grassland, open woodland, scrub and even riverine habitats. Understanding the dynamics of their interactions is key to preserving and restoring a rich forest biodiversity.'

**FRANS SCHEPERS**
Founder and Managing Director of Rewilding Europe

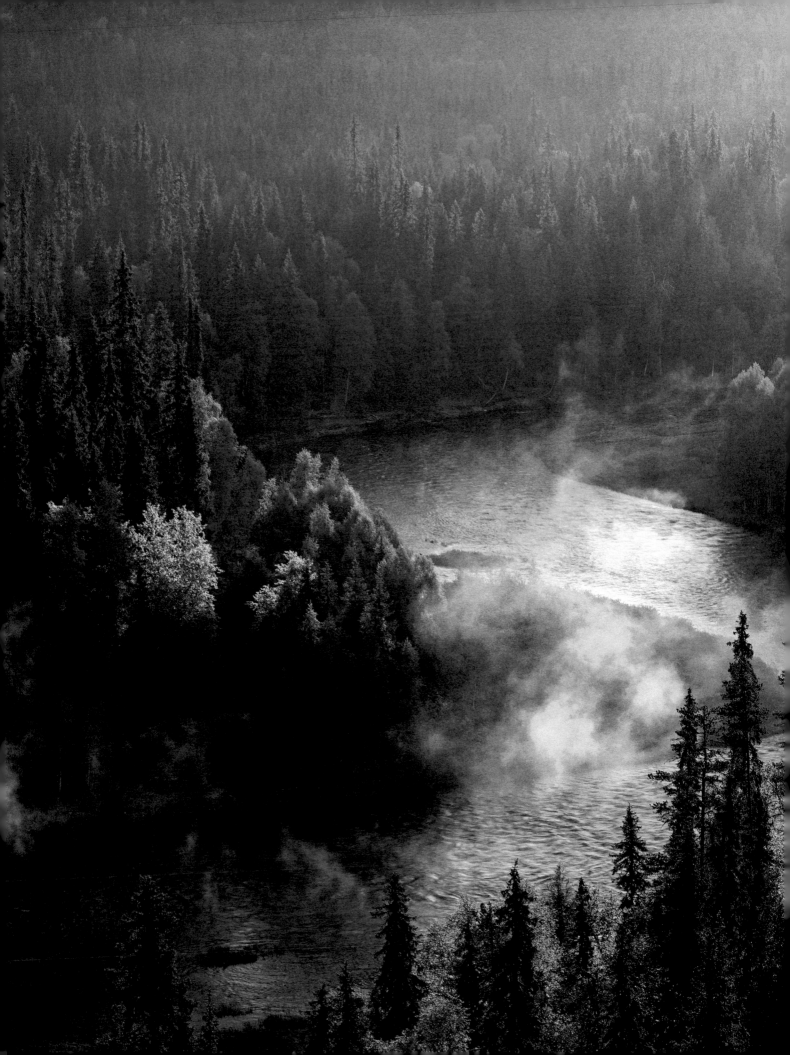

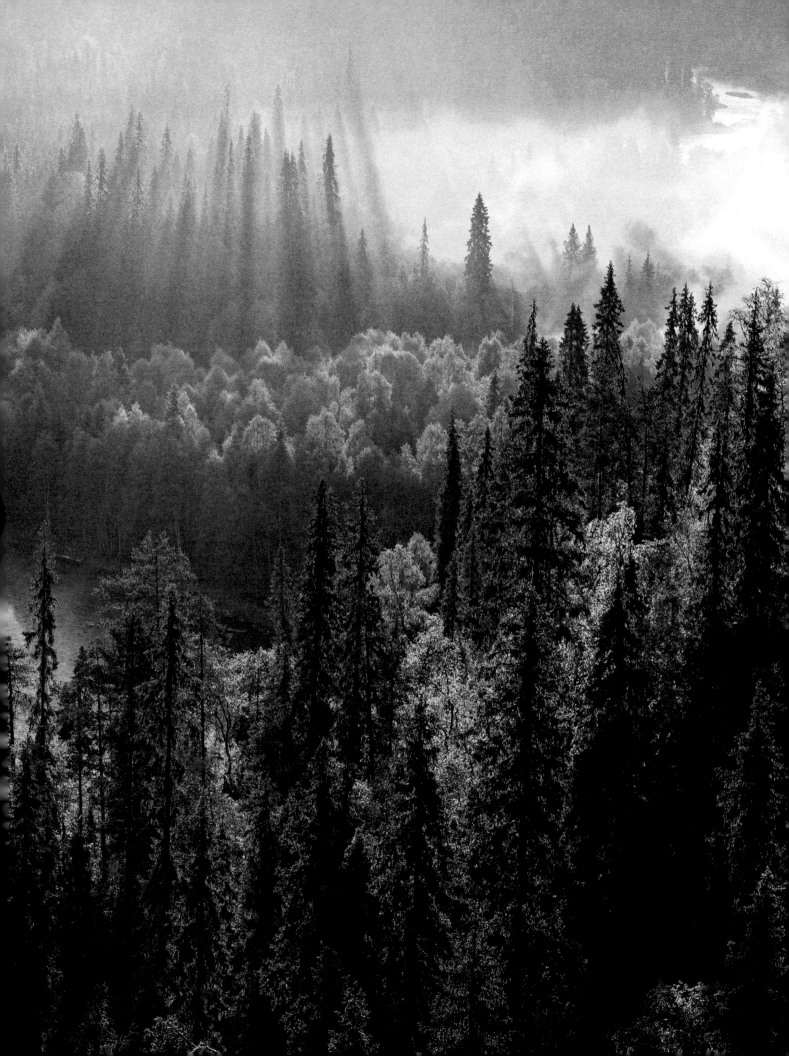

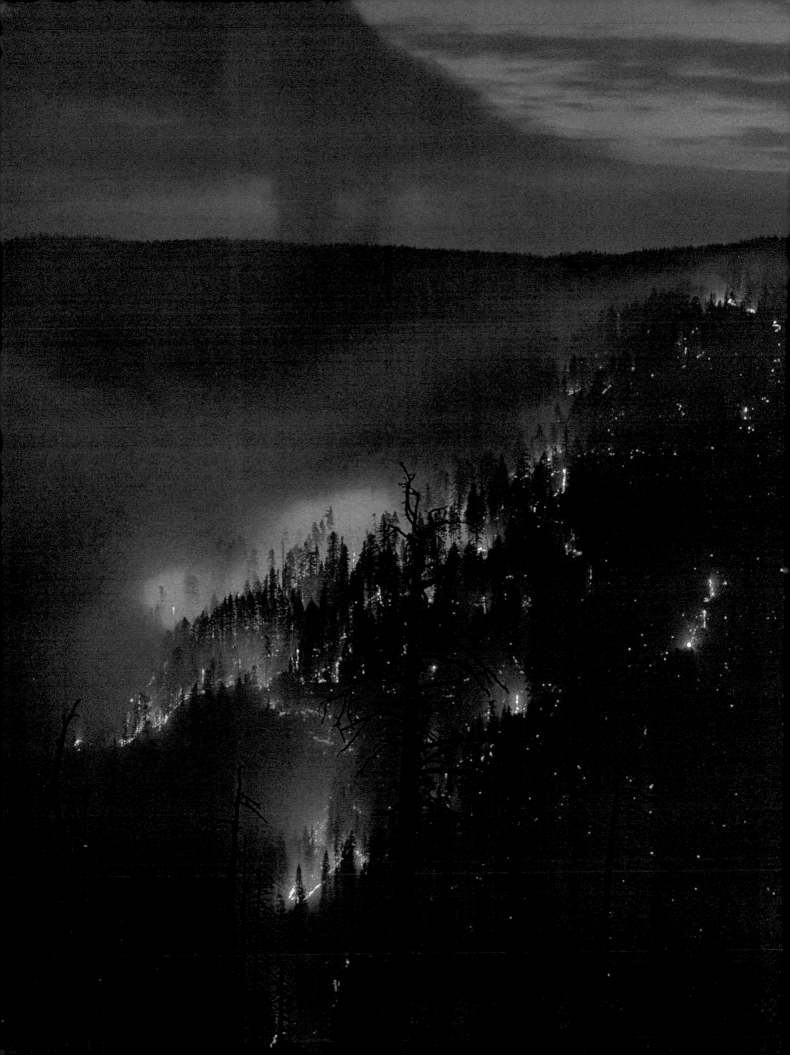

## FORESTS HAVE RESILIENCE AND A CAPACITY FOR RENEWAL THAT CAN COME TO OUR AID IN THE 'GREAT ECOLOGICAL RESTORATION'

Like most forest fires, the Eagle Creek blaze started with a spark. Unusually, there was a known culprit – a 15-year-old youth, seen throwing a firework into a ravine. It lit a bush and, blown by strong, dry winds, the inferno quickly spread along the Columbia River in the state of Oregon, eventually covering 200 square kilometres (77 square miles) of Douglas fir, cedar and hemlock forest. It made a terrifying spectacle for hikers over Labor Day weekend in 2017. A thousand firefighters and a dozen water-dumping helicopters could not douse the flames, until rains came to the rescue two weeks later.

That summer, all across the North American west, from the temperate rainforests of British Columbia to the giant redwoods of California, an area larger than Belgium went up in flames. Whoever or whatever started each blaze, the forests burned with greater than usual ferocity, because the summer had been exceptionally dry – something scientists blamed on climate change. And the fires spread further because there was more wood to burn – thanks to decades of forest management to suppress fires.

In future, we expect to see more fires and bigger fires, climate scientists said as the Eagle Creek blaze finally died down. Is that bad? Well, not necessarily – at least not for the forests. Because here's the twist: wildfires may be dangerous for hikers or anyone with a house in the woods, but they are generally a good thing for forests.

Wildfires are natural. If teenage boys don't set them, then lightning probably will. And they can be desirable. Ecologists once feared the heat and destructive power of forest fires. But today they see fire as vital to sustaining healthy forests. 'Fire is not an end, but a beginning,' says Oregon fire-guru Dominick DellaSala. 'It's nature's phoenix.'

In a natural, healthy forest, even the biggest fires do not kill all the trees. Most forests largely recover. Research in the American West suggests that the warmest, driest forests may not recover from the kind of major fires being encouraged by climate change. But in normal conditions, burning creates clearances that let in light and encourage new growth; the heat germinates seeds lurking in the soil for just that moment; and ash on the wind provides natural fertilizer. Sure enough, the spring after the big fire, the blackened embers along Eagle Creek were transformed by a burst of wild flowers. Nature was back.

OPPOSITE
**FIRE POWER**
A massive fire in California's Yosemite National Park, started by a lightning strike. Park foresters managed its path using fire breaks, but let it burn. They saw it as a natural and beneficial process of cleansing and renewal. But drought conditions have intensified the forest fires, and the late arrival of autumn and winter rains have allowed them to burn far longer than normal.

PREVIOUS PAGE
**THE GREAT BOREAL FOREST**
Natural, unlogged boreal forest in northern Finland, part of Oulanka National Park. In a cold climate with a short growing season, there are few tree species. Here, stands of Norway spruce dominate, with downy and silver birch on the river-valley floodplain or where fire has created openings.

OPENING PAGE
**RAIN-RICH FOREST**
Old-growth temperate rainforest in Oregon, on the west coast of the US.

FORESTS

# IF WE CAN CREATE SPACE FOR FORESTS AND OTHER KINDS OF WILDERNESS, NATURE CAN AND WILL BRING THEM BACK

Fire in forests is essential, says Stephen Pyne, a firefighter turned fire historian at Arizona State University. 'It shakes and bakes, it frees nutrients and restructures biotas.' A forest without fire is like the living dead. The US, he remembers, watched horrified back in 1988 as fire ripped through one of its iconic ecosystems, the Yellowstone National Park. A third went up in flames. Many believed the park would never recover. But three decades on, the forests have regrown. In retrospect, the fire was a great spring clean. Park foresters, who once had a zero tolerance of fires, now set their own smaller blazes to keep up a constant ecological renewal.

The same story holds for many of the world's forests, which are adapted to fires and depend on them. It tells us three things. First, that destruction is necessary for renewal. Second, that nature is dynamic and forever changing. And perhaps most importantly in the Anthropocene, it suggests that forests have resilience and a capacity for renewal that can come to our aid in the 'great ecological restoration' drive.

If we can create space for forests and other kinds of wilderness, nature can and will bring them back.

Forests and humans go back a long way. Folklore is full of enchanted forests, with sacred groves and clearings full of flowers, butterflies and songbirds. But in some fables, they evoke danger, too, as places where ogres live and bad things happen. Such stories reflect a time when forests covered most of the northern hemisphere. Across North America, through Europe to the Russian Far East and Japan, around the Mediterranean and south into what is now the Sahara Desert, it was forests most of the way – beech, lime, maple, oak, cedar and pine for thousands of kilometres. Some forests with unbroken canopies were dense and dark. But many let light onto the forest floor, and plants grew in profusion. The vegetation was eaten by herbivores such as deer that were in turn gobbled up by wolves, lynx and bears. Above, birds filled the branches, and below, insects and other invertebrates lived amid the undergrowth, recycling forest debris.

For thousands of years, humans have cut down forests. We have done it mainly to provide wood and to clear ground for growing crops, grazing animals and building settlements. About half of the world's forests have been lost – outside the tropics, much more than that.

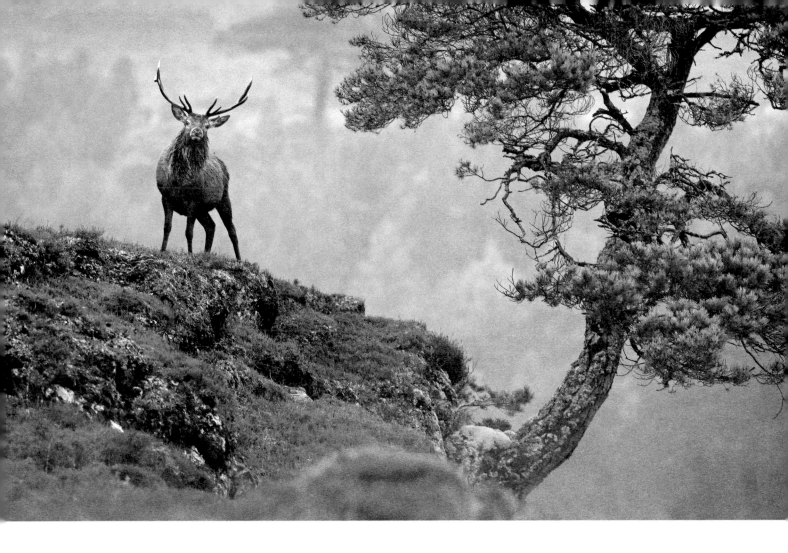

The cedars of Lebanon, which feature throughout the Bible are mostly gone. The Scottish Highlands are bare. In the southern hemisphere, much of what is today Australian outback was forest until burned to aid Aborigine hunting expeditions (forests need fires, but too many fires can destroy their resilience). Outside Russia, only 1 per cent of Europe's old forests remain. More than 90 per cent of the continental United States has been logged since European settlement began.

Globally, deforestation reached a peak in the twentieth century, by which time loggers were armed with chainsaws rather than axes. But in the twenty-first century, rapacious clear-felling of forests remains a threat even in Europe, and even in Europe's most precious forests.

Bialowieza Forest, a World Heritage Site on the Polish border with Belarus, is the continent's largest and best preserved lowland forest ecosystem and its last mixed-species old-growth forest. It is home to a rich species list, including 1,000 plants, 12,000 invertebrates and 58 vertebrates. It is the largest refuge for the European bison, with a third of the world's wild population. Its enormous biodiversity and resilience to outside threats depend on having a mix of trees of all ages and a forest floor where dead wood nurtures fungi and invertebrates, and where animals such as wolves and lynx can roam.

FORESTS

# CHACO FOREST – A MUSEUM OF DIVERSITY

The Paraguayan Chaco forest is South America's most mysterious wilderness – the heartland of the Gran Chaco. Much of it is almost impenetrable because of huge thickets of shrubs with brutal thorns. Among the thorns, however, is what Professor Toby Pennington of the University of Exeter calls 'a museum of diversity'.

The extreme environment, which switches between 50°C (122°F) summers and freezing winters, and between searing droughts and extensive floods, has led to adaptations rarely seen elsewhere and many bizarre animals unique to the Chaco. It is a land of giant anteaters, tapirs, maned wolves, flightless rheas as tall as a human and ten species of armadillo. The pig-like Chacoan peccary was known only through fossils until, in 1975, someone stumbled on one amid the thorns.

The Chaco's bizarre plants include many giant cacti and bottle-shaped trees that hold moisture like a camel's hump. Little is known about how these communities work. Soon it may be too late to find out.

Until recently, the Chaco, which covers half of Paraguay, was almost entirely uninhabited except for small groups of indigenous Ayoreo people, some largely uncontacted, and a colony of German-speaking Mennonites. But now the natives are coming face to face with ranchers clearing the forest to create cattle pasture. Many of the ranchers have crossed the border from Brazil, where in recent years the government has cracked down on deforestation in the Amazon. The Paraguay government seems less concerned. As a result, the Chaco is now being deforested faster than almost anywhere. An area the size of a soccer pitch disappears every 90 seconds.

This is madness, says Pennington. 'Without knowing it, we could be losing a flora that is not just evolutionarily distinct, but of vital importance ... At a time when we fear climate change, it seems especially crazy to be losing species that are obviously well adapted to extreme climate.'

ABOVE Paraguayan Chaco forest being stripped and the land converted into cattle pasture to grow beef for export.

Bialowieza was preserved for centuries as a royal bison-hunting ground. Many areas have never been logged, so old-growth oak, lime and elm thrive. On a crowded continent, it is irreplaceable. Yet the Polish government escalated commercial logging there. It claimed the aim was to defeat an outbreak of bark beetle that was killing spruce trees. But ecologists say this was a ruse. The beetles have been shaping the forest's ecology for centuries, says WWF. Its enormous biodiversity depends on dead wood, which harbours insects recycling the raw materials to make future life. The European Court of Justice sided with environmentalists, and in April 2018 the Polish government promised to abide by the ruling.

Despite such scandals, the front line of deforestation has in recent decades largely moved to the tropics. The sound of chainsaws echoes through the tropical rainforests, of course, but also through the dry forests of South America, Africa and Asia, which are now among the planet's most threatened ecosystems. In eastern Brazil, the once-giant Atlantic dry forest is home to thousands of species found nowhere else, including the black-faced lion tamarin, which was thought extinct until it was rediscovered in 1990. But how long will it survive? Three quarters of the Atlantic dry forest is now gone, broken into fragments by poor migrant farmers and large-plantation owners growing crops such as sugar cane and coffee for international markets.

This fragmentation is one of the biggest threats to forests globally. They are being cut into pieces by farms, but also by roads, rail tracks, pipelines and pylons. Less than a quarter of the world's forests are in what ecologists call 'intact forest landscapes', with unbroken expanses of trees where large predators and foragers such as tigers and bears can thrive. A single grizzly bear may need 1,000 square kilometres (385 square miles) to itself. These animals also spread seeds in their droppings, so they are an essential part of the forest ecology.

The planet's greatest forests gird the globe south of the Arctic tundra. From Scandinavia to the Russian Far East, and from eastern Canada to Alaska, the boreal forests of larch, pine and spruce stretch for thousands of kilometres. Large human settlements are rare.

NEXT PAGE
**LAPLAND WILDERNESS**
Bogs and frozen wetland interweave with stands of Norway spruce in a valley in the Laponia World Heritage Site in Swedish Lapland. The harsh climate limits plant reproduction to a brief period from June to August and also the number of species.

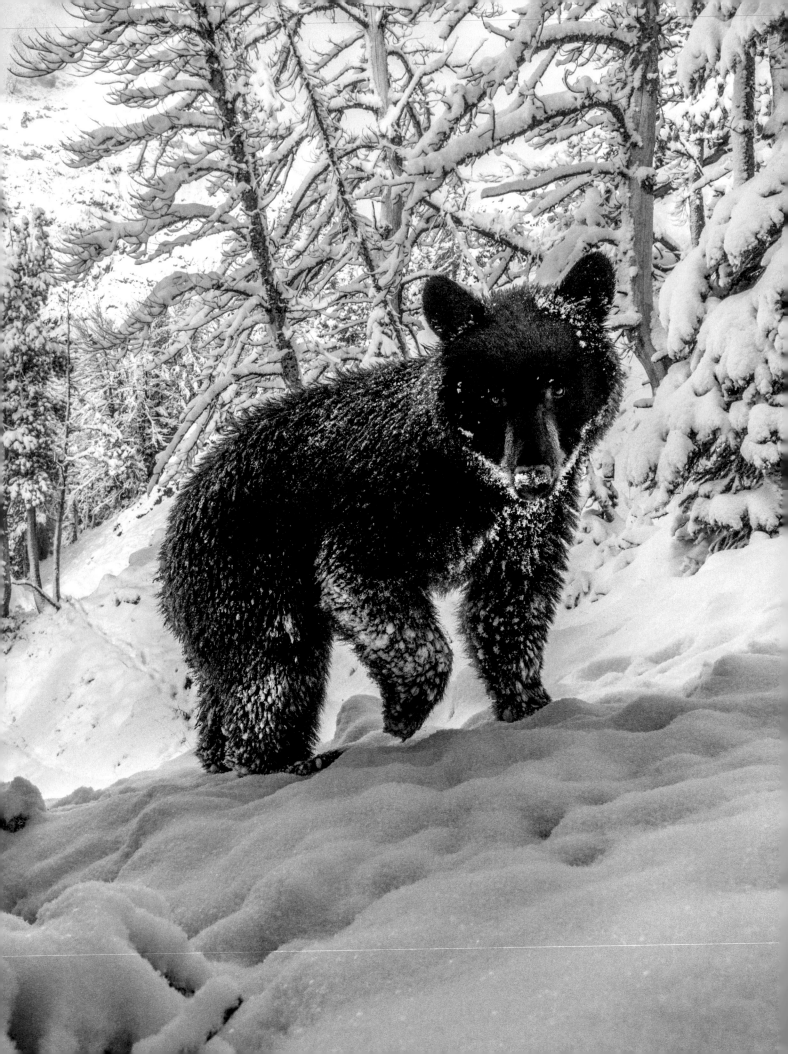

Loggers work in about two thirds of the boreal forests of the north, providing a third of the world's timber. But that still leaves about a third relatively intact – more than a million square kilometres (386,000 square miles) that contain probably one in four of all the world's trees.

The boreal forests are covered in snow for more than half the year and suffer temperatures as low as -50°C (-58°F). Their roots are often constricted by permafrost. No wonder the trees typically grow by only a few centimetres a year. They are superbly adapted to the bone-chilling conditions. But with global warming already much faster in the far north than elsewhere on the planet, the fate of these immense, resilient and seemingly timeless conifer forests is far from certain.

Already, they are being invaded by insects from the south, the higher summer temperatures are leading to water shortages, and forest 'browning' and ever-more-fierce fires are in places changing the mix of species. Fires are normal in the boreal forests – essential, even. They sustain spruce trees by opening their cones to release seeds. But new 'blowtorch' fires burn almost everything, leading to a takeover by deciduous trees such as aspen and birch.

That threatens the fate of the animals that live among them. Giant herds of caribou winter in the forests of the Canadian north, feasting on lichens that grow in foamy masses among the fallen leaves of spruce forests. But aspen and birch do not support these ground-living lichens. So how will the caribou get through the winter?

The ecosystems and the animals may just move north, into the warming tundra. Or they may not. In the far north, nature's resilience is being tested to its limits.

So, too, is the resilience of the Siberian tiger (also known as the Amur tiger) and its unique habitat. The tiger is hanging in there in pine forests of the Sikhote-Alin Mountains in the Russian Far East, probably the largest unbroken tiger domain in the world. After a crackdown on hunting, including hunting of its prey, the world's largest tiger is making a modest comeback. Back in the 1930s, it was reduced to fewer than 40 adults. But now there may be more than 500 roaming these mountains – a weird world of climate extremes, where normally tropical tigers and leopards share the slopes with creatures of the north, such as reindeer and brown bears.

OPPOSITE
**BEAR ON A HUNT**
A black bear photographed with a camera trap in Yellowstone National Park, Wyoming. The youngster is in search of food, using a deer and elk migration trail over a forested mountain ridge. To find enough to eat, whether pine nuts, small animals or even carrion, a bear needs a very large home range.

NEXT PAGE
**TIGER ON PATROL**
A male Siberian tiger – filmed by an *Our Planet* camera trap – patrols a mountain ridge in the Sikhote-Alin range in the Russian Far East. Its territory is huge. It has to be to provide enough prey for survival through the severe winters. Key to the tiger's survival is the region's mix of Korean pine and Mongolian oak, which provide the pine nuts and the acorns that sustain the deer and the wild boars through the winter. Law enforcement to prevent poaching of the highly endangered tiger and its prey has allowed the tigers to increase in the region from fewer than 30 to more than 500. But a major problem remains illegal logging of mature trees for a trade controlled by the Russian timber mafia. It opens up the forest and reduces the amount of nuts available for prey as well as for human harvests.

FORESTS

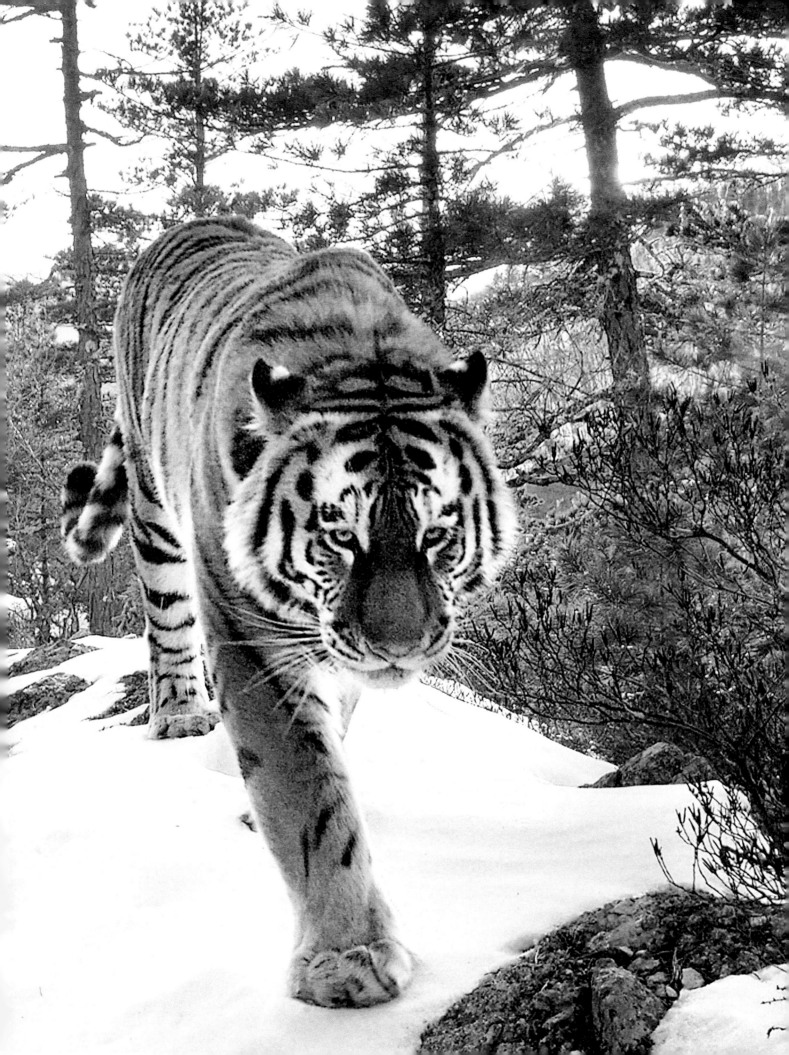

# MADAGASCAR'S LEMUR FORESTS – AT A TIPPING POINT

There is nowhere like the giant island of Madagascar. Marooned in the Indian Ocean for millions of years, its wildlife has taken a unique evolutionary path. As a result, the island is one of the world's great biodiversity hotspots. More than 80 per cent of its more than 15,000 species are found nowhere else. They include half the world's chameleon species, all 50 remaining species of lemurs, whose raucous calls fill the forest air, and the fossa – a cat-like creature most closely related to mongooses, which eats small lemurs.

But Madagascar is also among the world's most threatened wild places. Most of its original forest cover has gone, logged, burned or turned over to grazing. The loss is greatest in the dry deciduous forests of the north and west, a particular hotspot for biodiversity, where only fragments remain.

The island's biological resilience remains for now. The surviving forest fragments teem with life. But one link in the chain that sustains this cornucopia seems especially vulnerable. In the complex and varied forest ecosystems, lemurs are vital. They eat fruit and disperse tree seeds in their droppings. The disappearance of 17 species of large fruit-eating lemurs in the past few centuries has left many trees with no way to reproduce. No surviving lemurs have jaws big enough to eat the fruit from those trees, says Sarah Federman of Yale University. They are doomed 'orphan species'.

Many trees – including most of the 33 species of *Canarium* hardwoods that dominate the island's eastern forests – are now dependent for their reproduction on the two largest surviving lemurs, the red ruffed and the black-and-white ruffed lemur. Both lemurs have lost more than 80 per cent of their population in the past 30 years. If they disappear, Federman predicts a 'cascade of extinction', taking away more trees and the habitats they provide for other animals. Despite the warnings, the rate of deforestation in Madagascar continues to accelerate. The tipping point may not be far away.

ABOVE Black-and-white ruffed lemur, vital disperser of the seeds of *Canarium* trees in Madagascar's forest.

Times are tough. The tiger has to eke out a living through long winters. Its domain closely matches that of its chief winter food, the deer and wild boar, which in turn survive the winter feeding on fallen pine nuts on the forest floor. A single tiger needs to eat about 50 of these animals in a year, which requires a vast hunting territory of 600–1,000 square kilometres (230–385 square miles).

But the tiger is not just a beneficiary of the forest ecosystem; it helps maintain it. By keeping under control the number of deer, it prevents overgrazing of young trees. The relationships should work well, keeping the forest ecosystem in balance. Except that humans are still testing its resilience. Illegal logging continues, in particular extracting the valuable Korean pine trees, which are used for furniture and flooring in Europe and the US. Moscow has banned all logging of the pines, but illegal timber finds its way across the border into China, and China is still a major exporter of Korean pine.

What is clear is that fewer pines will mean fewer pine nuts and less prey for the hungry tigers. Only constant human vigilance against hunting and logging can maintain the tiger's domain. Failing that, it will join extinct cousins such as the Javan tiger, which disappeared in the 1970s, and the Caspian tiger, last seen in the remote Babatag mountains on the border between Afghanistan and Tajikistan in 1998.

For tigers, intact hunting grounds are vital. But some forests have always formed patchworks with other habitats, such as grasslands. And many have for thousands of years been moulded by human activity. Take, for example, the miombo and mopane woodlands – the dominant tree cover in southern Africa. Until recently, they provided refuges for wildlife in the African bush, forming a patchwork of woods amid savannah grasslands stretching from Angola east through Zimbabwe to Mozambique and Tanzania, where the Selous Game Reserve is one of Africa's largest protected areas. Their saviour was the tsetse fly that infests the woodland. The fly harbours a parasite that causes sleeping sickness in humans and kills cattle, deterring farmers and herders alike. It is often called the 'best game warden in Africa'. But though relatively thinly populated by humans, the miombo and mopane woodlands are far from pristine. Ecologists say that without fires set by humans for millennia they would have a closed canopy.

NEXT PAGE
**A PIECE OF THE PATCHWORK**
Miombo woodland in part of Niassa National Reserve, Mozambique's largest reserve. It connects with miombo woodland in Tanzania, forming part of the vast patchwork of savannah woodland that covers a huge swathe of southern Africa. Despite poaching, Niassa remains a refuge for a significant population of elephants, as well as African wild dogs and other endangered animals.

FORESTS

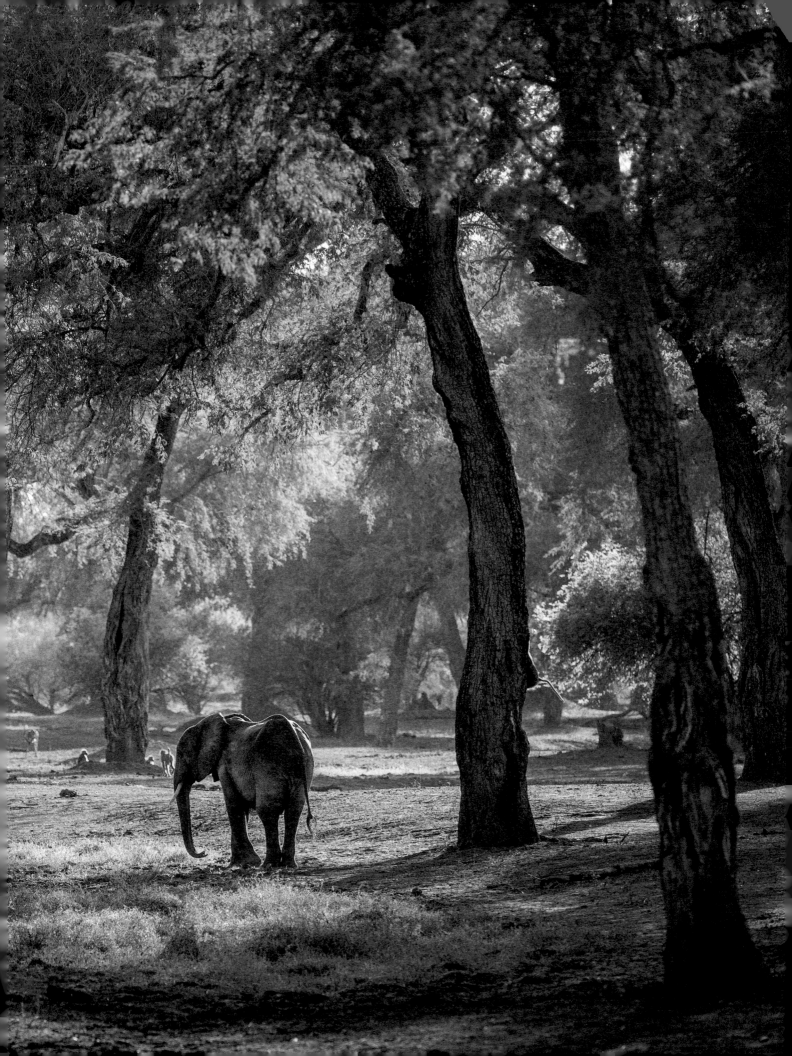

Today, the patchwork of miombo and mopane woodland supports the livelihoods of 100 million rural people spread over this vast area. The openness encourages animals in from the savannahs. Antelopes such as impala and sable find plenty of food, grazing heavily on grass shoots in the better-lit areas. They in turn provide a feast for packs of African wild dogs. Once numbering hundreds of thousands, the dogs are now an endangered species, and the woodlands are their most important refuges and hunting grounds.

Intriguingly, the forest is regenerated by animals that, at first sight, seem to be destroying it. Thousands of hungry elephants, among Africa's largest remaining populations, rip up bushes and trample trees in the miombo woodland to feed on their foliage, water-filled roots and nutrient-rich bark. Each spring, as fresh foliage spreads in the mopane woodlands, millions of mopane worms, the caterpillars of the emperor moth, strip the trees bare of leaves.

It can look like carnage. But actually these animals are nature's gardeners. Like forest fires, their destruction is transient and creates new habitat. Elephants create important dead-wood habitat and make space for new foliage, while the dietary habits of the mopane worms recycle nutrients from leaves onto the forest floor, where they fertilize the growth of new trees. Unless hemmed in by human barriers, the elephants move on, and the denuded trees simply respond with a second flush of foliage. And the crunchy caterpillars provide a much-valued food delicacy for humans, marketed as Zimbabwe's favourite snack.

These forests are dynamic and resilient, but they are not indestructible. Tsetse eradication is gaining ground. This and a fast-growing human population is resulting in encroachment by people and cattle. The erection of fences by farmers and the blocking of corridors force elephants into diminishing patches of forest, where they risk doing too much damage to trees.

We think today of the human exploitation of forests as a one-way process of destruction, in which once forests are gone they are lost for good. But history tells a more complicated story: of constantly advancing and retreating forest boundaries, and of humans often living in and using forests without destroying them.

**FOREST GARDENER**
An elephant in the woodland of Zimbabwe's Mana Pools National Park. It has moved from feeding on mopane woodland higher up the valley to browsing on winter thorn trees near the river. These produce seed pods and green vegetation in the dry season, when most other deciduous trees are bare. Though elephants may rip off branches and even push down trees, their damage is transient as they move through the woodland, and the trees resprout or younger trees fill the gap. The clearings the elephants produce give different vegetation a chance, and their nutrient-rich dung is not only a fertilizer and food source for other creatures but also helps disperse the trees' seeds.

THESE ANIMALS ARE NATURE'S GARDENERS. LIKE FOREST FIRES, THEIR DESTRUCTION IS TRANSIENT AND CREATES NEW HABITAT

FORESTS

## FEWER LOGS, MORE TREES

A recent global initiative charts a new course for the world's forests. The New York Declaration on Forests pledges an end to the loss of natural forests by 2030 and targets widespread restoration of forests. Many governments and companies have now signed up to support this.

**2020**
**NEW YORK DECLARATION**
Net loss of natural forest reduced to less than 45,000 km² a year

**2030**
**NEW YORK DECLARATION**
All loss of natural forest ended

**2020**
**NEW YORK DECLARATION**
1.5 million km² of forest under restoration

**2030**
**NEW YORK DECLARATION**
3.5 million km² of forest under restoration

OPPOSITE

### THE COMEBACK BEAR

A nervous brown bear peeks out from behind a tree in Slovenia. Its home is mixed deciduous and pine forest in mountains, which has survived logging and where bears have survived persecution. Today, more than half of Slovenia is forested, with a population of about 500 brown bears. Conservationists believe their spread to the Alps now depends on a significant reduction in the numbers killed by hunters and a trans-boundary nature-conservation area being established between Slovenia and Croatia.

For thousands of years, shifting cultivators have passed through most of the world's forests, clearing patches, planting crops and then moving on, allowing trees to return. Soils are often full of telltale pottery shards, rich in charcoal remains and pockmarked by earthworks from primitive urban settlements. Even forests that appear to be entirely natural are rarely pristine. Most contain natural regrowth from past clearances.

'There are no truly virgin forests,' says Kathy Willis, Science Director of the Royal Botanic Gardens, Kew in London. 'Forests can and do recover so completely that ecologists cannot spot the human element. After a few hundred years, they are completely indistinguishable.'

These are our forests in every sense – with mixed stands of trees of all ages, rich in wildlife but rich in human influence, too. That gives hope, surely, that even the calamitous deforestation of the twentieth century can be reversed – that deforestation need not be for ever. It won't be easy, but restoration of many of the world's lost forests may be possible.

We have plenty to work with. In the second decade of the twenty-first century, forests still cover almost a third of our planet's land. Many are fragmented, and some are bleak monocultures of fast-growing species such as eucalyptus and acacia, planted only so they can be cut down. But even so, 93 per cent of forests are still natural.

First we have to stop the rot. Here again there could be good news. The worldwide rate of forest loss may have started to slow.

## FOREST RESTORATION IS NOT JUST A RICH-WORLD FAD. MANY DEVELOPING COUNTRIES ARE SEEING THE BENEFITS OF BRINGING BACK FORESTS

The UN says that, since 2010, net loss has been about 65,000 square kilometres (25,000 square miles) a year. That is still an area almost the size of the Republic of Ireland, but it is only 60 per cent of the rate in the previous two decades. That chink of light at the end of the tunnel needs to become brighter quickly. Maybe it will.

Many governments and large agribusiness corporations – among them Unilever, the world's largest palm-oil purchaser, along with Nestlé, Kellogg's, McDonald's and Walmart – signed the 2014 New York Forest Declaration, pledging to cut the rate of natural-forest loss in half by 2020 and end deforestation by 2030.

But as well as ending deforestation, we need reforestation. In some parts of the world, forests are already in recovery – regenerating inside parks and reserves, advancing across abandoned farmland and regrowing where loggers have moved on. In New England, the magical sight of the fall trees changing colour, which attracts millions of tourists, is now far more extensive than it was a century ago. In central European countries such as Slovakia and Slovenia, nature is turning hundreds of former collective farms into impromptu forests.

The trick is to turn these renaissance islands into a global restoration. Again, promises have been made. The New York Declaration solicits pledges from non-governmental organisations and indigenous groups, as well as governments and corporations, to restore 1.5 million square kilometres (580,000 square miles) of deforested and degraded land by 2020 and 3.5 million square kilometres by 2030.

A good start would be to revive damaged forests. There are a surprising number of such places, left over from the rampaging of loggers, ranchers or farmers. Because forest soils are often poor, human invasions are frequently temporary. That gives nature its chance. The World Resources Institute puts the area of degraded-forest landscapes at about 20 million square kilometres (7.7 million square miles).

Compared to intact forest, such areas may sometimes look desolate, often dismissed as 'wasteland' ripe for development. But research shows that they can retain most of their former biodiversity. Species live on in small numbers ready to revive. If we stand back, nature will often reclaim its own. If these 'wastelands' are indeed ripe for restoration, then they should be the first target in the global campaign.

OPPOSITE
**LYNX ON A JOURNEY**
A male lynx patrols in his large woodland territory in Switzerland's Jura Mountains. Exterminated in most of Western Europe, Eurasian lynx were reintroduced into Switzerland from Eastern Europe in the 1970s, partly to control animals such as deer that were overgrazing the woodlands. There are ten separate populations of lynx in Europe, and some are doing particularly well. Some have also been translocated to Italy and Austria. Poaching is keeping these populations fragmented and absent from some regions where deer hunters see the lynx as a competitor. But overall, the European population (outside Russia and Belarus) is probably now 9,000–10,000.

NEXT PAGE
**THE BIG SEED DISPERSER**
Female great hornbills bill-grappling. They are fired up after witnessing rival males in aerial jousting displays over the forest in the Western Ghats, India. Males compete for territory and access to fruiting trees. If a male is successful in attracting a mate, the pair will choose a nest site in the trunk or a large branch of a big old tree. The great hornbill's survival depends on such old trees. And many forest trees depend on the fruit-eating hornbill to disperse their seeds. As a seed-disperser, the hornbill plays an important role in forest restoration.

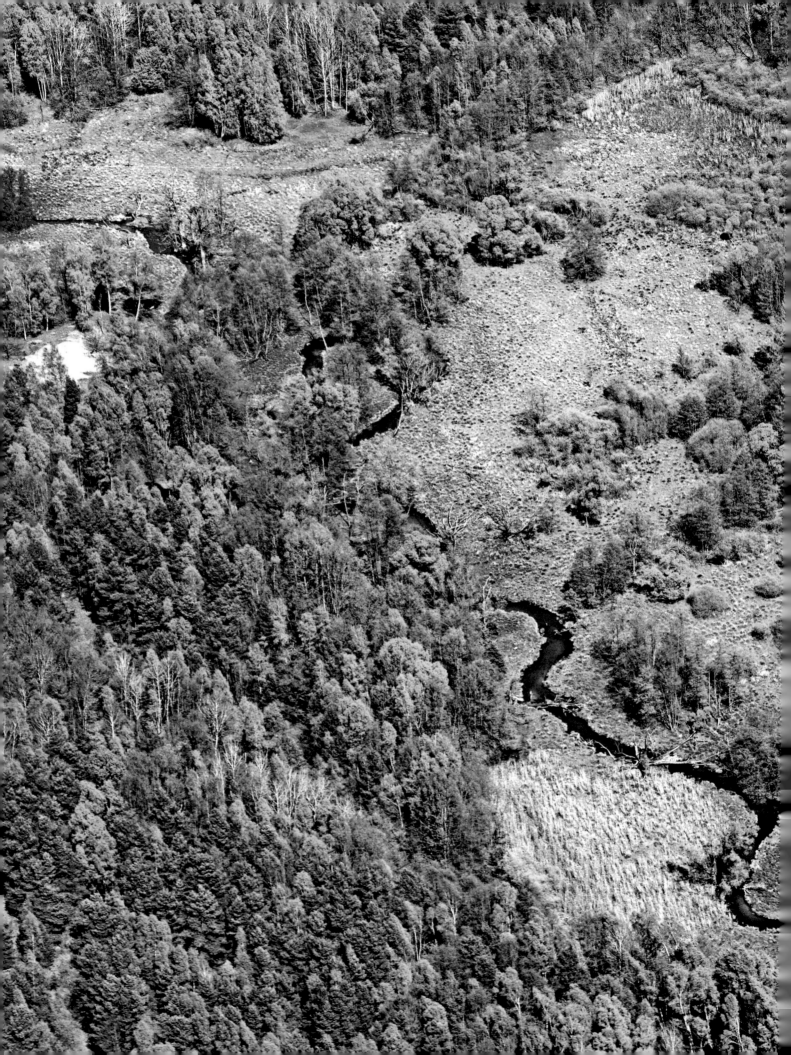

Next on the list should come places where the locals value their forests. Poverty may force rural people to destroy their forest surroundings to feed their families or earn an extra dollar. But forest-dwellers are more frequently good custodians. Usually it is outsiders who do the damage.

The World Resources Institute has found that community-run forests suffer less deforestation than state-run forests. And the people who know the forests best are likely also to be the most skilled and enthusiastic forest restorers.

'If you want to stop deforestation, give legal rights to communities,' says its chief, Andrew Steer.

Many people are already taking up the challenge to restore our planet's natural forests. In Scotland, local groups are replanting the ancient Scots-pine Caledonian Forest that once covered much of the highlands. In Germany, the government intends to return 5 per cent of its forests to a wild state by 2020.

The German model is the Königsbrücker Heath, north of Dresden. The formerly forested area was a military training ground until 1992. When the soldiers left, more than 7,000 hectares (17,300 acres) was put off-limits to humans to allow nature to regenerate. Since then, nature has begun to break up the barracks, concrete bunkers and parade grounds; birch, aspen and pine woodlands have colonized the heath; and at least one pack of wolves inhabits the area.

Forest restoration is not just a rich-world fad. Many developing countries are seeing the benefits of bringing back forests: for nature, for holding water to ensure year-round river flows, for reducing river flooding and soil erosion, for moderating local climates, for encouraging tourism and for much else.

The Central American state of Costa Rica is a shining example. Its forest cover declined from 75 per cent in 1940 to just 20 per cent by the late 1980s, mostly cleared for cattle ranches. Then the government began paying land users to protect surviving forests and plant new ones, partly to reduce floods and landslides and partly to encourage an ecotourism industry, now worth $2 billion a year. Forests once again cover more than half the country.

Many others are taking up the challenge. In Nepal, a system of community-managed forests has increased national forests by a fifth since the 1970s. On the Caribbean island of Puerto Rico, trees have

OPPOSITE

**WILDERNESS NO-GO RANGE**
Königsbrücker, a former German military training ground just north of Dresden, is now a reserve. After the fall of the Berlin Wall, it became a no-go zone for humans and a wilderness sanctuary for wildlife. Left alone, the huge area has transformed into a varied forest landscape, including wetlands, heath and dunes, with wildlife including beavers, deer and wolves.

FORESTS

OPPOSITE

**WOLVES, BACK FROM THE EAST**
Young wolf cubs playing on semi-wooded heathland southwest of Berlin. Wolves were exterminated in Germany in the nineteenth century, but in the past two decades, protection has allowed them to recolonize as they cross the border from Poland. Today Germany has at least 60 packs. All are strictly protected by law.

reinvaded abandoned farmland so well that forest cover has risen from just 6 per cent in 1960 to 60 per cent today. It is 'the largest forest recovery anywhere in the world during the second half of the twentieth century', says Thomas Rudel of Rutgers University, despite the ravages of recent hurricanes. Wildlife is taking full advantage. After dusk, the new forests once again resound to the mating calls of the male coquí frog, a national symbol.

Reforesting should bring back bigger animals, too. Kazakhstan, in central Asia, is restoring forests along the southern shores of the 600-kilometre-long (372-mile) Lake Balkhash, so it can reintroduce the tiger to its ancient hunting grounds, 70 years after poachers killed the last. The new forest reserve will first be stocked with native Bactrian deer, wild boar, endangered wild asses and other tiger prey. But sadly the Kazakhs won't be able to reintroduce the original Caspian tiger. It has been extinct for 30 years, and there are none in zoos. They will make do with its nearest cousin, the Siberian tiger.

The Kazakh tiger project is part of a plan to double wild tiger numbers worldwide. Mostly this will involve organized reintroductions. But other cats are returning home with not quite so much assistance.

The Eurasian lynx, for instance, is once again padding through the forests of Western Europe, stalking its favourite roe deer. Bans on hunting have allowed it to quadruple numbers to 9,000–10,000. Joining lynx as nature rewilds the planet's most densely populated continent are growing numbers of jackals, brown bears, wolverines, beavers and Alpine ibex. Even wolves can be heard howling.

Except perhaps for the tiger, nothing epitomizes the wild so much as the wolf. As American author Jack London famously put it, they are 'the call of the wild'. Packs of grey wolves once hunted across Europe. Legends are full of their alleged bad deeds, terrorizing communities and eating their livestock. As the wild forests were tamed, wolves slunk east to forest refuges in Russia. Britain's last wolf was shot more than 300 years ago.

But wolves are now returning from the east, crossing through Germany and France to Italy and Spain. An estimated 12,000 now inhabit the forests, travel down railway tracks, saunter through abandoned farmland and hunt and forage by night in the suburbs

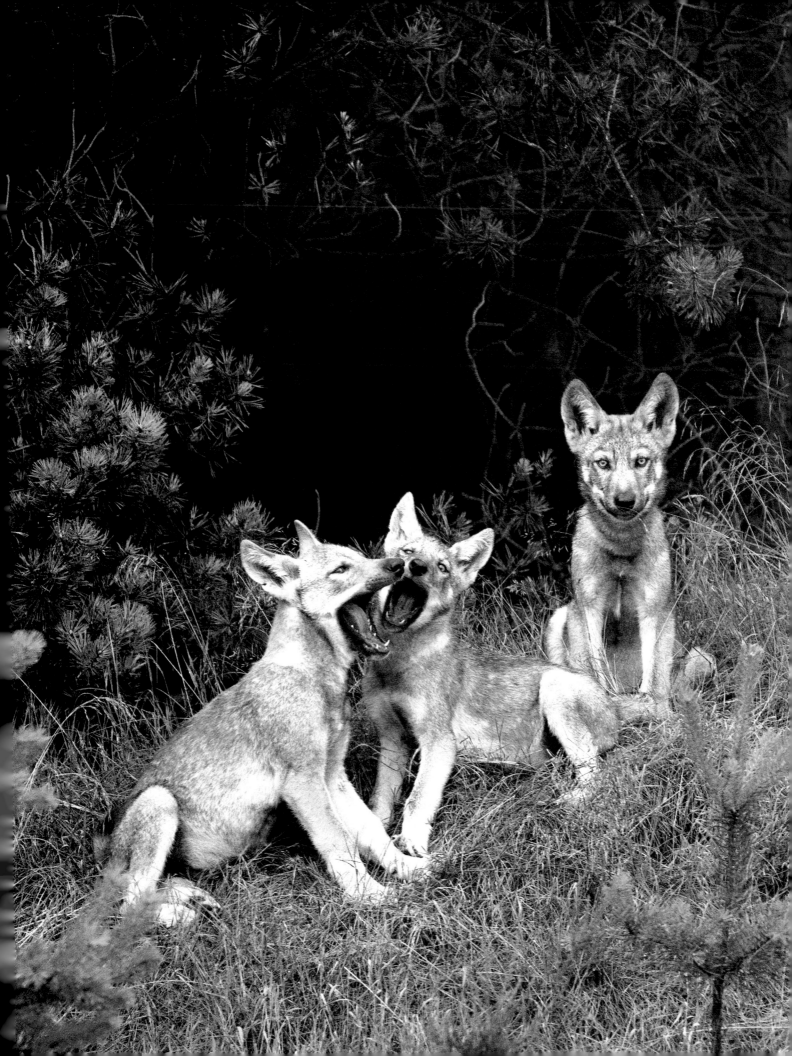

# IF IT CAN HAPPEN HERE, IT CAN HAPPEN ANYWHERE, PROVIDED WE LET IT

of big towns. Like foxes, they are slowly becoming part of human landscapes – anywhere where their main prey of deer exists. Attacks on humans by wolves are extremely rare. Forest species can, it seems, sometimes survive even without forests.

Wolves are central to Europe's biggest and strangest forest recovery. It is taking place in the radioactive exclusion zone enforced around the Chernobyl nuclear power station after it blew up in 1986, scattering radiation across the land. The zone is twice the size of Luxembourg and straddles the border between Ukraine and Belarus. It will probably remain too dangerous for permanent human occupation for many centuries. But the evacuation of about 100,000 people has given nature a chance.

Forests are colonizing the former atomic city of Pripyat, which is now the largest ghost town in the world, as well as hundreds of villages and thousands of farmsteads. Forests now cover almost two thirds of the exclusion zone. Under the cover of birch, oak, maple and pine, wildlife is returning big time.

Human visitors expecting to find a radioactive wasteland or animals glowing in the dark have a surprise in store. Instead, strutting round forests laced with isotopes of strontium, plutonium, americium and caesium are extremely healthy-looking lynx, grey wolves, Przewalski's horses, moose, deer, wild boar, foxes, hares and even a brown bear or two. Eagles soar in the air looking for prey. Animals are in greater profusion than in national parks and nature reserves in the two countries. They may be radioactive, but they are having a ball. Marina Shkvyria, a wolf expert at the Institute of Zoology in Kiev, calls the exclusion zone 'a window into the past of Europe, when bears and wolves were the bosses here'.

Nobody can be sure there isn't a downside to this radioactive renaissance. Subtle genetic changes caused by the radiation may escalate in future generations of animals, perhaps with big ecological impacts. But today, nature mostly thrives. In just 30 years, a farming landscape has been transformed into Europe's largest rewilding zone, a living laboratory of forest resilience in one of the most polluted places in the world. If it can happen here, it can happen anywhere, provided we let it.

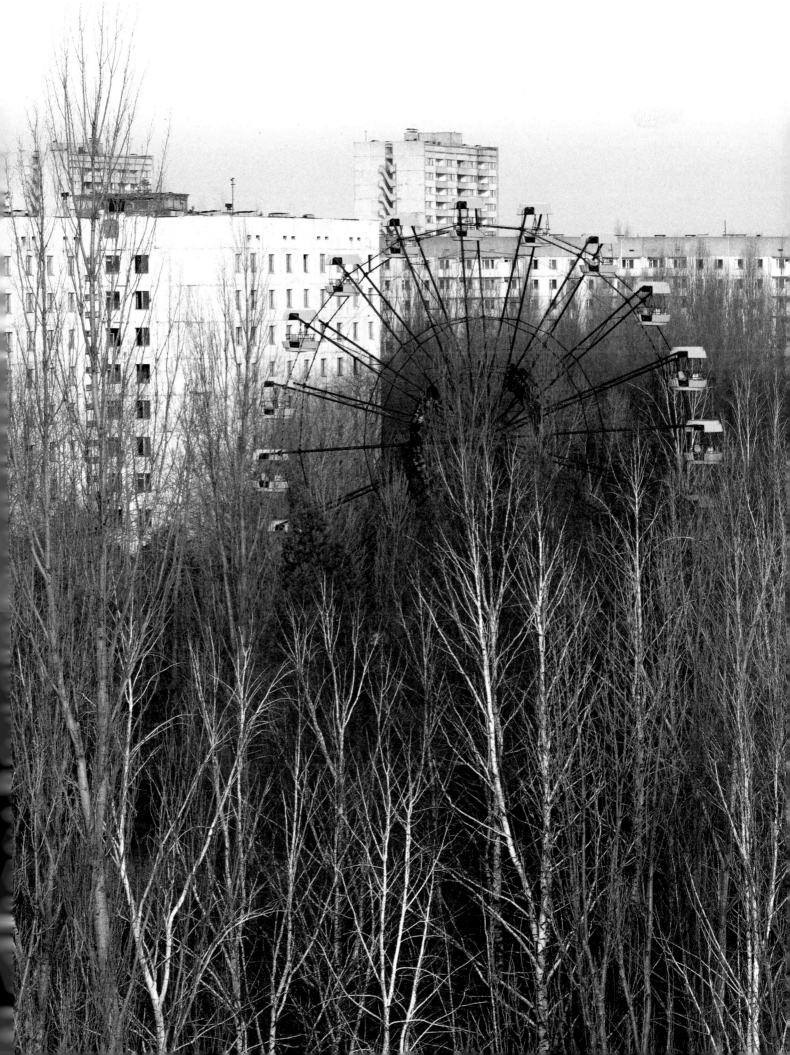

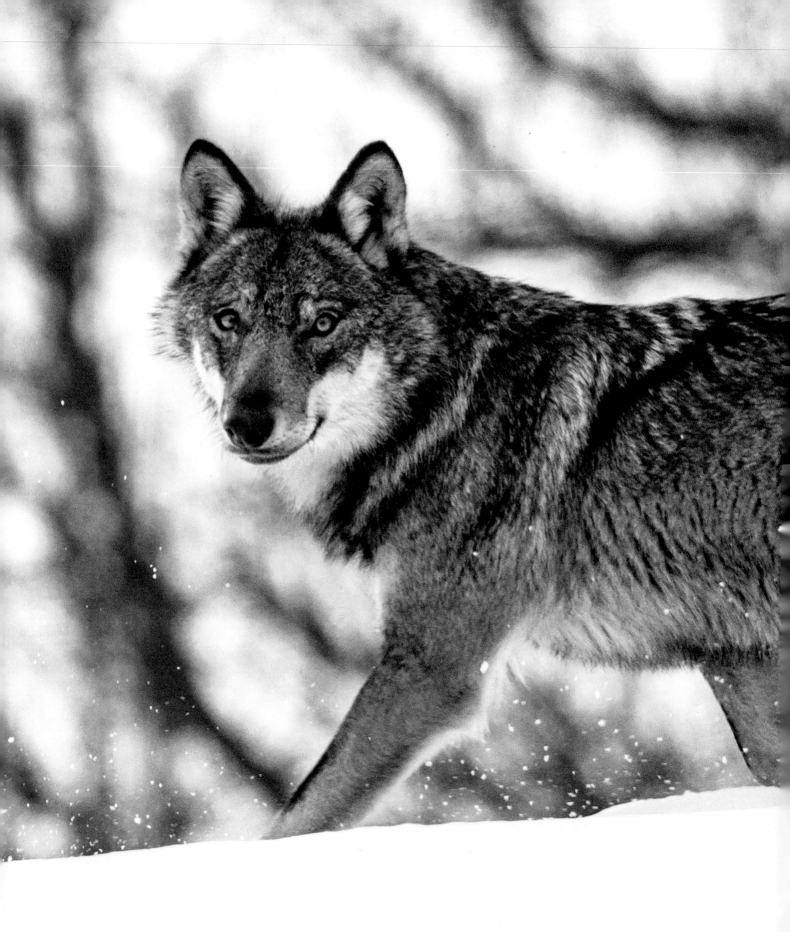

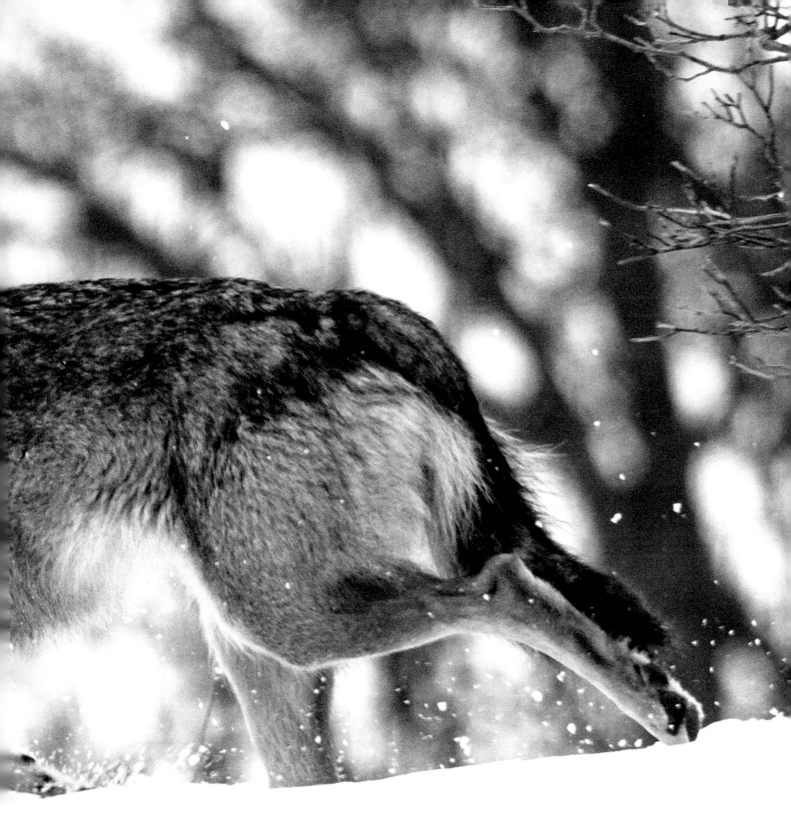

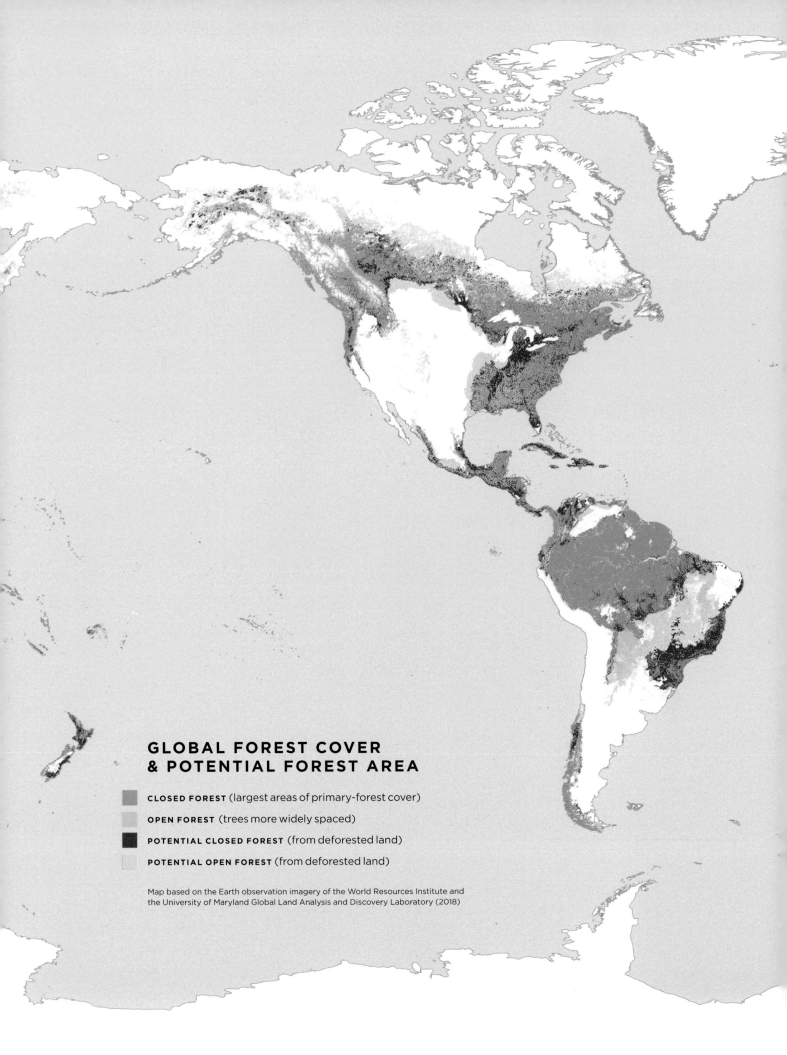

# GLOBAL FOREST COVER
# & POTENTIAL FOREST AREA

**CLOSED FOREST** (largest areas of primary-forest cover)

**OPEN FOREST** (trees more widely spaced)

**POTENTIAL CLOSED FOREST** (from deforested land)

**POTENTIAL OPEN FOREST** (from deforested land)

Map based on the Earth observation imagery of the World Resources Institute and
the University of Maryland Global Land Analysis and Discovery Laboratory (2018)

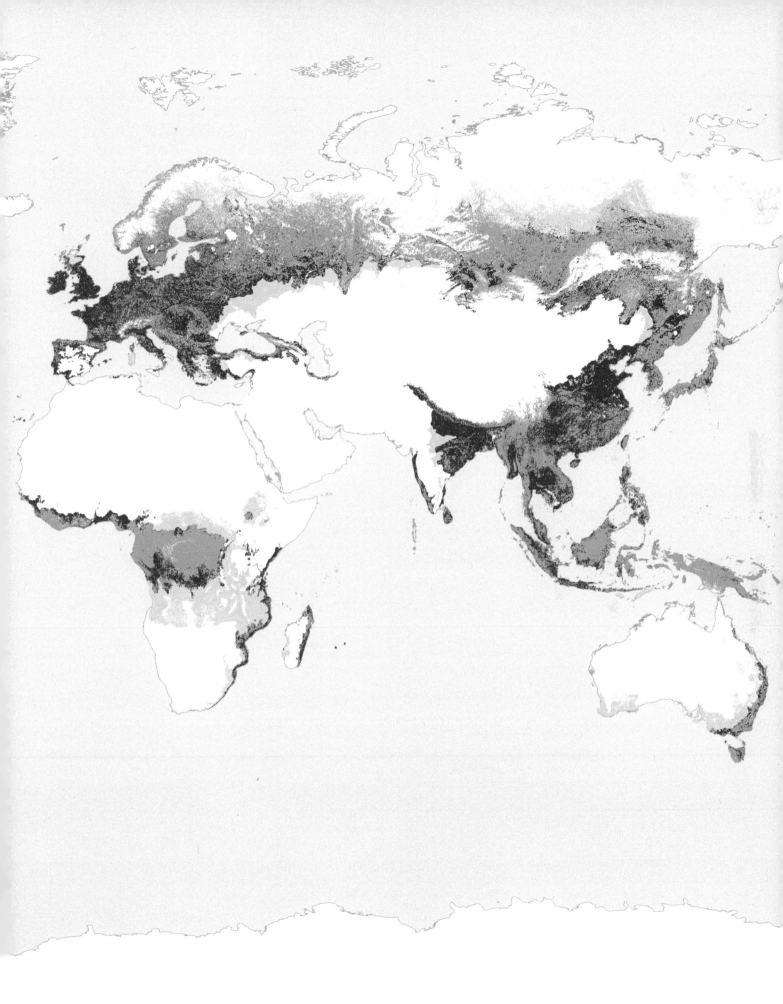

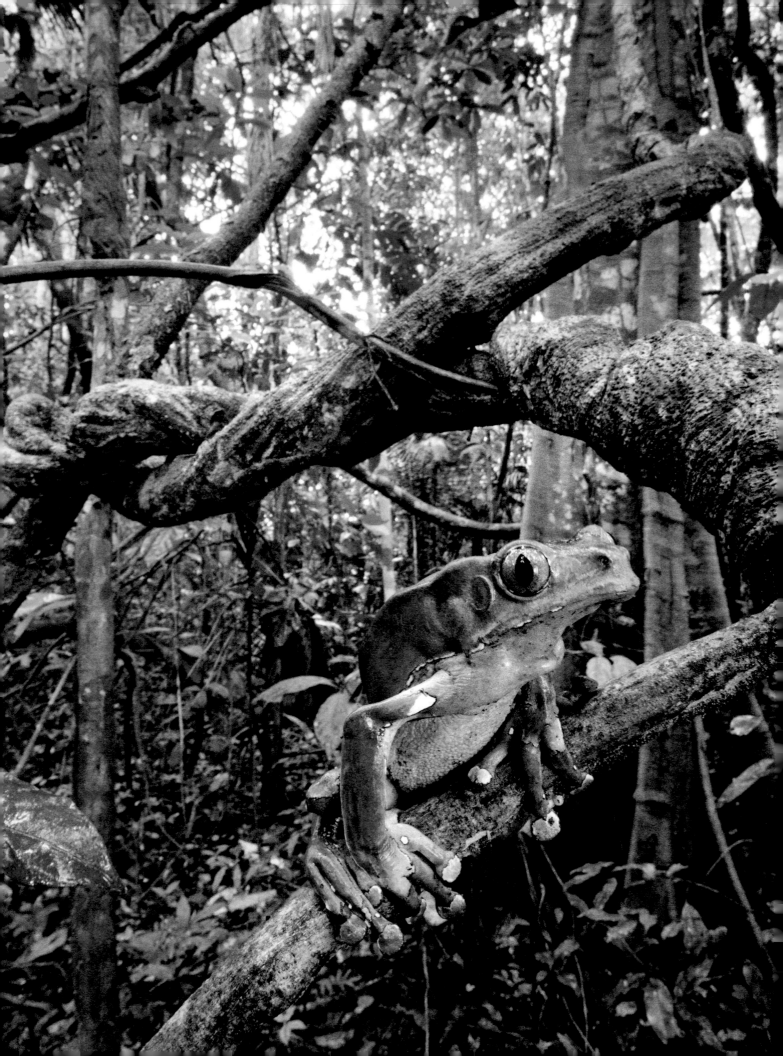

# JUNGLES

'The health of our planet depends on the rainforests, and the greatest is the Amazon. Its ecosystems harbour 10–15 per cent of the planet's land biodiversity. It contains 20 per cent of its flowing fresh water. And like a giant sponge, it absorbs and stores more than 120 billion tons of carbon. Its billions of trees recycle water back into the atmosphere contributing to abundant rainfall. But until now, Amazon development has meant replacing forest with agriculture, cattle ranching, mining and large-scale hydropower generation. That's an outdated model, for environmental, economic and social reasons. The new model has to be based not on getting rid of biodiversity but on benefiting from it, using scientific and traditional knowledge to create a standing-forest, flowing-rivers bio-economy.'

**PROFESSOR CARLOS NOBRE**
Leading Brazilian environmental scientist, senior researcher with the University of São Paulo's
Institute of Advanced Studies and senior fellow of the World Resources Institute Brazil

# TROPICAL RAINFORESTS ARE DISTINGUISHED BY THEIR CONSTANT WARMTH AND NEAR-PERMANENT RAINS. THEY HAVE NO SEASONS – NO DISRUPTIVE PATTERNS SUCH AS DRY-SEASON FIRES OR WINTER FREEZING

The Pan-American Highway is a marvel of engineering. It stretches from Alaska, down through Canada, the US, Mexico and the length of the Andes to Tierra del Fuego at the tip of South America. Or almost. For there is a gap of 100–150 kilometres (60–95 miles) at the narrowest part of the Central American isthmus on the border between Panama and Colombia. This is the Darién Gap. The road gives way to rainforest, stretching from the Pacific to the Atlantic. So far, environmentalists have successfully campaigned to give the forest right of way.

Some call the Choco-Darién rainforest here the most precious jungle of them all. It has many of the species found in the Amazon on the other side of the Andes – including headline-grabbers such as jaguars, tapirs, spider monkeys, tamarins and huge electric fish – but with a twist. Cut off from the Amazon for millions of years, many species have developed new forms. These include at least 120 amphibian species and more than 6,000 plants found nowhere else, including orchids in profusion.

Until recently, the only human inhabitants of this swamp forest, which has some of the highest rainfall on Earth, have been the indigenous Emberá people, who live in houses on stilts and travel by boat. But an incomplete road extending right up to the swamp's edge has brought farmers, ranchers and drug smugglers moving their goods north. The forest has become a front line in the war to protect the world's rainforests. Far from being a gap, say environmentalists, the Darién is a bastion against mankind's advances on nature. Could its survival be a turning point for rainforest conservation? The spot where the trucks have to turn back – where humanity chooses to turn back?

We often see jungles as scary impenetrable places, governed by the 'law of the jungle', to be pillaged and chopped down. Tropical rainforests, on the other hand, are inviting, full of beautiful creatures vital to the planet. Same places, of course, but different branding. The successful renaming of the jungles as rainforests shows how far the western world has changed its view of its wild places. In the Anthropocene, they are places we want to save. Nothing matters more to the 'great ecological restoration' than to turn back the tide of rainforest destruction. We have reimagined the jungles, now we must remake them.

OPPOSITE

**JUNGLE ICONS**
Red-and-green macaws mining beakfulls of sodium-rich soil at an exposed river bank in Peru's Manú National Park. Many birds, as well as mammals such as primates and bats, visit such sites to supplement their diets with this essential mineral which is in short supply in the western Amazon.

PREVIOUS PAGE

**JUNGLE ARCHITECTURE**
A streamside area of rainforest in Tawau Hills National Park, Sabah, on the island of Borneo. A strangler fig has enmeshed the buttress of a dipterocarp tree more than 80 metres (260 feet) tall. Borneo has the world's tallest rainforest trees – with the tallest being in this park. Borneo's forests are also the oldest in the world, at more than 130 million years.

OPENING PAGE

**JUNGLE GIANT**
A giant monkey frog, 22 centimetres (9 inches) long, in Suriname's rainforest. It builds a leaf nest over water and is usually found up a tree, calling from a branch.

# ANOTHER REASON FOR THEIR EXTRAORDINARY BIODIVERSITY IS THE RANGE OF DIFFERENT HABITATS, EACH WITH ITS OWN COMMUNITY OF CREATURES. RAINFORESTS ARE HIGH-RISE HIGH-DENSITY ECOSYSTEMS

OPPOSITE
**CANOPY CAT**
A male Bornean clouded leopard, caught by a camera trap, patrolling his territory in rainforest in Sabah, part of Malaysian Borneo. Though not a true leopard, it is the island's biggest predator. It hunts mainly on the forest floor but also climbs into the canopy to prey on monkeys and slow lorises. Along with the rarer Sunda clouded leopard of neighbouring Sumatra, it has the largest gape and longest upper canines of any living predator.

NEXT PAGE
**CANOPY EAGLE**
A Philippine eagle on the island of Mindanao in the Philippines, breast feathers fluffed out as she warms up on an early-morning perch. Her raised head feathers reveal that she is alert, possibly scanning for flying lemurs or even monkeys in the mountain rainforest. The world's second-largest forest eagle is also the world's most endangered eagle, mainly because of forest loss.

Tropical rainforests are distinguished by their constant warmth and near-permanent rains. They have no seasons – no disruptive patterns such as dry-season fires or winter freezing – no part of the year when nature is dormant. So the constant cycles of growth, procreation, death, decomposition and rebirth are in overdrive all year round. Many believe this is the key to their extraordinary biodiversity – the reason why rainforests are the most complex ecosystems on Earth.

Another reason is the extraordinary range of different habitats, each with its own community of creatures. Rainforests are high-rise high-density ecosystems – stretching from the forest floor, where animals scurry and insects consume and recycle foliage, to the canopy a hundred feet or more above.

Virtually nothing was known about rainforest canopies until the 1980s, when scientists stopped trying to reach them by climbing and began instead to descend onto them, suspended from balloons. What they found was a revelation. Much of the rainforest action takes place on its sun-drenched ceiling rather than its shaded floor. At least a tenth of all plants live up there, rooted in moss growing on tree branches. Earthworms live and die in these giant window boxes. Beetles, sloths, snakes, monkeys and many others also spend their lives in the branches. Feeding on them are top predators such as the clouded leopards of Borneo and Sumatra.

Almost half of the planet's 3 trillion trees are in the tropics, and most of them are in rainforests. For much of history, they have seemed so vast that humans could only ever do marginal damage. But they are now far too penetrable, and in the past half century, a human invasion has engulfed many of them. Central America, West Africa and the countries of mainland Southeast Asia have lost the most. In West Africa, some 90 per cent of the rainforest is gone. Of the 11 forested areas around the world that WWF considers most threatened, 7 are tropical rainforests.

But despite the carnage – caused by chainsaws, fires and axes – huge tracts remain. Most are in three areas. The largest is still the Amazon rainforest, an area ten times the size of France and extending from Brazil into surrounding Bolivia, Peru, Ecuador, Colombia, Venezuela, French Guiana, Guyana and Suriname.

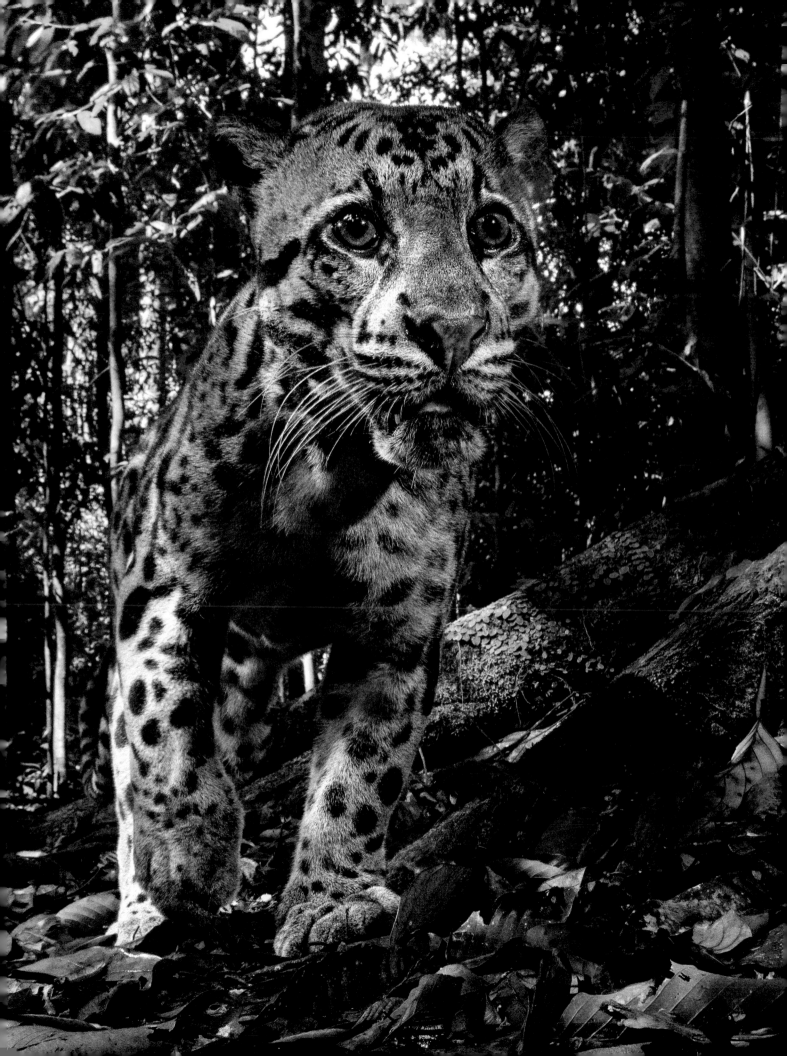

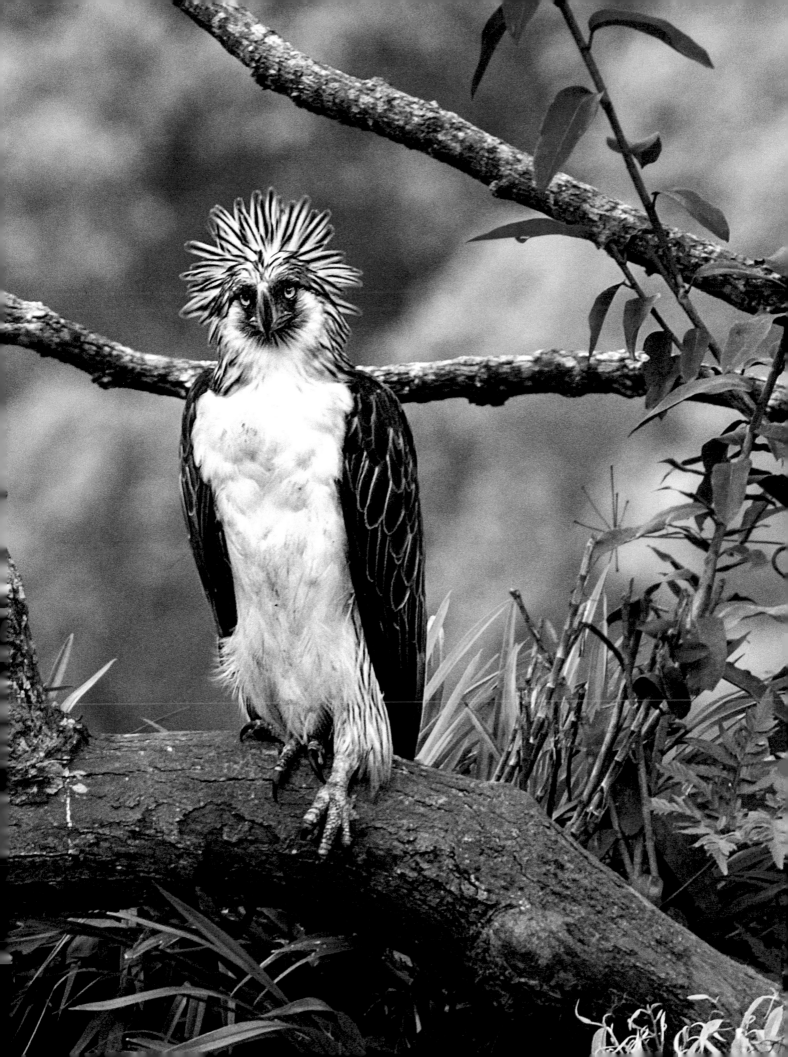

# AFTER THE AMAZON, THE CONGO BASIN IN CENTRAL AFRICA HOLDS THE LARGEST AREA OF TROPICAL RAINFOREST IN THE WORLD – A FIFTH OF THE WORLD'S TROPICAL FORESTS – AND MOST OF AFRICA'S SPECIES

OPPOSITE

**FOREST GARDENER**

A 'silverback' western lowland gorilla, leader of his group, in the rainforest of the Republic of Congo's Odzala National Park. Western lowland gorillas play a vital role in regeneration of forest trees. The seeds from the fruit they eat are spread in dung that falls from their night nests. The gorillas tend to build these nests in areas where the canopy is more open, and sunlight flooding onto the forest floor helps the seedlings germinate. Though protected in areas such as Odzala, western lowland gorillas remain critically endangered in equatorial Africa, because of disease (including Ebola), poaching and forest loss.

NEXT PAGE

**FOREST DIGGERS**

Family groups of forest elephants mining for mineral salts in the Central African Republic's Dzanga-Ndoki National Park. Elephant activity maintains forest clearings as well as creating networks of paths throughout the forest. Forest elephants are smaller than savannah elephants and their ivory is harder and even more sought after. In the past 15 years, more than 60 per cent of forest elephants have been killed for their ivory and meat.

In the final decades of the twentieth century, the Amazon's rampant deforestation became synonymous with nature's destruction. But thankfully, while losses continue, they are much slower than at their peak 15 years ago. Some 80 per cent of the forest remains. It is home to a tenth of all the known world species – with a new one found on average every two days. It stores in its trees and soils more than 100 billion tonnes of carbon that would otherwise be adding to global warming.

After the Amazon, the Congo basin in central Africa holds the largest area of tropical rainforest in the world – a fifth of the world's tropical forests – and most of Africa's species. But the extent was not always as it is now. Over past eons, there have been repeated oscillations between wet and dry climates, pushing both plants and animals back and forth across the frontiers between rainforest and grassland. Indeed, until the ebbing of the last ice age, beginning about 18,000 years ago, a large part of the Congo basin was covered by savannah. As the climate warmed and became wetter, the forest returned. In places it is still advancing, where humans allow. This comparatively new jungle still contains many open areas that are probably remnants of the old grasslands. Such a mixture of habitats may be one reason why the Congo has more big mammals than any other forest: elephants, buffaloes, antelopes, hyenas, gorillas, chimpanzees, bonobos and more.

Forest elephants – considered to be a distinct species that evolved in the forest – are critical to its fecundity, and their declining numbers through ivory poaching pose a threat to the ability of the forest to regenerate. For one thing, they eat the fruits of the trees, dispersing the seeds in their dung, from where they are buried by dung beetles, ready for germination. They are also vital to the maintenance of the forest clearings, known locally as bais, which are the Congolese equivalent of the clay licks of the Amazon. These forest clearings contain minerals essential to the health of many animals, and elephant digging keeps them open and gives other species access to the minerals.

For now, despite continuing poaching and prevalent illegal logging, the Congo basin in central Africa is the least disturbed. The crucible of rainforest destruction today is Southeast Asia.

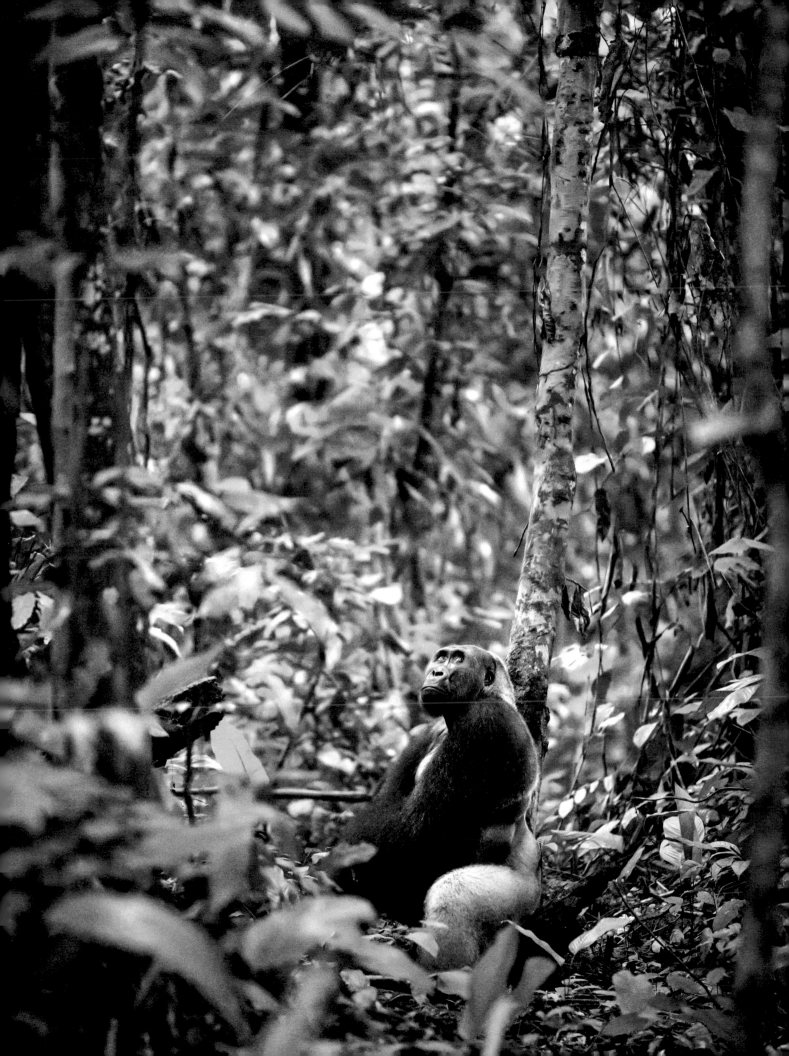

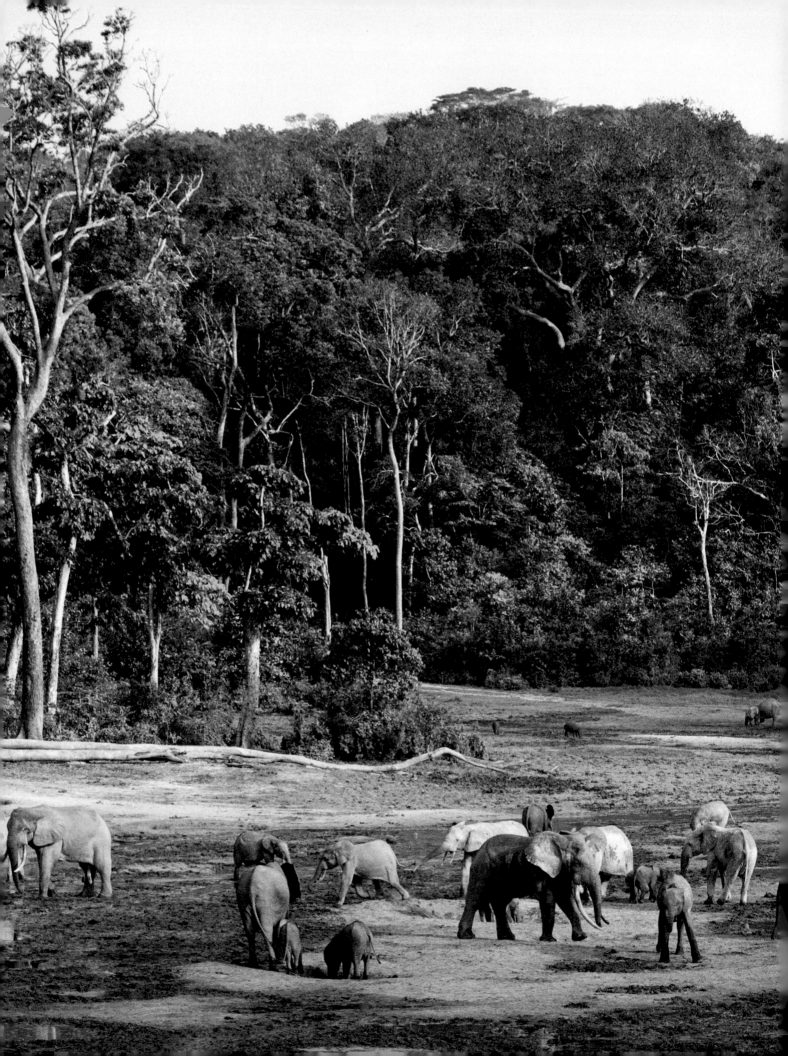

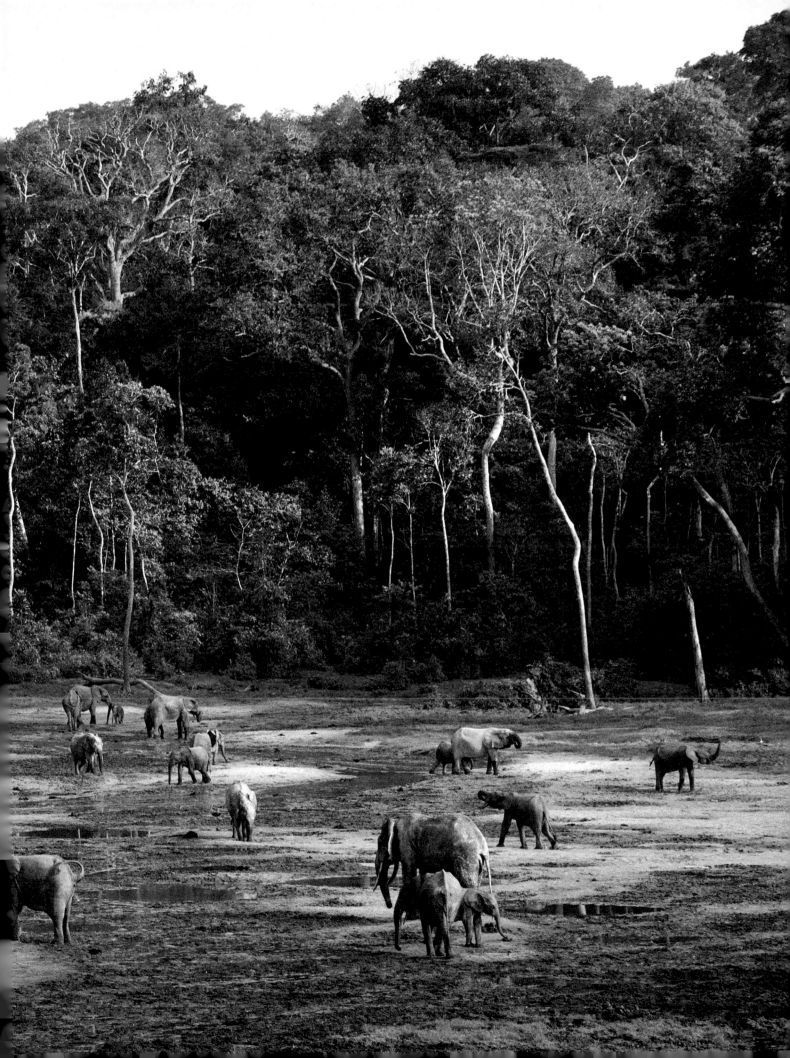

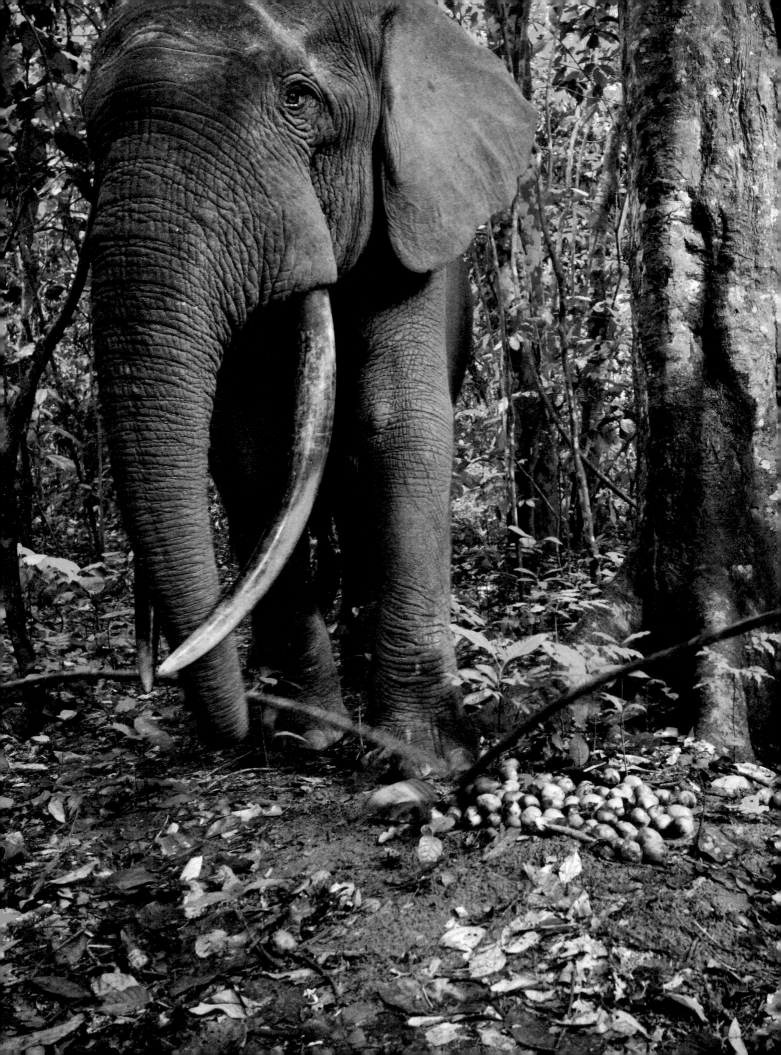

# REAL JUNGLES ARE WORLDS OF THE MOST EXQUISITE COOPERATION BETWEEN SPECIES THAT IN MANY CASES HAVE EVOLVED TOGETHER TO MEET EACH OTHER'S NEEDS

Sumatra, Borneo and New Guinea – respectively the world's sixth, third and second largest islands – were until recently almost entirely covered in jungle. But now these island forests are on a roller-coaster ride to oblivion, cleared and burned to feed global industries that demand huge areas of cheap land to produce paper for our printers and palm oil, the world's most widely used agricultural commodity. The three islands produce around half of the world's supply of palm oil, which is found in about half of all packaged products sold in supermarkets, from cosmetics and detergents to chocolates and cookies.

To see landscapes rich in nature's beneficence, a result of millions of years of evolution, turned into matchwood and pulp, and regrown with monocultures to supply vegetable oil is to witness an epochal tragedy. So, before discussing what we can put back, we need to understand what we have lost.

Ecologically speaking, what is the 'law of the jungle'? Some think of it as brutal combat, where winner takes all. They are wrong. Real jungles are worlds of the most exquisite cooperation between species that in many cases have evolved together to meet each other's needs. Even the biggest inhabitants depend on such symbiotic relationships.

Take the ties that bind the giant Brazil-nut tree and a large cavy-like rodent, the agouti. The Brazil-nut tree is the king of the Amazon. Growing to 50 metres (about 165 feet) high, it soars above the main forest canopy and lives for hundreds of years. Many of the trees standing today were towering over the jungle long before the Spanish conquistadors made it to the Amazon in search of Eldorado.

The tree reproduces by dropping grapefruit-sized seed pods onto the forest floor. Inside each pod are about 20 seeds. But the pods are extremely hard, and only one jungle animal has evolved with teeth sharp enough to liberate the seeds – the agouti. It chisels into the pods and hoards the seeds, burying them in caches. The seeds it doesn't eat later germinate. Brazil-nut trees are found only where there are agoutis.

But the tree needs another partner if it is to survive. Its flowers have to be pollinated. The most effective pollinators are large-bodied orchid bees, which alone are strong enough to lift the lids of the large flowers and get to the nectar inside. The presence of orchid bees in the forest in turn depends on the presence of particular species of forest orchids,

# SPECIES IN THE JUNGLE HAVE EVOLVED IN TIGHT SYMBIOTIC AND PARASITIC RELATIONSHIPS. IT IS A WAY OF LIVING THAT HAS HELPED DELIVER UNPRECEDENTED BIOLOGICAL DIVERSITY. THOUGH JUNGLES OCCUPY ONLY 7 PER CENT OF THE PLANET'S LAND SURFACE, THEY ARE HOME TO HALF ITS TERRESTRIAL SPECIES

**OPPOSITE**

**HOT-SPOT FROGS**

A variety of rainforest frogs from Peru's Manú National Park – the park with more species of frogs than anywhere else in the world. Each has its own habitat needs, and some are found only in one small area of rainforest.

CLOCKWISE FROM TOP LEFT
Tiger-striped leaf frog *Phyllomedusa tomopterna*. Red-skirted tree frog *Dendropsophus rhodopeplus*. Mimic poison frog *Ranitomeya imitator* (spotted morph). Mimic poison frog (Varadero morph). The newly discovered species *Ameerega shihuemoy* carrying tadpoles. Three-striped arrow-poison frog *Ameerega trivittata*. Fantastic poison frog *Ranitomeya fantastica* (striped morph). Mimic poison frog *R. imitator* (banded morph).

which offer a perfume that male orchid bees collect to use to attract their females. So no orchids means no orchid bees and no Brazil-nut trees.

A more disturbing example of complex interdependence among rainforest species is the life-and-death struggle of leaf-cutter ants. These ants are the Amazon's most important harvesters of vegetation, removing and recycling forest waste on a vast scale. They form huge armies that march across the forest floor slicing up leaves to take back to their giant colonies, which can be as big as shipping containers. The leaves serve as food for the fungi that they farm inside their colonies. The ants then get their nutrition from the fungi.

The ants appear to be in charge of this symbiotic arrangement. But life on the forest floor is rarely so simple. Another group of fungi have their own agenda. *Ophiocordyceps* fungi invade ants' bodies – though most commonly, carpenter ants – and take control of their nervous systems, turning them into zombies. They are programmed to climb up into vegetation, where they die. The fungi then burst out of the corpses and release reproductive spores into the forest air. The spores fall onto ants below, starting the process over again. This seems to have been going on for millions of years. You couldn't make it up. But nature did.

For all their strange habits, fungi are vital to rainforests, turning fallen leaves into nutrients for the trees. They do this both by decomposing the leaves and by living attached to tree roots, where they directly supply nutrients to the trees in return for receiving sugars from the trees for their own sustenance.

Rainforest species go to extraordinary lengths to sustain and reproduce themselves. Strangler figs, which are found in almost all rainforests, are veritable vegetable monsters. Their seeds germinate in moss in the forest canopy. Then, as the fig grows, it sends roots down the trunk of its host tree. The roots eventually reach the forest floor, where they compete with its host for soil nutrients. Now in overdrive, a strangler fig's trunk-encircling network of roots grows and slowly strangles its host tree. Even giant Brazil-nut trees will eventually succumb to the deadly embrace. In their turn, these jungle assassins

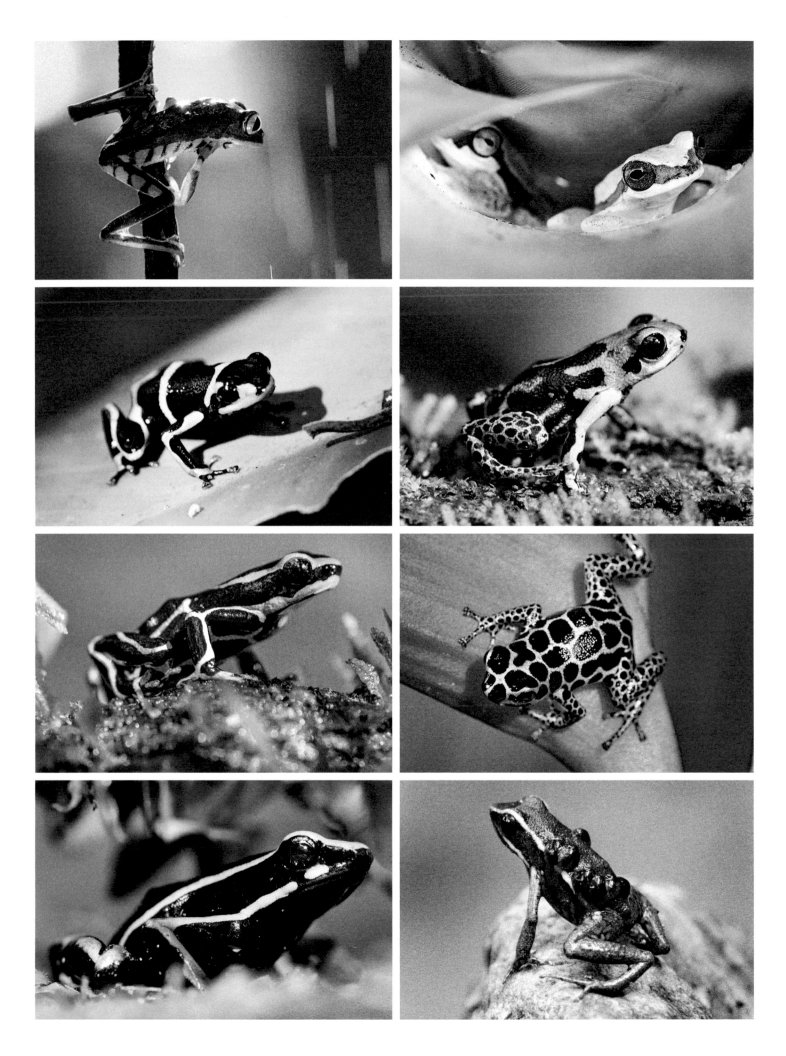

depend for their survival on tiny wasps that pollinate flowers growing inside the fig's fruits. To ensure the wasps perform this task, strangler figs emit a scent that can attract wasps from many kilometres away. Without them, even this titan of the jungle could not prosper.

Such stories show how species in the jungle have evolved in tight symbiotic and parasitic relationships. It is a way of living that has helped deliver unprecedented biological diversity. Though jungles occupy only 7 per cent of the planet's land surface, they are home to half its terrestrial species. One researcher found 18,000 species of beetles in a patch of Panamanian jungle the size of a soccer pitch. A piece of Amazonian rainforest the size of 25 soccer pitches contains 1,440 tree species – more than in all the northern hemisphere boreal and temperate forests.

A third of the world's 9,000 bird species live in the Amazon, and more than a tenth of them are in Peru's Manú National Park, the most astonishingly diverse part of this most astonishingly diverse rainforest. Manú is also a nirvana for amphibians, with more kinds of frogs than anywhere else. The diversity of Manú's mammals can be seen at its

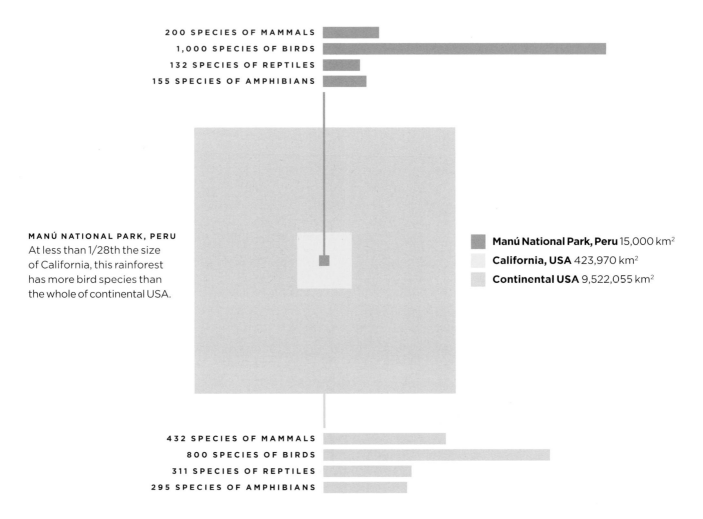

200 SPECIES OF MAMMALS
1,000 SPECIES OF BIRDS
132 SPECIES OF REPTILES
155 SPECIES OF AMPHIBIANS

**MANÚ NATIONAL PARK, PERU**
At less than 1/28th the size of California, this rainforest has more bird species than the whole of continental USA.

**Manú National Park, Peru** 15,000 km²
**California, USA** 423,970 km²
**Continental USA** 9,522,055 km²

432 SPECIES OF MAMMALS
800 SPECIES OF BIRDS
311 SPECIES OF REPTILES
295 SPECIES OF AMPHIBIANS

many clay licks – clearings containing exposed soil. Spider monkeys, peccaries, giant anteaters and many other mammals, as well as parrots, visit these mineral oases at all hours of the day and night to eat or lick the clay and extract salts that are in short supply in their forest diets.

Nobody quite knows why there is such a riot of biodiversity in almost all jungles. Theories abound. Maybe it is the high-energy input from the tropical sun, or their antiquity, or the unchanging seasons that allow many similar species to thrive by avoiding the extreme competition found outside the tropics, where reproduction is restricted to a few months.

Another great unanswered question is whether all this diversity and interdependence of species is a source of strength or weakness for the rainforest as a whole. Does it mean that if we take one piece away, the ecological house of cards might collapse? Or does it give the system more resilience, more options for keeping going if it comes under attack from loggers or climate change, farmers or fire?

Recent research backs the resilience theory, says Emmett Duffy of the Smithsonian Environmental Research Center. With so many species, 'it is more likely that some combination best suited to an area's conditions will flourish.'

ABOVE
**EARTH-MAKERS**
One of a multitude of rainforest fungi species in Cameroon, made visible here by its spore-producing fruiting bodies. Its main body mass is in the leaf-litter below, where it is feeding by decomposing organic matter, helping to form the soil that nourishes the forest. Some fungi are essential for seed germination and tree growth, connecting with a tree's roots to provide minerals and nutrients. A rainforest could not exist without fungi.

NEXT PAGE
**DOWN-TO-EARTH MONKEYS**
Black spider monkeys eating salt exposed in a bank on the outskirts of Peru's Manú National Park. Such 'clay licks' attract mammals as well as birds, which in turn attract predators. So the canopy-living monkeys are on high alert.

## CLOUD FORESTS – UNINHABITED AND MYSTERIOUS

The forest-covered Sacha Llanganates mountains in eastern Ecuador are permanently shrouded in fog. Uninhabited and mysterious, most have never been mapped from the ground. Yet hidden beneath the mountains' forest canopy is an eldorado of undiscovered species of mosses, orchids and other plants.

'Each ridge has its own microclimate in the clouds and its own species of orchids,' says American orchid-hunter Lou Jost, who has spent many years as a lone explorer of the misty mountains. Most orchids grow on the branches of trees, he says. 'Each species seems to specialize in a particular combination of rain, mist, wind and temperature.'

The forests of the Ecuadorian Andes are typical of one of the planet's least-explored ecosystem types: cloud forests.

These patches of moisture-drenched forest wrap around mountaintops in the Andes, Central America, Indonesia, the Himalayas and an area of Central Africa known as the Mountains of the Moon. They cover probably fewer than 400,000 square kilometres (154,440 square miles) – an area smaller than California. Yet they are home to many animals found nowhere else, including the mountain gorillas of Central Africa and the spectacled bears of the Andes.

Though small in extent, the cloud forests' ability to scavenge moisture from the air makes them vital water tanks, without which taps would run dry in a number of capital cities in the valleys and lowlands below – for instance, Tegucigalpa in Honduras and Dar es Salaam in Tanzania. But they are also uniquely vulnerable to climate change. Higher temperatures are raising the cloud base. The forests are responding in the only way they can, by retreating up the mountainside. But what happens when they reach the top and there is nowhere to go?

ABOVE An *Epidendrum* orchid in Panama's cloud forest.

But this resilience may have limits. In many places, our assaults on rainforests may be close to smashing their resilience to smithereens. Where the limits might lie remains a worrying unknown.

Their extraordinary biodiversity is only one element of the importance of tropical rainforests. As the planet's largest body of living matter, rainforests operate almost like single living and breathing organisms. They are the engines of so much – they link everything.

They inhale carbon dioxide ($CO_2$). The gas, along with water and the energy from the sun, are the ingredients for photosynthesis, the basic biological process that manufactures plant matter. Photosynthesis happens faster in the wet heart of tropical rainforests than anywhere else. By consuming carbon dioxide, rainforests – indeed, forests as a whole – are vital to curbing the rising carbon dioxide concentrations in the air that are today causing climate change. Meanwhile, as a fortuitous waste product of photosynthesis, forests breathe out oxygen, helping to maintain levels of the gas that are high enough for us to breathe, but not so high that the entire planet spontaneously combusts. They also exhale other gases, notably hydroxyl, which cleans pollutants from the air. So forests are our thermostat and air-conditioning system.

Just as important, rainforests are also rainmakers. As much as two thirds of the rain falling onto the canopy of rainforests never reaches the ground. It evaporates in the hot tropical sun. The evaporation forms 'flying rivers' of water vapour in the air above the forests. These soon condense to make new rainclouds that sustain forests downwind and prevent the land from becoming desert. Air that passes over large forest areas produces at least twice as much rainfall in the region as air that has passed over little vegetation.

Climate-modellers believe that the rainmaking power of rainforests extends for thousands of miles. The forests depend on constant rainfall to flourish, but that rainfall itself is sustained by the forests. Take away too many trees and the rains will falter. Humanity's assault on the jungles threatens these life-support systems for the planet. Without them, the planet would soon become unfit for nature as we know it, and for us.

NEXT PAGE
**RAINMAKING**
A great expanse of rainforest on the island of New Britain, off Papua New Guinea. The clouds of mist evaporating from the trees maintain the forest's humidity, leading to daily downpours that nurture both moisture-loving plants and animals as well as the trees themselves in a continuous cycle.

AS THE PLANET'S LARGEST BODY OF LIVING MATTER, RAINFORESTS OPERATE ALMOST LIKE SINGLE LIVING AND BREATHING ORGANISMS. THEY ARE THE ENGINES OF SO MUCH – THEY LINK EVERYTHING

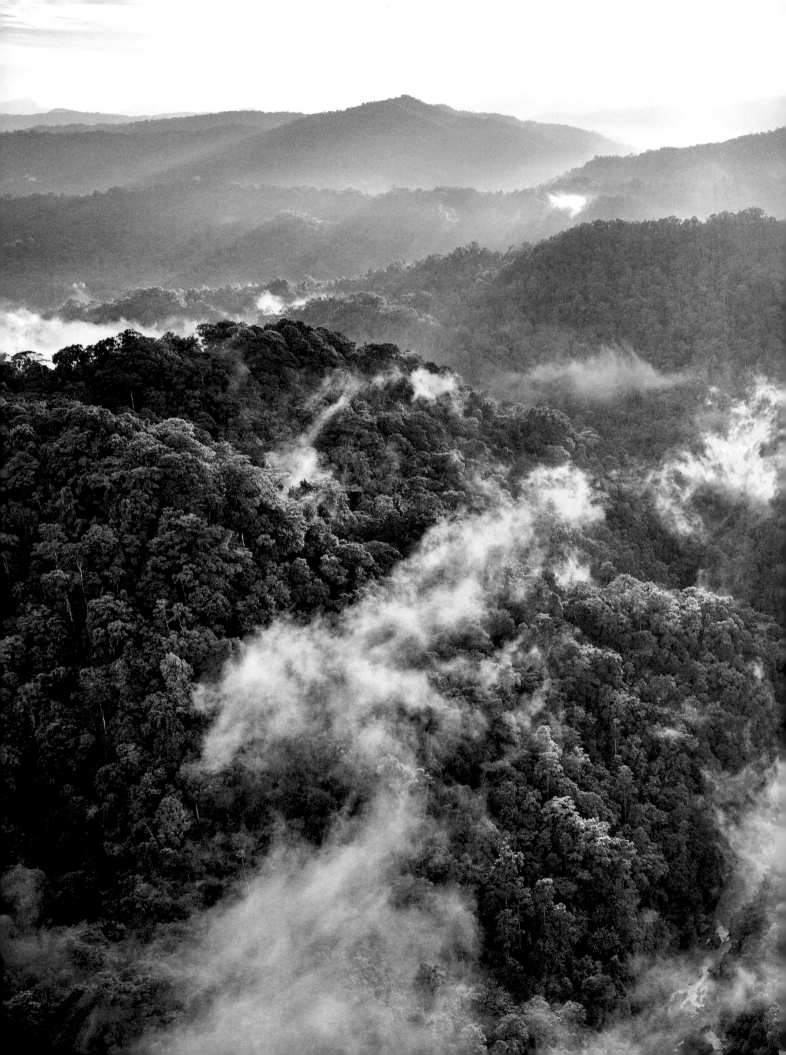

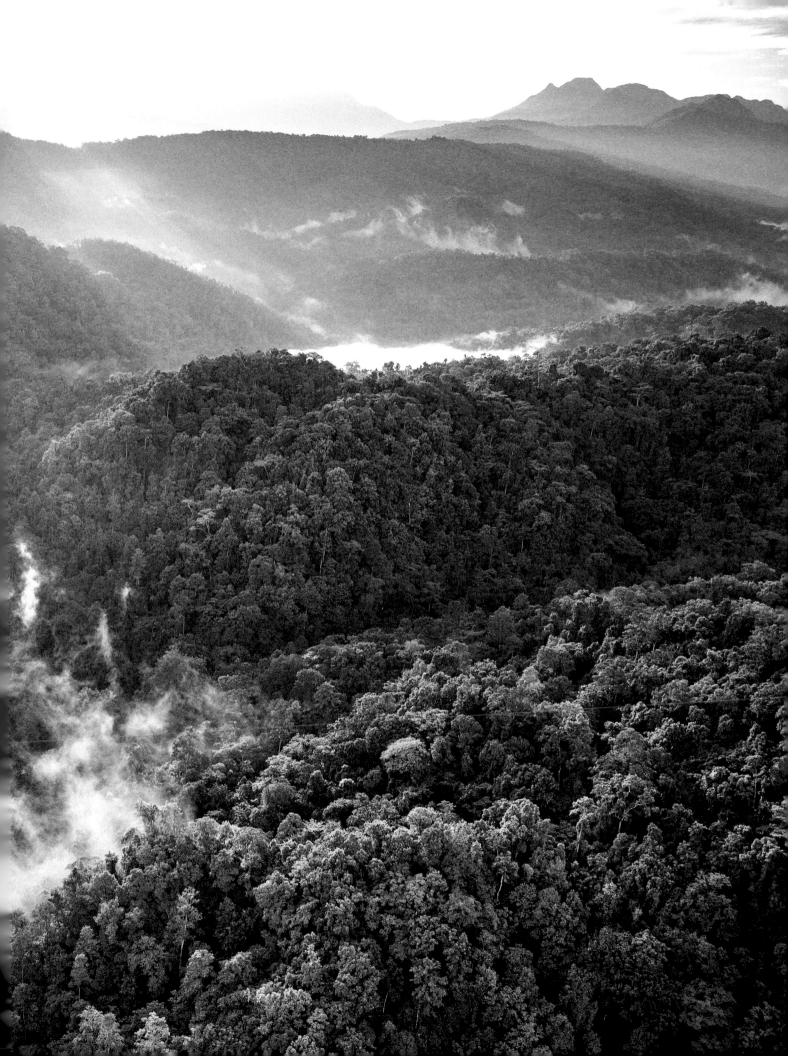

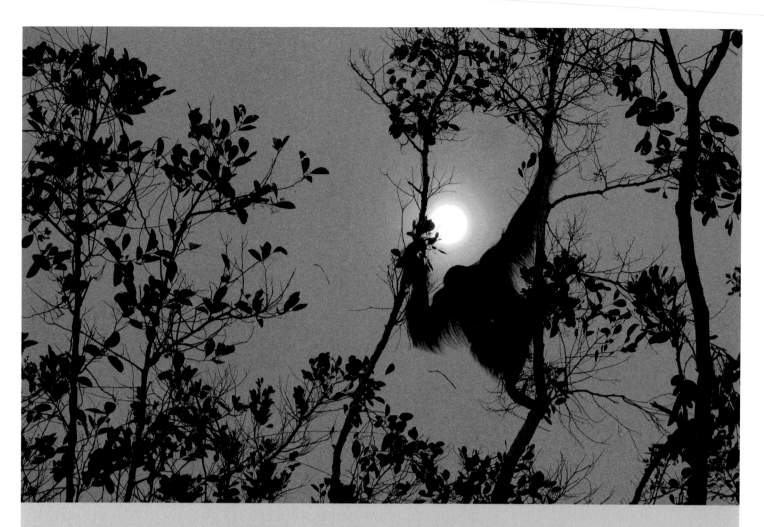

# INDONESIA'S SMOULDERING PROBLEM

Across Sumatra and Borneo, farmers big and small are setting fires to clear land for planting oil palms. They periodically cause massive forest fires that spread a lethal haze across the region, shutting schools and even downing aircraft. The fires are worst during droughts caused by the El Niño weather phenomenon.

The smoke is especially bad when the fires penetrate the deep peat bogs that underlie many forests on both islands. The bogs can smoulder for months, unleashing huge amounts of smoke and carbon dioxide into the air – far more than from the burning trees.

In autumn 2015, forest fires in Indonesia, a country that includes Sumatra and most of Borneo (Kalimantan), were for a while emitting more greenhouse gases into the air each day than the US.

The Indonesian government has made big declarations about ending illegal logging and land clearance. President Joko Widodo placed a moratorium on clearing forests regarded as having high conservation value. He wants to concentrate future clearance on already degraded forests. Meanwhile he has set up an agency to restore peatlands damaged by fires 'so that we can convince the world that we are very serious about overcoming the damage caused to forests and peatlands'.

Turning words into practice on such a huge archipelago covering 17,000 islands will be hard. And so far the evidence of change on the ground is slim. Despite the promises, the loss of trees in Indonesia in 2016 hit record levels. But things can be turned round.

There is nothing inevitable about forest destruction. The rule of law can prevail even in remote jungle – if there is a will. Brazil, under the leadership of former-president Lula in particular, has shown that, clamping down on deforestation a decade ago.

ABOVE A young Bornean orangutan in the smoke of a fire caused by forest clearing in Kalimantan, Indonesia.

So let's look in more detail at what has gone wrong in the rainforests and how we might put it right before it is too late. We start in Indonesia, where the jungles are being destroyed faster than anywhere else.

The giant Indonesian island of Sumatra has for thousands of years been a jungle world where people harvested its products without destroying the forests. They turned rattan into furniture, took honey from bee nests, cut timber to make their homes, and grew crops in clearings. In the past century, those commercial loggers selecting just a few trees and leaving most of the forest intact, have been 'compatible with conservation', says WWF.

But the clear-felling that has happened in Sumatra in the past three decades is different. Nowhere has been stripped of its forests faster. Since 1985, Sumatra has lost at least half of its forest cover. Thousands of square kilometres of dense jungle have been cleared to feed two of the world's largest pulp mills owned by two competing Indonesian oligarchs. The mills between them consume around 20 million tonnes of timber a year. The pulp is turned into paper that feeds office printers across the planet. Once stripped of trees, much of the land is handed on to palm-oil producers.

Unless this carnage stops and restoration takes place, charismatic species, such as the indigenous Sumatran rhino, its two orangutans, the Sumatran tiger and the island's small population of Sunda clouded leopards, seem doomed. The last clouded leopards live solitary lives, gliding unnoticed through the forest looking for prey. They use the canopy, too, making them probably the world's largest canopy predator.

Things are scarcely better on neighbouring Borneo, whose jungles are among the world's oldest having been around for more than 130 million years. As recently as the 1970s, three quarters of the island was forested. Today a third of those forests are gone, mainly thanks to logging of its valuable hardwoods.

Logging dominates local economies. In Central Kalimantan, the most remote and forested region of the island, the local phone book lists six times more sawmills than taxi companies. But as a result, the island's forest cover is now below 50 per cent, with many areas replaced by oil palms stretching to the horizon. An area of forest the size of Greece has gone.

Among the most famous residents of these two islands are orangutans, two species on Sumatra and one on Borneo. The habits and cultures of these highly intelligent primates fascinate researchers – because they are so like us. Each tribe has its own way of living, which mothers pass on to the next generation. Some teach their young to use twigs to scoop honey out of bees' nests or extract ants from their nests.

NEXT PAGE
**NEW ANCIENT RELATIVES**
A male Tapanuli orangutan and a young female look down from their rainforest refuge in Batang Toru, Sumatra. Only recently identified as a third species of orangutan, it is known just from this one forest region. It has hair that is slightly more frizzy than that of the Sumatran or Bornean orangutans, males also have prominent moustaches, as well as flat cheek flanges, and older females have beards. The rugged terrain has protected them from their greatest threat – the clearance of the island's rainforest to make way for plantations of oil palms. But now a China-backed hydroelectric project planned for the area of highest orangutan density may make the species the world's most endangered great ape.

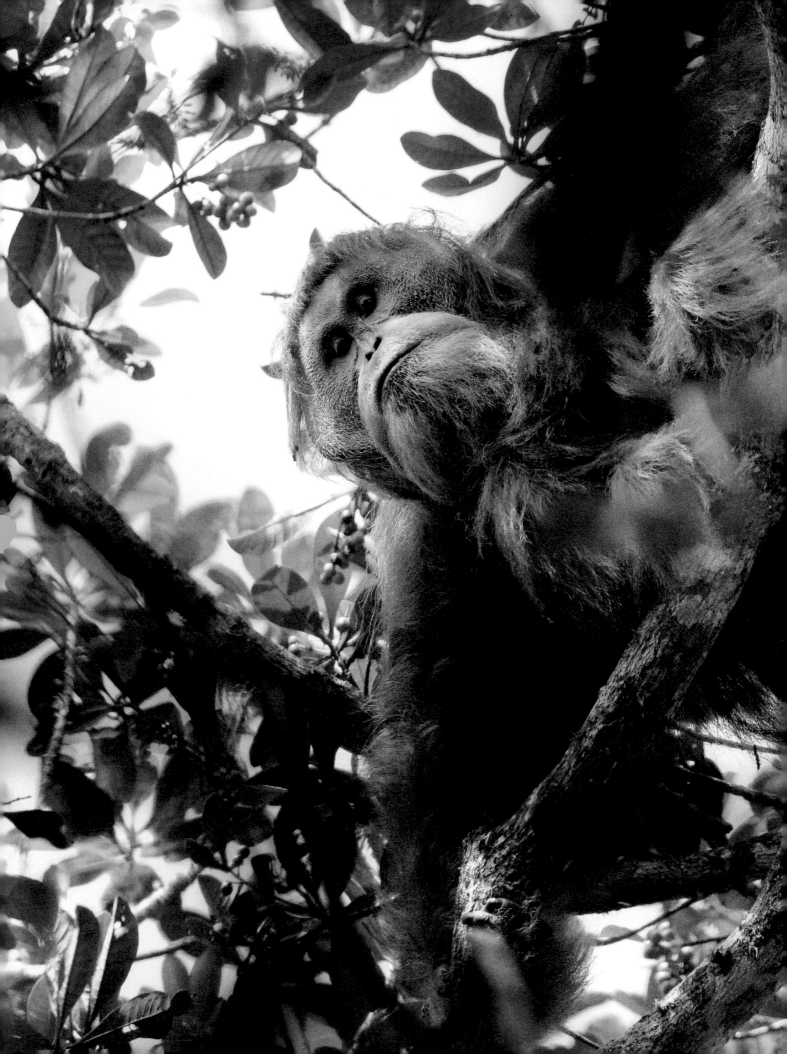

# JUST UNDER TWO THIRDS OF THE ISLAND REMAINS FORESTED, MAKING NEW GUINEA THE PLANET'S THIRD-LARGEST AREA OF CONTINUOUS RAINFOREST

Others use leaves as gloves to avoid getting pricked. And they enjoy playing. Like human kids on a camping holiday, some make squeaking noises by blowing leaves, or harness vines to swing across rivers, Tarzan-style. Today those lifestyles are on the line.

Until recently, deforestation has not been so intense on New Guinea. Just under two thirds of the island remains forested, making it the planet's third-largest area of continuous rainforest, after the Amazon and Congo basins. But logging is increasing and oil-palm companies are moving in. Many companies got rich exhausting the forests of Borneo and Sumatra, often with the encouragement of governments, but now need new forests and new land to maintain their businesses.

Is the Amazon rainforest ripe for restoration? It seems a crazy question to ask after the deforestation of the past half century. It has at times been a lawless frontier, as cattle ranchers and soya farmers pushed into the world's largest rainforest from the east and south. But as former WWF International President Yolanda Kakabadse puts it, 'most of the Amazon remains in good ecological condition.' Some 6.7 million square kilometres (2.6 million square miles) of jungle remains. It contains 400 billion trees. And in Brazil, the peak of deforestation may have passed.

Brazil's national parks are better protected today; laws on trading in the products of deforestation, such as beef, soya and leather, have been enforced; and many of the 385 indigenous groups have been given more power to control entry to their own reserves. Between 2004 and 2016, annual rates of deforestation in the Brazilian Amazon fell by 70 per cent.

But pressures remain. The largest rainforest in the world risks being broken into fragments by mining, roads and plans to add further dams to the Amazon and its tributaries for hydroelectricity.

Fragmentation impacts on biodiversity. Put simply, smaller fragments have fewer species, individually and collectively, than single coherent areas of forest of equivalent size. Primates, herbivorous mammals and birds suffer worst when the fragments become too small for them to hunt or find food. There are also 'edge effects'. In fragmented forests, nowhere is deep in the forest and more places are on the fringes, which are windier and drier and become invaded by species from surrounding habitats – including, of course, humans.

OPPOSITE, TOP
**DISPLAY OF AFFLUENCE**
A male western parotia bird of paradise (below) performing his balletic display for an interested female. He has cleared a dance floor under a suitable perch, from which a potential mate can look down onto the mesmerizing swirl of his black cape, setting off a collar of iridescent feathers. If she chooses him, the affair will last just seconds. She can afford to be a single parent and he can afford to spend so much time preparing his arena because life is easy in their New Guinea rainforest, offering a year-round supply of food. In this evolutionary nirvana, it is the survival of the sexiest.

OPPOSITE, BOTTOM
**SUPERB SHAPE-SHIFTER**
A Vogelkop superb bird of paradise spreading his cape to display as a female approaches. His feathers have a special structure that makes them jet black, setting off his shimmering shield and false eyes.

# FRAGMENTATION IMPACTS ON BIODIVERSITY. PUT SIMPLY, SMALLER FRAGMENTS HAVE FEWER SPECIES, INDIVIDUALLY AND COLLECTIVELY, THAN SINGLE COHERENT AREAS

OPPOSITE

**BORDER BETWEEN POLICIES**
A satellite image of the border between Guatemala and Belize in 2016, illustrating the effect of radically different government land policies. On the left is Guatemalan farmland. On the right, across the border, is the dense forest cover of Belize. Such Landsat images revealed that, from 1991 to 2014, forested land declined by 32 per cent in Guatemala, compared to only 11 per cent in Belize.

An important first task for ecological restoration is to reconnect forest fragments and allow the recovery of degraded forests. Alongside this, we need to secure the remaining extensive forest areas, which are a source of seeds and species that will aid the recovery of forests. But can it be done in a heavily used landscape such as that around the fringes of the surviving Amazon rainforest, where soya farmers and cattle ranchers crowd in? The task is not hopeless.

The first point to remember is that there is much forest still to work with. Even forests that have been badly degraded by loggers and farmers often keep many of their species, albeit with much reduced population sizes. El Salvador, for instance, has lost more than 90 per cent of its forests, and yet only 3 of its 508 bird species have disappeared. Similarly, 80 per cent of Malaysian Borneo has been logged, often many times over, yet even in the logged areas, the large majority of forest species have survived.

A second reason to be hopeful is that you don't need to cut down forests to reap their economic benefit. And people who find value in their forests will protect them.

Brazil has created many large extractive reserves in the Amazon – areas protected by local communities, who harvest forest products such as latex from natural rubber trees and Brazil nuts. The reserves now cover an area the size of England.

One commemorates the work of Chico Mendes, a rubber-tapper from the western Amazon, whose campaign to protect forests by creating such reserves was adopted by western environmental groups in the 1980s. He was assassinated by a local rancher in 1988.

An important lesson from the Amazon is that locals who are often demonized as forest destroyers can be its best defenders. Satellite images from the Amazon show clearly that reserves controlled by rubber-tappers and indigenous communities are often seas of luxuriant forest. So, if these people are the saviours of what remains of the forests, they are perhaps the people most likely to initiate the next step: the 'great ecological restoration'.

Evidence that they might do just that lies in the valley of the Xingu River. The Xingu is one of the largest tributaries of the mighty Amazon River. Over the past quarter-century, cattle ranchers and soya farmers in its long valley – an area as large as the UK – have been

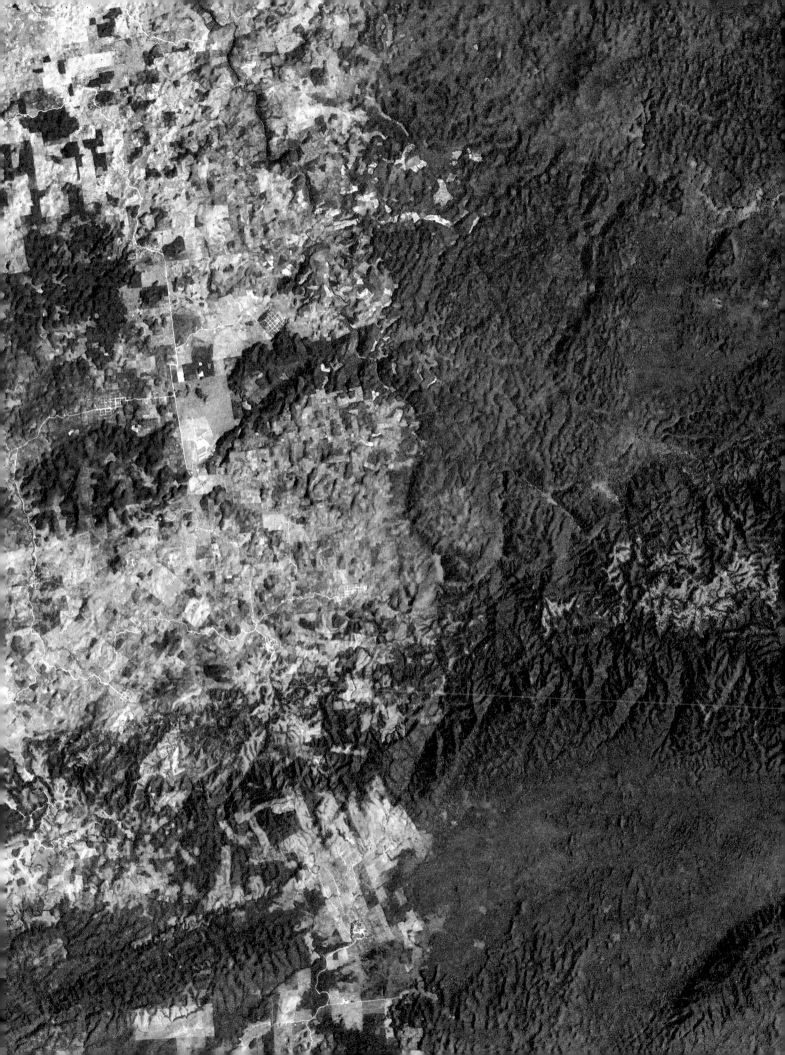

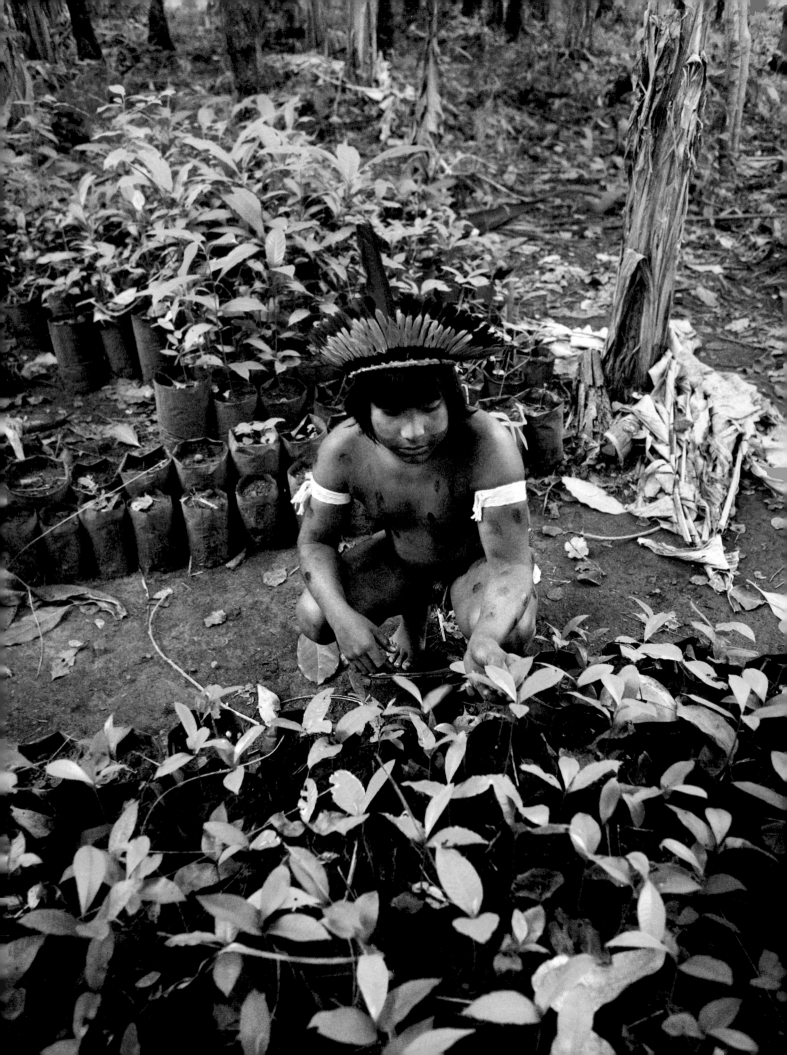

PERHAPS THE MOST PROFOUND CAUSE
FOR OPTIMISM ABOUT THE POTENTIAL TO
REGENERATE THE AMAZON AND OTHER
RAINFORESTS IS THAT THEY HAVE RECOVERED
FROM HUMANITY'S DEPREDATIONS BEFORE

responsible for some of the world's fastest rates of deforestation. In consequence, water supplies have dried up and fish have disappeared from the river.

Among the places worst hit has been the Xingu Indigenous Park in the river's headwaters in the state of Mato Grosso, where more than a dozen indigenous groups live. The inhabitants decided to do something about this. Working with Brazilian and international organizations, some 400 indigenous women from the park are collecting seeds from their forests. They are selling the seeds to landowners in deforested areas who have begun reinstating forests to comply with Brazil's Forest Code and to protect their own water supplies.

The project, which scatters seeds to mimic natural regeneration, aims to restore up to 3,000 square kilometres (about 1,200 square miles) of forest, creating what the Environmental Defense Fund, an American non-governmental organization, calls 'the world's largest continuous tropical forest corridor'. It is a rare instance of ranchers and indigenous people working together to protect and enhance their common landscape. And the idea is spreading, with new seed networks being set up across the Amazon. It could be the first sign of organized rainforest recovery in the Amazon.

Perhaps the most profound cause for optimism about the potential to regenerate the Amazon and other rainforests is that they have recovered from humanity's depredations before. The Amazon basin, for instance, was quite densely populated before Europeans arrived in the Americas. The first conquistadors chronicled whole cities on river banks. Those cities quickly emptied as local populations were decimated by disease and war, and the jungle reclaimed its territory so completely that ecologists have mistaken the regrowth for pristine forest. Jungles that Charles Darwin described during his voyage aboard HMS *Beagle* as 'primeval forests undefaced by the hand of humans' were, in fact, anything but. They were regrowth.

Some jungle soils in the Amazon and elsewhere contain 'dark earths', primitive mulches made of domestic waste mixed with burnt wood. They are often full of pottery, too, showing there can be little doubt they are man-made. These patches of improved soils cover at

OPPOSITE
**NURSERY FOR NATIVE TREES**
An indigenous Xingu young man examining seedlings grown from seeds that his community has collected in Brazil's Xingu Indigenous Park, in the state of Mato Grosso. The nursery – managed by a Brazilian charity, with support from European donors – sells the saplings to landowners so they can replant in the region's deforested areas. It is part of an initiative to regenerate Brazil's beleaguered forests.

least 1 per cent of the Amazon basin where there would otherwise be thin forest soils. They are highly valued by local farmers to this day, even though their origins are mostly forgotten.

Other jungles have regrown on top of earthworks that appear to have been primitive drainage systems or causeways. Archaeologists are discovering that the Mayans in Central America, the Angkor Wat urban civilization in Southeast Asia, and ancient and sophisticated societies in West Africa such as the Benin, all cleared forests on a large scale. Around 1,500 years ago, much of the Congo was cleared for growing crops, making charcoal and even smelting metal. Thanks to regrowth, these remains all now lie beneath what looks at first sight like pristine jungle.

All this is clear evidence of nature's past ability to recover its wilderness. And this is not just history. Forests are regenerating in the same way today, wherever loggers move on, cattle pastures lose their fertility or peasant farmers depart for the city.

In Panama, for instance, the Smithsonian Tropical Research Institute estimates that, while natural rainforest has been declining annually by 1.3 per cent, each year has seen another 4 per cent of former forest land begin to recover. As farmers abandon their land in central Cameroon, 'the forest is coming back really fast,' says Ed Mitchard of the University of Edinburgh. Within 20 years, new trees have grown 30 metres (about 100 feet), and a full canopy is reforming.

United Nations' data suggest that, at any one time around the world, an area of secondary rainforest equivalent to the size of Australia is in rehab. New wildernesses are emerging, shading the land, enticing the return of wildlife and capturing carbon from the air. We can easily forget this. Deforestation is usually sudden and easy to spot from satellite images. But natural forest regeneration takes time and may be missed.

It is true that recovered forests will take much longer to offer the full range of habitats, including big old trees. Some species may never return because they have become extinct or are cut off from regrowing forest. Once sundered, many of the interrelationships between species that once made forests so resilient may be hard to reassemble. But nature rebuilds. Much of what we today regard as pristine rainforest is itself secondary recovery from past human occupation. How much of this can be done in a crowded world?

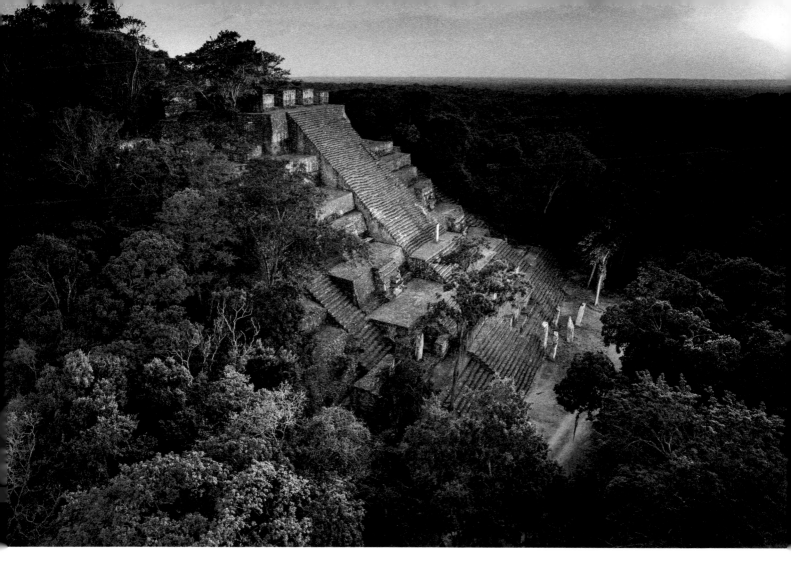

The 'great ecological restoration' will have to happen in a world of 9, 10 or 11 billion people. Can we, even with a revolution in hi-tech agriculture to maximize yields on farmland, really spare enough land to recreate the great forests? We should be realistic.

In places, we must bring back big forests – certainly if we want to keep the big creatures of the forests. But a parallel strategy is to create room for smaller woodlands to flourish alongside humans. We need to get better at sharing land with nature.

Again, this is not new. For thousands of years, Africa's elephants, buffaloes, giraffes and lions lived successfully alongside cattle-rearing human societies. They would not have survived otherwise. There are many highly productive modern farming systems that coexist with surrounding rainforest – among them, rubber gardens in Indonesia, cacao farms in Cameroon and rice smallholdings across Asia and Africa.

In a face-off between agriculture and forests, agriculture will often win. But forests and smaller patches of woodland can and do form productive parts of agricultural landscapes in tropical countries. Agroforestry provides wood, creates valuable shade, protects watersheds

ABOVE

**MONUMENT TO FOREST REBIRTH**
The ruins of a pyramid burial tomb rising above the rainforest of southeastern Mexico, part of the city of Calakmul, capital of the Mayan Snake dynasty in the seventh century AD. The fall of the city, probably due to a combination of drought and warfare, saw the rebirth of the forest.

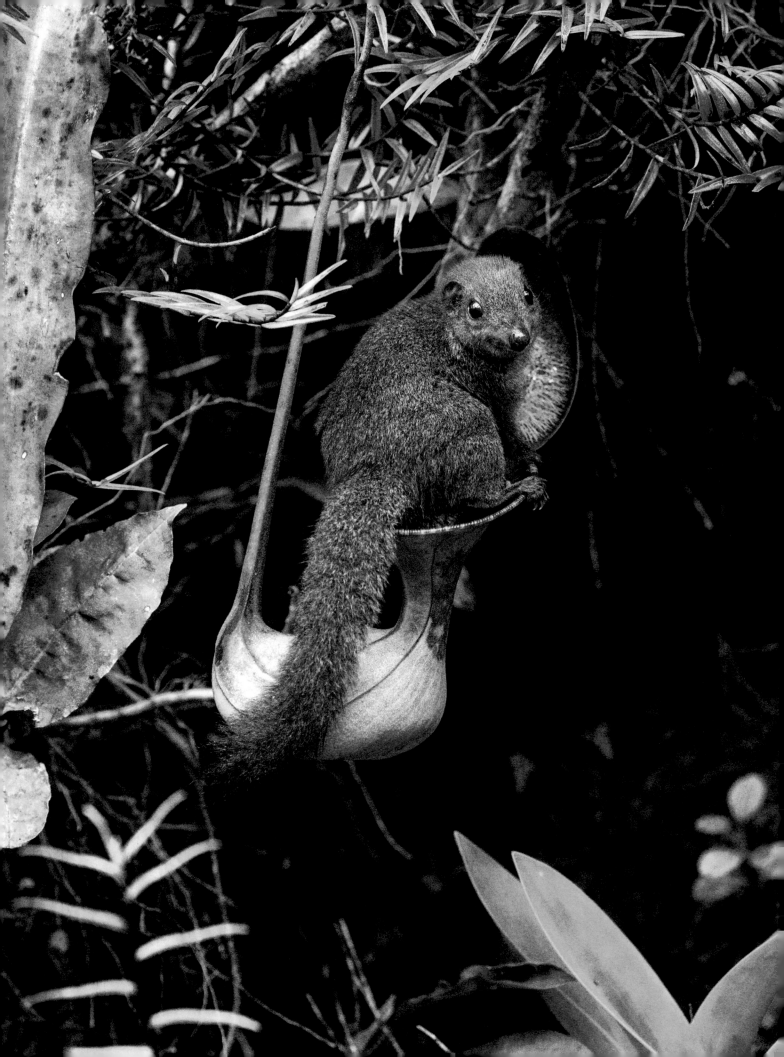

JUNGLES MORE THAN ANY OTHER PART OF NATURE HAVE BECOME A SYMBOL OF OUR NEED TO MAKE PEACE WITH OUR PLANET. THEY WILL BE THE TEST OF OUR DESIRE TO BEGIN A GREAT RESTORATION OF NATURE

from floods, provides other free natural services such as pollinators and can also provide alternative feed for livestock and fertilize soils. Agroforestry also harbours nature and can provide large animals with migration corridors. Such systems 'blur boundaries between human and natural, native and non-native, production and conservation', says Christian Kull of Monash University in Australia. They are not a substitute for expansive natural landscapes, but they can help sustain them. They can be good for people as well as the planet.

So there are grounds for optimism that, if we have a will, we can achieve a restoration of jungles and the species that inhabit them. Some of the drivers of deforestation are losing their force. Outside Africa, birth rates are falling fast. In Brazil, the average woman now has 1.8 children; in Indonesia she has 2.1. In many Western countries, consumers are changing their habits, with some eating less meat and demanding wood products certified not to destroy rainforests.

Under consumer and voter pressure, governments and corporations are pledging to turn from deforestation to reforestation. Global actions to save jungles include certification by the Forest Stewardship Council of the sustainability of harvested wood, and industry standards aimed at halting forest loss, such as those of the Roundtable on Sustainable Palm Oil, which now covers more than a fifth of global production. None works perfectly, but they are the building blocks of a global restoration of rainforests.

What needs to change completely are our attitudes and government policies towards these great jungles.

We humans came from the jungles. We began our great journey to domination of our planet when we climbed down from the trees and ran off across the grasslands. So it is perhaps not surprising that, somewhere in our collective memory, forests still hold a special place. But whatever the deep tribal truth, jungles more than any other part of nature have become a symbol of our need to make peace with our planet. Their future will be the test of our desire to begin a great restoration of nature.

# COASTAL SEAS

'We think of planet Earth as seven-tenths sea, but considering the
third dimension of depth, the oceans occupy 97 per cent of the world's
habitable space. They utterly dominate life. They drive climate, feed
millions and are a thoroughfare for trade. But they are in trouble.
Hundreds of millions of tonnes of ocean wildlife have been removed,
and hundreds of millions of tonnes of waste have been poured into them.
Climate change is transforming ocean systems, which in turn influence
air and land. Coral reefs are in serious decline. What can we do?
For a start, we can support a call for the global network of marine
protected areas to cover 30 per cent of the seas – a critical step
towards restoring the blue heart of our planet.'

**PROFESSOR CALLUM ROBERTS**
Marine-conservation biologist, oceanographer and award-winning author

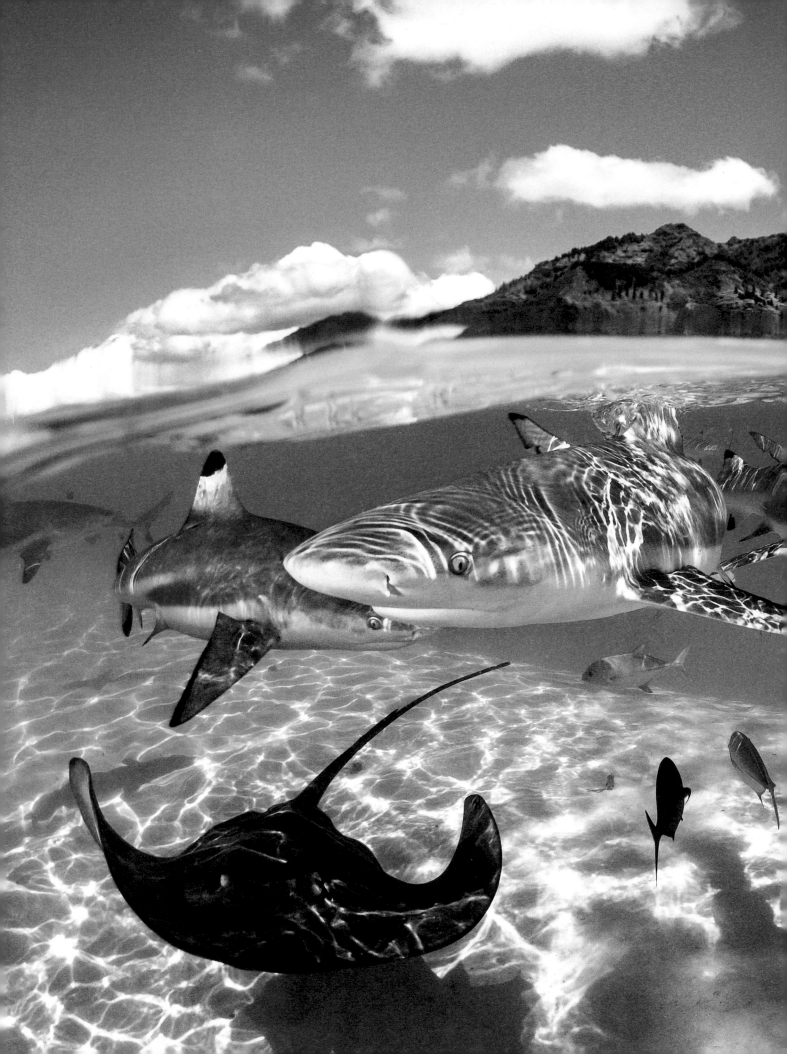

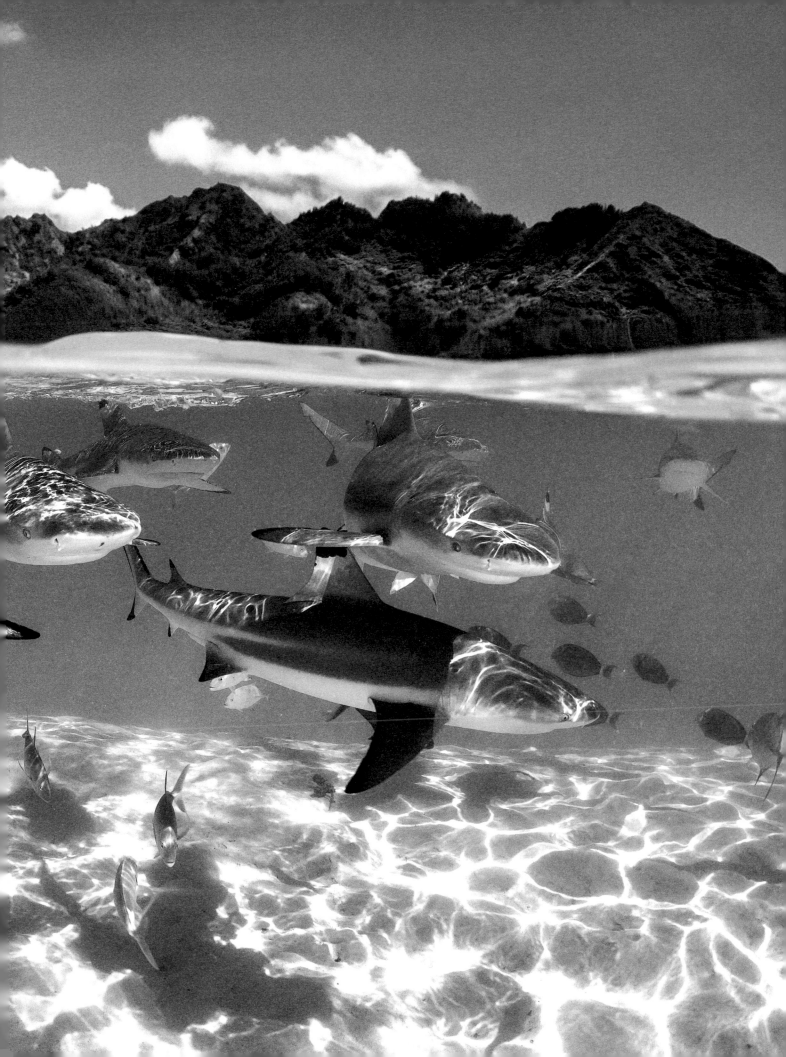

OPPOSITE
**CORAL RICHES**
A glimpse of the riches of the coral reef off Misool, in Indonesia's Raja Ampat archipelago, off West Papua. Soft corals, black corals, gorgonians and sponges provide the backdrop for a multitude of reef fish, including glassfish, groupers, panda butterflyfish and map puffers. Coral reefs are home to at least a quarter of all marine life.

PREVIOUS PAGE
**LAGOON OF PLENTY**
Blacktip sharks and stingrays in the lagoon of Mo'orea Island in French Polynesia. They are protected by a ban on commercial fishing. A coral reef protects the island itself from storm surges and has been healthy enough to withstand recent cyclones, an invasion of starfish and a season of overwarm sea water.

OPENING PAGE
**CANOPY LIFE**
A young California sea lion rests in the canopy of a forest of giant kelp off California's Santa Barbara Island.

NEXT PAGE
**SOFT-CORAL BED**
A common octopus swims over a bed of soft coral on the rocky east coast of South Africa. In this rich ecosystem, protected in Algoa Bay from strong wave action, sponges live among the leather and devil's hand coral.

Sharks cruise the reef. Hundreds of them, patrolling the warm, tropical water, and playing hide-and-seek with a multicoloured array of fish. It is a dazzling but deadly dance amid the complex organic architecture of the coral reef. Beneath the coral are worms and snails, limpets and conches, sea anemones and sponges, crabs and sea cucumbers all consuming and being consumed, recycling nutrients in this marine El Dorado. All this is within a few metres of the water's surface, through which tropical sunlight shines on the scene. Welcome to one of the richest, most biodiverse ecosystems on the planet.

Coral reefs grow around tropical islands and along shores, fringed by shallow lagoons. They are the world's largest living structures. The Great Barrier Reef off Australia is 2,000 kilometres (1,240 miles) long, visible with the naked eye from the moon. Reefs can be as rich in species as terrestrial rainforests. Many are also as old.

Reefs are composed of vast colonies of tiny soft-bodied coral animals, related to sea anemones. Each secretes a cup-shaped external skeleton, and billions of skeletons fused together make up the reef. They flourish through an exquisite relationship with algae known as zooxanthellae, which live inside each coral and give the otherwise translucent creature its colours. In return for shelter, the algae provide the corals with most of the nourishment they need to live and build their skeletons.

That relationship is the basis of these rich ecosystems. The reefs' nooks and crannies are where a constant struggle takes place between marine hunters and their prey. Gall crabs go to the extreme of allowing the coral to grow round them, leaving only a small opening through which they can feed on mucus and debris. But predators have their own strategies. Moray eels hide and wait for a meal to swim past. Others disguise themselves to blend in with the reef and grab passing prey. Many fish graze on the coral itself. Parrotfish even suck out the algae and grind up the skeletons with their teeth, creating the raw material for white coral beaches often found on nearby islands. Grazing is essential to maintain the health of the reefs, which otherwise would be overwhelmed by invasive algae. But the grazers in turn need to be kept under control by giant predator fish such as groupers, wrasse and the constantly circling sharks.

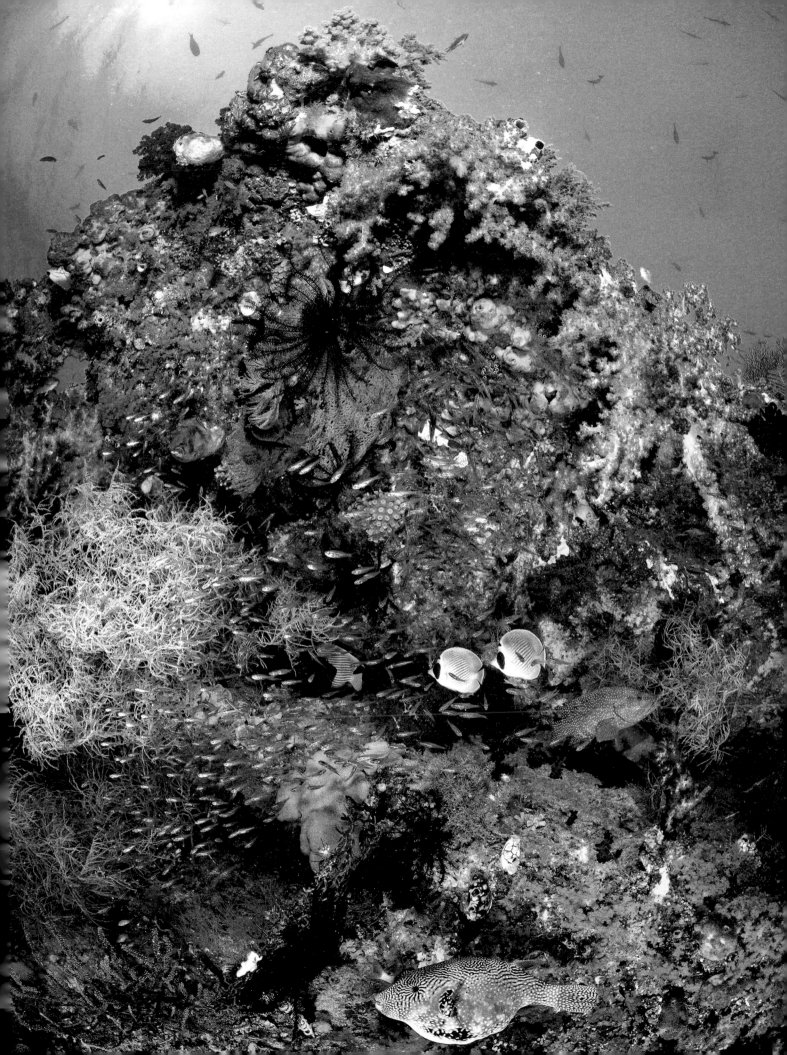

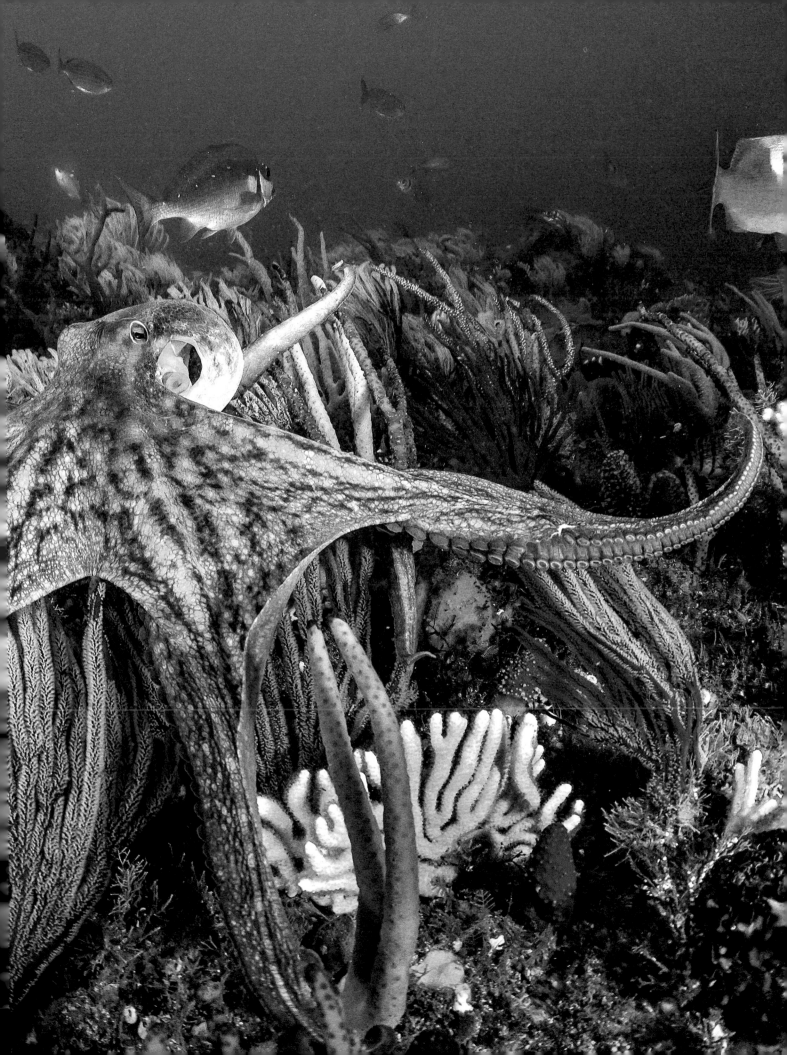

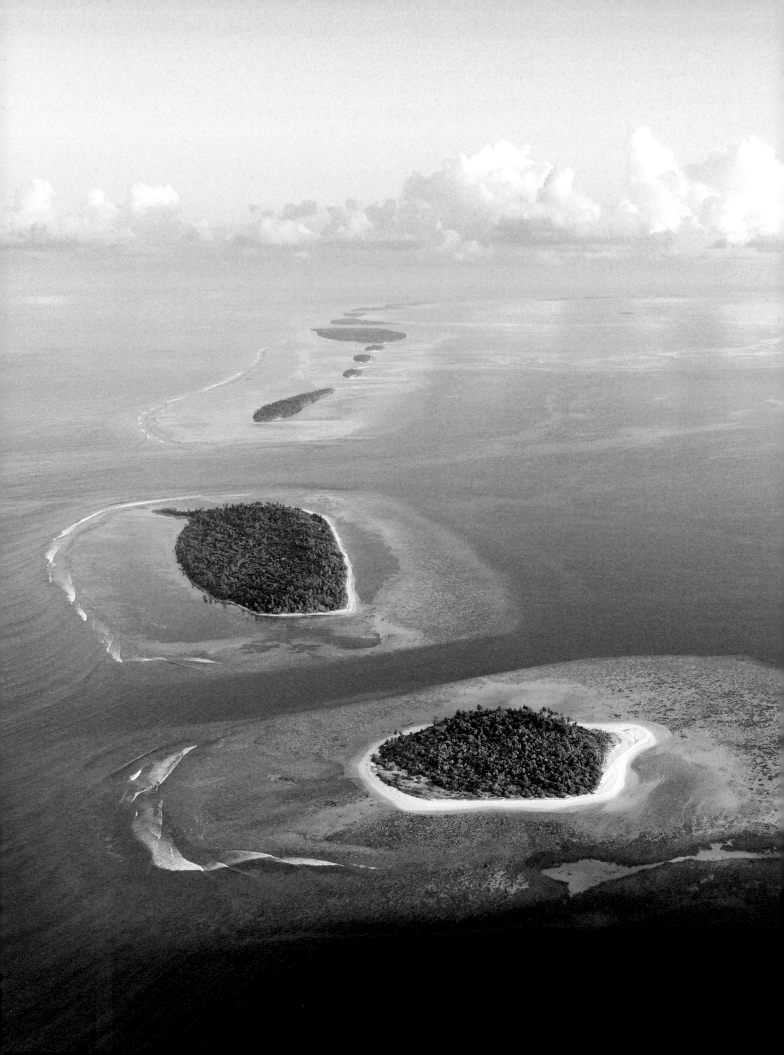

Coral reefs occur mostly in tropical waters from the Caribbean to the shores of East Africa, and from the atolls of the Indian and Pacific oceans to the vast Southeast Asian 'coral triangle' extending over six countries. Covering only a tenth of 1 per cent of the world's oceans, coral reefs are home to about a quarter of all the fish in the sea and are believed by many to have the highest biodiversity of any ecosystem – more than even tropical rainforests.

Most reefs grow as platforms stretching out from the shore or in shallow water. But others, known as atolls, form in circles far out at sea, extending downwards to the ocean floor. Warm-water coral reefs need to be close to the water's surface to get enough light for photosynthesis, so it was once a mystery how atoll rings formed. The riddle was solved when Charles Darwin pointed out that they were above submerged mountains. The coral, he said, first formed when the mountains were at the surface, and then grew over millions of years to keep pace as the mountains were eroded by the waves.

Such coral atolls can be immensely thick and extremely old. The coral at Enewetak Atoll in the Marshall Islands of the Pacific Ocean extends down for more than a kilometre. The product of the secretions of trillions of creatures over 60 million years seems indestructible. Much of it survived a series of US nuclear-bomb tests in its lagoon in the 1940s and 1950s, during the Cold War.

Coral reefs are the pinnacle of marine biodiversity. But they are part of a wider network of coastal ecosystems that combine to sustain marine life across the wider ocean. They include seagrass meadows, kelp forests and mangrove swamps. Without these, coastlines would be hard places for marine life, constantly buffeted by waves, tides, storms and the swirl of wind and water. But once these ecosystems become established, they provide protected places where creatures can eat, breed and grow and where the nutrients from their remains are recycled. They also protect the coast itself.

Many of the world's tropical coastlines are fringed by mangroves. At first sight, they may look uninviting – tangled masses of stubby trees growing in the shallow, muddy tidal waters of tropical coasts and estuaries. But being salt-tolerant, they can grow where few other plants can. And like coral reefs, they host a dazzling array of wildlife.

Above water, their branches fill with birds, roosting, nesting or feeding. Below water, their tangle of roots, which keeps the trees upright despite constant buffeting by waves and currents, harbour sponges, worms, molluscs, algae, shrimps, seahorses and young fish sheltering from predators such as larger fish and crocodiles.

OPPOSITE
**MALDIVE ATOLL RANGE**
Classic coral atolls of the Maldives. The 22 atolls – rings of coral reef surrounding more than 120 islands – have formed on the pinnacles of a volcanic mountain range in the Indian Ocean. Warm surface sea water associated with the 2015–16 El Niño weather event caused severe coral bleaching. Much of the coral has recovered, but the threat remains of rising temperatures and sea levels resulting from climate change.

NEXT PAGE
**MANGROVE SEA-CREEK**
A creek through the mangroves in the Indonesian archipelego of Raja Ampat. As the tide flows in and out of the roots of the salt-tolerant mangroves, sediment is trapped, building up the mud but leaving shallow tidal channels that are perfect habitats for sponges and fan corals. As well as acting as fish nurseries, the mangrove-forest fringe protects the coast from erosion and storm surges, especially during cyclones.

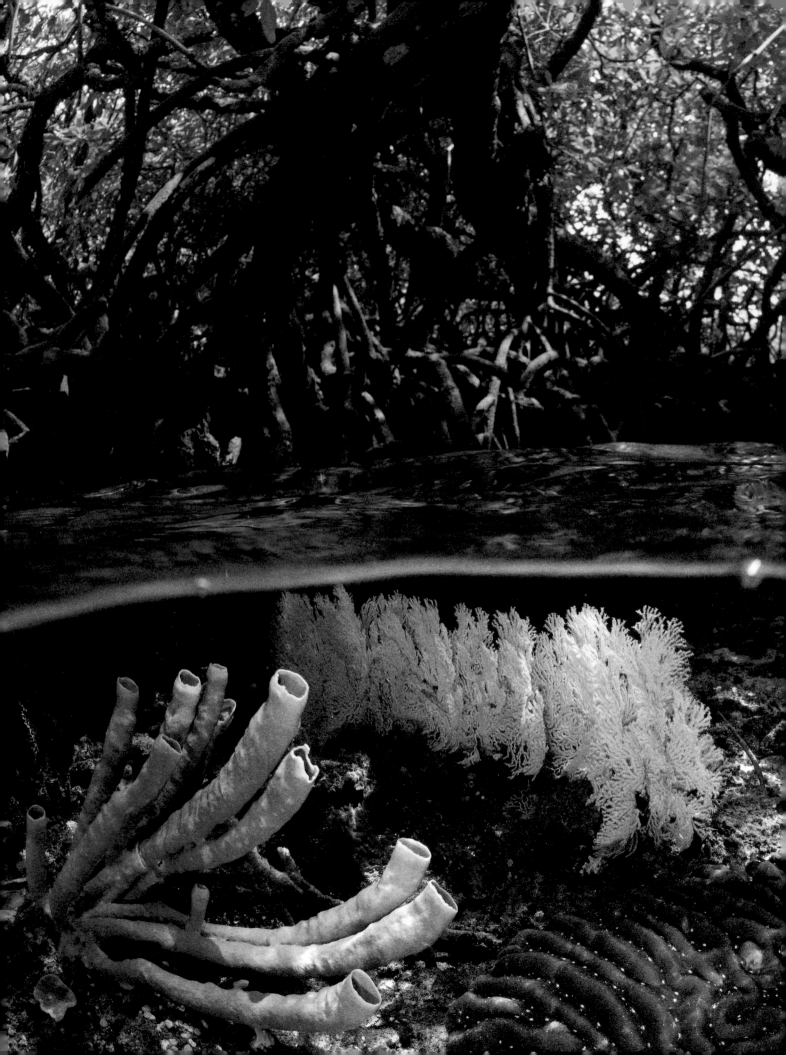

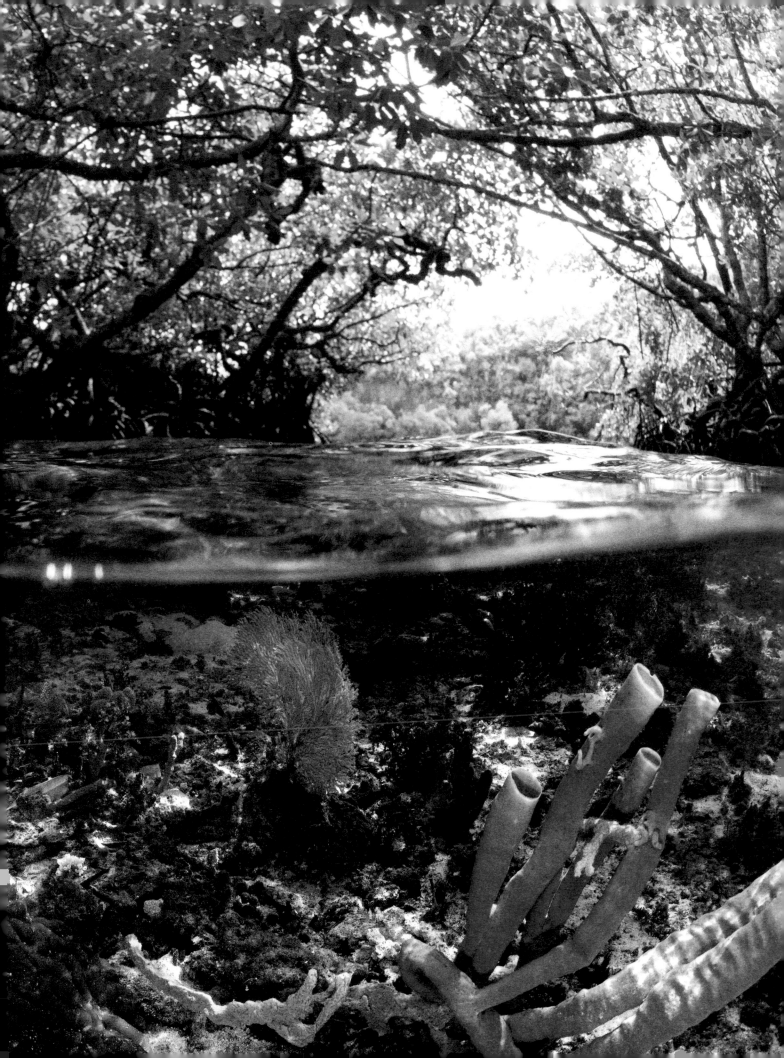

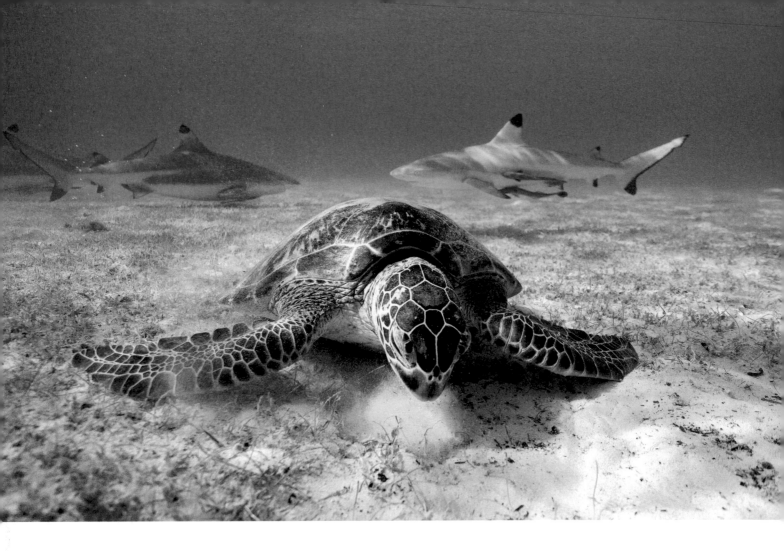

ABOVE

**SEAGRASS GRAZER**

A green turtle grazes on seagrass in a bay off Misool, one of the Indonesian Raja Ampat islands. Behind, blacktip reef sharks patrol in search of small fish and other sea creatures. This bay – once a shark-finning camp – is now part of a rich marine reserve, transformed in less than a decade. The seagrass provides food, habitat and nursery areas for numerous fish and other species, stabilizes the seabed and filters out pollution. Seagrass plants need light and therefore clear water to grow, and they can easily be smothered by sediment run-off or algal blooms caused by agricultural or other land pollution.

It has been estimated that more than 3,000 fish species (almost 10 per cent of those currently known) utilize mangroves systems. Many coral reef fish use mangroves as important nursery grounds, with older fish migrating to the reefs for their adult lives. Queensland's mangroves, for instance, help sustain the coral-reef fish just offshore.

Life above and below water mingle in unexpected ways. Mangroves host some of the few crabs that climb trees, which they do to avoid marine predators as well as to feast on leaves. Mudskipper fish can breathe out of water and walk out onto the mud to feed and socialize.

Mangroves flank tropical coastlines, river deltas, estuaries and tidal creeks. The largest mangrove area spans the delta of the River Ganges, straddling India and Bangladesh. Known as the Sundarbans, it is home to Bengal tigers and their swampland prey, including crocodiles.

For humans, too, intact mangroves are rich sources of marine food. One square kilometre of mangrove forest in the Philippines can yield 40 tonnes of fish, shrimps, crabs, molluscs and sea cucumbers a year. Just as important, mangroves protect coastal communities from the violence of the ocean. Their tangled roots absorb the energy of storm waves and trap sediment, preventing coastal erosion. Above water, their dense foliage takes the full force of storm winds blowing ashore.

COASTAL ECOSYSTEMS OCCUPY THE FERTILE
BOUNDARY BETWEEN LAND AND OCEAN
AND TOGETHER SUSTAIN MORE THAN ...
90 PER CENT OF FISH CAUGHT.

In 1999, a cyclone swept ashore in the Indian state of Orissa, killing
at least 10,000 people. Investigators later blamed the death toll on
the removal of most of the state's mangroves to make way for prawn
farms. Mangroves are also believed to have saved thousands of lives
after a huge tsunami swept ashore around the Indian Ocean in 2004.

Mangroves and coral reefs are largely restricted to the tropics. But
seagrass is more widespread. It occurs from the islands of Southeast
Asia to the Mediterranean, as far north as Iceland and as far south as
New Zealand. These are the grasslands of the coastal seas, rich in fish
and other sea creatures. A single hectare of seagrass around Florida,
the world's largest expanse, can contain 100,000 fish.

The dense meadows are also home to turtles, dugongs and their
close relations, manatees. These much-loved 'sea cows' graze almost
exclusively on seagrass and are the world's only herbivorous marine
mammal. Sea cows and other grazers in turn attract carnivores that
may ultimately control the ecosystem by deciding who lives and who
dies. Florida's coasts host alligators and pods of bottlenose dolphins.
The dolphins stir up the sediment around the grasses to send fish into
their paths. In Western Australia's Shark Bay, predation by tiger sharks
maintains the system in balance by keeping the grazers in check.

Coastal ecosystems occupy the fertile boundary between land and
ocean and sustain more than 80 per cent of the world's species of
marine fish and 90 per cent of marine fish caught. But for how much
longer? Everywhere they are under threat from human developments
along shorelines – everything from marinas to condominiums, golf
courses to oil refineries. Unsustainable fishing, too, is a major threat.

For thousands of years, humans have fished on coral reefs without
damaging them. But fishing nets and misplaced anchors can cause
irreparable damage, and in some places, small-scale fishers dynamite
reefs to kill fish. Others, especially on the reefs of Indonesia and the
Philippines, use cyanide to stun fish so they can catch them alive to
sell to the aquarium trade and restaurants in East Asia. Diners can
then choose their meals from fish in a tank. Tens of thousands of fish
are caught like this each year to feed the trade in live fish. But the
cyanide also kills both the coral and the algae inside them. For every
fish caught this way, a square metre of reef is reckoned to be lost.

NEXT PAGE
**NIGHT-TIME FEEDING FRENZY**
Hunting at night on Fakarava
Atoll in French Polynesia, grey
reef sharks converge in a frenzy
on small reef fish hiding in the
coral. In 2006, all but subsistence
fishing was banned in the waters
of the atoll. Today, it has the world's
highest numbers of grey reef
sharks. Shark numbers depend on
the huge aggregations of groupers
and other fish that arrive here in
winter to spawn and also on the
fact that they, too, are protected
from exploitation.

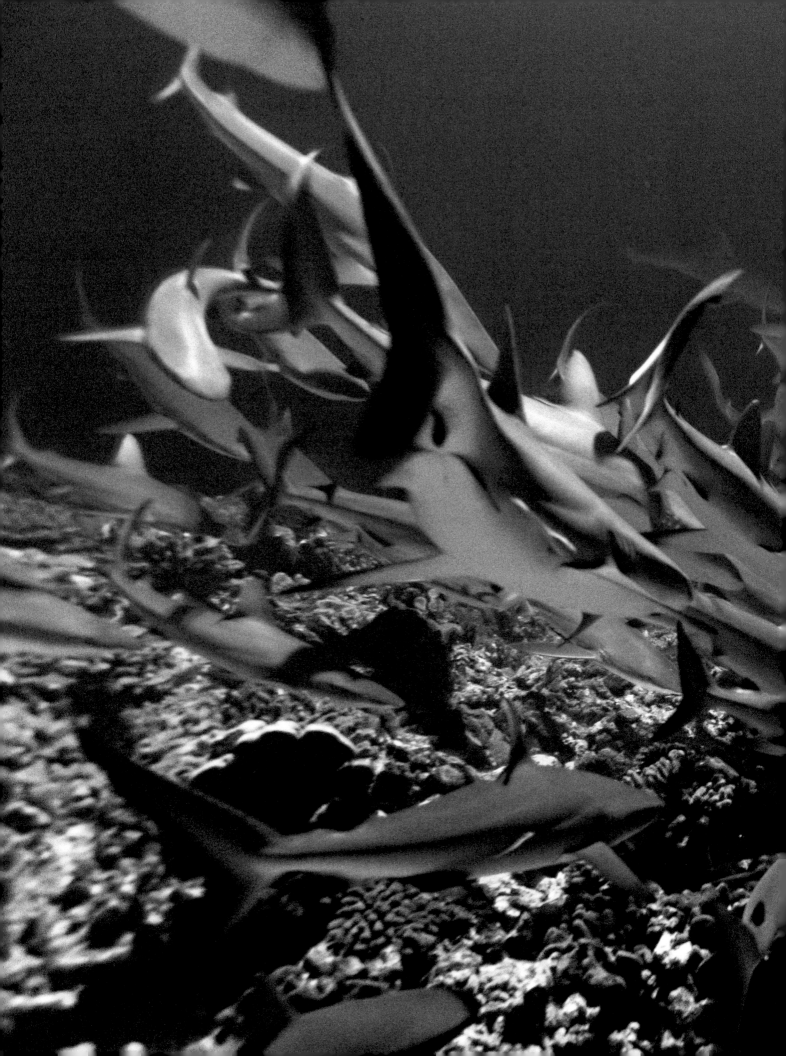

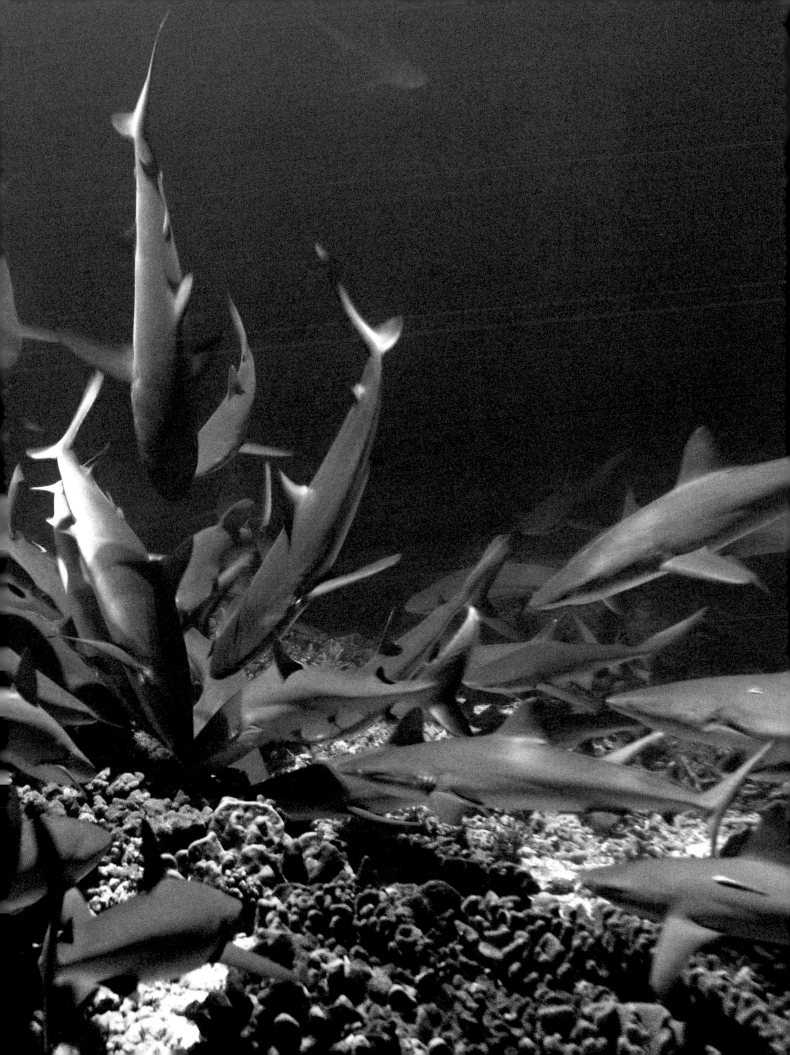

## WARM WATER AND THE BLEACHING EPIDEMIC

Conservation of coastal ecosystems can bring big benefits for both nature and the people who live off them. But it will only work if global threats are tackled, too, in particular, climate change.

Coral reefs are especially vulnerable as the world's ocean waters warm. While they are adapted to cope with seasonal temperature changes and natural cycles such as El Niño, additional temperature rises are pushing them beyond their limits. If water temperatures rise more than about 1°–2°C above normal for prolonged periods, algae are expelled from the coral communities where they live.

The resulting bleaching, in which reefs once coloured by the algae turn white, is dramatic. The coral is still alive but is more susceptible to erosion. And if the algae do not return within a few weeks, the coral starves to death.

Bleaching was once a rare event, and short-lived. But recent years have seen repeated epidemics. In 2016, when record global temperatures coincided with an El Niño warming event in the Pacific, bleaching was for the first time recorded almost globally. More than 50 per cent of the coral in parts of the northern Great Barrier Reef turned white.

Coral reefs are the first major ecosystem on the planet to suffer widespread damage from climate change. On current temperature trends, most could be dead by 2050. Related to climate change is the acidification of the oceans. Much of the excess carbon dioxide that causes warming in the atmosphere dissolves into the ocean making it slightly more acid. The extra acidity dissolves the calcium carbonate that makes up the shells and skeletons of many reef creatures, including the coral itself. Some studies have found that the rate of skeleton formation by coral may have already been reduced by as much as 40 per cent.

ABOVE Dead and dying coral in the northern Great Barrier Reef off Queensland, caused by exceptionally warm water.

There can be more subtle threats, too. Fishing can upset the natural balance of competing forces that sustains reefs. In the past 30 years, the crown-of-thorns starfish has been eating the coral of the Great Barrier Reef faster than it can regrow. This is partly because of the affect on coral of nutrient spikes from agricultural run-off, but another likely reason is that humans have given the starfish a free run by removing reef fish that eat them.

Reefs face other threats: from souvenir hunters, the anchors of ships and people looking for cheap building materials. Then there is silt from dredging and deforestation on land, and sewage discharges – all of which can smother the coral, cutting off the sunlight its algae need. Plastic in the ocean is also increasingly snagging on reefs, often carrying or incubating coral diseases.

All told, about half of tropical coral reefs are estimated to have been lost since the 1980s, with many more degraded by pollution or overfishing. Seagrass has been disappearing at an increasing rate, largely because of the flush of nutrients from farm run-off pouring down rivers. Perhaps a quarter have gone. And around a fifth of the world's mangroves has gone in the past three decades, as forests have been removed to make way for coastal development and to create room for prawn farms. The demise of these coastal ecosystems – many of which are breeding grounds and nurseries for small fish – leaves fisheries across the wider oceans in increasing peril.

Nature's coastal riches come in many and unexpected forms. Take bird droppings, for instance. Piled high on islands in the Pacific Ocean, just offshore from Peru in South America, this excrement – guano – can reach depths of more than 30 metres (100 feet). Seabirds such as Guanay cormorants, boobies and pelicans nest on the rocky edifices in huge numbers. In the nineteenth century, their nitrogen-rich guano was extensively mined. It was one of the world's biggest sources of fertilizer. Even though chemical fertilizer has since taken over, mining continues today, supplying global demand for organic fertilizer.

But why do the birds nest here? Why keep coming back? After all, the land on the neighbouring coast is one of the world's driest deserts.

They congregate because the ocean just offshore is among the most biologically productive in the world. Cold water upwelling from the depths along the continental fringe is known as the Humboldt Current. It carries nutrients from the seabed. As those nutrients rise into water where light penetrates, phytoplankton (algae) grow – in profusion.

NEXT PAGE

**THE GUANO BIRDS**
A colony of possibly half a million Guanay cormorants at the Punta San Juan guano reserve on the desert coast of Peru. They are totally dependent on the fish to be found in the cold water of the offshore Humboldt Current, in particular, the huge shoals of Peruvian anchovy, along with silverside and sculpin. If anchovy numbers crash, due to changes in water temperature or overfishing, so do cormorant numbers. Today, 2.5–5 million cormorants live along the coast of Peru and northern Chile. In the 1950s, there were more than 20 million.

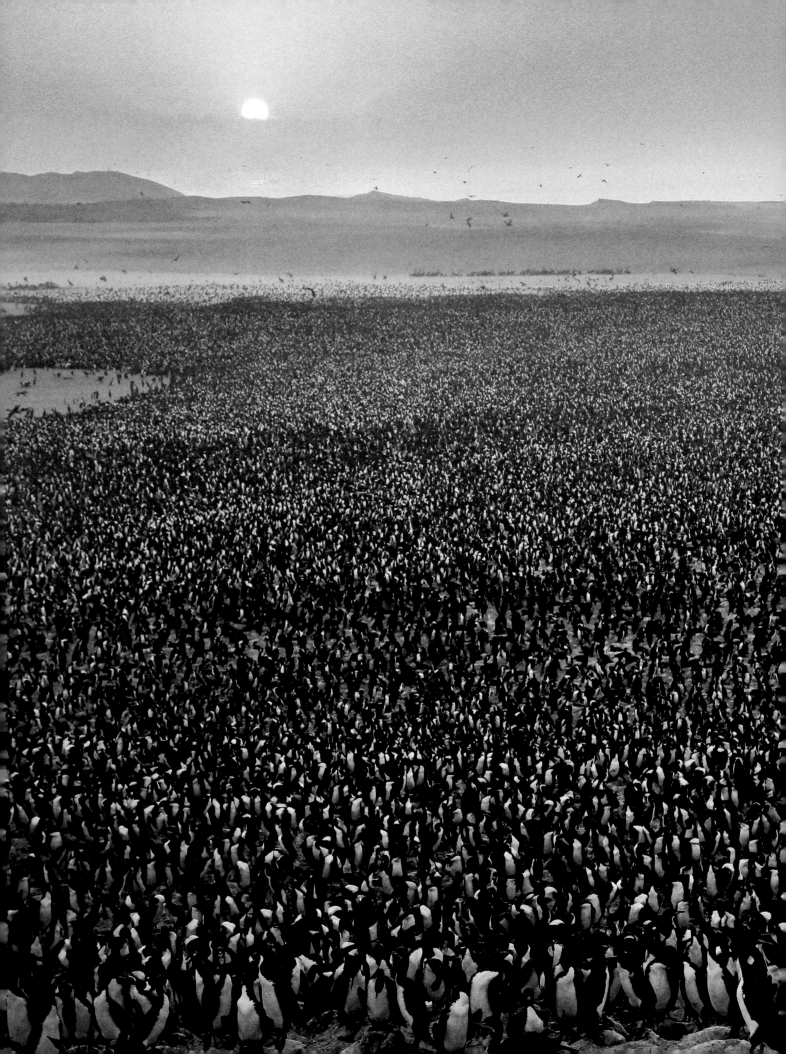

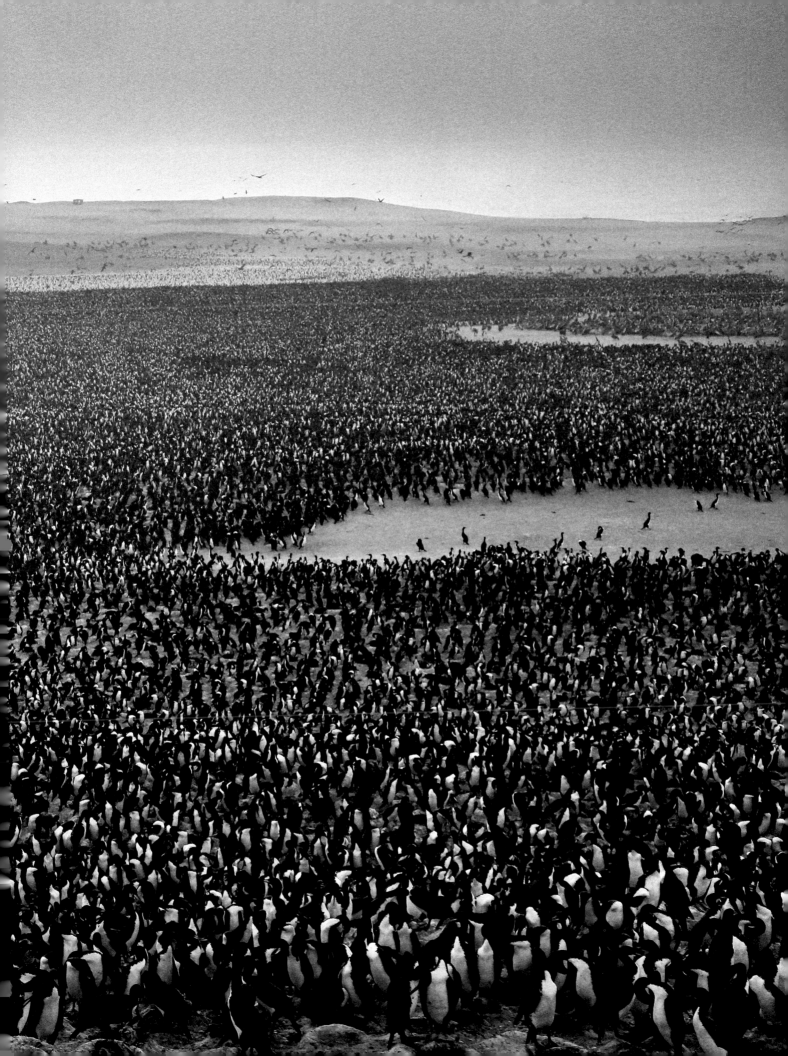

The blooms of plant life attract grazers, and the grazers attract predators. The resulting rich offshore ecosystem includes giant shoals of anchovy, mackerel and sardines. Birds love it, but so do humans. Some years, this small area of the ocean delivers a tenth of all the fish caught in nets anywhere in the oceans.

The oceans are our last great hunting grounds. Though at least 30 per cent of fish populations are already overfished, fish still fill nets. Fisheries provide jobs and protein for hundreds of millions of people. If fisheries are managed properly, and if depleted fish populations are allowed to recover, we can revive the ocean wilds, sustaining our needs long into the future.

Humans have, it is true, been overfishing for a long time. Coastal fish populations in parts of the world may have been in slow decline for a thousand years or more, Baltic herring being a prime example. But the enormous change that came with modern industrialized fishing, along with pollution and our destruction of many of the most biologically productive coastal ecosystems, has escalated that decline.

Many population crashes are sudden. In the 1950s, sardines – the largest fishery in the western hemisphere – abruptly disappeared from off the US west coast. In 1992, one of the Atlantic's great fish populations, the cod on the Grand Banks off Newfoundland, collapsed after decades of overfishing.

Other major fish populations are at risk today. Sometimes we don't even eat what we remove from the ocean. Estimates suggest that we take up to 100 million sharks a year, both through targeted fisheries or when fishing for other species. Previously, fishers just cut off their fins to supply the demand for shark-fin soup and threw the fish back in the sea to die, but now a market for shark meat is emerging. Many species of sharks are at risk of extinction because of the shark-fin trade.

The emptying of the oceans is seen in the WWF's *Living Planet Report*, which has recorded a 36-per-cent decline in marine life in the past half-century. The UN Food and Agriculture Organization (FAO), which also monitors the management of the world's fisheries, states that almost a third of fish stocks are still overfished. and a further 60 per cent are being fished at maximum levels of exploitation.

But all is not lost. Far from it. While some fish populations continue to decline, other are showing signs of recovery, including populations in the North Sea – the result of strong enforcement of fishery regulations. Could this herald the start of a revival for marine ecosystems?

Any serious recovery will have to address not just overfishing but also protection of the surviving coastal ecosystems that nurture so much life,

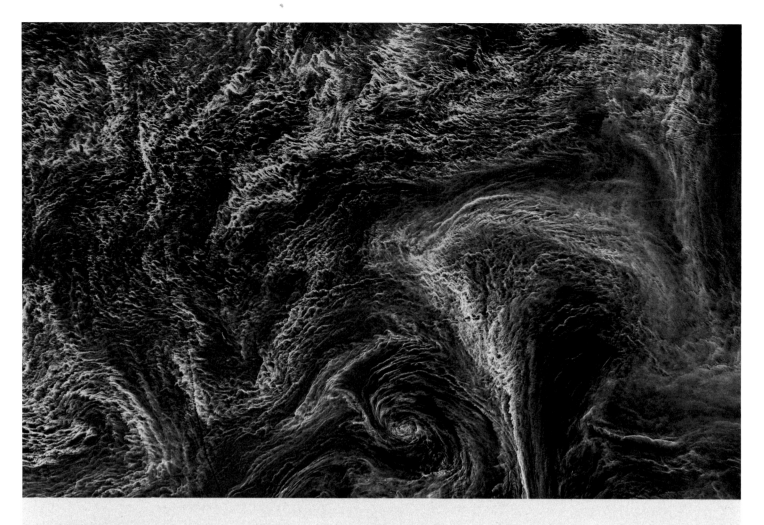

# REVIVING THE DEAD ZONES

Many of the world's regional seas that hug coastlines near densely populated areas are in serious trouble. The great rivers flowing into seas such as the Mediterranean, the South China Sea and the Gulf of Mexico bring huge amounts of pollution, especially nitrogen run-off from fertilized fields and sewage from cities.

This flush of nitrogen, aided by phosphates, stimulates the growth of blooms of algae and cyanobacteria (known as blue-green algae) that can cover large areas. They can be toxic. And even if not, as the algae dies, the rotting absorbs so much oxygen that there is none left in the water. Very little can live without oxygen. The outcome is dead zones – areas of ocean where everything has died.

More than 500 dead zones have been mapped. Since 1950, their extent has increased tenfold in coastal areas. In most summers, nitrogen pouring down the Mississippi from the US's agricultural heartland in the Midwest creates a dead zone in the Gulf of Mexico. In 2017, it spread across a record 20,000 square kilometres (7,700 square miles).

Natural dead zones can occur. One of the most persistent is in the depths of the Black Sea. But since the mid-twentieth century, pollution has extended the zone and killed seagrass meadows in the northwest of the sea. The grasses used to generate oxygen, keeping the surface of other parts of the sea alive. The sea's fish have mostly disappeared, replaced by an invasion of jellyfish that, at one point, made up 95 per cent of all the sea's biomass. Jellyfish enjoy warm, murky waters and can cope with low levels of oxygen. Reversing this and preventing it happening elsewhere will require better treatment of urban sewage and more efficient use of fertilizer and manure on farms.

ABOVE A vast bloom of cyanobacteria in the Baltic Sea, seen from space, causing an oxygen-depleted dead zone.

# THE OCEANS ARE OUR LAST GREAT HUNTING GROUNDS ... IF FISHERIES ARE MANAGED PROPERLY, AND IF DEPLETED FISH POPULATIONS ARE ALLOWED TO RECOVER, WE CAN REVIVE THE OCEAN WILDS

the coral reefs, mangroves and seagrass. That will not be easy. But there is evidence that, given proper protection, the number and size of fish in a marine protected area (MPA) can significantly increase. In turn this leads to improved catches outside the MPA as fish move in and out of the reserve. So coastal communities also see the benefits.

Take the story told by Azhar, head of the village of Lham Ujong in Aceh, an Indonesian province on the giant tropical island of Sumatra. Aceh suffered dreadfully during the Indian Ocean tsunami in 2004, which had its epicentre just offshore. Some 200,000 people in the province drowned as the tidal wave swamped the fish ponds and rushed into dozens of towns and villages in its path.

Where the coastal mangroves remained, people were often sheltered from the worst impact. But in Lham Ujong, villagers had removed most of the mangroves and turned the coastline into a succession of ponds to grow fish and prawns. It had been a lucrative business, but the human toll from the tsunami made everyone think again.

Azhar got behind an innovative scheme to combine fish farming with mangrove restoration. A decade on, he was able to show off 300,000 mangrove trees that his community had planted since the tsunami. Some were along the banks of the river running through the village; others had their roots in the waters of the fish ponds.

The trees had prevented erosion of the dykes and improved the quality of water in the ponds, raising fish yields and attracting crabs that villagers were now harvesting in large numbers.

The ecological benefits were clear, too. This was not a return to the days when wild boar, monkeys and even the occasional tiger lived here, but a tour of the ponds in the late afternoon sun revealed waterbirds everywhere and monitor lizards scurrying along the dykes.

Most of all, Azhar said, by bringing back mangroves, the village had improved the chances of future generations surviving another tsunami. At the same time, by planting the mangroves in clumps in the fish ponds, the village had kept the cash-raising power of the ponds. It was a good compromise that he hoped other communities still recovering from the tsunami would adopt, and not just in Aceh. His village has attracted visitors from other tsunami-hit countries, including Sri Lanka

OPPOSITE

**BRINGING BACK THE MANGROVES**
A team from the Bali Forestry Department plant mangrove seedlings in an estuary. As the mangrove trees colonize the mudflats, they will trap the sediment and create a barrier that will not only protect the area from erosion and storm surges but also create fish nurseries that will improve catches for the local fishers.

OPPOSITE
**NURSERY ROOTS**
An archerfish swims past
red mangrove roots covered
in soft-coral polyps in the
Misool reserve in Indonesia's
Raja Ampat archipelago.
The mangrove forest is home,
breeding ground and nursery
for marine species ranging from
corals to saltwater crocodiles.

NEXT PAGE
**PART OF THE COMMUNITY**
Father and son fishers in their
wooden outrigger glide over a
shallow coral reef in Kimbe Bay,
on the coast of New Britain, Papua
New Guinea. This deep-water
basin is punctuated by coral-
topped seamounts and fringing
reefs, with a huge diversity of
species. A network of protected
spawning, nesting and nursery
areas in the bay, overseen by
the local community, is helping
conserve the resources that the
fishers rely on.

and Thailand. All were keen to see how this novel combination
of old and new, of ecology and economics, was being achieved.

The Indonesian archipelago, with more than 13,000 islands
stretching between the Indian and Pacific oceans, has more
coral reefs, mangroves and seagrass than anywhere else on Earth.
And everywhere rural communities are starting to appreciate the
benefits of reviving coastal ecosystems. Since the 2004 tsunami,
Aceh alone has planted 2 million mangroves and other trees
along its coastline.

There is similar interest in reviving coral reefs in the Raja Ampat
islands, off the province of West Papua. Here coastal communities
have helped establish the Misool Marine Reserve – nearly twice the
size of Singapore – to protect one of the world's most biodiverse
reef systems.

The reserve encompasses 120,000 hectares (296,525 acres) of
reefs that had previously been damaged by dynamite fishing, general
overfishing and shark fishing. But such activities are now banned, and
at the heart of the reserve is a 'no-take zone' where all fishing and
other activities such as collecting turtle eggs are prohibited.

The villagers have leased part of the reef to a high-end diving resort,
which generates tourist revenues. In return they also receive incomes
from jobs as park rangers and pilots on patrol boats that see off
foreign fishing boats after shark fins and turtles.

The ecological effects have been dramatic. In the first six years of the
scheme, local fish stocks increased by an estimated 250 per cent; shark
and manta ray numbers were 2,000 per cent higher. The project has
become a pathfinder as the Indonesian government recruits coastal
communities to police a planned 20 million hectares (49.4 million
acres) of marine protected areas that it intends to establish across
the country by 2020.

Indonesia is not alone. Sri Lanka, which lost more than 30,000
lives in the 2004 tsunami, has become the first country to promise
to protect all of its mangroves. In 2015, its government made good
on this promise. Through the Small Fishers Federation – a local
non-governmental organization – it began recruiting 15,000 village
women to help protect the 9,000 hectares (22,240 acres) of surviving
mangroves and plant 4,000 hectares (9,885 acres) of new mangroves
in 48 coastal lagoons.

Sri Lanka is a global hotspot for mangrove biodiversity, with
at least 20 different species around its shores. The mangroves are
also day-to-day life-givers for much of the country. Two thirds of
Sri Lanka's protein come from fish, and 80 per cent of its fish
come from the coastal lagoons where mangroves grow.

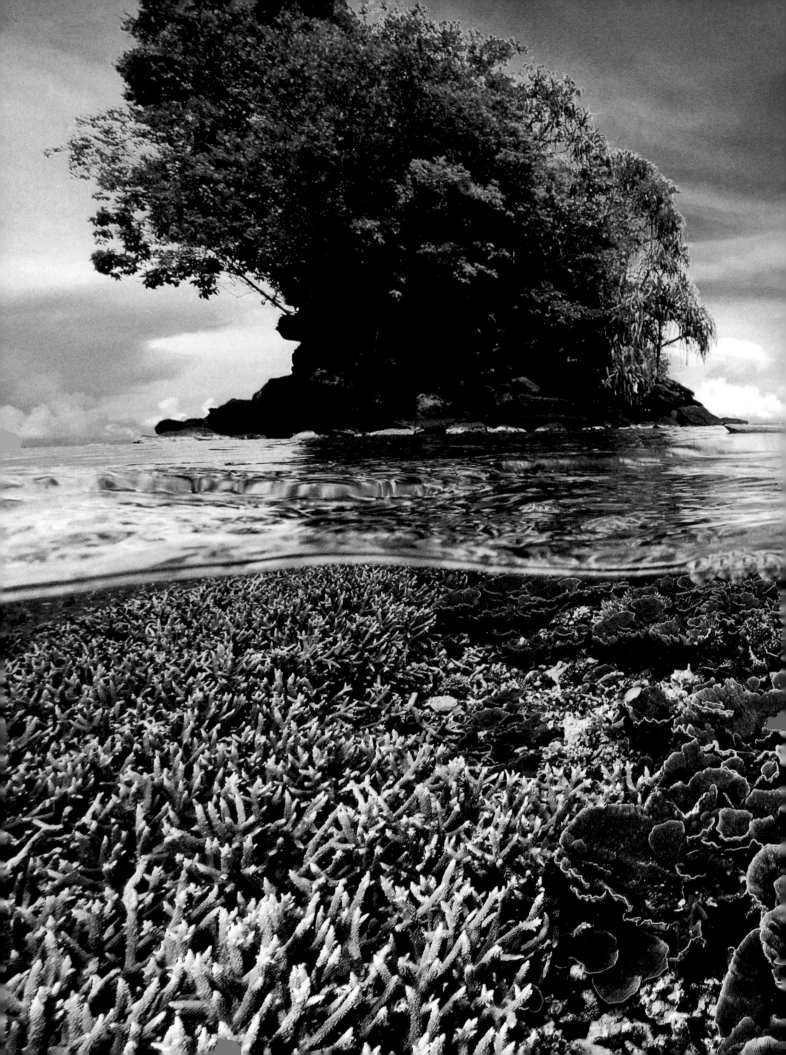

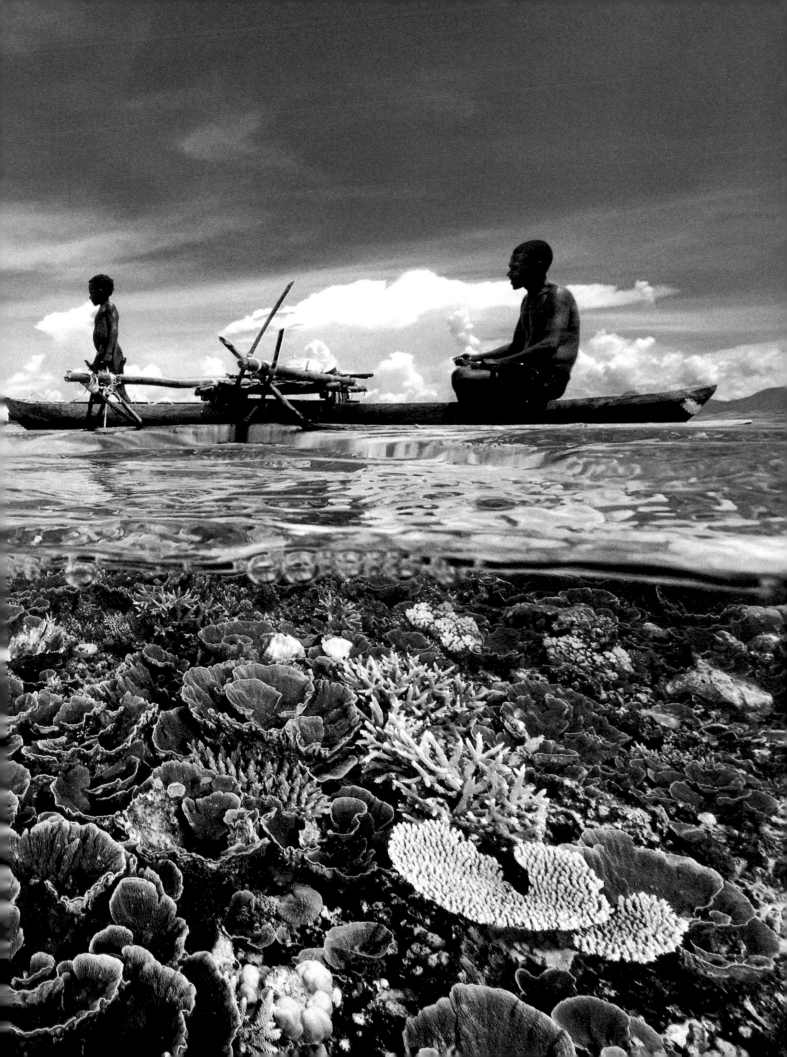

# FORESTS IN THE SEA

Coastal ecosystems outside the tropics are often dominated by forests of kelp. This giant seaweed looks more like an underwater tree. It is one of the fastest growing plants on Earth. It sinks roots into the seabed and can grow up to half a metre (1 foot 8 inches) a day, reaching 45 metres (148 feet) high and spreading a thick canopy across the water near the ocean surface. Kelp forms giant underwater forests off Australia and southern California, and can be found from southern Chile to Scotland, and Tasmania to the Russian Far East.

Kelp forests are not well mapped in much of the world, but some estimate that they cover as much as a quarter of all the world's coastlines. Many are rich in biodiversity, including commercial fish and shellfish.

Kelp forests may be big and fast-growing, but they are also vulnerable to intensive grazing by marine life whose own predators have been fished out, and they can also be ripped up by storms. Sea urchins eat kelp in such quantities that they can destroy entire forests. In Tasmania, they are held largely responsible for a 95 per cent decline in the once-extensive kelp forests there. Biologists call the resulting marine deserts 'urchin barrens'.

A global study in 2016 found declines in 38 per cent of kelp forests. Sea urchins were partly to blame. But the survey also found that in 27 per cent of regions, kelp forests had increased their extent. Off the west coast of Canada, they have been expanding because of the resurgent populations of sea otters, which eat sea urchins. Lobsters have done the same good deed off New Zealand, and so have sheephead wrasse in California's Channel Islands. The good news is that, like much in the coastal oceans, despite their vulnerability, kelp forests are also able to recolonize fast.

ABOVE A California sheephead wrasse among a forest of giant kelp. It is a key predator of kelp-eating sea urchins.

But in recent decades, as many of the mangroves have been replaced by prawn farms, catches in the lagoons fell from 20 kilograms (44 pounds) a day to about 4 kilograms (9 pounds), says the Small Fishers Federation's founder Anuradha Wickramasinghe. He hopes the restoration will bring back the fish too. He says, 'For Sri Lankan fishers, the mangroves are the roots of the sea.'

Such initiatives need scaling up. The great hope globally for marine ecosystems and the fish they nurture is for the development of a global network of marine protected areas to complement protected areas on land.

The spread of marine protected areas since 2000 has been rapid. They now cover about 7 per cent of the world's oceans, ten times more than two decades ago. And the coverage rises to 16 per cent for coastal waters within national jurisdictions, which is roughly the same as the proportion of land protected worldwide.

The biggest new additions since 2010 have been around the Pitcairn Islands, a British overseas territory in the South Pacific that has some of the world's most pristine and deepest coral reefs; the adjacent Cook Islands, with 15 atolls that are home to some of the world's rarest seabirds; and the US's Hawaiian Islands in the North Pacific, the largest protected area on the planet and home to the endangered Hawaiian monk seal and more than 1,500 species found nowhere else.

Many of these protected areas cover coral reefs. About a quarter of all reefs now have some form of protection. They include some of the largest and most important. Protection, though, is far from perfect. The Great Barrier Reef off Australia, for instance, is now largely inside a marine park. But no-take zones, where breeding fish are protected by a ban on all fishing, cover only about a third of the park. And ships headed for foreign markets carrying coal from Queensland and other materials continue to sail through the reef. There have been accidents.

Better news is that, in 2017, oil prospecting was banned from around the 300-kilometre-long (190-mile) Belize Barrier Reef, home to some 1,400 marine species, including hawksbill turtles, manatees, rays and six types of shark, and part of the Mesoamerican Reef, the largest reef system in the western hemisphere.

## FISHING: WHEN LESS IS MORE

Of the marine fish populations that are commercially exploited, more than 30 per cent are overfished and nearly 60 per cent are being fished to maximum levels, according to the UN Food and Agriculture Organization. At the same time, fish consumption is increasing. The solution is to set and enforce quotas, remove subsidies, reduce bycatch (the capture of non-target animals) and provide marine protected areas where populations can recover.

**FISH EXPLOITATION 1974**

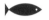

**Populations overfished** 10%

**Populations fully fished** 50%

**Populations underfished** 40%

**FISH EXPLOITATION 2016**

**Populations overfished** 31.4%

**Populations fully fished** 58.1%

**Populations underfished** 10.5%

OPPOSITE
**RUBBISH**
A box of 'bycatch' – in this case, the unwanted bottom-living creatures from a Mediterranean dredging haul. The incidental catch about to be thrown overboard includes starfish, sea urchins, gurnards, octopuses, anglerfish and juvenile horse mackerel. Market demand rather than legal constraints determines what gets thrown away, but the trawling itself is indiscriminate.

NEXT PAGE
**BATTERED BARRIER**
Part of the Great Barrier Reef, a World Heritage Site that provides coastal protection to Australia's east coast. Its future depends on curbing mining development and nitrogen and sediment run-off from agriculture and logging. But a real threat is a warming ocean that has already killed half of the coral.

The evidence is that a well-run marine protected area can have spectacularly beneficial effects. 'Species come back more quickly than people anticipate – in three or five or ten years. And where this has been done, we see immediate economic benefits,' says Boris Worm, marine conservationist at Dalhousie University in Canada. In some cases, marine protected areas can increase fish catches fourfold and raise biodiversity by a fifth. But while protected areas can ensure that more young fish leave their coastal nurseries for the oceans, the benefits for fish stocks will be small unless there are also restrictions on fishing across the oceans. But here again there is growing evidence that simple measures to prevent overfishing can have major benefits for both ecosystems and fish populations.

A recent study of almost 5,000 fisheries worldwide, covering four fifths of the global fish catch, concluded that common-sense management could within about ten years increase the fish in the sea by more than 600 million tonnes, generate $53 billion in profit and allow a sustainable catch about a fifth higher than today.

These findings are a vivid reminder that sensible conservation can both revive nature and increase the amount that humans can safely take from it, supporting both people and the planet.

## SIMPLE MEASURES TO PREVENT OVERFISHING CAN HAVE MAJOR BENEFITS FOR BOTH ECOSYSTEMS AND FISH POPULATIONS

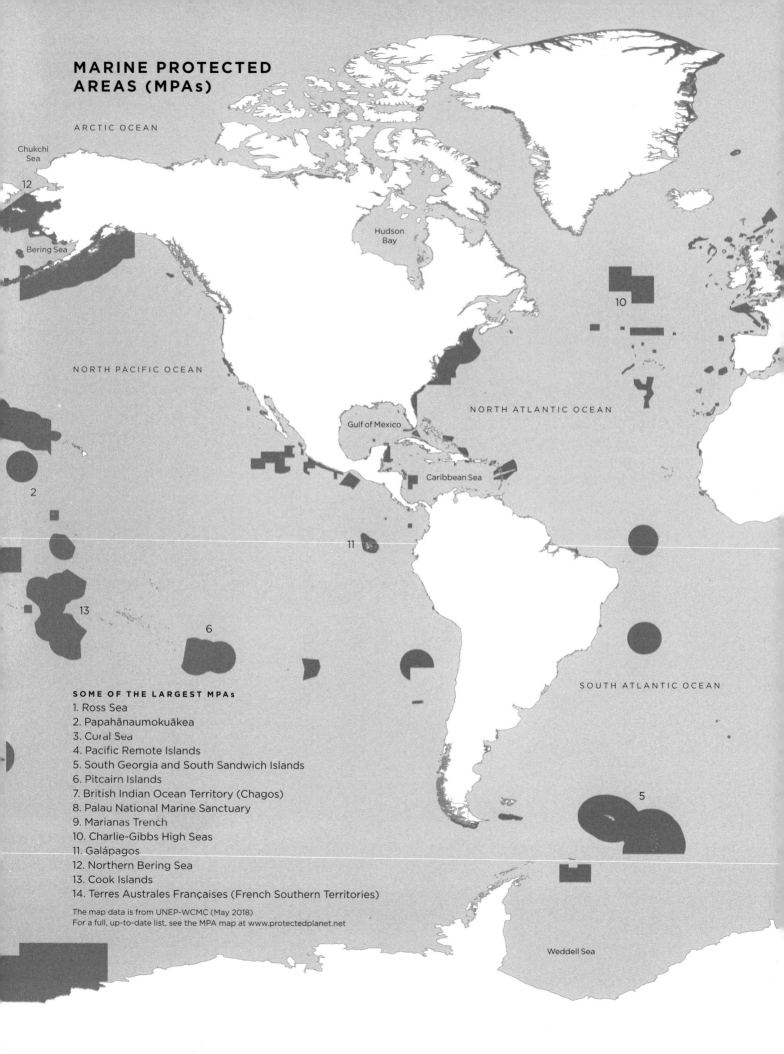

# MARINE PROTECTED AREAS (MPAs)

ARCTIC OCEAN

Chukchi Sea

12

Bering Sea

Hudson Bay

NORTH PACIFIC OCEAN

10

NORTH ATLANTIC OCEAN

Gulf of Mexico

Caribbean Sea

2

11

13

6

SOUTH ATLANTIC OCEAN

**SOME OF THE LARGEST MPAs**
1. Ross Sea
2. Papahānaumokuākea
3. Coral Sea
4. Pacific Remote Islands
5. South Georgia and South Sandwich Islands
6. Pitcairn Islands
7. British Indian Ocean Territory (Chagos)
8. Palau National Marine Sanctuary
9. Marianas Trench
10. Charlie-Gibbs High Seas
11. Galápagos
12. Northern Bering Sea
13. Cook Islands
14. Terres Australes Françaises (French Southern Territories)

5

The map data is from UNEP-WCMC (May 2018)
For a full, up-to-date list, see the MPA map at www.protectedplanet.net

Weddell Sea

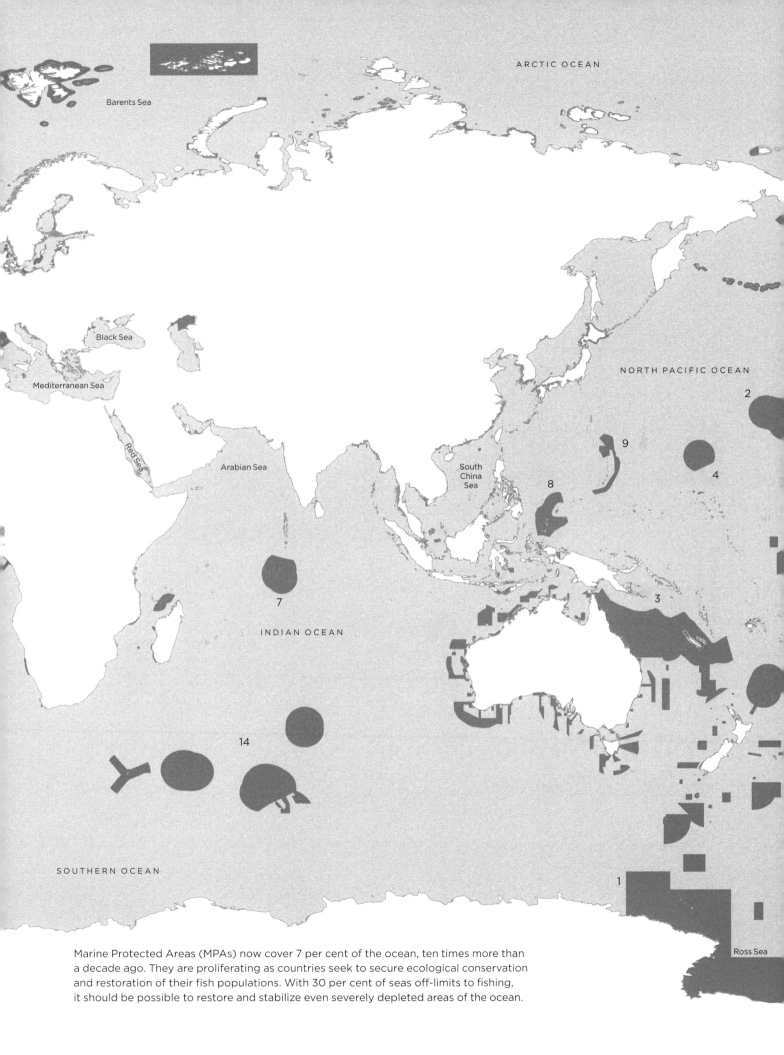

ARCTIC OCEAN

Barents Sea

Black Sea

Mediterranean Sea

Red Sea

Arabian Sea

NORTH PACIFIC OCEAN

2

9

4

8

South
China
Sea

3

7

INDIAN OCEAN

14

SOUTHERN OCEAN

1

Ross Sea

Marine Protected Areas (MPAs) now cover 7 per cent of the ocean, ten times more than
a decade ago. They are proliferating as countries seek to secure ecological conservation
and restoration of their fish populations. With 30 per cent of seas off-limits to fishing,
it should be possible to restore and stabilize even severely depleted areas of the ocean.

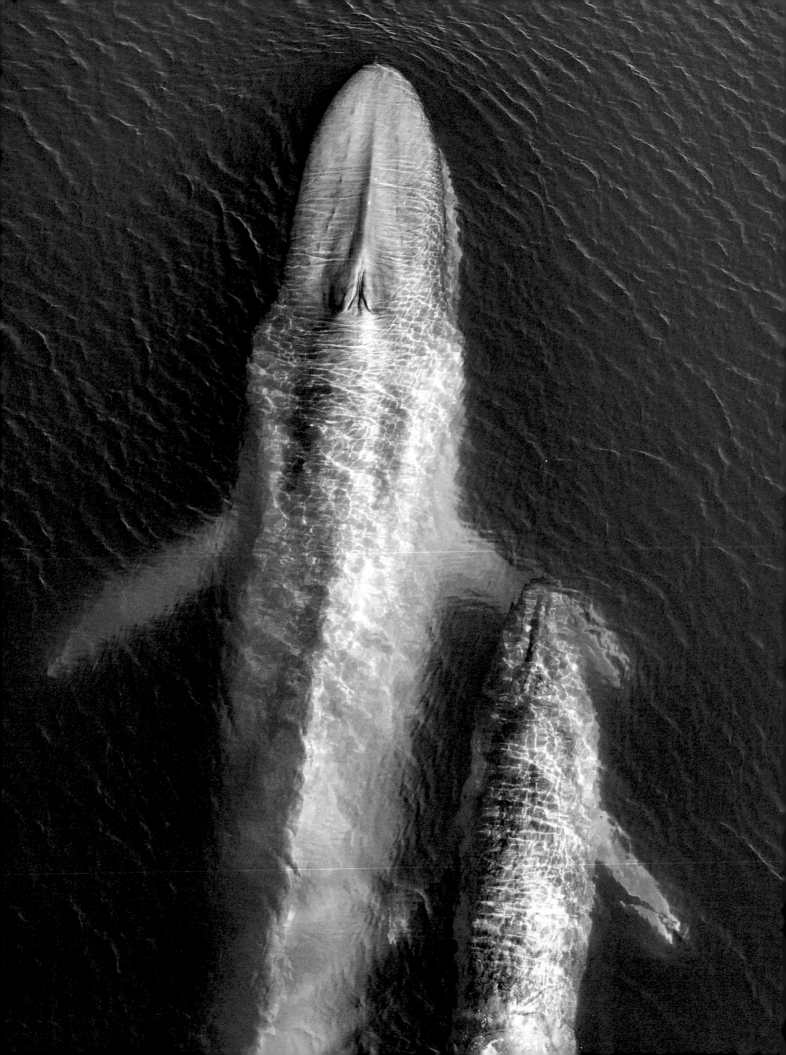

# HIGH SEAS

'For millennia, the ocean has been the lifeblood of all living things and the crossroads of civilizations. Humans have only been able to explore under the sea with comparative freedom since 1943, when Jacques Cousteau first tested his Aqua Lung device. In the short time since then, we have barely begun to unravel the ocean's mysteries, but we have managed to unleash a torrent of destruction. We have changed the climate, our plastics and chemicals have reached the depths and what was once seen as an inexhaustible bounty of seafood is now disappearing. Still, hope exists. History suggests that, if we try, there is no problem we cannot solve, no challenge we cannot overcome. We possess the ability to build a thriving, healthy world for ourselves and for future generations.'

**PHILIPPE AND ASHLAN COUSTEAU**
Ocean explorers, environmental advocates, journalists and film-makers

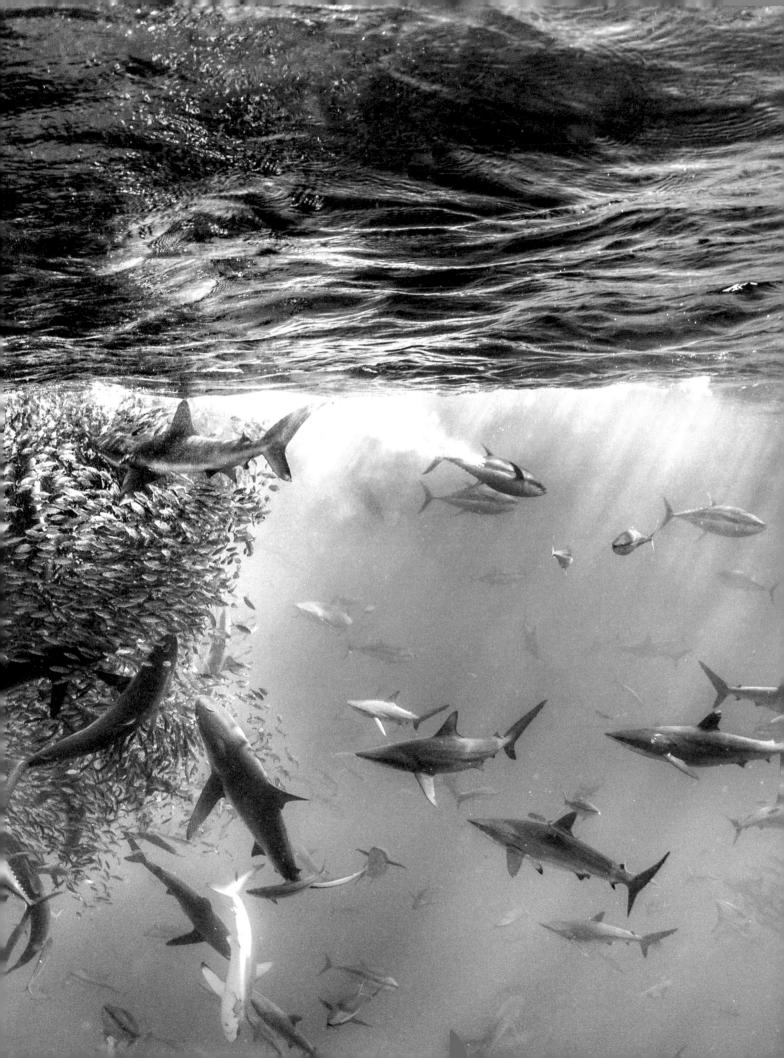

# THE MORATORIUM … HAS GIVEN THE GREAT WHALES A WINDOW FOR RECOVERY AND OFFERS A BEACON OF HOPE FOR RESTORING NATURE IN THE TWENTY-FIRST CENTURY

OPPOSITE
**HOW IT USED TO BE**
A super-pod of more than 100 humpback whales feeds in the South Atlantic, off South Africa, consuming krill and other small crustaceans in the nutrient-rich waters. This may well have been a common sight in the days before industrial whaling decimated humpback numbers.

PREVIOUS PAGE
**PREDATOR PLENTY**
A feeding frenzy of open-ocean predators in the Pacific off Mexico's remote Revillagigedo Islands. Feeding together on a ball of chub and shad are sharks – silky, dusky, Galapagos and blacktip – yellowfin tuna and rainbow runners. Attacking from all sides, they are keeping the circling ball trapped against the surface, blocking the fish from fleeing to the depths.

OPENING PAGE
**BLUES COMING BACK**
A blue whale mother and calf off Mexico. Before whaling, there were probably a quarter of a million great blue whales; today there are 10,000. But numbers of these long-lived giants are slowly increasing.

NEXT PAGE
**BIG MOUTH**
A humpback whale feeding off South Africa takes a huge mouthful of krill. In a day, it may strain more than half a ton of krill from the water.

In the 1970s and 1980s, environmental campaigning included much about whales, about halting the barbarities of a global whaling industry in full cry and the exploitation of these huge marine mammals. By the 1980s, more than two thirds of the great whales had disappeared into the bowels of giant whaling ships, destined to be turned into everything from corsets to sushi, candles to margarine, and perfume to lipstick. The final indignity for these great creatures was that the harpoons that exploded in them often contained nitroglycerine made from their blubber.

During its heyday, whaling had social kudos. But the reputation of whalers was shredded by the imagery of campaigners riding tiny inflatable boats to place themselves between harpoon and whale.

In 1986, the International Whaling Commission finally voted to impose a global moratorium on commercial whaling. Despite transgressions from Japan, Norway and Iceland, the moratorium persists. It has given the great whales a window for recovery and offers a beacon of hope for restoring nature in the twenty-first century.

The 13 species of great whales are the giants of the oceans. They include the largest animal ever to live on the Earth. Blue whales grow up to 30 metres (100 feet) long, weigh up to 175 tonnes and have hearts the size of a car. No dinosaur was ever bigger.

Before the whalers got to work, their vast numbers and large size ensured that they dominated ocean ecosystems. Two thirds of all the plankton consumed by marine life in the North Pacific ended up feeding them.

But they are not plunderers of marine life; they help sustain it. By eating at depth and excreting at the surface, they recycle nutrients from the depths, a phenomenon known as the 'whale pump'. And then when they die, their rotting carcasses sink to the ocean floor, providing meals for scavenging creatures for up to 80 years, delivering millions of tonnes of nutrients back to the marine ecosystems.

They stir the oceans laterally as well as vertically. Humpbacks, for instance, are known to migrate as much as 19,000 kilometres (11,800 miles) over a year, feeding for half the year in polar waters and then swimming to the tropics to breed but not feed, taking nutrients with them as they go. Far from ransacking the oceans, whales maintain nutrient cycles for the benefit of all marine life.

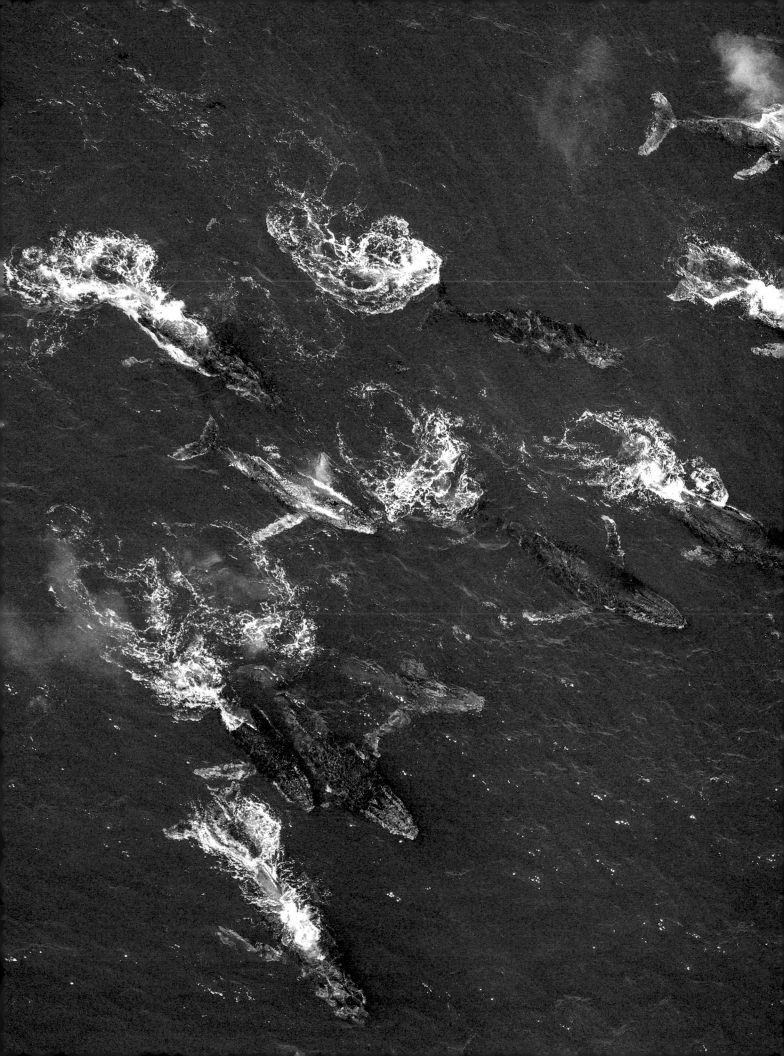

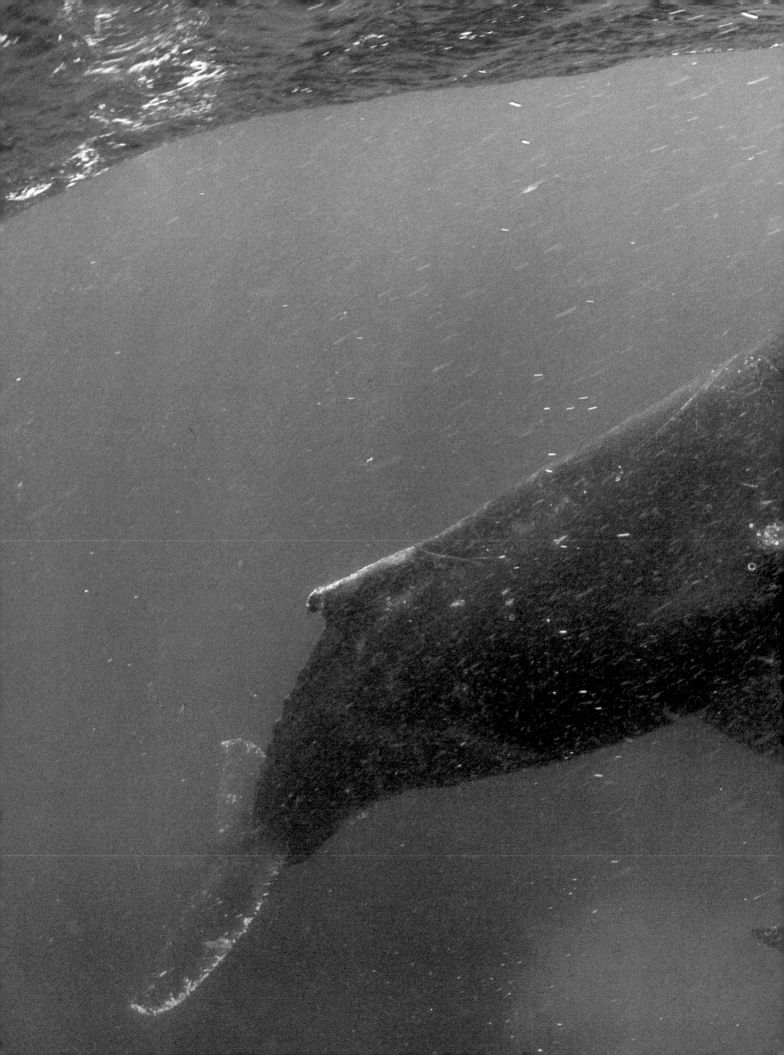

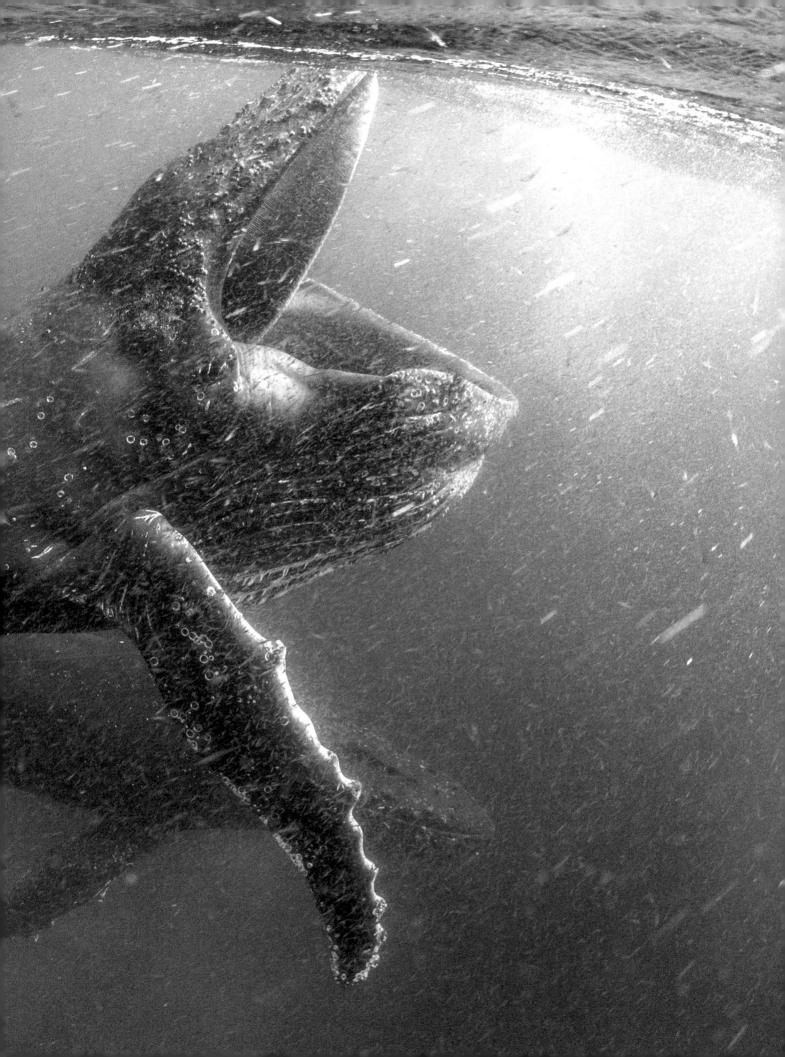

# THE HIGH SEAS ARE THE LAST AND LARGEST WILDERNESSES ON EARTH ... THEY PROVIDE MOST OF THE SPACE FOR LIFE ON EARTH

OPPOSITE

**TUNA FEAST**

Pacific bluefin tuna feed on a mass of northern anchovies off California. In turn, tuna – the most valuable of fish – are hunted by humans. Ninety-seven per cent of Pacific bluefin tuna have been fished out. Anchovies reproduce fast and populations can recover relatively quickly, whereas tuna, like many large, slow-growing predators, take years to mature.

NEXT PAGE

**PREDATORS AS PREY**

Wild-caught Atlantic bluefin tuna, some nearly 2 metres (6 and a half feet) long, being fattened up in a holding pen in the Mediterranean. Both Atlantic and Pacific bluefin tuna have been overfished, putting their populations at risk in the wild.

The decline of the great whale populations started a long time ago. Commercial whaling goes back a thousand years, to when the Basque people of Spain first set sail to catch Atlantic right whales. The hunt spread, and as coastal whale populations were hunted out, their pursuers went further afield. By the late eighteenth century, fortunes were being made in the Arctic, and later across the planet. Whaling was one of the first truly global businesses.

By the mid-twentieth century, in an era of giant factory ships that processed carcasses at sea, as many as 50,000 whales were being killed annually. Much of the slaughter was never officially recorded. Memoirs of Russian whaling inspectors published after the moratorium revealed that, in the three years from 1959 to 1961, Soviet whaling fleets killed 25,000 humpback whales in the Southern Ocean alone, while reporting a catch of just 2,710.

Whaling fundamentally changed ocean ecosystems. Modern genetic studies suggest there may have been 1.5 million humpback whales cruising the world's oceans, a similar number of minke whales, and perhaps a quarter of a million giant blue whales. With both humpbacks and blue whales reduced to a few thousand animals, the oceans are dominated by small creatures. In the tropical Pacific, for instance, where sperm whales once flourished, squid now do. With most of the blue whales gone from the Southern Ocean, there is more krill to be eaten by growing populations of fur seals.

Can we return to the days when the leviathans ruled the high seas? It is hard to be sure, especially with the growing threats to whales from pollution, noise, strikes from ship propellers and fishing nets. But these days, with whale-chasing boats mostly full of tourists – a 2-billion-dollar industry – a partial recovery is under way.

Half a century ago, blue whales were thought 'functionally extinct'. But since the moratorium, their numbers – though still very small – have roughly doubled. Grey whale calving grounds in the Sea of Cortez off the west coast of Mexico are again full of whales. Humpbacks are doing even better. A surviving population of a few thousand has in three decades grown more than tenfold to around 100,000. This may be a fraction of the population in the distant past, but it is approaching the number in the oceans at the start of the twentieth century. And their numbers are still growing – a triumph for the fecundity and resilience of the oceans. Maybe the era of the big beasts can return.

274

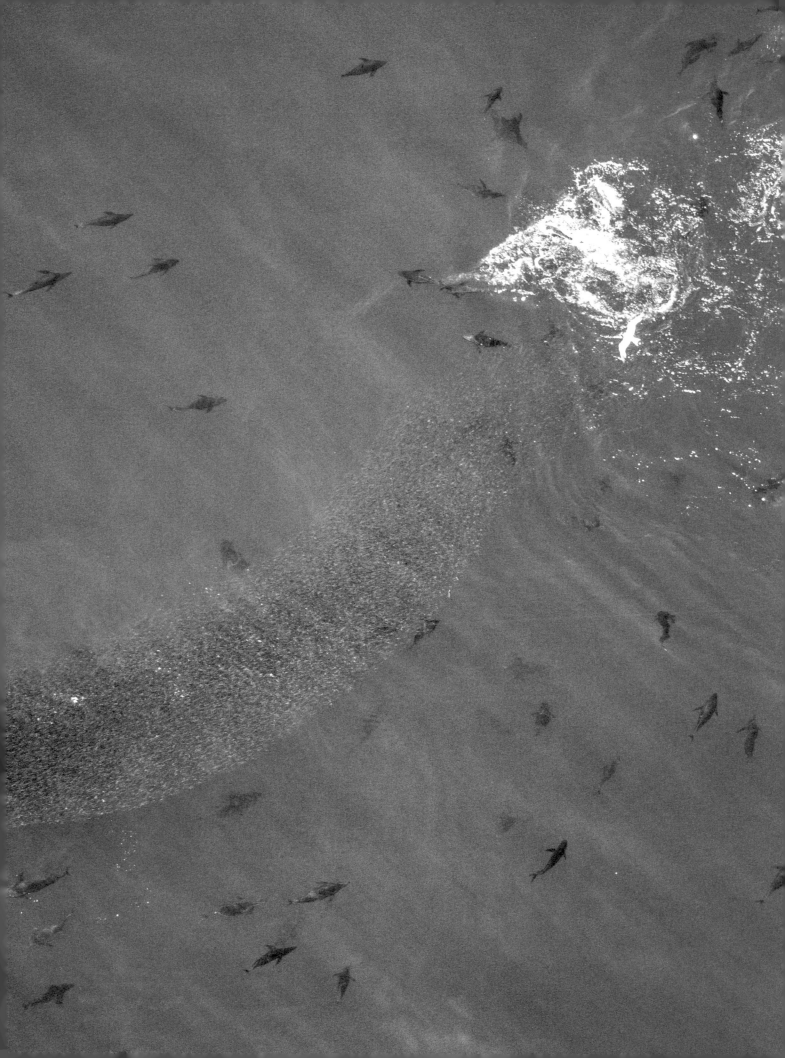

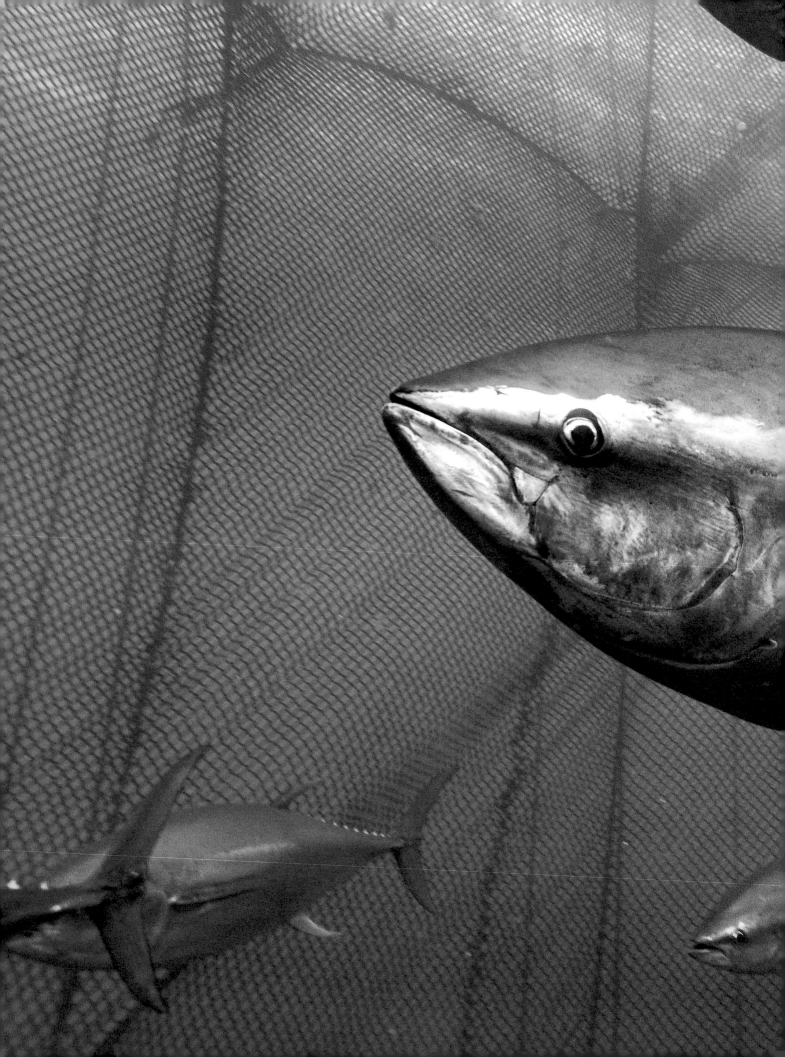

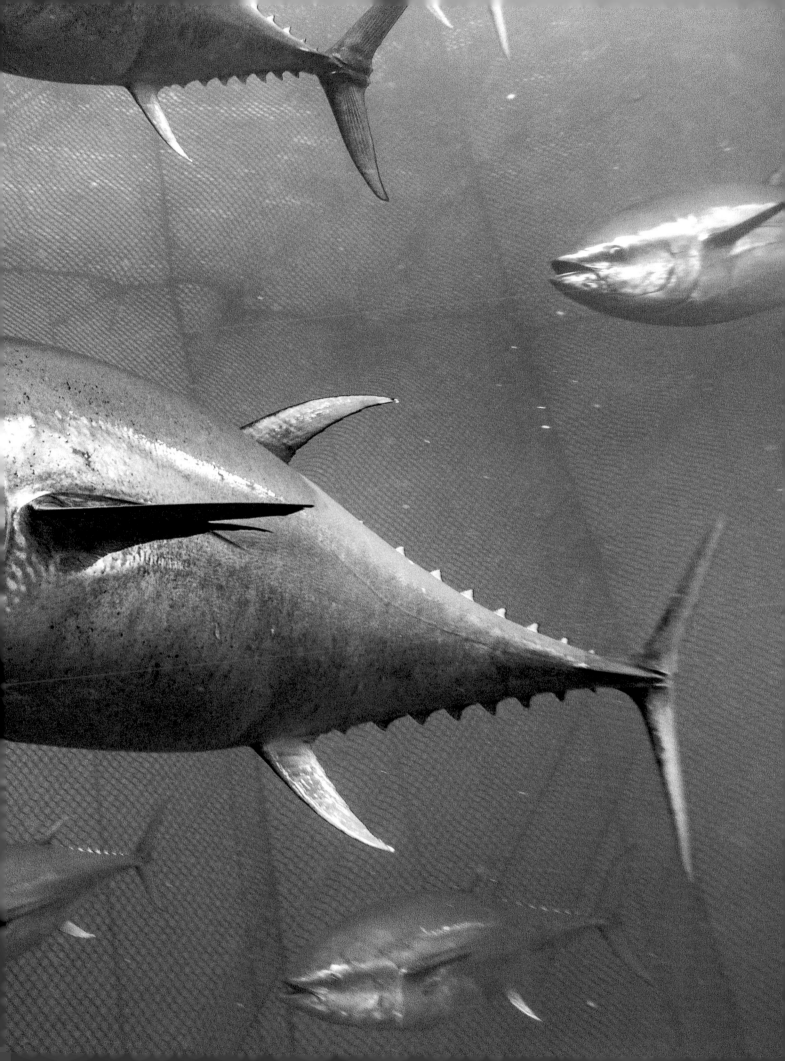

The high seas are the last and largest wildernesses on Earth. Stretching to the horizon from the shallow shelves that fringe the continents, they cover half the planet's surface, and are on average 4 kilometres (2.5 miles) deep. The high seas also provide most of the space for life on Earth – from surface ecosystems powered by sunlight, to species-rich hotspots on the dark seabed around volcanic vents. Just half a century ago, we did not know such deep ecosystems existed. Even today, less than 5 per cent of the oceans have been explored.

Let's begin at the surface. On the high seas, bluefin tuna are the kings of fish. They can live for up to 50 years and grow as heavy as a horse. And, like horses, they are speedy, able to power through the ocean at up to 80 kilometres (50 miles) per hour. Unlike most fish, tuna are also warm-blooded, allowing them to hunt in cold water and achieve bursts of energy unattainable by most cold-blooded creatures.

They work in packs, moving in on shoals of fish such as mackerel, herring and anchovies. When they feed, the commotion draws in other predators. Seabirds move in to snatch fish driven to the surface. Distant sharks detect fish oils in the water and arrive to take what the tuna leave behind. But despite their skills and ability to travel almost anywhere in the oceans, all three species of bluefin tuna are in dire straits. Not surprisingly, perhaps, for they are now million-dollar fish, literally.

The Japanese eat 80 per cent of the world's high-end tuna, mostly for sushi and sashimi. Much of the world's catch is sold in Tokyo's fish market. At the pre-dawn auctions, a single bluefin tuna more than 2 metres long (6 and a half feet) can sell for up to a million dollars. The market in bluefin tuna alone is worth more than $2 billion a year.

About 10 per cent of the world's total fish catch comes from the high seas. But in cash terms, tuna and other high-value ocean-going fish mean their value at market is far greater. Such riches encourage these species to be targeted and overfished. Some 90 per cent of all the big fish that once populated the high seas are gone, which includes the largest predators such as billfish and sharks as well as tuna. The Pacific bluefin tuna has lost 97 per cent of its population.

As the number of fish at the surface dwindles, fishing fleets are setting their nets at ever greater depths. Around 40 per cent of the world's fishing grounds are now in waters deeper than 200 metres (655 feet), and bottom trawlers are scraping seabeds at as much as 2 kilometres

# DEEP-SEA CORAL RICHES

They aren't the most famous ecosystems. Few people hit the streets to protect the Louisville Ridge, the Hatton Bank or the Flemish Cap. But these little-known biological wonders of the deep have cold-coral ecosystems that are threatened by fishing trawlers scraping heavily chained nets along the sea floor – a process that destroys whole ecosystems.

'Most of the deep ocean is unprotected from these and other activities and so we risk losing so much of enormous value, even before we fully understand it,' says Lyndsey Dodds, Head of UK and EU Marine Policy at WWF. They include the Rockall and Hatton banks, west of Scotland. Parts of Rockall are within European Union territorial waters and protected by an EU ban on bottom-trawling below 800 metres (2,625 feet). But those outside Hatton Bank are not, despite recommendations from the International Council for the Exploration of the Sea, a body that provides the scientific advice to the European Union on fisheries.

On the other side of the Atlantic, more than a third of sponges and corals are at risk from trawlers scraping the Grand Banks and the nearby Flemish Cap, two important fishing grounds outside Canadian waters. But the regional fisheries organization continues to allow fishing there, threatening the ecosystems on which future fishing will depend.

Things are no better in the South Atlantic, where fleets trawl the Patagonian shelf off Argentina, hunting grounds for seals, sea lions and penguins. And in the Southwest Pacific, New Zealand fishers continue to trawl for orange roughy on the Louisville ridge, a chain of underwater mountains 4,000 kilometres (2,485 miles) long that is rich in rare species such as bioluminescent bamboo coral.

Cold-water coral in the deep oceans turns out to be almost as threatened as the coral reefs of the tropics.

ABOVE A basket star on a deep-sea, cold-water *Lophelia pertusa* coral reef in the Gulf of Mexico.

**DEEP-SEA GIANT**
At night, a 7-metre (23-foot) oarfish swims up from the deep in the Mediterranean to feed on plankton. It's the world's longest fish, which can be up to 17 metres (56 feet) long. As with almost all deep-sea creatures, very little is known about its behaviour or the ecology of its environment.

NEXT PAGE
**SPINNER SQUADRONS**
Hundreds of spinner dolphins, in pods – small social groups – travel to their feeding grounds off Costa Rica. These oceanic predators are built for fast travel, cutting down on water drag by alternately swimming and coasting. They travel far over distance and depth, sweeping the ocean with ultrasound in search of high-energy food such as the deep-sea lanternfish. Huge pods of spinners come to this area of the Pacific, where lanternfish have not been overexploited by fisheries.

(1.25 miles) down. It is a serious threat to marine ecosystems. For one thing, the trawls can destroy deep-water ecosystems, notably cold-water coral reefs and sponge communities. For another, the fish themselves are much more vulnerable to overfishing. At the surface, survival goes to the swiftest. Such species generally have fast metabolisms and often reproduce quickly. But at depth, fish grow slowly and live longer. These populations can decline rapidly and recover only very gradually.

Once it was thought that waters away from the surface were largely empty. That seemed logical. They lacked nutrients from coastal ecosystems and had little or no light. Thus the two basic requirements for life were missing. But that turns out to be wrong. Life below is thriving, adapted to the cold, dark and high-pressure conditions.

As you descend beneath the waves, and light levels drop, some fish are bioluminescent, making their own light to lure prey or spot predators. Go deeper again, and eyes have little purpose. Some fish compensate for the scarcity of prey at depth with big mouths that catch whatever they encounter. The extreme case is the black swallower fish. By unhinging its jaw and extending its stomach, it can swallow prey as big as itself and as much as ten times its weight.

This is the stuff of nightmares. Giant squid have tentacles that can grow to 18 metres (59 feet). It was only in 2012 that the first living specimen was filmed in its natural habitat. Then there are oarfish. Shaped like an oar, they can grow to 17 metres (56 feet) in length. They live mostly at depth, but make a nightly vertical migration, knifing upwards for hundreds of metres to feed on plankton in the still surface water. Then they disappear back to the depths as dawn approaches. Rarely seen unless brought ashore after a storm, the oarfish may be the origin of myths about giant sea serpents. In Japanese folklore, they are called 'messengers from the sea god's palace', as their occasional appearances are thought to portend tsunamis.

Still further down are even more weird and wonderful beasts. There are few myths about these, because they never surface. Even the most abundant were completely unknown until recent times. They depend for sustenance on the nutrient fallout from above, when whales and other creatures defecate and die – a fallout known as marine snow.

The hadal zone is the name given to the ocean's deepest areas, named after Hades, the Greek god of the underworld. The deepest-living fish we know of currently is the small, translucent hadal snailfish. These have been found more than 8 kilometres (5 miles) down, where they experience pressure 800 times that at the surface. The snailfish eat amphipods – crustaceans that themselves live on the marine snow.

But not all life on the ocean floor depends on fallout from above. The richest ecosystems on the deep ocean floor are volcanic vents.

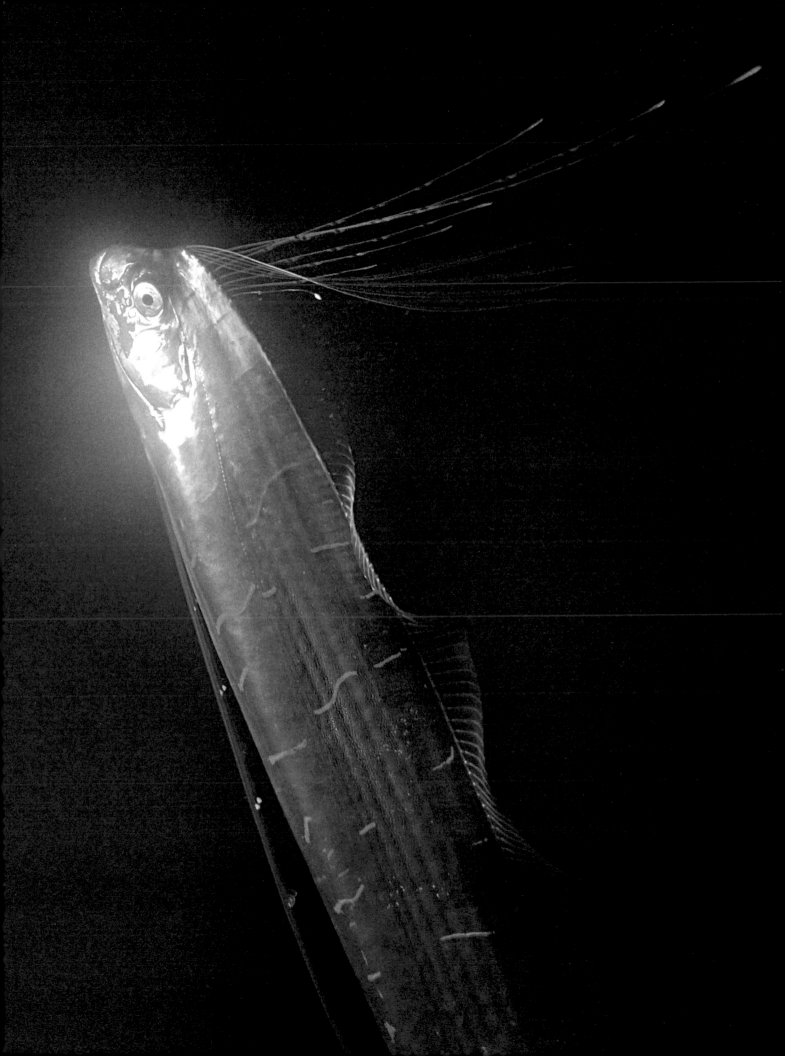

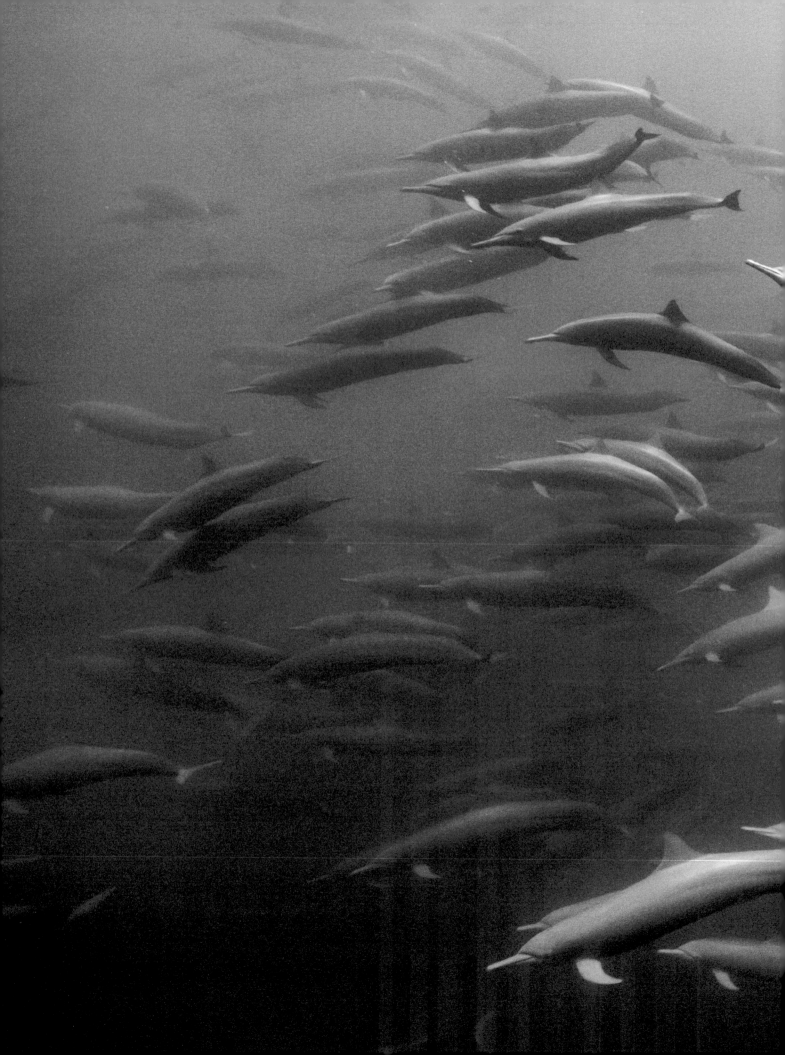

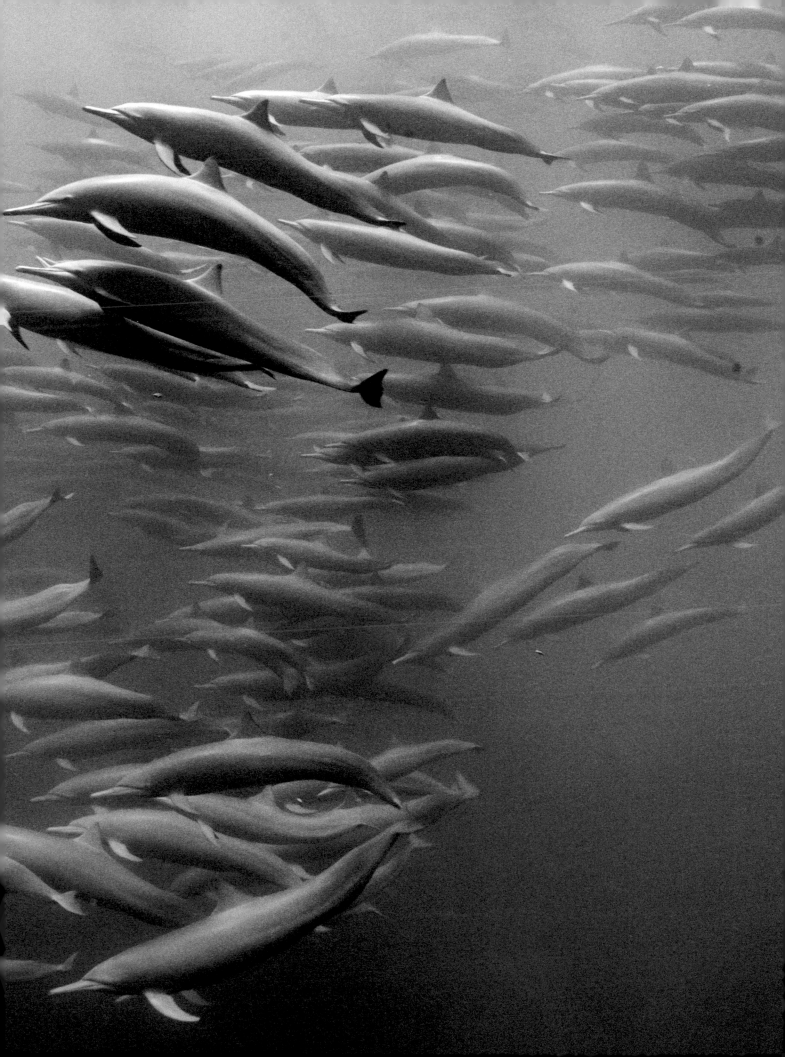

Also known as hydrothermal vents, or black smokers, they occur at the edges of the continental plates on the ocean floor. These cracks allow sea water to penetrate down into the hot crust of the Earth. This water is rapidly heated and often dissolves minerals and metals from the rocks – among them sulphur, gold and copper. Where the scalding water bursts back into the cold ocean, its rapid cooling causes the minerals and metals to come out of solution and pile up in funnels of metal sulphides that can grow tens of metres high around the vents.

From time to time the funnels collapse and spread over the seabed. In these piles, biological alchemy happens. Specialized deep-ocean bacteria invade the rubble and process the sulphides, converting them to energy and organic matter for their own growth. This process is chemosynthesis – a deep-water equivalent of the photosynthesis that happens at the surface, but without the need for light.

The bacteria form thick mats that attract other creatures such as amphipods, which graze on the bacteria, and other creatures that prey on the amphipods. Tube worms standing up to 2 metres (6 and a half feet) high are usually the largest creatures in these black-smoker ecosystems. Also frequent are yeti crabs, with hairy legs and claws, and deep-sea versions of snails, barnacles, white eels and octopuses.

The first hydrothermal vents were discovered in only 1977 near the Galápagos Islands in the Pacific. Dozens more are now known, on the Mid-Atlantic Ridge, around the fringes of the Pacific, in the Indian Ocean and as far south as Antarctica. Many scientists think life on Earth may have begun in these vents more than 4 billion years ago. They should have the highest conservation priority. But there is a snag. The vents are releasing metals in concentrations richer than any other deposits now available. So, despite the cost and risks of operating kilometres beneath the waves, some specialized mining companies are prepared to invest heavily in the hope of significant rewards.

The oceans are not just potentially vast reservoirs of minerals and fish. They are the drivers of the climate and the weather. Their huge stores of heat taken from the atmosphere make them a stabilizing influence. Today, as the atmosphere continues to warm, much of the heat in the air is absorbed by the oceans and works its way down. The oceans also absorb polluting gases from the air, including about a third of the carbon dioxide we pump into the atmosphere. This is

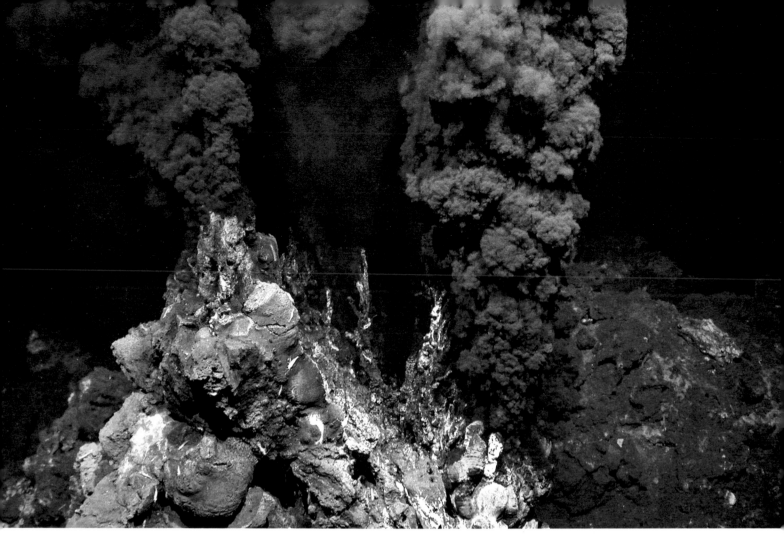

another way in which the oceans currently protect us from the worst-case climate change scenario. As well as absorbing gases and heat, the oceans also 'breathe out'. Half of all the oxygen we breathe comes from phytoplankton growing in the surface of the oceans.

Critical to the ocean's ability to keep our planet's surface habitable is a deep-ocean circulation known as the ocean conveyor. It is the great distributor. It begins at the surface in the Arctic, where cold sea water sinks to the ocean floor, and travels the depths around the planet for roughly a thousand years before surfacing in the warm Atlantic current known as the Gulf Stream, the current that brings warmth to northwest Europe. It stirs the oceans but also absorbs harmful things such as carbon dioxide from the atmosphere. Recent research suggests the conveyor may be vulnerable to climate change. That is alarming because its loss could reduce the high seas' ability to absorb heat and carbon dioxide and so accelerate atmospheric warming.

The oceans matter to us on land in other ways, too. Almost all the water that falls from the clouds over land evaporated from the surfaces of the oceans. And it turns out that the vital nuclei around which water vapour in the air turns into raindrops are often tiny particles of the chemical dimethylsulphide that is emitted by ocean phytoplankton.

ABOVE
**DEEP-SEA TREASURES**
A black smoker chimney and sulphide mounds sit over hydrothermal vents along the volcanic Mid-Atlantic Ridge. Communities of strange deep-sea creatures – many yet to be discovered – live in the extreme conditions surrounding these hot springs, which pump minerals into the sea water. Some of their minerals, including gold and silver, are attracting the attention of specialized mining companies.

NEXT PAGE
**THE INTERFACE**
Anchovies at the surface of the Pacific – the world's deepest and widest ocean. The Pacific controls the world's weather, shifting heat around and creating global currents and wind patterns as well as fuelling giant storms. Oscillations in the abundance of anchovies are linked to Pacific cycles.

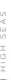

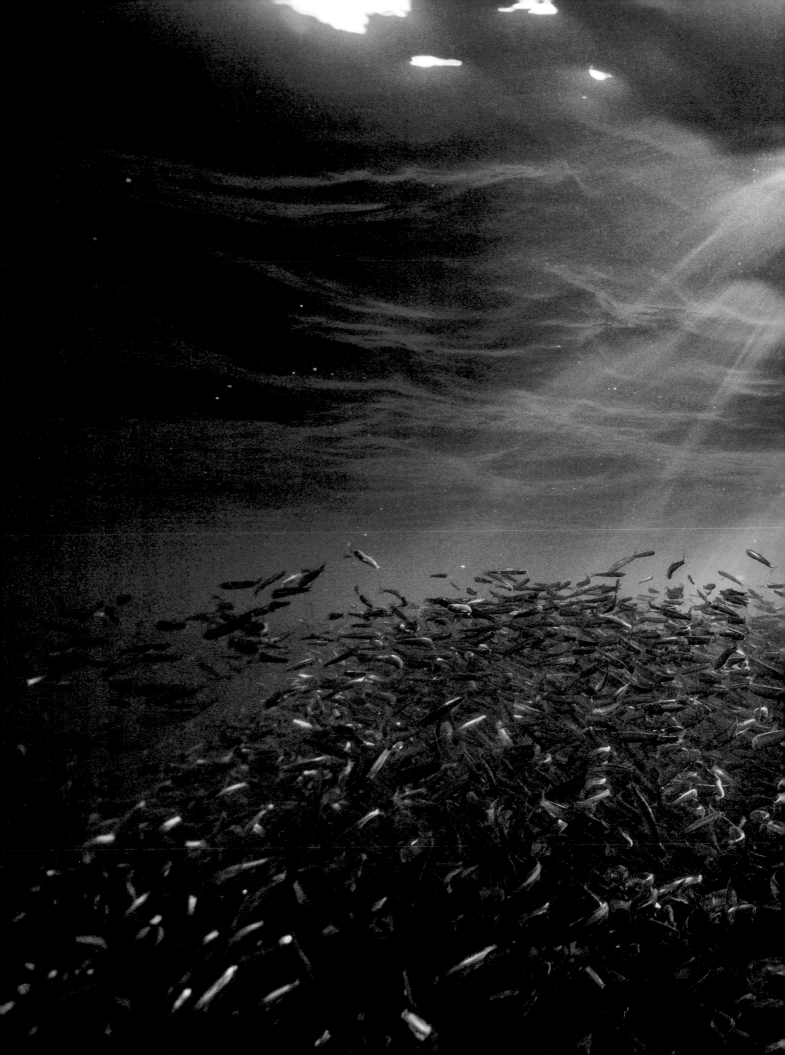

Without the phytoplankton there would be less dimethylsulphide, and probably less rainfall and fewer clouds as well. Meanwhile, the health of the oceans also depends on the land. The desert dust that spreads on the winds and falls onto the oceans is an important source of phosphates and iron, both essential to the growth of phytoplankton. In many remote areas of the ocean, the amount of iron or phosphates dissolved in the water limits how much phytoplankton can grow, and hence how much food there is for everything from krill to whales.

Today we are living in the Anthropocene, the name given to the new geological era in which humans are the dominant force on the planet. It is our planet now. Certainly in the twenty-first century, we are impacting our planet's life-support systems in ways so great that we have to take responsibility – to grab the controls of spaceship Earth.

We have global treaties designed to control the gases that cause climate change and to conserve endangered species by creating safe spaces for them. We have curbs on some toxic pollutants and commitments to halt deforestation. Such advances give hope that we can halt the emerging crisis and begin an ecological restoration of the planet. But what about the oceans? Who is in charge of them? The answer is mostly nobody. And that urgently needs to change.

Territorial waters extend up to 200 nautical miles (370 kilometres) from the shore in the so-called exclusive economic zones (EEZs). Beyond those zones are the international high seas. They are overseen by the United Nations Convention on the Law of the Sea (UNCLOS), which came into force in 1994. Most countries, with the notable exception of the US, have signed up to it.

In principle, the UNCLOS governs all aspects of the ocean space, including environmental controls and economic and commercial activities. In support of these, it created an International Seabed Authority. One of the authority's key roles is to regulate deep-sea mining and to ensure that the marine environment is protected from any harmful effects. To date, it has issued exploration licences to almost 30 contractors, including several for sites around hydrothermal

## ACID OCEANS

It has been called ocean warming's evil twin. The rising concentration of carbon dioxide in the air is resulting in more of the gas dissolving in the oceans. About a third of the $CO_2$ we put into the air currently ends up there. That helps moderate global warming, but the dissolved gas makes carbonic acid, which changes the chemistry of the oceans. They are on average 26 per cent more acid than 200 years ago.

This matters because many marine animals need calcium carbonate to make their shells and skeletons, and in acidic conditions, less of this is available in the water. Corals, clams, sea urchins, and many other species will find it harder to absorb enough calcium carbonate to grow and flourish. It will take more energy. This is on top of other threats, such as the warming of ocean waters.

Algae and seagrass might benefit from more $CO_2$ because they use it to grow. And most ocean creatures are adapted to cope with some variation in acidity of the water.

But only so much, and only for limited periods. Many could be pushed beyond the brink. Studies have already found impacts on about half of marine species, including Atlantic cod, blue mussels, sea butterflies, sea urchins and starfish in the waters around Antarctica.

Shells are at special risk. The larvae of oysters, like those of other shellfish, are very vulnerable. There have been massive die-offs in US oysterbeds where the more acidic water has prevented the larval oyster's essential shell-growth spurt from getting going.

There may be other, more subtle effects. The threads that mussels use to cling to rocks don't work so well in more-acid water. Fish may find their blood getting more acid and will have to exert more energy to expel the acid, leaving less for eating, evading predators or breeding. How much can marine ecosystems cope with? We simply don't know.

ABOVE Swimming sea butterflies – open-water molluscs. Their shell formation is affected by seawater acidification.

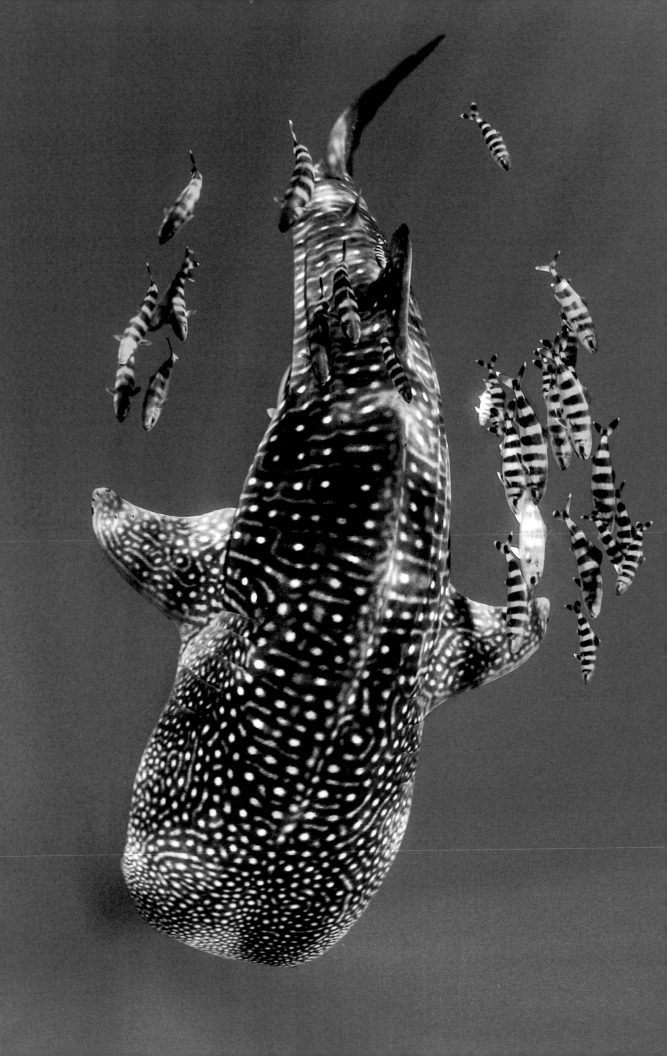

vents that scientists say would cause irreversible biodiversity loss. Yet at the start of 2018, it still had no environment committee and said little publicly about how it reaches its decisions or how it proposes to protect hydrothermal vents and the communities around them.

Many other ocean activities are still managed via a patchwork of international agreements, covering waste dumping and fisheries management, for instance. A rare exception to environmental lawlessness on the high seas are the marine protected areas (MPAs) in international waters, such as the six in the Northeast Atlantic. One of these, the Charlie-Gibbs MPA, covers an area the size of England where cold northern and warmer southern waters meet, making it rich in marine life from both zones.

Another is the Ross Sea MPA in the Antarctic, set up in 2016 by the Convention for the Conservation of Antarctic Marine Living Resources (CCAMLR), part of the Antarctic Treaty System, which regulates activities in the Southern Ocean. The Ross Sea is the most southerly stretch of sea on the planet, and one of the most pristine, with large populations of killer whales, minke whales, hundreds of thousands of Weddell seals and more than a quarter of the world's Adélie and emperor penguins.

Little more than 1 per cent of the world's international waters have any form of ecological protection. Once, when fish populations were considered limitless and oceans too big to pollute, that might have been enough. But with human impacts now extending to the most remote and deepest parts of the oceans, this has become a dangerous state of affairs.

We urgently need a coherent network of MPAs. Scientists and conservationists now argue for 30 per cent of the high seas to be protected from fishing and mining. And beyond those areas, we need a presumption that the high seas no longer belong to no one – they belong to everyone. The change may be coming.

One of the sustainable development goals adopted by the United Nations in 2015 was to 'conserve and sustainably use… the oceans, seas and marine resources'. Now its General Assembly has begun negotiating a new High Seas Treaty to protect marine life outside national jurisdictions. It needs to take an integrated approach to managing the different uses of the oceans, such as shipping, fishing, mining and oil and gas exploitation, rather than treating each in isolation. Core to the discussions will be that the conservation of marine life is a legitimate use and value of the ocean.

Protected areas will be part of its agenda. One candidate might be the fabled Sargasso Sea in the tropical North Atlantic. This huge area of doldrums is full of Sargasso seaweed – the only free-floating seaweed.

**SHARK HOTSPOT**
A whale shark – the world's biggest fish – dives into deeper water off a seamount in the Pacific Ocean. Seamounts (submerged mountains) form important navigation points for many sharks and are also social gathering points, perhaps linked to mating. Currents running over these underwater islands result in upwellings that bring nutrients up from the deep. These are vital to the growth of phytoplankton, which support rich seamount communities. As fishing vessels move into deeper water, there are increasing calls for seamounts to be given greater protection.

NEXT PAGE

**THE OVERHUNTED HUNTERS**
A large group of Atlantic sailfish eats the last fish in a shoal of Spanish sardines off Mexico's Yucatan Peninsula. Because the species is highly migratory, population numbers are difficult to assess. But it is thought that Atlantic sailfish are still being overfished – caught faster than they can reproduce. Also, significant numbers are still being caught incidentally by longline fisheries.

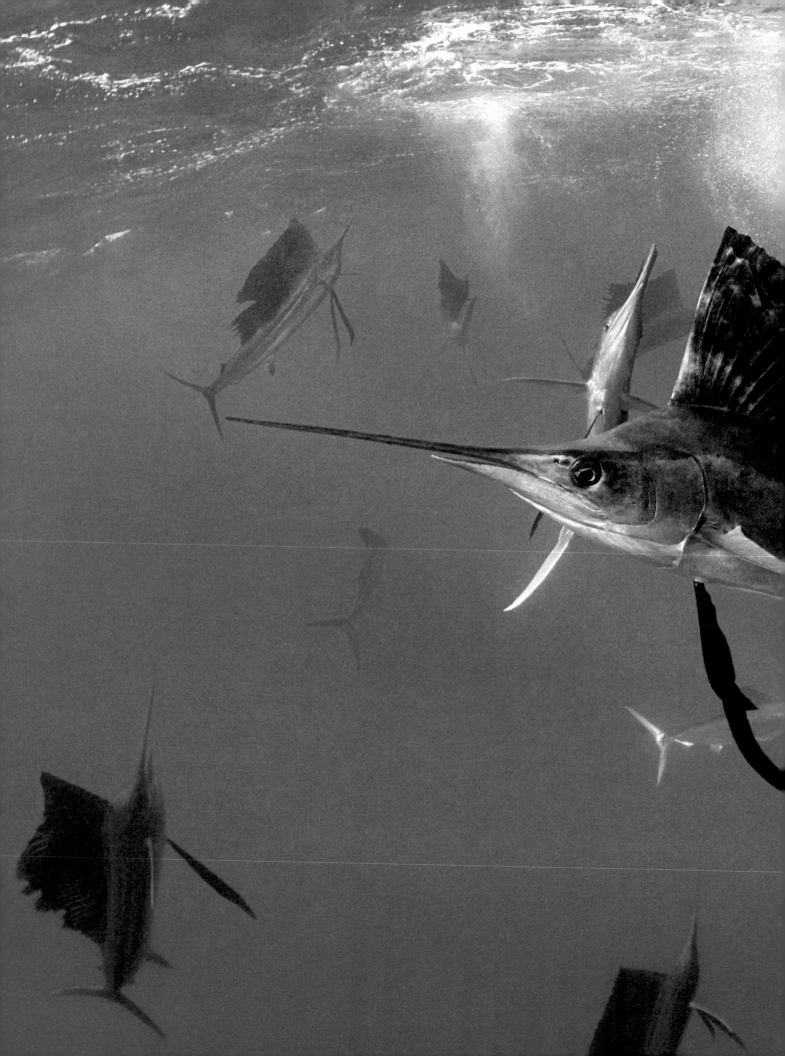

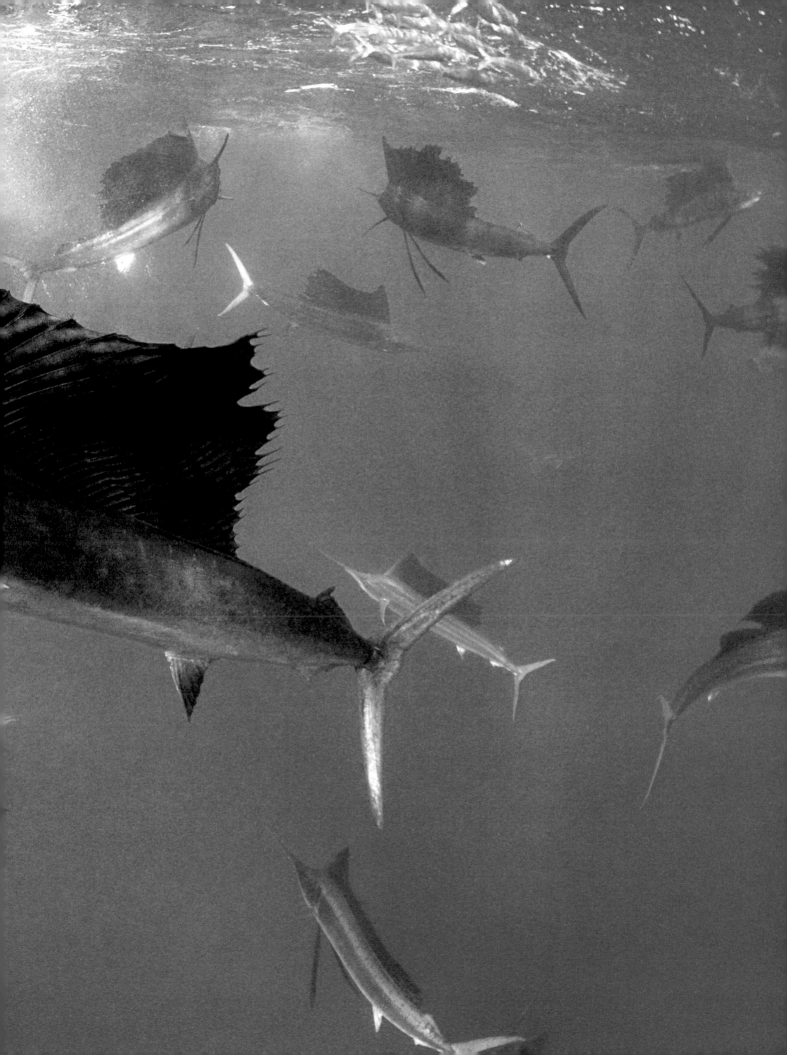

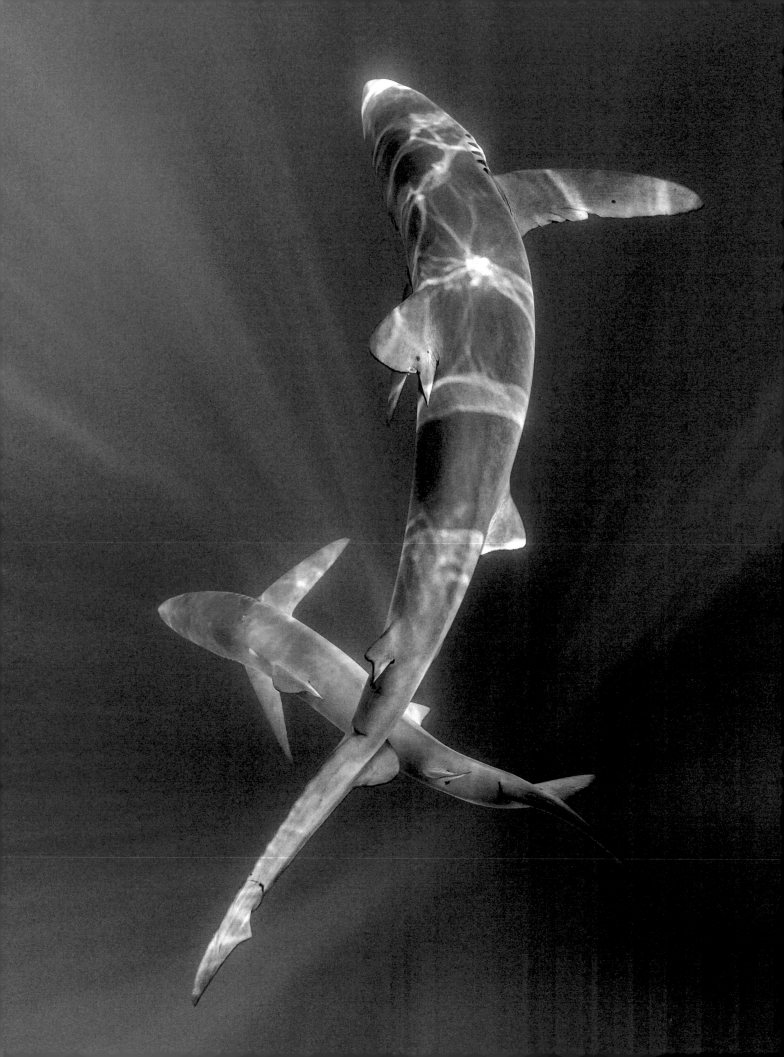

# WHAT ABOUT THE OCEANS? WHO IS IN CHARGE OF THEM? THE ANSWER IS MOSTLY NOBODY. AND THAT URGENTLY NEEDS TO CHANGE

It is where both European and American eels go to spawn and where loggerhead turtles hide from predators as they grow.

Environmentalists are also pushing for protection for the Weddell Sea on the Atlantic side of Antarctica, to complement the Ross Sea MPA on the Pacific side. This haven for blue whales, leopard seals, killer whales and much else could be five times the size of Germany.

Beyond protected areas, the world needs a grand strategy for protecting the fish of the high seas. What undermines efforts to manage fisheries is the global extent of illegal, unreported and unregulated fishing. This now accounts for 12–28 per cent of all catches. That could mean a one in four chance that the fish on your plate is illegally caught.

Much of the illegal fishing and overfishing takes place because of poor governmental oversight. Perversely, this can be compounded by subsidies for fishing fleets – short-term efforts to support employment that, in the end, can only destroy the fisheries themselves.

In 2017, a group of nine giant seafood companies pledged to clamp down on illegal fishing. Their power to do so is clear. Just 13 companies control up to 40 per cent of the fished populations of the most valuable species – including tuna, Alaskan pollock, Peruvian anchovies and Patagonian toothfish. Four of the companies are Norwegian, three are from Japan. But this does not address legal overfishing.

As the UN's Food and Agriculture Organization figures show, 90 per cent of the world's fisheries are either overfished or are 'fully fished'. Satellite data has also revealed that more than half the world's oceans are being fished by industrial vessels, covering a greater surface area than agriculture.

While setting up protected areas and stronger management and control of fishing and mining will do good, neither will protect marine life from pollution. Though 80 per cent of marine pollution is from the land, it can be found throughout the ocean, moved by the currents. That includes the rising volumes of virtually indestructible plastic waste spreading on the world's ocean currents. An estimated 8 million tonnes of plastic waste enters the oceans each year. Much of it effectively stays there for ever, gradually breaking down into smaller and smaller pieces. There are places where currents accumulate the plastic particles. Most famous is the Pacific garbage patch, an area of doldrums around the Midway Atoll at the centre of the North Pacific Gyre.

OPPOSITE
**BLUE SHARK DRIFTERS**
Blue sharks – the most abundant and widespread oceanic shark but also the most heavily fished. About 20 million are caught every year, in driftnets and especially on long-lines set for other fish, such as swordfish or tuna, and the unrecorded catch may be a third more. Though blue shark meat is considered almost worthless and most bodies are discarded at sea, there is a lucrative market in the fins. As with so many oceanic fish species, there is no accurate population estimate, and much is unknown about its biology, but declines are being observed across its range.

NEXT PAGE
**THE ALBATROSS OCEAN**
Off the Falklands, low-flying black-browed albatrosses snatch krill and fish from the water's surface. The islands host more than 70 per cent of the global breeding population of the albatrosses, which are protected there. But albatrosses also travel more widely, risking being caught on baited long-lines or when scavenging from trawling vessels. But the increasingly widespread use of weighted fishing lines or bird-scaring lines is starting to reduce the unnecessary deaths.

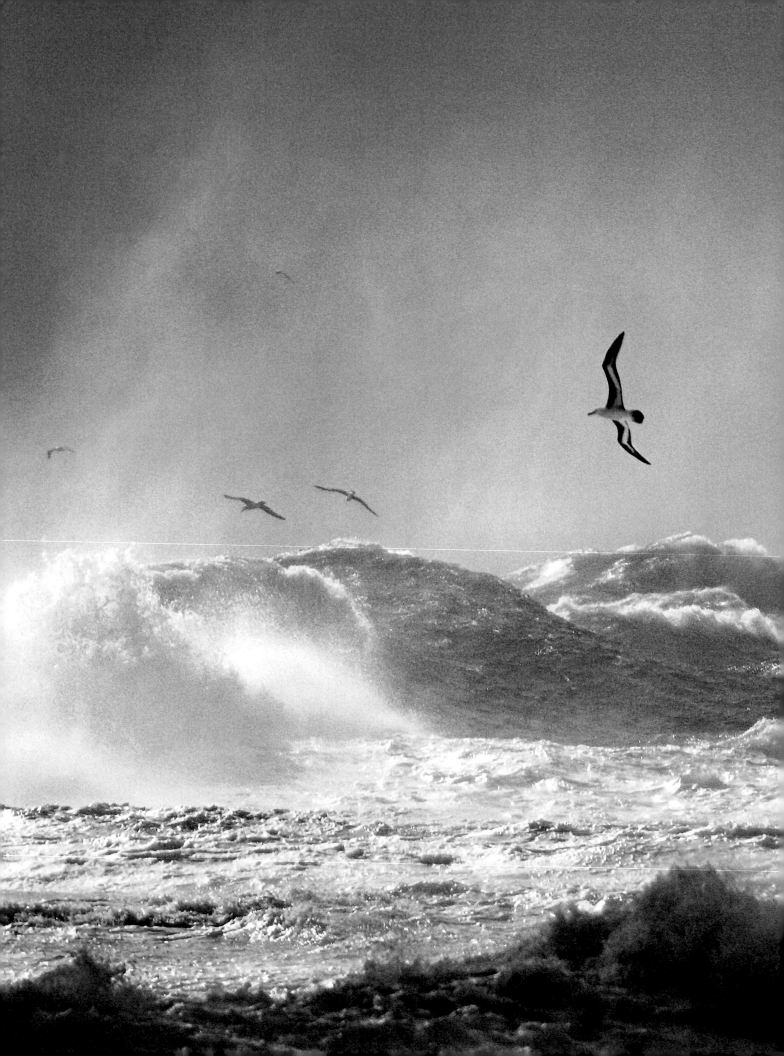

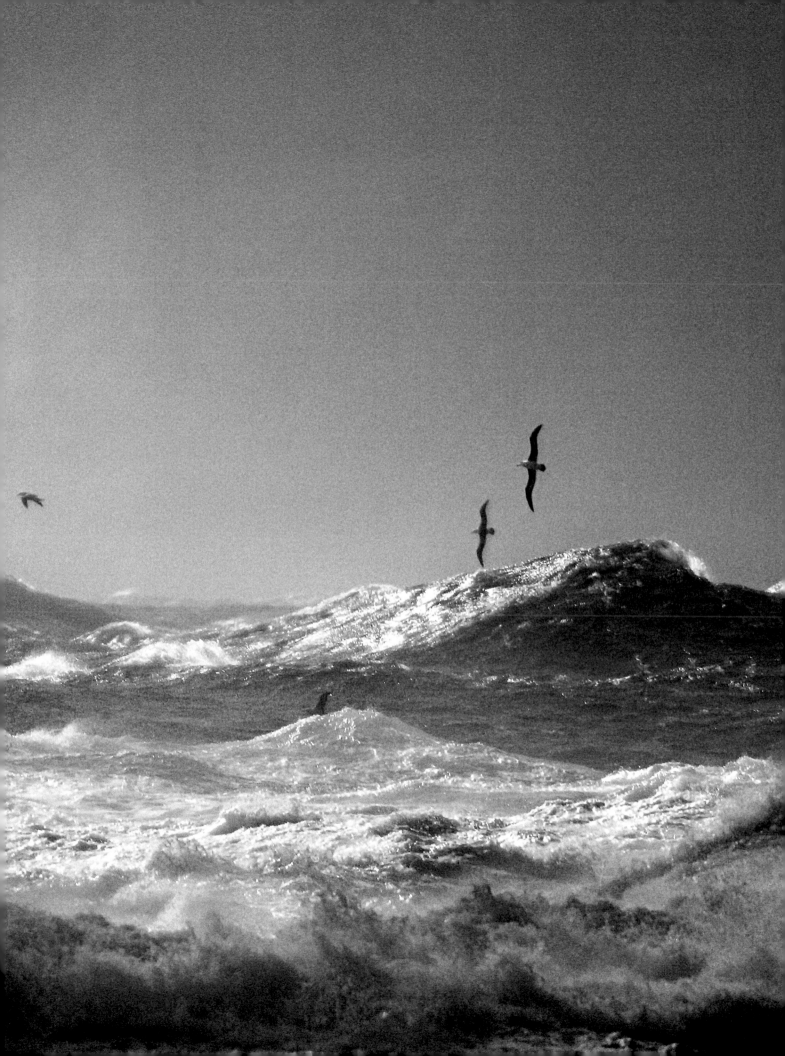

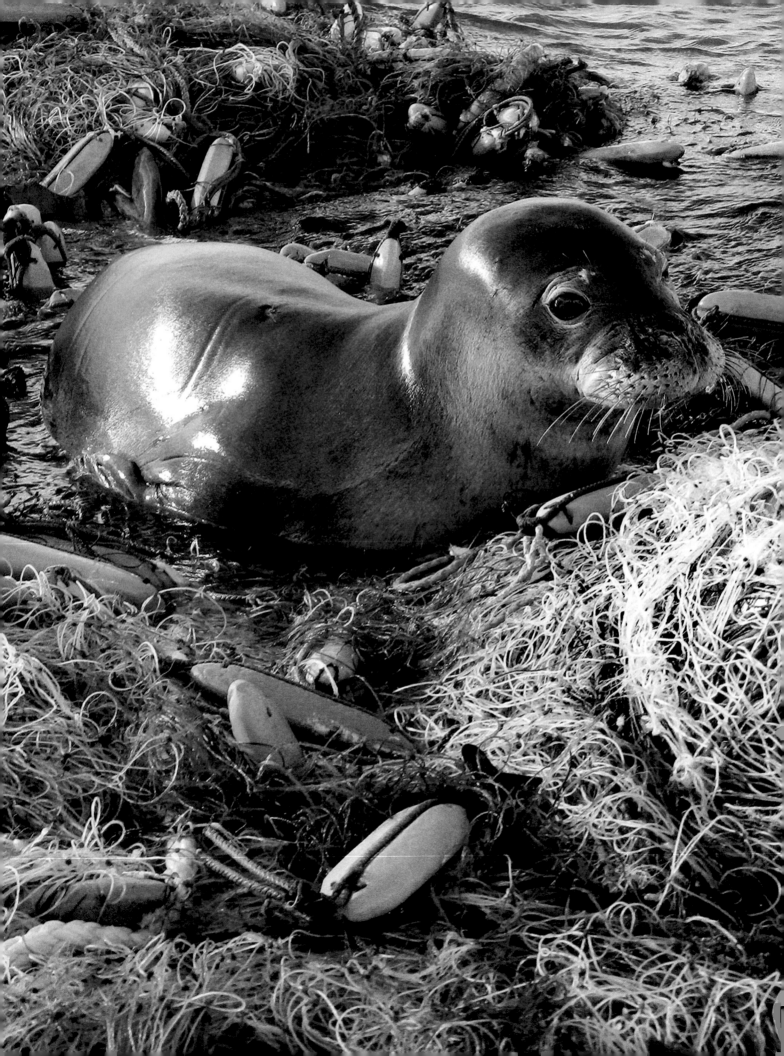

## THE QUICKER WE ACT, THE GREATER WILL BE THE CAPACITY OF DAMAGED MARINE ECOSYSTEMS ... TO RECOVER TO THEIR FORMER GLORY. THE RESULT WILL BE A THRIVING OCEAN ECONOMY

But nowhere is safe, not even the polar regions or the deepest trenches. Seventy per cent of deep-sea fish may have ingested plastic. We humans also ingest it when we eat the fish, though long-term effects of this are as yet unknown. Arctic scientists find floating plastic trapped in vast quantities in ice, with more than 200 pieces of plastic in a single litre. And few species are immune from being snagged, strangled or suffocated by plastic. In the North Sea, whale carcasses have washed up on beaches with their stomachs full of plastic objects that had probably been mistaken for squid. One stomach contained a 13-metre-long (43-foot) fishing net and a metre-long piece of plastic from a car body.

Less obvious but potentially at least as deadly for marine life is noise, from oil and gas drilling and offshore wind turbines, but especially from thousands of ship propellers. Thanks to the capacity of ocean waters to transmit sound, propellers can be heard up to 100 kilometres (62 miles) away. There is growing evidence that whales which rely on sound for communication, for navigation and to find food are being disoriented and stressed, and starve as a result. The likelihood is that many fish may also be deafened and fail to breed.

There is much that needs doing in the oceans. The quicker we act, the greater will be the capacity of damaged marine ecosystems – the fish we catch for food, the cold-water corals and hydrothermal vents, the vast pods of whales and the mysterious denizens of the deep – to recover to their former glory. The result will be a thriving ocean economy that provides food and jobs well into the future.

The good news is that the world is waking up to what is happening in the poorly governed oceans. The spread of plastic waste has become a global concern – perhaps because the damage it causes to wildlife is very visible. In the oceans, though, out of sight is definitely not out of harm's way. But the story of how public attention was grabbed by the horrors of whaling in past decades and about plastic in the oceans today suggests a strong public appetite to right the wrongs. And the success of nature in restoring populations of humpback whales in particular is a sign that nature has huge powers of recovery. Now it is time to save the rest of the oceans, and the rest of the planet.

OPPOSITE

**TRAPPED BY A GHOST-NET**
An endangered monk seal caught in an abandoned fishing net. Derelict fishing gear forms one of the main types of debris in the ocean and at least 10 per cent of the plastic waste. A Global Ghost Gear Initiative is promoting solutions to the problem of discarded, lost or abandoned nets. These include recycling depots in ports and industrial reuse of the plastic.

NEXT PAGE

**SEA OF GIANTS**
A great meeting of sperm whales in the Indian Ocean. The function of the gathering is social, but in the process, the whales release great amounts of skin, urine and dung – fertilizer for the ocean. Feeding at depth, they also bring nutrients to the surface, and their dead bodies then return more nutrients to the deep. Open-ocean large fish – in particular, sharks – play a similar nutrient-recycling role, transporting organic matter around the oceans. Increasing evidence suggests that the reduction in numbers of many of these large, top-of-the-food-chain animals jeopardizes the functioning of whole marine systems.

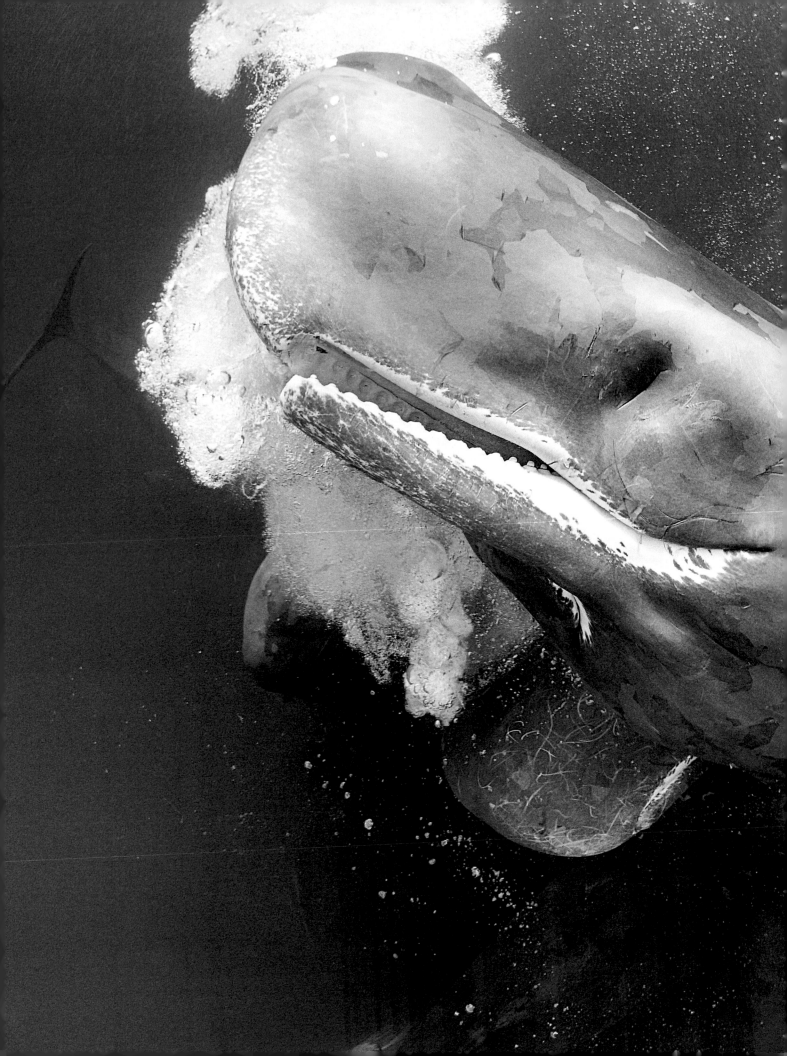

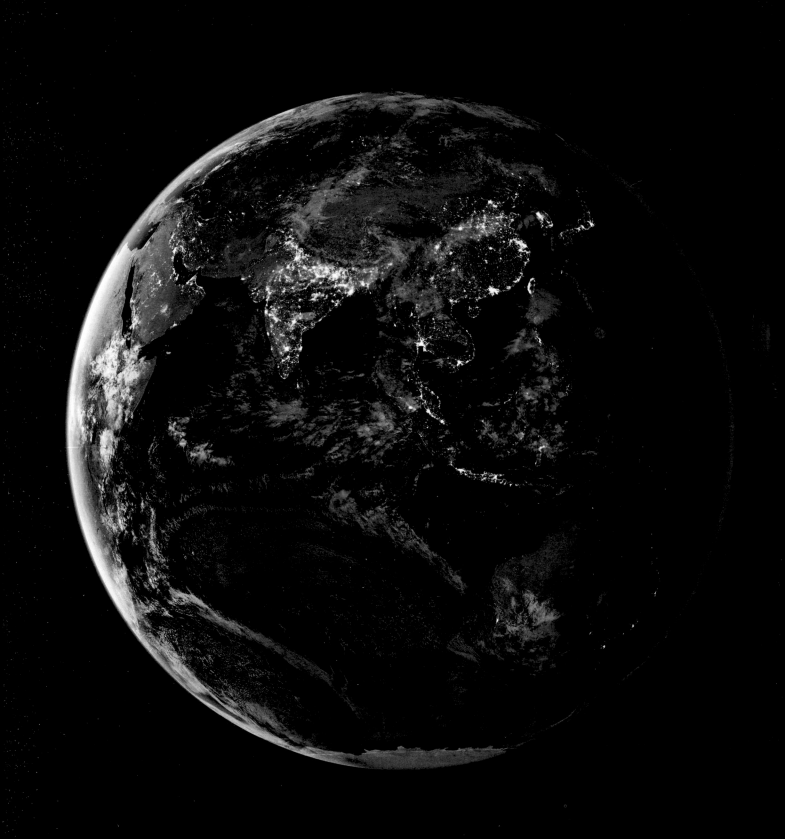

# OUR PLANET
# OUR FUTURE

Nature is cornered. Take a flight almost anywhere in the world and what you will see below, almost whenever the clouds clear, is the mark of people. *Homo sapiens* rules down there. Less than a quarter of the ice-free land surface of the planet is without signs of human settlement or land use. The Earth has entered the Anthropocene, a new geological epoch in which humans shape the planet. It is, for good or ill, our planet now.

The challenge is to make a good Anthropocene. Not a scary dystopian age of disaster, but a joyful Anthropocene where we humans rise to the challenge of managing our planet, of being good stewards of nature. That means learning to love nature again and finding practical ways for 10 billion or more of us to live well while respecting the natural world that underpins our planet's life-support systems. It means changing how we behave and what we consume to reduce our impact and keep our planet's temperature from rising more than 1.5 degrees Celsius. Above all, it means a great restoration of nature in the twenty-first century.

# AT THE START OF THE TWENTY-FIRST CENTURY, WE ARE REACHING WHAT SCIENTISTS CALL PLANETARY BOUNDARIES – LIMITS BEYOND WHICH ... GRABBING MORE OF NATURE BRINGS MORE PENALTIES THAN BENEFITS

OPPOSITE
**RAINFOREST CHILD**
A baby Bornean orangutan and her mother feed on berries in a protected area of forest in Central Kalimantan, Indonesian Borneo. As they feed, they disperse the seeds of many of the forest trees. The great ape and its trees evolved together and their futures are linked. Bornean orangutans are now critically endangered through ongoing forest loss, mostly because of its conversion to oil-palm plantations, and through killing: more than 100,000 have been lost since 1999. Its future depends on stopping the expansion of oil-palm and paper plantations, on the long-term security of large, strictly protected forests and on keeping populations big enough to cope with catastrophic events such as fires and disease outbreaks.

There is no more important task than making us once again part of nature rather than its adversary. And it can be done. This book has told stories of heart-wrenching environmental decline, but it has also found many seeds of recovery and grounds for hope. We have seen how nature can regenerate itself where and when we give it room.

Sometimes this grand restoration will be conventional conservation, protecting the wild that we still have by saving forests from chainsaws, grasslands from the plough and urban spread, rivers from pollution, coastal ecosystems from destruction, and everywhere from climate change. Sometimes it will be rewilding places we have messed up, by giving nature space to regrow, recolonize and evolve. That will involve tearing down fences, undamming rivers, shutting roads, abandoning coal mines and declaring large marine areas off-limits.

But we cannot and should not always set ourselves apart from nature. Sometimes the great restoration will be more like planetary gardening. By treating the inhabited parts of our planet less like farms and more like gardens, we can create landscapes that are valuable for both us and nature, through trees and parks in cities, agro-ecological farming and nurturing ecosystems and wildlife populations that are exploited but not destroyed.

This task must involve us all. Scientists and technologists should prioritize new ways of providing our needs more cleanly, efficiently and sparingly. Governments need to be told to reward protection and restoration of nature and penalize its abuse. And most of all, there must be a revolution in our hearts and minds, curbing our personal appetites for consuming the planet's resources, and changing our relationship with nature.

The twentieth century was a disaster for nature. As human numbers grew fourfold, we moved from being a primarily rural to a primarily urban-based species. As we severed many of our links to the natural world, our despoiling of the planet went into overdrive. At the start of the twenty-first century, we are now reaching what scientists call planetary boundaries – limits beyond which further plunder and pollution is clearly dangerous, beyond which grabbing more of nature

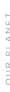

ABOVE
**JUNGLE FLOWERING**
The rainforest canopy of Soberanía National Park, Panama, revealing the wide diversity of plant species, which supports an equally diverse community of animals. A year-round warm, wet climate means that, at any one time, there will always be trees flowering and fruiting, providing a constant source of food.

brings more penalties than benefits, for us as well as for our planet. We are damaging our own fundamental life-support systems. Burning fossil fuels causes climate change that floods coastal cities. Excessive chemical fertilizers on fields add little to crop yields but instead kill fish in our rivers and oceans. One region's dam to capture water leaves millions downstream with empty taps. Cutting forests for timber leads to droughts hundreds of miles away. Ploughing soils creates deserts. And hunters and fishers cause extinctions that destabilize entire ecosystems. We must draw back before it is too late and begin a great restoration. Time is short, but we do have time, and we know a lot of what we need to do.

Some of it is technocratic. We must end our dependence for energy on fuels such as coal and oil that are warming our atmosphere to dangerous levels. Thanks to advancing technology, we now have alternatives, and we are deploying them. Today, around the world, twice as much money is invested each year in renewable energy such as solar and wind power than in fossil fuels. That transformation would have been unthinkable just a few years ago. Coal-burning has peaked and has started to decline. We may be heading towards peaking carbon-dioxide emissions, too. And thanks to rising energy efficiency, peak energy demand may follow. Europe's energy use is

already 10 per cent down on a decade ago. Electric cars are the next big thing, probably followed by electric planes. It will take decades to replace all our dirty energy and transport infrastructure, but we know now how to create the carbon-neutral global economy needed to halt the progress of climate change. We have no excuse for failing.

Technology is also allowing us to be far more efficient in how we use the planet's resources, whether metals from the earth, wood from forests or water from rivers. We are wasting less and recycling more. Information technology is allowing farmers to grow crops with much less water and far fewer chemicals – keeping our rivers fuller and less polluted. We are doing more with less.

But technology alone will not deliver our salvation. Rampant consumption in the rich world has replaced population growth as the greatest threat to nature. We humans – all of us – have to rein in our appetites and our desires. This is a cultural change that will require us to rethink what we actually want. Is it material goods or happiness? Quantity or quality? Gluttony or health? Short-term gains for us or long-term contentment for our children and our children's children?

The answers may surprise us. We are already changing. In rich countries, we are slowly losing our addiction to 'stuff'. These days when people get richer, they often spend money on things that require people and skills – art or activities, for example, or dining out – rather than more possessions. Nature potentially takes fewer hits. Digital technologies replace a lot of the gadgets that once cluttered our lives – everything is on our phone. In rich countries, we are also discovering how to appreciate products that are well-made and long-lasting, how eating less meat and cycling can make us healthier while reducing our impact on the environment, how green spaces and access to nature can make us more contented. Maybe, just maybe, we can transform the way we live, the way we consume and the way we eat, fast enough to preserve and restore the nature and natural processes on which we ultimately depend. That is the prize.

But for sure we will not do it without governments. Governments need to take responsibility for the global changes that are required. We must elect the ones that will accept leadership responsibility,

# NOW IT IS TIME TO APPLY THE SAME APPROACH TO THE MOST FUNDAMENTAL REQUIREMENT OF ALL FOR OUR FUTURE WELL-BEING – PROTECTING NATURE

both nationally and internationally. The international community has many agreements: on trade and finance, on human rights and property law. All are rightly deemed essential to a functioning global civilization of more than 7 billion people. Now it is time to apply the same approach to the most fundamental requirement of all for our future well-being – protecting nature.

There are precedents. Agreements on saving the ozone layer and halting the slaughter of whales were among our proudest achievements in the final decades of the twentieth century. But nature as a whole – its species and their habitats, our planet's great ecosystems and the services they provide – awaits its saviour. We believe that now is the moment to end this grievous oversight.

At the close of the last century, the 1992 Earth Summit delivered two resounding declarations in conventions on climate change and biodiversity. But neither convention had teeth. Only in 2015, did the climate treaty find force in the Paris Agreement and its promise to halt climate change. More is needed to ensure its implementation. But now we need to do the same for nature.

The 1992 Convention on Biological Diversity must be turned from aspiration into greater action. We need strong, enforced global targets and laws to protect nature in all its guises, and a properly funded global plan for restoration of forests, of wetlands and rivers, of grasslands and oceans, of biological diversity itself. As this book has shown, the elements for such a great restoration are already in place. We know, in essence, what to do. But soon it could be too late. Biodiversity is being lost every day. Ecosystems are being eaten away. The moment for action must come when the convention's strategic plan is rewritten in Beijing at the end of 2020. It may be the decision-makers' – and our – last chance to save and restore our planet. They must take it.

Having a good Anthropocene, one we share with nature, won't come easily. As WWF International's Director General Marco Lambertini puts it, the task to 'decouple human and economic development from environmental degradation [will be] perhaps the deepest cultural and behavioural shift ever experienced by any civilization'. Can we do it? We must hope so. For our planet, and the future of our species, needs nothing less.

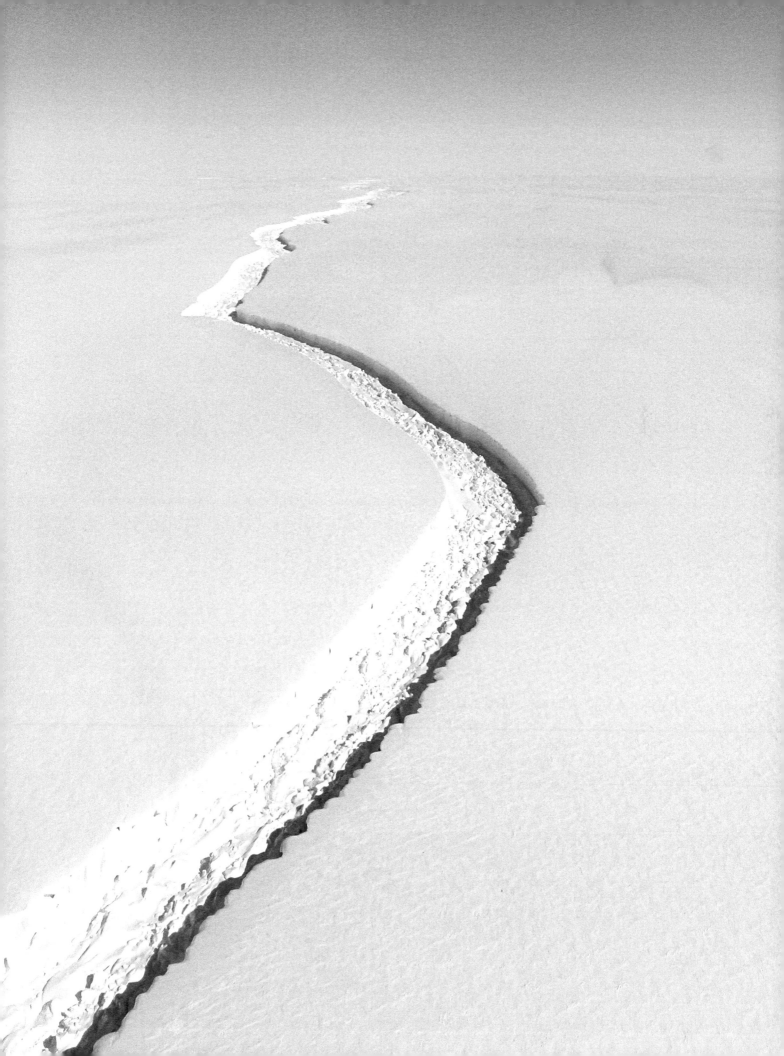

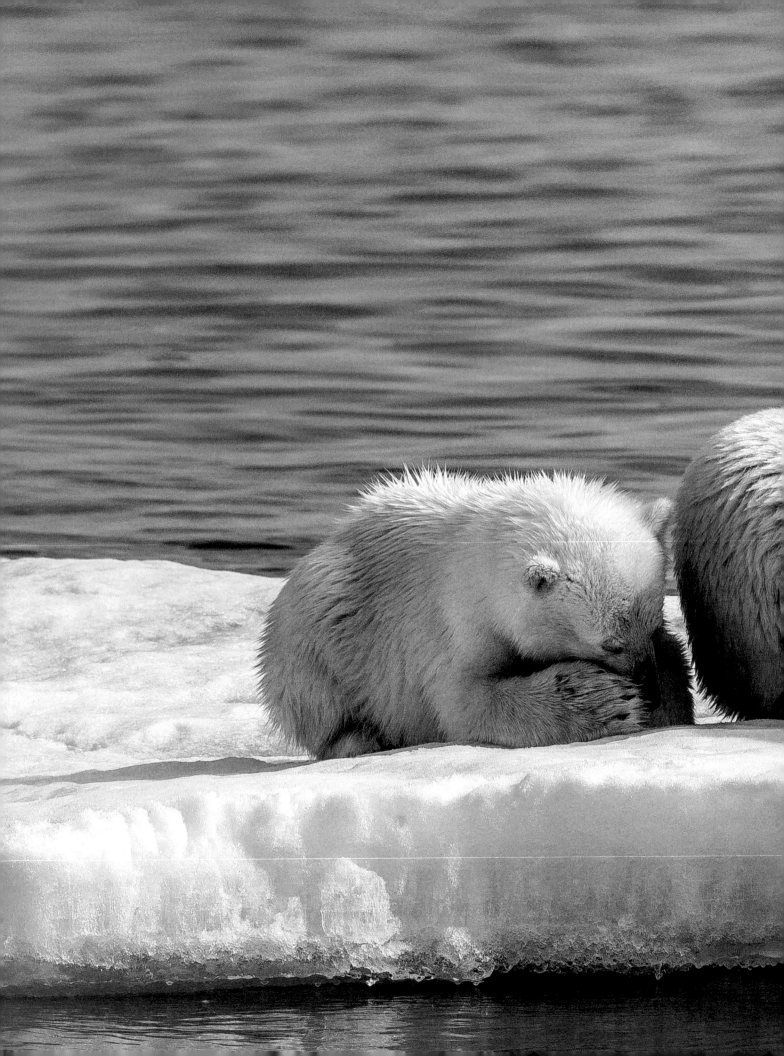

# ACKNOWLEDGEMENTS

From the beginning, *Our Planet* has been a partnership between Netflix, WWF and Silverback Films. The aim has been to make a documentary series, combined with the whole range of media, to convey to the world the natural wonders we still have, what makes them special and how we can ensure their future. Without this partnership, our goal would have been impossible to achieve.

First, we needed to be able to reach millions of people across the world with a compelling series. Netflix, from the moment we first pitched the idea, believed in the mission and has tirelessly supported us through the journey and made it a reality. There are many wonderful people in the Netflix team who have contributed much. However, two have been by our side from the very beginning: Lisa Nishimura, Vice President of Original Documentary and Comedy, and Adam Del Deo, Director of Original Documentary Programming. Through all the complexity of producing this project, they have always made things happen and have given a huge amount of valuable editorial advice.

Second, we needed to draw attention to the right places and issues. Here the partnership with WWF was essential. The vast knowledge base about the natural world and conservation that resides within WWF is a wonder to behold and it has enriched this project in so many ways. Again, the list of individuals who have contributed is long but two people have been crucial in achieving our goals. Colin Butfield, Executive Director Our Planet WWF, developed the original idea with us and has been a tireless dynamo ever since, creating ideas and enabling them to become a reality. Mark Wright, WWF's Chief Scientific

Advisor, has given the project the scientific backbone it needed. Both in this book and across every aspect of the series and in other media, *Our Planet* needed to be accurate and Mark has ensured that it is.

Third, we needed the Silverback production team. Their names are listed below, and it goes without saying they are the salt of the earth. They have worked tirelessly, faced huge adversity and above all brought to the project creativity the likes of which we, in our long careers, have never witnessed before. And, yes, they have been a joy to work with.

The aim of this book has been to draw all aspects of the *Our Planet* project together. We desperately wanted it to be a book of such importance that it needed to be read, rather than simply looked at. We knew that the task of selecting the crucial issues would be extremely complex and that telling the stories would require skill and style. We needed a world-class environmental journalist to make this possible. We think we found the best with Fred Pearce.

As one of the world's top environmental and science journalists for the past three decades, Fred has used his lifetime of knowledge about the natural world to boil down the essentials of what we all need to know about our planet and, crucially, what needs to be done to ensure that it thrives in the future. The natural world and its conservation issues are endlessly complex. Conservation may have suffered because focus is rarely brought to bear on the few most crucial issues and their solutions. Here, Fred has achieved this with great skill, and we believe that is what makes this book special.

**PRODUCTION TEAM**
Adam Chapman
Dan Clamp
Jon Clay
Darren Clementson
Lisa Connaire
Rebecca Coombs
Huw Cordey
Marcus Coyle
Tash Dummelow
Charles Dyer
Amy Ferrier
Alastair Fothergill
Rebecca Hart
Jane Hamlin
Hal Hampson
Jo Harvey
Dan Huertas
Jonnie Hughes
Tara Knowles
Nancy Lane
Sophie Lanfear
Ben Macdonald
Ilaira Mallalieu
Fiona Marsh
Laura Meacham
Susie Millns
Simon Nash
Elisabeth Oakham
Kieran O'Donovan
Sean Pearce
Hugh Pearson
Keith Scholey
Oliver Scholey
Niraj Sharda
Vicky Singer
Mandi Stark
Gisle Sverdrup
Sarah Wade
Hugh Wilson
Jeff Wilson

**CINEMATOGRAPHY**
Matt Aeberhard
John Aitchison
James Aldred
Guy Alexander
Doug Anderson
Tom Beldam
Levon Biss
Dane Bjermo

Howard Bourne
Ralph Bower
Barrie Britton
Keith Brust
Darren Clementson
Tom Crowley
Sophie Darlington
Tom Fitz
Flying Camera Company
Ted Giffords
Roger Horrocks
Sandesh Kadur
Richard Kirby
Paul Klaver
Denis Lagrange
Tim Laman
Ian Llewellyn
Alastair MacEwen
David McKay
Jamie McPherson
Justin Maguire
Hugh Miller
Blair Monk
Simon Niblett
Nathan Pilcher
Owen Prumm
David Reichert
Tim Sheppherd
John Shier
Andy Shillabeer
Hector Skevington-Postles
Warwick Sloss
Alastair Smith
Mark Smith
Robin Smith
Rolf Steinmann
Paul Stewart
Gavin Thurston
Alexander Vail
Alex Voyer
Ignacio Walker
Tom Walker
Mateo Willis
Miguel Willis

**ADDITIONAL
CINEMATOGRAPHY**
Ryan Atkinson
Steve Axford
Chris Bryan
Jim Campbell-Spickler

Gene Cornelius
Gemilang Dini Ar-Rasyid
Murray Fredericks
Will Goldenberg
Markus Kreuz
Katie Mayhew
Matthew Polvorosa Kline
Edwin Scholes
Sam Stewart
Alex Tivenan
Darren Williams

**CAMERA ASSISTANTS**
Santiago Cabral
Ferando Delahaye
Trent Ellis
Neil Fairlie
Joe Fereday
Jeff Hester
Tyler Johnson
Casey Kanode
Jean-Paul Magnan
Felipe Pinzon
Sam Quick
Mark Sharman

**FIELD ASSISTANTS**
Sergey Abarok
Hadi Al Hikami
Khalid Al Hikami
Peter Amarualik
Evgeny Basov
Duncan Brake
Timothy Bürgler
Maxim Chakilev
André De Camargo Guaraldo
Einar Eliassen
Jimmy Ettuk
Yoann Gourdin
Juliette Hennequin
Chad Hanson
Carlos Hernández Vélez
Richard Herrmann
Lingesh Kalingarayar
Valeriy Kalyarakhtyn
Norman Kisisipak
Anatoly Kochnev
Peter Koonoo
Maxim Kozlov
Magnus Løge
Tatiana Minenko

Sergei Naymushin
Yelizaveta Protas
Prakesh Ramakrishnan
Nikolai Reebin
David Reid
Israel Schneiberg
Oleg Slovesnyi
Oskar Strøm
Franck Sur
Evgeny Tabalykin
Stanislav Tayenom
Kieran Tonkin
Emily Vaughan Williams
Myloh Villaronga
Emilio White
Andrew Whitworth
Kim Ten Wolde
Mike Wright

**ADDITIONAL PRODUCTION**
Kat Brown
Matt Carr
John Chambers
Samantha Davis
James Dubourdieu
Patrick Evans
Nicola Gunary
Rachel James
Rosie Lewis
Rachel Norman
Judi Obourne
Eleanor Perryman
Sarah Pimblett
Elly Salisbury
Gina Shepperd

**POST-PRODUCTION**
Matt Chippendale-Jones
Films at 59
Miles Hall
Gordon Leicester
George Panayiotou
Wounded Buffalo Sound
  Studios

**MUSIC**
Abbey Road Studios
Philharmonia Orchestra
Steven Price

**FILM EDITORS**
Nigel Buck
Andy Chastney
Martin Elsbury
Matt Meech
Andy Netley
Dave Pearce

**ONLINE EDITOR**
Franz Ketterer

**DUBBING EDITORS**
Kate Hopkins
Tim Owens

**DUBBING MIXER**
Graham Wild

**COLOURIST**
Adam Inglis

**GRAPHIC DESIGN**
BDH Creative

**VISUAL EFFECTS**
AXIS VFX

**WWF TEAM**
Amy Anderson
Paige Ashton
Will Baldwin-Cantello
Mike Barrett
Jessica Battle
Karina Berg
Colin Butfield
Leanne Clare
Sarah Davie
Rod Downie
Louise Heaps
Brandon Laforest
Melanie Lancaster
Michelle Lindley
Gilly Llewellyn
Martin Sommerkorn
David Tanner
Dave Tickner
Sarah Wann
Yussuf Wato
Mark Wright
Julia Young

# PICTURE CREDITS

### COVER AND BACK COVER
NASA/BDH Creative/Silverback Films

**1** NASA Apollo 8 Bill Anders/data visualization courtesy Ernie Wright NASA Scientific Visualization Studio; **2-3** NASA Apollo 8 Bill Anders; **6-7** Art Wolfe; **8-9** Hougaard Malan/naturepl.com; **10-11** Alex Hyde/naturepl.com; **12-13** Mark Carwardine.

### Introduction
**14** NASA; **17** Daniel Beltrá; **18** Emmanuel Rondeau/WWF-UK; **20-1** Oliver Scholey/Hector Skevington-Postles.

### FROZEN WORLDS
**22** Justin Hofman; **24-5** Daisy Gilardini; **27** Vincent Munier; **28-9** Paul Nicklen/National Geographic Creative; **30** MZPhoto.cz/Shutterstock; **32-3** Oliver Scholey; **34** NASA image courtesy MODIS Rapid Response Team ·NASA GSFC; **36** Sophie Lanfear; **38-9** Hector Skevington-Postles & Jamie McPherson; **41** NASA/GSFC Scientific Visualization Studio; **42-3** Florian Ledoux; **45** Chris Linder; **46** Florian Ledoux; **48-9** Sergey Gorshkov; **51** Sophie Lanfear; **53** Paul Nicklen/National Geographic Creative; **54-5** Espen Lie Dahl; **56** Peter Leopold/UiT The Arctic University of Norway; **59** Amelia Brower/NOAA Fisheries Service (Marine Mammal Permit 14245); **61** Matthew Guy Cooper; **62-3** Oliver Scholey.

### FRESH WATER
**64** Design Pics Inc/National Geographic Creative; **66-7** Morgan Heim; **68** Design Pics Inc/Alamy; **70** Timothy Allen/Getty; **72** Paul Souders/worldfoto.com; **74-5** Dhritiman Mukherjee; **77** Mario Cea Sanchez; **79** Chris Brunskill; **80-1** Luciano Candisani; **82** George Steinmetz/Getty; **85** Angel M. Fitor; **86-7** Peter Elfes; **88-9** Mal Carnegie; **90** Peter Mather; **93** John Moran & David Moynahan; **94-5** Charlie Hamilton-James; **97** Alex Mustard/naturepl.com; **98-9** Réka Zsirmon; **100** Imre Potyó; **103** Ronald Messemaker/Minden Pictures/FLPA; **104-5** Joel Sartore/National Geographic Creative.

### GRASSLANDS & DESERTS
**106** Federico Veronesi; **108-9** AirPano; **111** Anup Shah/naturepl.com; **112-3** Federico Veronesi; **114** George Steinmetz/National Geographic Creative; **116-8** Peter Mather; **121** Marcio Cabral; **122-3** Luciano Candisani/Minden Pictures/FLPA; **124** Tim Flach/Endangered (New York: Abrams Books, 2017) courtesy Blackwell & Ruth; **126-7** Ingo Arndt; **129** Jim Brandenburg/Minden Pictures/FLPA; **130-1** Joe Riis; **132** Wim van den Heever/naturepl.com; **135** David Willis; **137** Jacques Descloitres/MODIS Rapid Response Team NASA/GSFC; **138** Luiz Claudio Marigo/naturepl.com; **140-1** Federico Veronesi; **142** Geoffrey Clifford/Getty; **144** Mishka Henner; **146-7** Federico Veronesi.

### FORESTS
**148** Frédéric Demeuse; **150-1** Jarmo Manninen; **152** Don Smith/Getty; **155** Scotland: The Big Picture/naturepl.com; **156-7** Frédéric Demeuse; **158** Michael Edwards/Alamy; **160-1** Orsolya Haarberg/naturepl.com; **162** Joe Riis; **164-5** Kieran O'Donovan/Silverback Films; **166** Konrad Wothe/Minden Pictures/FLPA; **168-9** Will Burrard-Lucas; **170** Federico Veronesi; **173** Bruno Cavignaux/Biosphoto/FLPA; **174** Laurent Geslin; **176-7** Sandesh Kandur/Silverback Films; **178** Dirk Synatzschke; **181** Axel Gomille; **183** Jeff Wilson; **184-5** Bruno D'Amicis; **186-7** Transworld Publishers – map information courtesy World Resources Institute & University of Maryland/Global Land Analysis and Discovery (GLAD) 2018.

### JUNGLES
**188** Piotr Naskrecki/Minden Pictures/FLPA; **190-1** Huw Cordey; **192** Nick Garbutt; **195** Chien C. Lee; **196-7** Klaus Nigge; **199** Will Burrard-Lucas; **200-1** Andrea K. Turkalo; **202** Ian Nichols; **205** Paul Stewart/Silverback Films; **207** Cyril Ruoso/naturepl.com; **208-9** Charlie Hamilton-James; **210** Christian Ziegler; **212-3** Huw Cordey; **214** Gerry Ellis/Minden Pictures/FLPA; **216-7** Tim Laman; **218t** Tim Laman & Ed Scholes/Silverback Films; **218b** Tim Laman; **221** NASA/METI/AIST/Japan Space Systems US/Japan ASTER Science Team; **222** Ton Koene/Alamy; **225** David Coventry; **226** Ben Macdonald; **228-9** Frédéric Demeuse.

### COASTAL SEAS
**230** Alex Mustard; **232-3** Greg Lecoeur; **235** Alex Mustard; **236-7** Greg Lecoeur; **238** AirPano; **240-1** Juergen Freund/naturepl.com; **242** Roger Horrocks; **244-5** Gisle Sverdrup; **246** Grace Frank; **248-9** Santiago Cabral; **251** created by Daily Overview/source NASA; **252** Tim Laman; **255** Alex Mustard; **256-7** David Doubilet/National Geographic Creative; **258** Joe Platko; **261** Angel M. Fitor; **262-3** AirPano; **264-5** Transworld Publishers – map information courtesy UN Environment World Conservation Monitoring Centre 2018.

### HIGH SEAS
**266** Oliver Scholey/Hector Skevington-Postles; **268-9** Ralph Pace; **271** Dan Rasmussen; **272-3** Steven Benjamin; **275** Richard Herrmann; **276-7** Gisle Sverdrup; **279** NOAA/Lophelia II 2009 Expedition; **281** Hugh Miller/Silverback Films; **282-3** Hugh Pearson; **285** MARUM – Center for Marine Environmental Sciences, University of Bremen; **286-7** Santiago Cabral; **289** Alexander Semenov; **290** Andrea Casini; **292-3** Doug Perrine/naturepl.com; **294** Oliver Scholey; **296-7** Frans Lanting; **298** NOAA/Alamy; **300-1** Tony Wu.

### Epilogue
**302** NASA Earth Observatory images Joshua Stevens/Suomi NPP VIIRS data from Miguel Román NASA's Goddard Space Flight Center; **305** Tim Laman; **306** Christian Ziegler; **309** NASA photograph John Sonntag; **310-1** Florian Ledoux.

Permits: 20 and 266 (Scientific Research Permit 01823-17, Semarnat, Mexico); 59 (Marine Mammal Permit 14245).

## SPECIAL THANKS TO
Centre D'Études Nordiques (CEN)
Manuel Duarte
Ecuagenera, Ecuador
Ernest Eblate
Emanuel Goulart
Paul Guarducci
Alun Hubbard
Bazili Kessy
Ben Lambert
Emmanuel Masenga
Mike Oblinski
Salto Morato Nature Reserve, Brazil
Natacha Sobanski
Swimming with Whales (Government of the Azores permit #02-ORAC-2017)
Ann Thiffault
Jared Towers
Don Wilson

### FROZEN WORLDS
Arctic Bay Adventures
Arctic Bay Hunters and Trappers Organization
Basecamp Explorers
Bird Island Research Station researchers, 2016
British Antarctic Survey
Terry Edwards
Greenpeace MV *Arctic Sunrise* crew
Jean-Michel Moreau-Dumont
Polar Continental Shelf Program, Resolute Bay
Dion Poncet
Resolute Bay Hunters and Trappers Association
Jason Roberts
Ryrkaypiy community, Russia
Government of South Georgia and the South Sandwich Islands
Enurmino community, Russia
Nansen Weber

### FRESH WATER
BioAqua Pro Kft.
Parque Nacional Natural Caño Cristales
CORMACARENA, Colombia
Crane Trust, Nebraska
Angel Fitor
Florida State Parks: Rainbow Springs & Ichetucknee Springs
Howard T. Odum Florida Springs Institute
Film location courtesy of Audubon's Iain Nicolson Audubon Center at Rowe Sanctuary
Ministry of Information, Youth, Culture & Sport, Tanzania
Nahuel Huapi National Park, Argentina
NSW Government, Office of Environment & Heritage
Platte River Recovery Implementation Program
Tanzania National Parks
Tiwi Land Council and Landowners
Vatnajökull National Park, Iceland
Wes Skiles Peacock Springs State Park, Florida

### FROM DESERTS TO GRASSLANDS
His Highness Shaikh Abdullah bin Hamad bin Isa Al Khalifa, personal representative of His Majsty the King, President of the Supreme Council for Environment, Kingdom of Bahrain
Dave Black
Paul Brehem
Femke Broekhuis, Project Director, Mara Cheetah Project
Hustai National Park, Mongolia
Vladimir Kalmykov, Director, Stepnoi Reserve, Russia
Digpal Karmawas
Mohan Kumar
Samuel Munene

Andrew Spalton
Nikolai Stepkin
Andras Tartally
Jeremy Thomas
David and Judy Willis

### FORESTS
African Wildlife Conservation Fund
Beyond Asia
BC Wildfire Service
Sergei Gaschak
High Commission of India, London
McDonald Forest
Ministry of External Affairs, New Delhi
Nehimba Lodge, Hwange National Park, Imvelo Lodges
Oregon State University
Save Conservancy
Sikhote-Alin Biosphere Park
State Specialised Entreprise 'Ecocentre'
WCS Russia

### JUNGLES
Crees Foundation, Peru
Veno Enar
Milou Groenenberg
Andrew Hearn, Wildcru
Ministère de l'Economie Forestière, Congo
Mulu National Park, Malaysia
National Film Institute, Papua New Guinea
Philippine Eagle Foundation
Shita Prativi
Jenni Serrano
Sumatran Orangutan Conservation Programme, SOCP
Tawau Hills Park, Malaysia
Wildlife Conservation Society, WCS

### COASTAL SEAS
*The Aqua Tiki II* crew
*The A'boya* crew
Eric Coonradt
Ernie Eggleston
Laura Engleby
Great Barrier Reef Marine Park Authority
Garl Harrold
Misool Eco Resort
Fernando Olivares Chiang
Punta San Juan Program, Peru
Philip J. Sammot
Jan Straley
*The Truth* crew
Carlos Zavalaga

### HIGH SEAS
Alucia Productions
Steve Benjamin
Jean-Christophe Cane
Dan Fitzgerald
Diane Gendron, CICIMAR/IPN, Mexico
Nico Ghersinich
Richard Herrmann
Jennifer Hile
Charles Hood
Danny Howard
Tina Kutti
Haseeb Randhawa
Dr Sandra Brooke
FS *Sonne* crew and scientists, cruise SO258

TRANSWORLD PUBLISHERS
61–63 Uxbridge Road, London W5 5SA
www.penguin.co.uk

Transworld is part of the Penguin Random House
group of companies whose addresses can be found
at global.penguinrandomhouse.com

First published in Great Britain in 2019 by Bantam Press,
an imprint of Transworld Publishers

This book is published to accompany the television series
entitled *Our Planet* first broadcast on Netflix in 2019

A CIP catalogue record for this book is available
from the British Library.

Commissioning editor: Susanna Wadeson
Project editor: Rosamund Kidman Cox
Design: Smith & Gilmour
Picture researcher: Laura Barwick
Image grading: Stephen Johnson, www.copyrightimage.co.uk
Production: Catriona Hillerton

ISBN 9780593079768

Colour reproduction: AltaImage, London
Printed and bound in China by Toppan Leefung Ltd

Penguin Random House is committed to a sustainable future
for our business, our readers and our planet. This book is
made from Forest Stewardship Council® certified paper.

10 9 8 7 6 5 4 3 2 1

### ALASTAIR FOTHERGILL

In his almost 30-year tenure at the BBC Natural History Unit, Alastair Fothergill was responsible for the landmark series *The Blue Planet, Planet Earth* and *Frozen Planet*, among a range of productions. Since 2006, he has also worked for Disney, directing six wildlife movies for its Disneynature label. In 2012, he set up Silverback Films with Keith Scholey. Silverback produced *The Hunt* series for the BBC and *Our Planet* for Netflix – the first natural history Netflix Original Documentary Series. This book is Alastair's fifth. A fellow of the Royal Geographic Society and recipient of its gold medal, he also has honorary doctorates from the universities of Durham, Hull, York St John and Bristol. He lives in Bristol with his wife, two sons and two Jack Russells.

### KEITH SCHOLEY

Raised in East Africa, Keith Scholey studied zoology at the University of Bristol, gaining both a BSc and PhD. In 1982, he joined the BBC Natural History Unit as a researcher on the David Attenborough series *The Living Planet*. Later he became a producer and then series producer, running series including *Prisoners of the Sun, Wildlife on One* and the *Wildlife Specials* and creating and producing *Big Cat Diary*. In 1998, he became Head of the BBC Natural History Unit and subsequently Controller of BBC Specialist Factual Commissioning. Finally, he became the Controller of all BBC Factual Productions. In 2008, he left the BBC and is now is the joint director of Silverback Films. In this period, he has directed and produced three Disneynature feature films – *African Cats, Bears* and *Dolphin Reef* – and has been responsible for the Discovery series *North America* and *Deadly Islands* and the Netflix Original Documentary Series *Our Planet*.

### FRED PEARCE

An author and journalist based in London, Fred Pearce is a former news editor of the UK-based *New Scientist* magazine, and he has been its environment consultant since 1992, reporting from 87 countries. He also writes regularly for the *Yale E360* US website and *The Guardian* UK newspaper, as well as other UK newspapers, and irregularly for many other outlets. He won a lifetime achievement award for his journalism from the Association of British Science Writers in 2011 and was voted UK Environment Journalist of the Year in 2001. His recent books include *Fallout, The New Wild, When the Rivers Run Dry, Earth: Then and Now* and *Confessions of an Eco Sinner*, which have been translated into 24 languages. *When the Rivers Run Dry* was listed among the all-time 'Top 50 Sustainability Books' by the Cambridge Institute for Sustainability Leadership.

ourplanet.com

WHETHER WE ACK[NOWLEDGE IT OR]
NOT, WE ARE TOTA[LLY DEPENDENT]
ON THE NATURAL W[ORLD. IT FEEDS]
US WITH EVERY MO[UTHFUL OF FOOD]
WE EAT AND EVERY[...]
IT IS THE MOST PRE[CIOUS THING WE]
HAVE, AND WE NEE[D TO PROTECT IT.]
OUR FUTURE DEPE[NDS ON OUR]
ABILITY TO TAKE A[CTION...]